THE HISTORY
OF A PERIPHERY

JOE R. AND TERESA LOZANO LONG SERIES IN LATIN AMERICAN AND LATINO ART AND CULTURE

THE HISTORY OF A PERIPHERY

Spanish Colonial Cartography from Colombia's Pacific Lowlands

Juliet B. Wiersema

University of Texas Press ᚛ᚉᚉᚉ Austin

Copyright © 2023 by the University of Texas Press
Printed in the United States of America
First edition, 2023

Requests for permission to reproduce material from this work should be sent to:
 Permissions
 University of Texas Press
 P.O. Box 7819
 Austin, TX 78713-7819
 utpress.utexas.edu

♾ The paper used in this book meets the minimum requirements of ANSI/NISO Z39.48-1992 (R1997) (Permanence of Paper).

Library of Congress Cataloging-in-Publication Data

Names: Wiersema, Juliet B., 1967– author.
Title: The history of a periphery : Spanish colonial cartography from Colombia's Pacific
 lowlands / Juliet B. Wiersema.
Description: First edition. | Austin : University of Texas Press, 2024. | Includes
 bibliographical references and index.
Identifiers: LCCN 2022051898 (print) | LCCN 2022051899 (ebook)
 ISBN 978-1-4773-2774-6 (hardcover)
 ISBN 978-1-4773-2775-3 (pdf)
Subjects: LCSH: Cartography—Colombia—History—18th century. | Cartography—
 Colombia—History—19th century. | Land use—Colombia—History—18th
 century—Sources. | Land use—Colombia—History—19th century—Sources. |
 Colombia—Maps—Early works to 1800. LCGFT: Maps.
Classification: LCC G1731.S12 W54 2024 (print) | LCC G1731.S12 (ebook) | DDC
 912.861—dc23/eng/20230613
LC record available at https://lccn.loc.gov/2022051898
LC ebook record available at https://lccn.loc.gov/2022051899

doi:10.7560/327746

CONTENTS

ACKNOWLEDGMENTS

Like a river fed by its tributaries, this book has been nourished and enriched by many individuals, institutions, and organizations. I am deeply indebted to all.

In Bogotá, I thank Mauricio de Tovar at the Archivo General de la Nación for sharing his vast knowledge, the archivo's maps, and key publications with me at an early stage in this research. His tireless efforts to digitize the AGN's maps and case files have made this historical treasure trove accessible to researchers both at the archive and outside of it. Freddy Quitian, in the AGN Biblioteca, presented me with historical resources that I never would have found on my own. Archivists at the AGN, as well as Anthony Picón at the Biblioteca Nacional de Colombia, and Victor González and Francisco López at the Instituto *Colombiano* de Antropología e Historia, led me to foundational maps, books, and documents. Colleagues and friends, including María Alicia Uribe, Marianne Cardale Schrimpff, Ana Maria Groot, Clemencia Plazas, Hector Llanos, Marta Herrera Ángel, Cesar Giraldo, and Moisès Bertran, provided generous counsel, enlightening conversation, and memorable excursions.

Archivists and academics at the Archivo Central del Cauca in Popayán graciously made available dozens of case files and were warm hosts on each of my visits to Popayán. I thank Lina Maya Mejia, Hedwig Hartmann, Zamira Díaz López, Yurany Perdomo, Hernán Torres, Maria Cecilia Velásquez López, and Diógenes Patiño for their generosity and insights. In Cali, Ana Henao and archivists at the Archivo Histórico de Cali enabled me to study important case files and documents. I thank Mario Diego Romero and Francisco Zuluaga for their interest in this project as well as their ideas and support.

I was fortunate to collaborate with scientists and scholars at the Library of Congress, including Fenella G. France, Meghan Wilson, Tana Villafana, Hadley Johnson, Paulette Hasier, Julie Stoner, Mike Klein, Cynthia Smith, and John Hessler. I am grateful to the Geography and Map Division and the Preservation Research and Testing Division for facilitating imaging analysis on the *Manuscript Map of Dagua River Region, Colombia* and am indebted to Meghan, Tana, and Hadley for the resulting report and a very enjoyable day in Washington, DC. A summary of this research is presented in appendix B. Early on, José Carlos de la Puente offered up his time, profound archival knowledge, and reassurance that this project was in fact feasible. His support and encouragement helped launch this study.

I owe a particular debt to Kris Lane, Matt Nielsen, Max Deardorff, and an anonymous reviewer for reading the full manuscript and providing comments that helped focus the text and refine my thinking about rivers, mining regions, the Pacific Lowlands, and New Granada. Their sagacious counsel and steadfast support enabled this book to take a more fluid form. I thank John Douglass, Christine Beaule, and our 2018 Amerind group, as well as Richard Weiner, Anthony Mullan, Augusto Oyuela-Caycedo, Chet Van Duzer, Lori Diel, Lucia Abramovich, Andrea Pappas, Julie Johnson, Scott Sherer, Spencer Abrusesse, Jorge Galindo Díaz,

Catherine Dossin, Béatrice Joyeux-Prunel, and Delia Cosentino for their suggestions on strengthening individual chapters of this book. I thank Sarahh Scher for creating the book's index, which was no small task.

I express heartfelt gratitude to the members of the Southwest Seminar and participants at the 2018 meeting, including Alex Hidalgo, Ryan Kashanipour, Kevin Gosner, Martha Few, Mark Lentz, Joaquín Rivaya-Martínez, José Carlos de la Puente, Jay Harrison, Dana Velázquez Murillo, Ignacio Martínez, Michael Brescia, Kittiya Lee, Max Deardorff, Mark Hanna, Bianca Premo, Christoph Rosenmüller, Meghan McDonie, Eva Mehl, and Jessica Criales, for their creative and critical approaches to the Spanish colonial Americas and for their collegiality and friendship.

Aspects of this book were nurtured by resources and conversations in Providence, Rhode Island. I thank Val Andrews, Kimberly Nusco, Pedro Germano Leal, José Montelongo, Bertie Mandelblatt, Michele Carreiro, Karin Wolff, and Neil Safier, as well as fellow John Carter Brown Library fellows Coni López, Davíd Rex Galindo, Ximena Sevilla, Daniella Skeehan, Anna Ficek, Johnathan Schroeder, James Almeida, and Drew Konove. I am grateful to Parker VanValkenburgh, Felipe Rojas, Joseph Correia, Kasther Bragatto, Robin Halpren Ruder, and Michele Mericle for hospitality, culinary outings, and musical interludes.

Photographs and images for this book have been graciously provided by John M. Anderson, David Fayad Sanz, Javier Peña-Ortega, and José Manuel Restrepo Ricaurte. Transcriptions and translations are mine, but Juan José Ponce Vázquez, José Carlos de la Puente, and Bill Fisher provided assistance with arcane terms and passages. Jesse Cromwell, Gloria Lopera, and Daniela Vásquez Pino have generously shared their research and resources with me. Editorial expertise has come from Bethany Murphy. Hannah Wong has been an important sounding board from the beginning.

I am grateful to Jonathan Brown and Colin Eisler for early, foundational thinking about image and text and to Marjorie Venit and Chris Donnan for their encouragement and mentorship. Important paleography training came from the Mellon Foundation, the Harry Ransom Center, and our 2011 summer Spanish paleography cohort. I am eternally grateful to funding and support from the National Endowment for the Humanities. It is a rare intellectual luxury to have a full funded year to put to uninterrupted thinking and writing. I thank the John Carter Brown Library for five months of funded research in a visually spectacular and intellectually fruitful setting. A University of Texas San Antonio Tenure-track Research Award Competition grant supplied the financial means to begin this project, and the Dean and the Senior Associate Dean for Research and Graduate Studies of the College of Liberal and Fine Arts, respectively, Glenn Martinez and Jason Yaeger, kindly furnished the means to complete it.

Kerry Webb, Christina Vargas, Robert Kimzey, Gloria Thomas, and skilled staff at the University of Texas Press are to be thanked for seeing this project from manuscript to printed publication.

I thank Kenko for both supporting this project and providing much-needed diversion from it. From his treehouse retreat in the California coastal redwoods, this book moved from ideas to words on the page. The project also benefited from the four-legged furry presence of Butters and Jasper. I thank them for their frequent reminders to stretch and hydrate.

ABBREVIATIONS

ACC Archivo Central del Cauca, Popayán
AGI Archivo General de Indias, Seville
AGMM Archivo General Militar de Madrid

AGN Archivo General de la Nación, Bogotá
AHC Archivo Histórico de Cali
BNC Biblioteca Nacional de Colombia, Bogotá

GLOSSARY

Definitions of terms here apply to their usage in New Granada in the eighteenth century.

aguardiente: cane brandy

alcalde: magistrate

alférez real: senior regidor; also, municipal standard-bearer

arrastradero: road that unites two waterways for travel

arroba: unit of weight of approximately 25 pounds (11.5 kilograms)

audiencia: the highest judicial tribunal, endowed with administrative powers

blanco: a Spaniard, non-Spanish European, or criollo

boga: canoe poler

cabildo: municipal government

cabo: captain

cacique: Indigenous chief or leader

canoero: canoe poler

carguero: overland porter of cargo

caserío: village

champán: large, roofed watercraft used in river navigation, powered by men wielding long poles

chicha: fermented corn beverage

chontaduro: peach palm

cimarron/a: runaway slave; also, Indian who fled a reducción in search of freedom or refuge

colegio: seminary

comerciante: merchant

cordillera: mountain range

corregidor: Crown official appointed to oversee the administration of a corregimiento; also, magistrate who presided over a district of Indian settlements

corregimiento, or *corregimiento de indios*: district of Indians settled by the Spanish and governed by a corregidor

criollo: person born in Spanish America, sometimes of Spanish heritage

cuadrilla, or *cuadrilla de negros*: enslaved labor gang

cura: priest

diezmos: mandatory ecclesiastical tithe amounting to a tenth part of agricultural produce collected

encomienda: institution in Spanish America wherein a colonizer was given land and a group of Indigenous people to work it and was expected to provide protection and Catholic evangelization for them in return

estancia: estate; also, house and grounds

dueño de minas: mine owner

entrada: expedition for the purposes of trade, raid, exploration, or conquest

esclavo: a Black African brought from West or Central Africa through the transatlantic slave trade who had not yet obtained manumission; also, the offspring of enslaved people brought from Africa

esclavo de todos colores: enslaved person of mixed ancestry

estanco: state monopoly on goods such as aguardiente and tobacco

estanquero: official who oversaw the sale of aguardiente

estanquillo: official place where aguardiente was sold

gente libre: non-enslaved people, free people

gente libre de todos colores: non-enslaved people of color; also, free people in any ethnic category who could not be defined as blanco, negro, or indio

gobernación: governing body

hacendado: owner of a hacienda

hacienda: landed property or plantation, including all its appurtenances (laborers, tools, houses, etc.)

inconveniente: drawback, complication, or obstacle

indio: Indian; Indigenous person

indio forastero: Indigenous person who came from elsewhere

indio infiel (pl. *indios infieles*): unchristianized Indigenous person

legajo: case file

libre: person who was born free; also, person who had recovered her or his freedom

libre de todos colores: free person of color in any ethnic category that could not be defined as blanco, negro, or indio; catchall term for free negros, mulatos, zambos, mestizos, pardos, and montañeses

maíz: corn

manatiero: manatee fisherman

mayordomo: steward; also, administrator

mestizo: person of mixed European and Indigenous heritage

mina de oro: gold mine

montaña: mountainous area

montañes (pl. *montañeses*): person inhabiting the mountainous areas near the Anchicayá, Bitaco, Pepita, and Dagua Rivers

monte: dense tropical forest

mulato: person of mixed European and African heritage; pardo

natural (pl. *naturales*): Indigenous inhabitant

negro: person of African heritage

palenque: palisaded camp formed and inhabited by runaway slaves

pardo: person of mixed European and African heritage; mulato

patacon: peso of eight reales; silver coin weighing 1 ounce (28.35 grams)

peso: coin with a value of eight reales; patacon

piragua: Indigenous watercraft that is square at each end and has a keel

placer, or *placer gold*: minerals/gold that has been eroded, transported, and deposited by water in a location other than where it was formed

plátano: plantain

pleito: lawsuit

población: city, village, or place that is inhabited by people

presidio: fortification

pueblo: town

pueblo de indios: settlement created by a Spanish administrator to facilitate Spanish control over reduced Indigenous subjects, collect tribute from them, provide religious instruction, and use their labor; reducción

pueblo de libres: free town

quebrada: ravine, gorge, mountain stream, or streambed

quintos: royal mining tax

real (pl. *reales*): royal; also, anything that pertains to the king; also, unit of money worth thirty-four maravedis

real cedula: royal decree

real de minas (pl. *reales de minas*): large mining operation

reales cajas: royal coffers

Real Hacienda: Royal Treasury

reducción: settlement created by a Spanish administrator to facilitate Spanish control over reduced Indigenous subjects, collect tribute from them, provide religious instruction, and use their labor

regidor: person who governs

resguardo: communal agricultural land assigned to Indigenous communities

sembreria: crop

sitio: informal settlement

tambo: humble inn for travelers

trapiche: sugar mill

tribute: portion or quantity paid by a vassal or reduced Indian to the owner of an estate or a corregidor; labor as well as goods could be given as tribute

vara: unit of length of 1 yard (about .91 meters)

vecino: citizen or resident, a designation that brought with it privileges as well as obligations and responsibilities

vigía: watchtower; lookout; defensive post

visita: royal inspection usually undertaken by a government official to investigate works of government

visitador: royal inspector

víveres: provisions

zambo: person of mixed Indigenous and African heritage

THE HISTORY
OF A PERIPHERY

INTRODUCTION

Discovered and colonized by the Spanish in the early sixteenth century, the territory that became the viceroyalty of New Granada, with its treacherous rivers, impassable mountains, and dense tropical jungles, proved challenging to traverse and impossible to govern. Many regions putatively under Spanish control were distant from New Granada's major urban centers of Cartagena, Santa Fé de Bogotá, and Tunja (figure I.1). One such región, the Pacific Lowlands, also called the Greater Chocó—the geographic focus of this book—was a periphery on the Pacific coast famed for its rich placer, or gold, deposits (figure I.2).[1] In the Spanish colonial period, gold mined from the Pacific Lowlands represented a key source of revenue for the monarchy.[2] Because this gold-mining region was situated weeks and sometimes even months from colonial cities and centers (in contrast to the silver mines in Potosí, Bolivia, and Zacatecas, Mexico, located in dense urban centers), it was rarely visited by colonial administrators, engineers, or topographers. As a result, many areas in the Pacific Lowlands were never officially mapped by the viceregal government.[3] Writing in 1808, the famous Colombian scientist and polymath Francisco José de Caldas expressed incredulity that three centuries after New Granada's discovery and colonization by Spaniards, there still was no map that offered an accurate picture of the interior of the viceroyalty or the extent of its rivers, their origins, their difficulty to navigate, or potential ways to connect them.[4] Half a century later, the Italian engineer Agustín Codazzi, who directed the Comisión Corográfica

(the Chorographic Commission of Colombia, 1850–1859) in the monumental task of defining and mapping Colombia's young republic with an eye toward asserting national sovereignty, strengthening governance, and spurring economic development, noted that neither the king nor his viceroys nor the local authorities understood the extents of the rivers and tributaries in the Pacific Lowlands.[5]

Printed circulating maps of New Granada produced at this time tended to show the Pacific Lowlands as a void, suggesting terra incognita. Hand-drawn maps of these same areas, however, reveal geographies that were well understood to the people who inhabited them. One such map is the manuscript *Mapa de la costa del Pacífico desde Buenaventura hasta el río Naya, con mención de todos los otros ríos* (Map of the Pacific coast from Buenaventura to the Naya River, with mention of all the other rivers, plate 1), which I will refer to as the Map of the Yurumanguí Indians. This 1770 map depicts an alluvially rich area stretching from Buenaventura in the north to the Naya River in the south. The absence of towns and churches suggests the space as remote, uninhabited, and unsettled. Nevertheless, when one zooms in to the center of the map, house-like emblems come into view (see figure I.3). These symbols identify the locations of the dwellings of the so-named Yurumanguí Indians, an Indigenous group first documented by Spaniards in 1742. While this cartographic work appears to depict a timeless landscape, it instead captures a fleeting moment on the space-time continuum.[6] It chronicles both the Spanish "discovery"

of the area's Indigenous inhabitants as well as their demise. By the time the map arrived to its intended recipient in 1770, most of the Yurumanguí Indians had fallen victim to European disease.[7]

Like other manuscript maps discussed in this book, the Map of the Yurumanguí Indians depicts a place that was geographically distant from New Granada's capital, Santa Fé. This distance, along with the area's topography and climate, meant that despite being rich in alluvial mines it was infrequently visited or documented by colonial officials. Resultantly, it did not appear in any detail on printed maps of the period. This map, like others examined in subsequent chapters, advocated for needed infrastructure and made claims to land. Geographically and temporally specific in its representation of place, the map captures and suspends space-time.[8]

The manuscript maps explored in this book emerged from concrete local conditions and circumstances. A close analysis of these maps and their related archived case files (called *legajos*, *expedientes*, or *signaturas*) enables us to recapture specific moments on the space-time continuum, resurrect forgotten places of economic possibility, and unlock as-yet-untold narratives about individuals, ethnicities, provincial industries, and local politics in this peripheral area of the Spanish Empire. Through these maps, we learn about ambitious Spanish settlers and the factors that thwarted their colonization efforts in the Pacific Lowlands: resistant and independent Indigenous groups, autonomous and enterprising Africans and free people of African descent, and the wild, impossibly steep, densely forested, and intensely tropical zones that the Spanish tried, unsuccessfully, to tame.

My original intention in writing this book was to present a broad but cursory look at dozens of

FIGURE I.1 The portion of New Granada with sites discussed in this book. Shaded area is present-day Colombia. Created by Milenioscuro and adapted by author.

FIGURE I.2 The Pacific Lowlands (shaded area on overall map) stretches from the Darién Gap near Panama to the northern coast of Ecuador, encompassing almost ten million hectares of tropical rain forest. Creative Commons Attribution-ShareAlike 4.0 International license.

FIGURE I.3 Detail of the Map of the Yurumanguí Indians, 1770 (plate 1), showing locations of Indigenous dwellings along rivers (thick white lines) and paths (thin brown lines).

little-known manuscript maps from lesser-known corners of New Granada. The most significant repository for these cartographic works is the Mapoteca (Map Library) of the Archivo General de la Nación (AGN) in Bogotá, Colombia, with over four hundred hand-drawn maps created between 1592 and 1819.[9] More than half of these maps have eighteenth-century dates.[10] Spanning geographically from Panama to the Amazon jungle, maps in the AGN's collection provide information on the founding of towns and cities, disputes over land use and land rights, the exploitation of minerals, the precarious nature of boundaries and frontiers, and the location and relocation of Indigenous groups.[11] Importantly for this study, many of these manuscript maps recorded information about areas of the viceroyalty that were rarely visited by engineers or topographers and were seldom included on maps of New Granada itself.[12] For scholars of art history, history, cartography, anthropology, and archaeology, these manuscript maps offer a rich and untapped resource.

My initial archival work in Colombia revealed that many of the surviving manuscript maps were accompanied by letters of explanation. In other words, this visually striking but enigmatic body of cartography was not intended to be self-evident. These maps formed one piece of a larger puzzle, one part of an image-and-text whole. Maps and their corresponding letters were ultimately archived in case files with related documents. In some instances, these case files spanned hundreds of folios and several decades. Within these case files are local histories for forgotten places and social, political, cultural, and economic context for

the associated maps. Meanwhile, the manuscript maps ground these historical narratives in concrete space-time.

Despite the fact that maps were originally intended to be understood in the context of a trove of documents, maps at the AGN were severed from their case files in the 1960s. This was done with an eye to ensuring their proper care and conservation and to making the maps more accessible for study. Maps and case files remain separated to this day. At the time of separation, notations were made that cross-referenced maps with their original case files (referred to as *signaturas de procedencia*, "originating subject matter"). Despite these efforts, several maps became permanently unmoored from their original documentary contexts.[13] This book is the first attempt to restore these contexts, reconnecting the letters, official documents, and other information in the case files to these fascinating cartographic works.

Given the rich contents and contexts available for manuscript maps of the Pacific Lowlands, I have opted for depth over breadth. Correspondingly, this study undertakes a critical analysis of a small subset of these maps, considering them together with the rich archival documentation available at the AGN and other Spanish colonial repositories. Through this approach, a more textured, nuanced, and complete picture of New Granada's Pacific periphery and its place within Spain's overseas empire comes into view.[14] Apart from the detailed overview and catalog written by Vicenta Cortés in 1967, surprisingly little research has been undertaken on the AGN's handsome visual and historical corpus.[15]

Aims of This Book

The History of a Periphery: Spanish Colonial Cartography from Colombia's Pacific Lowlands addresses current gaps in scholarship by illuminating a remote region of a lesser-known viceroyalty and by critically examining and historically contextualizing a small but instructive corpus of eighteenth-century manuscript maps.[16] These maps bring into focus distant regions of the Spanish Empire and direct us to areas of economic potential.[17] They preserve information about ephemeral settlements that are recorded nowhere else, providing us with a novel and as-yet-untapped source of information on geography, society, and economy for the eighteenth-century Pacific Lowlands. They illuminate how representations of geographical space were conceived, manipulated, and deployed in late eighteenth-century New Granada to serve colonists' ends while preserving little-known stories of Africans and native people who adapted to the extreme challenges of environment and colonization, actively participated in the economy, and shaped society in distinctive ways.

In this study, I investigate four manuscript maps from the Greater Chocó created between 1759 and 1783. Each map forms the subject of its own chapter (chapters 3 through 6). For each of these, archival documents historically contextualize the specific circumstances that led to the map's creation.

Throughout this book, I interrogate maps as complex visual systems of communication. From each, I extract local narratives about ephemeral places that have thus far been overlooked in historical scholarship.[18] The manuscript maps examined preserve within their borders stories that unfolded in a region of abundant rivers, impenetrable forests, impassable mountain chains, and infrequent roads. These maps provide the settings for the stories. Meanwhile, other story elements—characters, plot, conflict, and resolution—must be teased from the historical documents preserved in archival repositories. These resultant histories reveal that peripheral areas of the Greater Chocó were not sleepy, passive backwaters but instead were dynamic, multicultural spaces of ingenuity, opportunity, and adaptation.[19]

I explore why these manuscript maps were made, by whom, and for whom. I examine the various ways that manuscript maps from the Pacific Lowlands were deployed to argue for needed defense and infrastructure in this area of rich placer deposits. I also consider what manuscript maps can tell us about the process of colonization in one of Spain's understudied viceroyalties, New Granada. The maps highlight the margins of empire as opposed to its epicenters, illuminating the dark and distant corners of Spain's overseas realms. They serve to substantiate what Kris Lane observed in his groundbreaking book *Quito 1599: City and Colony in Transition*: "The dead certainties of the center (Lima, Mexico City, Seville) seem far less convincing at the mercurial or unstable periphery."[20] It is my hope that this study will provide a stimulating counterpoint to the robust corpus of scholarship on the cartography of Spanish America, much of which has focused geographically on the viceroyalties of New Spain (today's Mexico) and Peru, temporally on the sixteenth and seventeenth centuries, and sociopolitically on urban centers.[21]

What Are Manuscript Maps?

Maps can be defined as graphic representations that facilitate a spatial understanding of things, concepts, conditions, processes, or events in the human world.[22] Manuscript maps, meanwhile, are cartographic works created by hand as opposed to being printed. Manuscript maps are not diametrically opposed to printed maps, but they do differ from their printed counterparts in significant ways.

Printed maps tend to depict cities, countries, and continents. They confirm an order and a connectedness through the presence of roads. Printed maps privilege the built environment, highlighting churches, towns, and capitals. Conversely, manuscript maps examined in this book shine a light on unsettled and undeveloped areas. Instead of projecting a connection to a larger whole, manuscript maps of the Greater Chocó assert isolation, where any vestige of human presence is eclipsed by the omnipresence of the natural world. Where printed maps might suggest the idea of human dominance over nature, manuscript maps of New Granada's Pacific peripheries reveal that such control was an illusion.

Another important distinction between manuscript maps and printed ones concerns their production. Printed maps were often the result of large commissioned or state-sponsored projects.[23] The geographers at the heart of such initiatives

were professionals who relied upon the most recent scientific knowledge and instrumentation available. These experts leveraged the work of other professionals and looked to myriad sources of collected information, including earlier maps.[24] Often, professional mapmakers did not possess first-hand knowledge of the geographies they rendered two-dimensionally. Many printed maps of New Granada, including those recognized as the most accurate for the time, were made an ocean away, in the Netherlands or in France, by cartographers who had never set foot in the viceroyalty.[25]

Those who sat down to hand draw maps of the Pacific Lowlands did not have state-of-the-art instrumentation at their disposal, nor did they have the luxury of looking to previously existing maps, because such maps had not yet been created or were not in circulation. Instead, manuscript maps were the product of local knowledge and firsthand experience. Manatee fishermen (*manatieros*) were important informants in the Chocó. Farther south, along the Dagua, Yurumanguí, and Naya Rivers, Spaniards likely undertook their own reconnaissance but still relied heavily on the knowledge of Indigenous and African inhabitants. Furthermore, manuscript maps did not involve a mechanical process, nor did they cross media, from paper to copperplate to print, meaning that fewer steps and fewer hands went into their creation.[26]

One last significant difference between printed maps and the manuscript maps explored in this book is their audience. Printed maps were circulated widely, across countries and seas. Manuscript maps, however, were created for a restricted audience and were not intended to be mass produced. Manuscript maps made immediate, tangible, and legible areas of the viceroyalty of New Granada that most colonial officials would never venture to see or experience for themselves. The maps, once complete, would travel from their place of origin (e.g., Quibdó, Beté, Cali) to the viceregal palace in Santa Fé, where they would be viewed by the viceroy's secretary or his aide. From there, map and accompanying letter and any related documents would be filed in a government archive. What remained of these archives later became the Archivo General de la Nación in Bogotá, where many of the manuscript maps examined in this book reside today.[27]

Through their seemingly impressionistic projections of sparsely inhabited space, manuscript maps reflect the isolated nature of many parts of New Granada. The geographical features on these maps and the absence of coordinates or scale suggest they were imprecise renderings of geography. As I will demonstrate, however, these locally produced cartographic works provide a specific view of places that occupied just a brief moment on the space-time continuum. Because details about this coastal periphery are absent from printed maps, manuscript maps offer one of our richest sources of cartographic information for infrequently visited and little-documented areas of New Granada.

Creating Manuscript Maps of the Eighteenth-Century Pacific Lowlands

While manuscript maps can defy easy categorization, those from the eighteenth-century Pacific Lowlands most closely align with administrative cartography, one of the most prolific areas of cartographic production in Europe between 1650 and 1800.[28] In Spanish America, most administrative maps were created and submitted in manuscript form, often as part of extensive court cases or reports that relied on oral testimony in addition to graphic representation.[29] Because these administrative maps contained sensitive information, they were not commonly reproduced, distributed, or circulated.[30] Today, these maps and their associated documents are dispersed among dozens of different archives, remaining undiscovered and unexplored, resulting in what Stepháne Blond calls "a situation that impedes our complete knowledge of this vast field."[31]

The production of the manuscript maps explored in this book coincided with the economically driven Bourbon reforms under Charles III (r. 1759–1788).[32] These reforms aimed to extract every last resource from every possible corner of Spain's overseas colonies and led to ambitious expeditions and initiatives throughout the Spanish Empire.[33] Several of these expeditions unfolded in or moved through New Granada, yet none appear to have resulted in the creation of circulating geographic knowledge about the Pacific Lowlands. Consequently, these ambitious projects tell us almost nothing about the geographically peripheral mining regions that were of central economic importance to the Spanish Crown.

Through the lens of manuscript maps, New Granada's Pacific Lowlands—a remote region in

a fringe viceroyalty, and an area long considered "the periphery of the periphery"[34]—comes into high relief. Because this region lay outside the purview of imperial mapmaking, there were few if any existing maps to serve as points of reference. José Mosquera, in his book about land litigation in the Chocó, observes that this dearth of maps led to land disputes. To resolve these conflicts, hand-drawn maps were produced.[35]

Manuscript maps from the eighteenth-century Pacific Lowlands were usually commissioned or made by *vecinos* (a designation meaning citizens or residents) who had specific, often local, vested interests. Maps they commissioned accompanied written appeals that were sent to powerful colonial officials who had personal and political stakes of their own. Some of the manuscript maps I discuss can be attributed to named authors, while the authors of others are unnamed. What seems clear is that all the maps commissioned by Spaniards were informed by Indigenous inhabitants. As Neil Whitehead observes, bilingual native informants were a staple element of European cartographic efforts. Old World outsiders solicited information from New World people to make up for the interrogators' lack of geographic understanding.[36] Despite the fact that Indigenous knowledge was often encoded by distinct conceptual schemas, native people were able to recodify this spatial knowledge in ways Europeans could understand.[37] Alexander von Humboldt stressed the critical role of native informants, writing that the Indians were the only geographers of the Indies. In addition to being able to forge or find paths, they had a clear understanding of the distances that separated places. With their knowledge, Humboldt wrote, he was able to make his own map of the Orinoco River.[38]

Manuscript maps from the Pacific Lowlands vary in size, style, and orientation.[39] The largest map discussed in this book measures 22.8 x 48.8 inches (58 x 124 centimeters) and is rendered across twelve sheets of laid paper (see plate 1).[40] The smallest map is contained on two sheets and measures 12.2 x 16.5 inches (31 x 42 centimeters) (see plate 2). Some of these maps employ iron gall ink and watercolor, while others use ink alone.[41] Pigments for many of these cartographic works have not yet been identified. However, the use of azurite, verdigris (or a copper-resinate), and vermilion has been confirmed for one of the watercolor maps in this study.[42]

It is important to underscore that the manuscript maps discussed in this book were not the result of a single project, initiative, or commission.[43] Each map was made by a different person (or persons) and responded to a distinct set of circumstances and needs. As a result, each map exhibits its own aesthetic, its own style, and its own argument or objective.

These manuscript maps are not concerned with the accurate representation of geographical space. Some are intentionally selective and even misleading in their depictions. As Mark Monmonier has written, for any map to portray "meaningful relationships for a complex, three-dimensional world on a flat sheet of paper," it must distort reality and present "a selective, incomplete view" of this reality.[44] Accordingly, the maps discussed in this book are in every way subjective. All maps present their makers' intentions, biases, aims, and arguments and tell only the "truth" that supports the claims they wish to make.[45] These maps purposely distort geography, each doing so in its own way.[46] A map might exaggerate one area while minimizing another. Meanwhile, places or features not central to the mapmaker's argument are not depicted at all. Through these clever, calculated manipulations, these manuscript maps make pointed visual arguments. It is our task as viewers to carefully tease these arguments from the maps and their associated historical documents.

In this book, I will illustrate ways in which manuscript maps of the Pacific Lowlands intentionally manipulate not only space but time. In other words, they do not necessarily reflect the present they were produced in. Some maps project forward, concretizing Spanish colonial objectives or desires. Other maps, meanwhile, project backward, presenting an anachronous view of a place.

The late Spanish colonial-era manuscript maps we will examine share traits with maps produced by traditional African, American, Arctic, Australian, and Pacific societies, whose maps were also handmade, the product of local knowledge and experience, and created with specific purposes in mind.[47] Similar to maps made in traditional societies, maps from Colombia's Pacific Lowlands feature qualitative aspects of the local landscape as opposed to quantitative ones. Mapmakers placed areas of key importance at the center of a map's composition and rendered them at a larger scale, while relegating lesser-known or less relevant areas

to the map's margins. Maps often exhibit linear itineraries, where a route is dictated by a river and often follows its trajectory. Manuscript maps from the Pacific Lowlands, similar to maps produced by traditional societies, also lack a systematic scale reflecting standard units of distance. In the Greater Chocó, distance of travel was dependent upon physical distance but also upon topographic and climatic conditions, including mountains and rivers, as well as inundations and tides. Jennie Erin Smith, writing of her travels through the Darién in 2013 for the *New Yorker*, observes that the topography of the region is so varied and the rainfall so localized, it is impossible to predict the state of a river that lies only a few miles away. High rivers require travelers to backtrack. When navigating a river, it is imperative to factor in whether one is headed upstream or down, with upstream navigation by canoe often requiring twice as much time.[48] Distances in the twenty-first century, similar to those in the eighteenth, are measured in days, not in leagues or kilometers.[49]

A Sense of Place: The Pacific Lowlands as Aquatic Space

The intensely tropical environment of the Pacific Lowlands—an aquatic space rather than a terrestrial one—must be taken into account when examining eighteenth-century manuscript maps from this coastal periphery. The Pacific Lowlands encompass millions of hectares of rain forest, from the Darién Gap, near Panama, to the northern coast of Ecuador (see figure I.2).[50] With 120 to 400 inches (305 to 1016 centimeters) of annual rainfall, this region is one of the wettest in the Americas.[51] Its climate, assisted by its remoteness, has engendered a unique ecology that supports one of the world's most significant zones of tropical biodiversity.[52] The botanist and horticulturist Édouard André, who traveled through Colombia in the late nineteenth century to study its volcanoes and plants, observed that the lush vegetation of the Pacific Lowlands lent it a beautiful, exotic, and wild character, and that the climate resulted in distinct botanical species that he had not encountered anywhere else.[53] Over a century later, half of the plant species thriving in this environment remain to be identified.[54]

While this book is principally concerned with the Pacific Lowlands and its presence and absence on maps, it is also focused on rivers, riparian environments, and the various ways that multiethnic people—Indigenous, Africans, Europeans, and their mixed descendants—adapted to and experienced this aquatic space in the late Spanish colonial period. A vivid sense of place is captured in nineteenth-century travel accounts. The French explorer and diplomat Gaspard-Théodore Mollien, visiting in 1823, observed that the great humidity and excessive rain made the *piragua* (Indigenous watercraft) the most logical place for an inhabitant to live.[55] The French doctor and explorer Charles Saffray, traveling through the region in 1869, referred to the rains as "proverbial."[56] Agustín Codazzi, director of the mid-century Comisión Corográfica, mentioned earlier, remarked that rain fell nearly year round and the jungles were so thick one could barely see the ground. Furthermore, the tremendous humidity gave one the sensation of being in a bath of vapor.[57] The Colombian engineer Jorge Álvarez Lleras, writing in the early twentieth century, concurred that the humidity there compromised everything. It caused leather to rot, textiles to decompose, and iron to corrode. Even lighting a cigarette—never mind a fire—required extraordinary measures.[58]

Perhaps the most evocative description of life in the Pacific Lowlands has come from Ulrich Oslender, a political and cultural geographer who has conducted research in the Pacific Lowlands for more than two decades. In *The Geographies of Social Movements: Afro-Colombian Mobilization and the Aquatic Space*, Oslender observes that living in a place where one is literally surrounded by water—rain pouring down from above, rivers below, and humidity all around—requires inhabitants to develop novel adaptive strategies. For example, generations of Pacific Lowlanders along the Guapi River have adopted the custom of smoking with the lit end of the cigarette *inside* of their mouths to keep it from being extinguished by rain or wind. This method of smoking, called *pa'dentro*, has the added advantage of enabling one to smoke while navigating a canoe through rough water.[59]

Canoes in the Pacific Lowlands have taken on vital importance for inhabitants both past and present.[60] They enabled eighteenth-century residents and visitors to navigate this densely riparian space. It was primarily on rivers, not roads, that locals, explorers, and merchants moved from place

to place in the early days of colonization. As a result, the canoe became imperative for daily life. It remains so today: before learning how to walk, young children in rural areas of the Pacific coast move about in small dugout canoes, and many of them master canoe navigation before they know how to swim.[61]

The role of rivers here goes well beyond one of boulevards for travel. Along riverbanks, people construct their houses, bathe, wash clothes, and exchange news. On rivers, people collect water and procure fish and shellfish. The rivers and their many tributaries serve to connect people to resources and to each other.[62] Human strategies of adaptation are organized around the rivers but also are shaped by what Oslender refers to as the "aquatic space," which he describes as "an assemblage of [always shifting] spatial relations" that stems from "human entanglements with an aquatic environment characterized by intricate river networks, significant tidal ranges, labyrinthine mangrove swamps, and frequent inundations."[63] Inhabiting this aquatic space "transcends the idea of mere human adaptation to a physical environment."[64] The maps examined in this book center peripheries of the Pacific Lowlands around principal rivers: the Atrato, the Dagua, and the Naya and Yurumanguí, all aquatic spaces.

While most travel transpired on rivers, some occurred on roads. Historical descriptions indicate, however, that overland journeys were extremely arduous. Terrain in the Pacific Lowlands was steep, uneven, and slippery. André described the region's dramatic stratigraphy as being at times diagonal and at other times vertical.[65] Roads were little more than paths that washed away in the rainy seasons. Charles Empson, traveling in the 1830s, described these roads as "no roads at all but channels worked by the after currents of the deluge."[66] The lack of reliable terrestrial routes, together with treacherous terrain, led many nineteenth-century travelers—including the most intrepid—to travel by *silla*: a seat strapped to the back of a human porter, or *sillero* (figure I.4).[67] From all accounts, this frequently inundated environment, with its myriad rivers and smaller streams, was not conducive to the construction of roads.[68] And yet, many maps in this book campaign for roads to be built as a way to connect Pacific peripheries to New Granada's interior.

Periphery and *Frontera*

"Periphery," a term and concept central to this book, is used to refer to places that are located far from an urban, administrative, or otherwise conceived center. The *Cambridge Dictionary* defines "periphery" as (1) the outer edge of an area or (2) the less important part of a group or activity.[69] These definitions suggest periphery as marginal, remote, idle or inactive, and unvalued. Sociologist Edward Shils, in a 1961 essay, explores the notion of periphery as it relates to the center, observing center as a place where authority is possessed and periphery as a place over which authority is exercised.[70] More recently, center/periphery has been examined by geographer Maoz Azaryahu. The suggested distinction between a center and a periphery, Azaryahu writes, is "an uneven distribution of political and economic power and cultural capital."[71] Whether one defines "center" in geographical or sociological terms, it represents the locus of power, dominance, and the source of prestige, whereas periphery occupies a position that is subordinate.[72] Peripheries in the Roman Empire, referred to as provinces, were ruled by the imperial center and existed as administrative units. They had the disadvantage of being geographically and politically distant and were viewed as backwards and lacking in sophistication. Being peripheral to a metropolitan center evoked cultural inferiority and diminished prestige.[73]

When the term "periphery" is applied to an area of economic significance like the Pacific Lowlands, it seems somehow paradoxical. Gold extracted from this and nearby regions during the later Spanish colonial period accounted for nearly 100 percent of New Granada's total export.[74] And yet, the Pacific Lowlands remained a political periphery during three centuries of Spanish colonial rule.

For the Spanish, periphery was evoked through terms like "distante," meaning far away. In *Distance and Documents at the Spanish Empire's Periphery*, Sylvia Sellers-García observes that in eighteenth-century Guatemala, "distancia," and especially "mucha distancia" and "gran distancia," referred to places that lay far from the center. Peripheries were understood to be temporally and spatially inaccessible; economically or commercially marginalized; demographically, socially, or culturally unimportant; and administratively

insignificant.[75] Concomitantly, for colonial administrators, peripheries were understood to be places beyond bureaucratic reach or control.[76]

Another term relevant to our discussion is "frontera" (frontier). As Fabricio Prado notes, the concept of frontera had long conveyed the fringes of empire, spaces of wilderness, disputed territories, and zones where intrepid individuals sought resources and trade opportunities.[77] In the past few decades, however, scholarship has reversed its course, revealing frontiers to be populated, fluid, and dynamic spaces that permitted the negotiation of ethnic and racial status.[78] In these distant corners, miscegenation was more common and social hierarchy was less rigid than in densely populated urban centers. As such, frontiers offered opportunities and upward mobility to free and enslaved Africans and *mestizos* (people of mixed European and Indigenous heritage).[79] Frontiers also required Spaniards to rethink their deep-rooted institutions of mission, *encomienda* (an institution in Spanish America wherein a colonizer was given land and a group of Indigenous people to work it and was expected to provide protection and Catholic evangelization for them in return), military, town, and family, adapting these institutions to each specific frontier situation.[80]

David J. Weber and Jane Rausch discuss frontiers as "geographic zones of interaction between two or more distinctive cultures . . . places where cultures contend with one another and their physical environment to produce a dynamic that is unique to time and place." They also note that frontiers are environmentally dependent and see place and process as inextricably linked.[81] This understanding of frontier seems particularly apt when considering the Pacific Lowlands. While all peripheries discussed in this book were places of active entanglement between Indigenous groups, foreign interlopers, Africans, vecinos, and Spanish officials, each space was shaped by individual factors, resulting in unique outcomes and histories.

The Pacific Lowlands was not an obvious periphery, nor was it a region peripheral to all areas. Geographically, the Pacific Lowlands was easily connected by sea to other regions' *audiencias* (the highest judicial tribunals, which were endowed with administrative powers) and to other viceroyalties. As chapter 4 reveals, "periphery" is a relative term dependent upon the defined center.

FIGURE I.4 Maillart, *El monte de la agonía* (The mountain of agony). This mode of travel, where strong male Indigenous and African porters carried human cargo on their backs using a silla, was common in remote areas of New Granada. Published in Eduardo Acevedo Latorre, *Geografía pintoresca de Colombia: Nueva Granada vista por dos viajeros franceses del siglo XIX, Charles Saffray y Edouard André*, 1968: 150.

What is peripheral to one center of power might be critical for other key networks and regions.[82] The Pacific Lowlands, while distant from Santa Fé, was nevertheless an important source of gold as well as timber and tar. The problem facing the Pacific Lowlands was not a lack of potentially lucrative natural resources but its gran distancia from New Granada's capital. In sum, political circumstances, not geographical ones, shaped the perception of the Pacific Lowlands as periphery.

FIGURE I.5 The primary rivers and mountain ranges of Colombia. Map created by Milenioscuro, adapted by author.

Book Structure and Chapter Outlines

The History of a Periphery unfolds in six chapters. In chapter 1, I provide an overview of New Granada, highlighting the characteristics—topography, demography, and economy—that distinguished it from other Spanish viceroyalties. New Granada's economy privileged the mining of gold, often in remote areas. This mining was undertaken largely by Africans who were brought to New Granada to replace the diminished Indigenous populations. With time, Africans purchased their freedom, leading to the emergence of a large class of *libres de todos colores* (free people of color), the most numerous demographic in eighteenth-century New Granada. Chapter 2 establishes a cartographic baseline for the Pacific Lowlands, using manuscript maps to fill in voids left by printed

maps. As I will demonstrate, areas of the Greater Chocó come into focus only through a close examination of these hand-drawn maps.

The book's primary contributions are found in chapters 3 through 6, where I present little-known manuscript maps from different areas of the Pacific Lowlands. The maps to be discussed were chosen both for their pictorial interest and for the significant amount of archival documentation available for them. After visually analyzing each map, examining its documentary context, and locating unmoored case files relating to it, I reconstructed a preliminary history for these overlooked places in the Spanish Empire. I posit that each map makes an argument for an emerging and often ephemeral place on the local landscape, places that are currently absent from historical scholarship. The very existence of these manuscript maps suggests that the places depicted experienced at least fleeting moments of importance. By mining the contents of the associated documents—rather than analyzing the maps in isolation—it is possible to arrive at an understanding of the rich and nuanced historical circumstances that led to the maps' creation. To better illustrate that each periphery was distinct in character, shaped by factors such as geography, environment, demographics, and minimal colonial oversight, chapters 3 through 6 are organized, relative to each other, spatially (or geographically) from north to south, as opposed to chronologically.

Chapter 3, centered on the Atrato River, works from a c. 1759 map that identifies the locations of autonomous Cuna Indian pueblos (plate 2). As we will discover, the map also points us to the Cuna *reducción* (a settlement whose creation by Spanish administrators facilitated control over Indigenous subjects and use of their labor) of Murindo and its neighboring *vigía* (lookout post). Murindo was one of several short-lived settlements to emerge in response to Crown restrictions on the Atrato. By privileging Murindo and its proximity to the Atrato vigía, the map reveals that regional authorities hoped to make up for the area's lack of military defense through the establishment of settled Indigenous populations.

Chapter 4 examines the Atrato through the lens of a 1783 map that emphasizes the river's connection to the Pacific port of Cupica (plate 4). Cupica was another short-lived Spanish colonial town that emerged in response to prohibitions on travel and commerce along the Atrato. Cupica's location, on the Pacific Ocean and close to Panama and other Pacific ports, questions our notion of periphery. Cupica was a convenient node along a Pacific trade route that extended north and south, but Cupica's great distance from Santa Fé relegated it a periphery in the eyes of viceregal administrators. Similar to the Indigenous reducción at Murindo, the reducción at Cupica lasted only briefly. As such, Cupica's port and settled Indigenous population have largely been forgotten, today consigned to little more than a historical footnote. An archival investigation into Cupica's history, using a manuscript map as our point of entry, enables us to identify Cupica's geopolitical and economic importance in the late eighteenth century.

In chapter 5, we travel south, from the Chocó to the Dagua River, a critical artery of connection between the Cauca Valley and the Pacific port of Buenaventura. A 1764 map of the Dagua River region (plate 5), created to support a land dispute centered at Las Juntas, illustrates the area's isolation and the river's importance. This map also enables us to recover a story about Africans who, while forcibly brought into the area to mine gold in the late seventeenth and early eighteenth centuries, quickly adapted to local riparian conditions and, within decades of their arrival, came to control overland and fluvial transport in the region. The *sitio* (informal settlement) near the center of this map, Sombrerillo—home to some two hundred Africans and libres de todos colores—was the largest community in the area. Sombrerillo, despite its historical importance, does not appear on other Spanish colonial maps and has been discussed only briefly in historical scholarship.[83]

Chapter 6 takes us even farther south, to the Yurumanguí and Naya Rivers, where we return to the 1770 map introduced at the beginning of this chapter (plate 1). Created to accompany a proposal for a road that would connect this remote gold-mining area to the Cauca Valley, this map preserves the story of an Indigenous group—the Yurumanguí Indians—who, until the 1740s, had managed to evade discovery and subjugation by the Spanish. The map and its associated documents provide granular detail about Yurumanguí site planning, lifeways, language, and their symbiotic relationship with the environment. At the same time that the map documents their discovery, however, it also chronicles their demise.

In the book's conclusions, I review what

manuscript cartography from Colombia's Pacific Lowlands reveals about maps and mapmaking, peripheries, and the Spanish Empire during the second half of the eighteenth century. I also reflect on how manuscript maps illuminate an understanding of landscape. Given that this vast region, the Greater Chocó, has barely been studied by historians, and has been studied even less by art historians, manuscript maps of this area constitute valuable primary source documents. These maps shift our attention to the periphery, give visual primacy to little-known frontier areas, and subordinate (or omit) larger, better-known administrative or bureaucratic centers. They point us to areas of economic potential, including those of mineral and natural-resource extraction. Because manuscript maps preserve cartographic vestiges of fleeting places on the space-time continuum and document short-lived settlements that are absent on other maps of the period, they enable us to fill in geographical gaps left by printed maps. Because they contribute to a more complete view of empire, manuscript maps from the Pacific Lowlands are an invaluable resource for art historians, historians, cartographers, demographers, anthropologists, and archaeologists.

1

NEW GRANADA
A Categorically Different Viceroyalty

New Granada, one of four Spanish viceroyalties, differed from its counterparts—New Spain, Peru, and Río de la Plata—in its topography as well as its demography and economy. In the eighteenth century, New Granada encompassed the northwestern portion of South America and included the audiencias of Santa Fé, Panama, Quito, and the Captaincy General of Venezuela, areas that correspond to today's Colombia, Panama, Ecuador, and Venezuela. Spain's "discovery" of northern South America, and its efforts to conquer and colonize it, began in the early sixteenth century. The town of Santa María de la Antigua del Darién was established in 1510.[1] Vasco Núñez de Balboa explored the Atrato River in 1512. The following year, he was the first Spaniard to lay eyes on the Pacific Ocean.[2] The Caribbean coastal cities of Santa Marta and Cartagena were founded in 1526 and 1533, respectively. An expedition to the interior in 1536, led by Gonzalo Jiménez de Quesada, resulted in the founding of Santa Fé de Bogotá in 1538.[3]

Despite these early colonial forays, two centuries would pass before New Granada was established as a viceroyalty, in 1717.[4] Its first iteration, motivated by declining revenues and threats of foreign encroachment, was short lived: by 1723, the Spanish Crown had concluded that the cost of maintaining New Granada as a viceroyalty outweighed

any benefits.[5] But sixteen years later, in 1739, it was reinstated in a decision stoked by fears that New Granada's mineral wealth—namely, gold—was slipping into the hands of foreigners.[6] It was at the urging of Cartagena official Bartolomé Tienda de Cuervo, who cited New Granada's rich natural resources and its great economic potential as reasons to bring it back into the fold, that the viceroyalty was reestablished.[7] Nevertheless, a decade later Viceroy Sebastián de Eslava (1740–1749) complained that New Granada was virtually ungovernable.[8] Eslava faulted the corruption of local officials who "love disorder more than good government," but he understood that New Granada's topography was also to blame. In Eslava's view, the only way to effectively administer so many disparate regions was for each region to have its own viceroy.[9]

New Granada's Defining Characteristics: Topography, Demography, and Economy

New Granada's dramatic topography distinguished it from other Spanish viceroyalties. In Colombia, three mountain chains vertically divide the landscape: the Cordillera Occidental, the Cordillera Central, and the Cordillera Oriental (see figure I.5). Each of these cordilleras is at least 15,600 feet

(4,750 meters) at its summit and extends more than 620 miles (1,000 kilometers) at its base.[10] People traveled through New Granada primarily on fluvial highways, or rivers. Some relied on mule trains along narrow paths, which frequently washed away in the rainy season. Both modes of transportation were unreliable, hazardous, and slow.[11] Additionally, ports of entry were not well connected to the urban areas in the interior.

The itinerary of José Celestino Mutis (the future director of the Royal Botanical Expedition), who journeyed from Madrid to Santa Fé, provides an example of how lengthy and complicated travel from Spain's capital to New Granada's interior could be.[12] Departing on 28 June 1760, Mutis traveled by mule from Madrid to Cádiz. From Cádiz, he boarded a warship (*barco de guerra*) for New Granada's port of Cartagena, arriving on 29 October.[13] After a two-month stay in Cartagena, Mutis continued on to Mompox. From Mompox, he departed for Santa Fé, arriving on 24 February 1761. Mutis's six-month voyage from Madrid to Santa Fé illustrates that, even in the final century of Spanish colonial rule, many regions in New Granada were still isolated and beyond easy imperial reach.

New Granada's demography, from its population density to its ethnic makeup, also differed from that of other viceroyalties. In 1780, New Granada had only eight hundred thousand inhabitants. Its capital of Santa Fé (home to just twenty thousand) was one-fifth the size of Mexico City (in 1790) and one-third the size of Lima (in 1791).[14] Census documents indicate that by 1780, nearly half of New Granada's population lived dispersed in areas that were distant from the major centers of Santa Fé, Tunja, and Cartagena.[15] It did not have the sizeable Indigenous, Spanish, or *criollo* (people born in the Americas, some of whom had Spanish ancestry) representation of New Spain or Peru.[16] Instead, by 1770, nearly half of New Granada's population was composed of free people of color and of mixed ancestry (*libres de todos colores*, 46 percent), and just over a quarter were European (*blancos*, 26 percent). Indigenous people (*indios*) comprised 20 percent of the population, and enslaved Africans (*esclavos*) 8 percent.[17] These four socio-ethnic categories—libres de todos colores, blancos, indios, and esclavos—formed the basis of the 1778–1780 census. "Blancos" referred to Spaniards born in Spain or in the Americas, as well as non-Spanish Europeans. "Indios" referred to Indigenous inhabitants, while "esclavos" referred to enslaved laborers of African descent.

As Margarita Garrido observes, racial mixing in New Granada over generations made it impossible to determine mixtures of ethnicity, so "libres de todos colores" was a blanket term referring to anyone who could not be classified as blanco, indio, or esclavo.[18] Garrido notes that the high proportion of libres de todos colores living in New Granada was equivalent to the percentage of Indigenous populations in other parts of the Spanish Andes.[19] As a bureaucratic category, "libres de todos colores" is fairly revealing about the distinctive demographic nature of New Granada. In this primarily mixed-race society, racial divisions mattered much less than they did in societies with more rigid ethnic hierarchies.[20]

New Granada was also less opulent than cosmopolitan centers like Mexico City or Lima. In 1740, a visitor to New Granada's capital noted that the silks, laces, and fine linens worn by upper-class women in wealthier cities like Lima were absent in Santa Fé. Fashion was decidedly behind the times, with women reportedly donning their grandmothers' shawls.[21] Decades later, in 1789, Francisco Silvestre described the viceroyalty as the richest—teeming with gold, silver, emeralds, and pearls—but also the poorest, citing its corrupt politicians and ineffective government.[22]

Another defining feature of New Granada was its economy, which privileged mining and the extraction of gold.[23] Gold financed external commerce, including the importation of global merchandise.[24] Gold and mining also enabled the development of internal economic sectors such as manufacturing, ranching, and agriculture.[25] The products of New Granada's regional industries, including cloth produced in Quito, Pasto, Tunja, and Socorro and livestock and crops from Pasto and the Cauca Valley, fed the mining industry. As Jaime Jaramillo Uribe notes, New Granada's entire economy was linked to the production of gold.[26] Succinctly illustrating this point is a remark made by an administrative official in a 1783 letter to the viceroy that noted that the principal, and almost sole, motive for the subsistence of this vast kingdom and its commerce with Spain was the gold that was taken from the numerous mines that were worked in the provinces of Popayán, Chocó, and

Antioquia.[27] It was not until the final two decades of the eighteenth century (with the implementation of *reglamento de comercio libre*, "free trade," in 1778) that the Crown worked to diversify its assets, but even then, gold still comprised 90 percent of New Granada's export, with agricultural products accounting for only 10 percent.[28] Gold was the principal motivation for establishing New Granada as a viceroyalty in 1717 and the only reason for reinstating it in 1739.[29] In a 1772 report, Francisco Antonio Moreno y Escandón, a bureaucrat who served multiple viceroys, affirmed that, without a doubt, the stability and survival of the viceroyalty depended upon the *minas de oro* (gold mines) in the Chocó and their continued development. Gold was the only thing that sustained the *rentas reales* (royal revenues), commerce, and the miners themselves.[30]

While the viceroyalties of New Spain and Peru were active forces in a vibrant global economy, New Granada was largely sustained by a regional economy. This was due in large part to New Granada's topography, which increased distances, complicated travel and communication between places, and isolated it from the Atlantic economy.[31] Even products that were able to survive long periods of transport without spoiling could always be obtained elsewhere for less.[32] As a result, the majority of New Granada's inhabitants—and particularly those in the periphery—were limited to the offerings of regional markets. Meanwhile, in mining areas, basic staples were grossly overpriced, which opened a door to illicit trade and contraband.[33]

Gold Mining and African Labor

Mineral extraction in New Granada was vastly different from the mining that took place in New Spain and Peru. In New Spain and Peru, vein mining (which targeted ore deposits) occurred in wealthy, urban, and geographically well-connected centers. In New Granada, mineral extraction consisted largely of placer, or alluvial, mining and transpired along rivers in sparsely populated, remote regions.[34] "Placer" refers to gold that has been eroded, transported, and deposited by water in a location other than where it was initially formed. The term "placer" stems from the Spanish *placer*, which means "alluvial sand" and refers to any

deposit formed by water.[35] Given the great number of rivers throughout New Granada, placer mining was much more common there than vein mining.[36]

Centers of gold extraction in New Granada were ever changing because placer sources were quickly depleted. With an economy dependent on gold, the search for new placer deposits was constant, and, concomitantly, so was the movement and displacement of people from one mining area to another.[37] This quest for new sources of gold drove exploration and expansion into otherwise inhospitable frontier zones like the Pacific Lowlands.[38] From 1715 until the end of the eighteenth century, this region was one of the most important sources for New Granada's gold.[39] While New Granada's very subsistence depended on the productivity of gold mines from sites in the Pacific Lowlands, these areas were described in viceregal *relaciones de mando* (reports on the current state of the colony's government written to the king by the outgoing viceroy) as some of the poorest in the viceroyalty.[40]

Because mining areas were remote, colonial oversight was minimal, resulting in significant underreporting and rampant contraband. Some scholars estimate that as much as half the gold mined in New Granada escaped taxation.[41] As Allan J. Kuethe observes, the viceroyalty of New Granada was a "sieve through which trade entered and left on its own terms, quite independent of royal policy."[42]

In New Spain and Peru, precious metals were mined by Indigenous inhabitants. In New Granada, this arduous work fell to Africans who had been brought to replace the near-extinct Indigenous labor force. Early in the colonial period, European diseases and overwork had decimated native populations.[43] As Jesuit priest Alonso de Sandoval observed in his 1627 treatise on slavery, the abuses suffered by Indians in New Granada at the hands of the Spanish left very few Indians in some provinces and none in others.[44] Africans replaced the native workforce, and as they did, they resisted disease, adapted to their new environment, and eventually acquired their freedom. By the end of the eighteenth century, Africans—both enslaved and free—comprised the greatest percentage of New Granada's population.[45]

Africans were brought to New Granada and in particular to the Greater Chocó from West and Central Africa via the transatlantic slave trade.

The early years of slave trade (1570–1640) brought people from Upper Guinea (corresponding to today's Ghana, Togo, and Benin), Lower Guinea, and Angola.[46] The later trade brought Africans to New Granada from a more concentrated area of the Lower Guinea Coast: the Gold Coast and the Bight of Benin, corresponding to today's Ghana and Nigeria.[47] In earlier periods, enslaved Africans had been sent to cities and urban centers to undertake domestic labor. Later, however, from 1740 to 1760, Africans were sent to remote mining areas in the provinces of Chocó and Raposo in the Pacific Lowlands.[48]

Many Africans destined for the Pacific Lowlands passed through Cartagena, one of the most active slave ports in the Americas.[49] Long before arriving at Cartagena, however, Africans aboard slave ships were subjected to the unspeakable horrors of the Middle Passage. In his sobering in-depth study on health, slavery, and the slave trade in New Granada, David Lee Chandler estimates that anywhere between 5 and 73 percent of Africans perished while crossing the Atlantic.[50] Mortality was due to overcrowding and squalid conditions, which led to diseases such as smallpox and dysentery.[51] Unsurprisingly, depression took a large toll as well.[52]

There were other dimensions to the horror of these journeys, which Chandler describes as "almost beyond the power of the imagination to reconstruct."[53] Africans who were enslaved in the Americas had first been enslaved in Africa, during precolonial African warfare.[54] Through this process, they had been "wrested from the security of tribes, families, and homelands."[55] In West African ports, Africans were hauled onto ships, "stripped and shorn and packed into the filth-reeking, contagion-ridden, suffocating confinement of a slave ship's hold."[56] The journey up the African coast, making stops to acquire more enslaved people, took up to seven months. Another one to four months was spent crossing the Atlantic, a voyage of some three to four thousand "nauseating miles."[57]

Africans who survived the Middle Passage were subjected to further suffering in the slave yards and auction blocks of Cartagena, where, after landing, they changed hands several times. Their journey, however, was far from over. Still ahead was the arduous trek from Cartagena to the Andean interior, which posed great dangers and health hazards for those recently arrived.[58] Given New Granada's geography, much of this leg of the trip happened on foot, as the groups being transported ascended mountains of up to 10,997 feet (3,352 meters) and then descended into deep valleys. Africans who were destined for the gold-mining regions of the Greater Chocó trekked from Cartagena to Popayán and from there to the Chocó. In an attempt to curb contraband and the entry of foreigners, the Spanish forbade travel on key routes (including on the San Juan and Atrato Rivers). This meant that only the most circuitous and harrowing itineraries were permitted.[59] While aquatic channels facilitated a 350-mile (560-kilometer) trip from Cartagena to the Chocó, Crown restrictions forbade fluvial travel along the Atrato, meaning Africans and their enslavers were forced to make an overland trip on foot totaling some 1,180 miles (1,900 kilometers).[60]

Other routes to the mining regions of the Pacific Lowlands forced caravans of enslaved people to trek 75 miles (120 kilometers) overland from Cartagena to the Magdalena River, where they traveled by *champán* (large, roofed watercraft) upriver to Honda, a trip of some 500 miles (800 kilometers). From Honda, they moved overland along the *camino real* (the royal or principal Spanish road) up and over the Cordillera Occidental before heading either northwest toward Antioquia or southwest toward Cali or Popayán. In addition to enduring months of travel through rugged terrain, Africans undertook these journeys while chained and handcuffed together. Many who made this inland trek died from dysentery, exposure, and exhaustion.[61] Those who survived these travails demonstrated uncommon strength, fortitude, and forbearance.

Africans' resilience and perseverance served them well in the mining camps, where—as they endured mistreatment, abuse, disease, malnutrition, and the potential hazards of the terrain, including drowning and snakebites—they quickly adapted to their new environment. Colonial documents suggest that Africans fared far better in these tropical climates than did their white counterparts.[62] A genetic resistance to yellow fever and malaria was one contributing factor.[63] Africans' resistance to the lethal falciparum malaria made certain ecological zones, such as the mangrove forests found on the west coast of Africa as well as the coastal areas of the Greater Chocó, particularly appropriate places for their refuge, survival, and self-manumission.[64] Judith Carney argues that

FIGURE 1.1 Gold mining tools used in New Granada, 1764. Archivo General de la Nación, Bogotá, Sección: Mapas y Planos, Mapoteca 4, Ref. 200A.

this tropical ecosystem, viewed by Europeans as an "incubator of deadly afflictions," enabled the adaptation and survival of Africans in the neotropical coastal regions of South America during almost four centuries of slavery.[65]

Frontier conditions in the Pacific Lowlands, coupled with African adaptation and perseverance, enabled enslaved Africans and their descendants to work for themselves, which opened the door to eventual self-purchase.[66] Germán Colmenares, in reviewing some 472 manumission documents from Popayán from 1720 to 1800, observes that in nearly all cases where freedom was acquired by an enslaved worker at a mine or *hacienda* (landed property), this freedom was not granted by an *amo* (enslaver) but was purchased by the enslaved.[67] Claudia Leal maintains that Colombia's Pacific Lowlands stands out for being one of few places in the Americas where self-purchase accounted for the largest percentage of manumissions.[68] The

change of status brought through manumission moved many Africans from esclavos to libres de todos colores.

Types and Scales of Gold Mining

Gold mining in many parts of the viceroyalty, including the Greater Chocó, consisted of extracting minerals from *quebradas* (ravines, gorges, mountain streams, or streambeds) using standardized techniques and simple tools. Stream placering, or panning, was one method. Another was pit placering, which required digging a large depression to reach gold-bearing sands.[69] A third method, ground sluicing, which was more labor intensive and called for a larger workforce, consisted of excavating a *canelón* (ditch) along the base of a gravel terrace. Miners then dug back into the terrace face using *barras* (long iron crowbars) and *barretones*

(iron-tipped poles), moving gold-bearing sand and gravel into the sluice. Water running through the sluice washed the fine material away, and workers used concave wooden *cachos* (plates) to toss aside large cobbles. They then washed off the remaining gravel, and once the gold had settled to the bottom of the sluice channel, they scraped the channel with an *almocafre* (a tool with a hooked metal blade), heaped the fine residue, which was rich in concentrated gold dust, into piles within the sluice, and washed out the metal in shallow, round bowls called *bateas* (gold pans).[70] Because ground sluicing required a significant amount of labor and preparation, it was a method employed largely by mine owners with large *cuadrillas* (enslaved labor gangs).[71]

All methods of mineral extraction necessitated a steady water supply, which depended on complex stream-diversion projects requiring hundreds of enslaved laborers.[72] These workers constructed *pilas* (reservoirs) on hilltops and dug *acequias* (canals) to channel water to mining areas. The heavy rains that fell nightly in the Pacific Lowlands filled the reservoirs (save for in the dry months of January and February), enabling the enslaved laborers to work without interruption.[73] This method of mining, which strips small areas of forest cover to get to the gold in the subsoil, has had, as Leal describes, ecological and environmental repercussions.[74]

An illustration from 1764 preserves images of metal implements used in the late Spanish colonial period (figure 1.1). These tools were critical to mining operations but were costly to import and resultantly in short supply. In the illustration, the size and weight of each implement is carefully noted, suggesting that people valued mining tools as much for their raw material as for their functionality. These objects are registered in late colonial-period mining inventories and appear in last wills and testaments, where even worn tools were itemized and assigned a value.[75]

Gold mining in the Greater Chocó happened at two different scales. *Mazamorreros* (free prospectors) engaged in small-stream and pit placering along rivers and quebradas during the dry season, when water levels were low.[76] Larger-scale mining operations, meanwhile, were the realm of wealthy *hacendados* (owners of haciendas), merchants, and people of means who had obtained the mining rights to promising quebradas. These larger mining operations, referred to as *reales de minas*, were worked by enslaved labor gangs made up of Africans and their descendants.[77]

Mining inventories provide a sense of the size of larger operations. One particularly large mine, Nuestra Señora de la Concepción, in the province of Nóvita, had 364 enslaved African workers.[78] Another, owned by doña Clemencia de Caicedo, had 70 enslaved African laborers.[79] Meanwhile, the mines of Santa Barbara del Salto along the Dagua River had 26 enslaved African laborers.[80] Another mine in Nóvita, owned by Miguel de Velasco y Solimán, a *negro libre* (free Black), had 20 enslaved laborers.[81]

Many mining sites in the Pacific Lowlands were small, remote, ephemeral, and scattered. The most common type of mining settlement was the shifting placer camp, located along a quebrada or in the auriferous gravels of an interfluve.[82] Mining in this region unfolded in densely forested tropical lowlands or mountainous hinterlands that were largely inaccessible, lying weeks distant from major population centers.[83] These very areas are documented in the manuscript maps to be examined in this book.

Conclusions

Shaped by its topography, geography, demography, and economy, New Granada was categorically different from other Spanish viceroyalties. The three mountain ranges traversing its territory made long-distance travel onerous, leaving the Pacific Lowlands disconnected from the viceregal capital of Santa Fé. Like other viceroyalties, New Granada had European and Indigenous inhabitants, but its largest constituent was libres de todos colores, who, with enslaved Africans, comprised 54 percent of New Granada's population in the late eighteenth century. In the Pacific Lowlands, libres de todos colores and enslaved Africans comprised between 61 and 88 percent of the population. This majority opened a door to opportunity and autonomy for Africans, as we will see in later chapters.[84] Gold remained New Granada's only global export until the end of the Spanish colonial period. By the eighteenth century, this gold was mined almost exclusively by Africans in remote tropical areas of the Greater Chocó.

2

COMING INTO VIEW

The Pacific Lowlands in Manuscript Maps

In 1772, Francisco Antonio Moreno y Escandón, an influential and efficient bureaucrat who served a succession of viceroys beginning with Pedro Mesía de la Cerda, completed his official mandate to create the most current and comprehensive map of New Granada to date. The resulting work, the *Plan geográfico del virreynato de Santafé de Bogotá* [. . .], depicts the totality of the viceroyalty, which encompassed today's Panama, Venezuela, Colombia, and Ecuador (figure 2.1).[1] On this map, Moreno y Escandón delineated New Granada's provinces and identified roads that connected major urban centers. Meanwhile, in the margins, he provided information about population numbers and revenues gleaned from taxation. Despite its seemingly exhaustive detail, Moreno y Escandón's map of New Granada relays precious little about a periphery of high economic importance to the Spanish Crown: the gold-mining regions of the Pacific Lowlands.

In this chapter, we examine an array of maps of New Granada produced between 1610 and 1772, many of which include gold-mining areas. These maps provide a cartographic baseline for New Granada and call attention to the geographic voids that exist on printed maps from the period, especially where the Pacific Lowlands was concerned.

As I will demonstrate, it is only through a careful examination of locally produced manuscript maps that a more accurate picture of the Pacific Lowlands comes into view.

In the twenty-first century, it is easy to forget that prior to the completion of the Panama Canal in 1914 there was no easy way to reach the Pacific Ocean from Spain. Sixteenth-century explorers to the New World—including Vasco Núñez de Balboa, Hernán Cortés, and Francisco Pizarro—reached the New World through the Caribbean Sea, not the Pacific Ocean. To arrive at the stretch of the Pacific coast we are concerned with here, English pirates in the late seventeenth century traveled from the Atlantic to the Caribbean and then abandoned their ships on the northern coast of Panama before proceeding overland across the isthmus. Guided by local inhabitants, they arrived at the Pacific Ocean some twenty to thirty days later.[2] Because the Pacific was difficult to reach from Spain, the Spanish Crown exerted less control over this sea and the coastal areas contiguous to it. Spanish navigators did reconnoiter this shore, but the resulting charts were treated as highly classified secrets.[3] Given this historical context, it is no surprise that Moreno y Escandón's map maintained cartographic silences about the Pacific Lowlands.

FIGURE 2.1 Reduced printed copy of Francisco Antonio Moreno y Escandón's *Plan geográfico del virreynato de Santafé de Bogotá* [. . .], 1772. The area corresponding to the Pacific Lowlands is circled in black. Archivo General de la Nación, Bogotá, Sección: Mapas y Planos, Mapoteca 2, Ref. 1248, 22 x 31.5 in. (56 x 80 cm).

Because state-sponsored and printed maps of the period provide only a partial picture of New Granada, manuscript maps become an invaluable source for understanding the geography of the eighteenth-century Pacific Lowlands. In this chapter, I demonstrate that the Pacific Lowlands are largely absent from printed maps created before the nineteenth century. These Pacific peripheries come into view only through a careful examination of locally produced manuscript maps. Manuscript maps are not, however, self-evident. Additional information is needed to properly interpret them. Such information includes accompanying explanatory texts and often disassociated historical letters and documents.

Empire, Expeditions, and Cartographic Knowledge in New Granada

In the eighteenth century, cartographic knowledge resulted from scientific, yet often secondhand, information. Professional cartographers employed state-of-the-art instrumentation and the most recent data available, but they lacked direct knowledge of the places they were re-creating two-dimensionally on maps. Between 1759 and 1808, the Spanish Crown funded almost sixty scientific expeditions across its territory.[4] Through these, Spain aimed to more precisely delineate the extent of its empire, curb rampant contraband and smuggling, and identify untapped natural resources that could boost colonial economies. Despite differences in character and

scope, all expeditions had economic as well as political and geographic objectives. By identifying and exploiting the colonies' natural resources—spices, medicines, hardwood, and minerals—the Crown could be more competitive in the global marketplace. Several of these expeditions unfolded in or moved through New Granada, and yet none appear to have resulted in formal or circulating geographic knowledge about the Pacific Lowlands.

Given the value Spain placed on precious metals and the fact that New Granada had been designated by the Crown as a primary producer of gold, we are prompted to question why, at a time of extensive exploration resulting in prolific imperial cartography, no state-sponsored maps were commissioned or created for the mineral-rich regions of the Pacific Lowlands.[5] One possible explanation is that this information was deemed sensitive and proprietary.[6] Pedro Vicente Maldonado, in finalizing his Crown-commissioned *Carte de la Province de Quito* (1751), attempted to scrub mineralogical information—including the locations of gold mines—from the final version of his map.[7] This example reveals that mapmakers consciously excluded sensitive information from printed maps.

Another possible factor contributing to the dearth of cartographic information about the Pacific Lowlands at this time is the area's topography and isolation. Very few eighteenth-century colonial officials or early nineteenth-century explorers ventured to this rugged and remote Pacific frontier. Jorge Juan and Antonio de Ulloa, in their voluminous *Relación histórica del viaje a la América Meridional* (A Voyage to South America), 1748, detailed various aspects of Spanish colonial life, including Spanish colonial geography, but provided no information on the Pacific Lowlands.[8] While Juan and Ulloa discussed the Chocó, it is not clear that they ever traveled there. Buenaventura and other neighboring parts of the Pacific coastal region do not factor into their narrative either.[9] Likewise, the Royal Botanical Expedition (1783–1816, led by José Celestino Mutis), which sought to identify, document, and ultimately exploit the wealth of New Granada's tropical resources, never ventured west of Neiva or Popayán, meaning that the botanists and scientists who were part of this multi-decade undertaking never came to know the flora of the Pacific Lowlands.[10] Not even the indefatigable Alexander von Humboldt, traveling with

Aimé Bonpland through Colombia in 1801, got any closer to the Pacific Lowlands than the colonial city of Popayán.[11]

Because the Pacific Lowlands was often ill defined on printed maps, individuals residing in this peripheral area—especially those who needed to settle land disputes, register gold mines, argue for infrastructure, or pinpoint the location of unconquered Indians—were left to create maps on their own.[12] It is through these hand-drawn, locally generated manuscript maps that we are given the first detailed glimpses of remote and little-known landscapes that would not materialize on printed, circulating maps until decades after independence.[13] Locally made manuscript maps, which contain information about ethnicity, society, industry, and economy, in addition to that about geography, topography, and hydrography, presage the ambitious reconnaissance-based chorographic undertakings of the mid-nineteenth century, in particular that of the Comisión Corográfica.[14]

Coming into View: The Pacific Lowlands on Maps

On manuscript and printed maps, the Pacific Lowlands took cartographic shape over the course of many centuries. Maps produced in the seventeenth and eighteenth centuries by foreign nations, including the Netherlands and France, provide some detail on this geographical area. Meanwhile, the maps produced within the viceroyalty of New Granada offer almost no information about large swaths of its territory.[15] In this section, my aim is to establish the Pacific Lowlands as terra incognita on many maps of the period. This underscores the important place of handmade cartography depicting the Pacific Lowlands, which preserves the location of short-lived *pueblos de indios*, little-known ports, free African settlements, and previously undocumented Indigenous communities.

As early as 1610, Spaniards had recognized Colombia's Pacific coast as a region of economic interest. The 1610 manuscript *Mapa de la tierra donde habitan los indios, Piles, Timbas y Barbacoas* (Map of land inhabited by Indians, Piles, Timbas and Barbacoas), oriented with south at top, identifies the rivers that drain into the Pacific Ocean (Mar del Sur, at right). This map does not,

FIGURE 2.2 *Mapa de la tierra donde habitan los indios, Piles, Timbas y Barbacoas*, 1610. This early manuscript map, oriented with south at top, identifies mining areas along the Pacific coast (*at right*) as well as the urban centers of Pasto, Almaguer, Popayán, and Cali, situated on the eastern side of the Cordillera Occidental (*at left*). Ministerio de Cultura y Deporte. Archivo General de Indias, MP-Panama, 30.

however, accurately represent the rivers' morphology or their extent (figure 2.2). The coastal areas noted as having *minas de oro* lie far from the urban centers of Pasto, Almaguer, Popayán, and Cali, which are situated on the other (eastern) side of the Cordillera Occidental, depicted as a squiggly line at the far left of the map. The map also approximates the locations of Indigenous presence. South of Buenaventura, near the river labeled "San Juan River" (later called the Micay River), a gloss reads "cacique [chief] Ornoco," and just off the Cedros River are notations about "cacique Yyama" and "cacique Mapacay," referring to areas of Indigenous occupation.[16] This map provides evidence of an

early awareness of the gold-bearing quebradas in the Pacific Lowlands, and yet, despite Spaniards' interest in these gold deposits and the Indigenous populations here, this area would remain largely unconquered, sparsely colonized, and only vaguely mapped during the Spanish colonial period.

A printed seventeenth-century map of New Granada, produced in Leiden by the Dutch geographer, cartographer, and engraver Hessel Gerritsz, demonstrates that minimal information was in circulation about the Pacific Lowlands at this time. Gerritsz's influential *Tierra Firma item Nuevo Reyno de Granada atque Popayán* (Terra Firma. The New Kingdom of Granada and that of Popayán) was the most frequently reproduced cartographic image of New Granada until the mid-eighteenth century and was the product of scientific data gathered by the Dutch East India Company (figure 2.3).[17] First published in 1625, Gerritsz's map identifies more than a dozen cities along the Caribbean coast. It includes the extensive Cauca and Magdalena Rivers flowing northward from New Granada's interior to the Caribbean Sea. It also highlights major mountain chains.[18] Gerritsz's map, however, provides limited information on areas in the interior or along the Pacific coast.[19]

Especially sparse on Gerritsz's map is information about the Pacific Lowlands and specifically its northern region, the Chocó, the mineral potential of which had been established as early as 1573 (figure 2.4).[20] Gerritsz's map is also silent about the gold-mining areas identified on the earlier Piles, Timbas, and Barbacoas map (see figure 2.2). Meanwhile, farther south, the bay of Buenaventura (discovered by Spaniards in 1525) is labeled, but the extents of the rivers leading to it are only vaguely delineated.[21] These Pacific coastlines would be extensively mapped by Spanish navigators, as well as English pirates, by the late seventeenth century.[22]

A 1699 printed map by William Hacke and Robert Morden, *A New Map of ye Isthmus of Darién in America, the Bay of Panama, the Gulph of Vallona or St. Michael, with Its Islands and Countries Adjacent [. . .]* (figure 2.5), while focused on the Darién, provides more coastal detail than we find in Gerritsz's 1625 map.[23] If we compare the same geographic section of the two maps—from Punta Garachine to Puerto Pinas (see figures 2.4 and 2.6)—we see that the only river Gerritsz identified between these two ports is the Congo

FIGURE 2.3 (*above*) Hessel Gerritsz's printed *Tierra Firma item Nuevo Reyno de Granada atque Popayán*, 1625, 16 x 13 in. (41 x 33 cm). Archivo General de la Nación, Bogotá, Sección: Mapas y Planos, Mapoteca 4, Ref. X 63.

FIGURE 2.4 (*left*) Detail of Gerritsz's map *Tierra Firma item Nuevo Reyno de Granada atque Popayán* (figure 2.3), illustrating areas of the Pacific Lowlands from Punta Garachine in the north to Buenaventura in the south.

FIGURE 2.5 (*above*) William Hacke and Robert Morden's printed *A New Map of ye Isthmus of Darién in America, the Bay of Panama, the Gulph of Vallona or St. Michael, with Its Islands and Countries Adjacent* [. . .], 1699, 19 in. (49 cm) wide. Original held in the John Carter Brown Library, © John Carter Brown Library, C-6603, Cabinet Eh69 JeJ.

FIGURE 2.6 (*right*) Detail of Hacke and Morden's 1699 map (figure 2.5), depicting the coastal area from Punta Garachine to Puerto Pinas.

River. Hacke and Morden, meanwhile, detailed an intricate coastline near Punta Garachine, labeling at least seven rivers. Hacke and Morden's map also pinpoints the location of the Spanish town of Santa María, sacked in 1680 by English pirates, and gold-mining areas to the south. This map was likely informed by Spanish sea charts that had been taken by English pirates in 1681.[24] Hacke and Morden's use of this illicit intelligence resulted in a particularly informative coastal chart.

A half-century later, in 1756, the printed *Carte des provinces de Tierra Firme, Darien, Cartagene et Nouvelle Grenade* (figure 2.7) was produced in

Paris by Jean-Baptiste Bourguignon D'Anville, one of the most authoritative mapmakers of his time. D'Anville's cartographic oeuvre of more than two hundred works covered all regions of the globe and boasted the most precise and up-to-date scientific information available. Appointed as geography tutor to Louis XV of France (1710–1774) and given the title "geographer to the king," D'Anville had at his disposal measurements, data, and observations collected by one of the foremost scientific entities of the time, the French Academy of Sciences.[25] To produce his *Carte des provinces de Tierra Firme, Darien, Cartagene et Nouvelle Grenade*,

FIGURE 2.7 (*above*) Jean-Baptiste Bourguignon D'Anville's printed *Carte des provinces de Tierra Firme, Darien, Cartagene et Nouvelle Grenade*, 1756. Biblioteca Luis Ángel Arango, Bogotá, Sig. H 709.

FIGURE 2.8 (*right*) Detail of D'Anville's 1756 map (figure 2.7), illustrating the Pacific Lowlands from Punta Garachine to the Cedros River. D'Anville included the Atrato River but did not label it.

D'Anville did not need to venture to New Granada; he had all the information he required in Paris.

D'Anville's map identifies many more rivers, regions, and places than does Gerritsz's. If we zoom in to the area depicting the Pacific coast, we see that D'Anville has identified the Chocó in capital letters (figure 2.8). The Atrato, a central river in the Chocó, is included but is not named. The towns of Nóvita and Zitará are also indicated. Just south of Nóvita, the Dagua River is identified, named, and shown to stretch east and then south, nearly to Cali. Further south lies the bay of Buenaventura. Continuing

FIGURE 2.9 (*above*) Jean-Baptiste Bourguignon D'Anville's printed *Amérique Méridionale*, 1748. Biblioteca Luis Ángel Arango, Bogotá, Sig. H 78.

FIGURE 2.10 (*right*) Detail of Moreno y Escandón's 1772 map *Plan geográfico del virreynato de Santafé de Bogotá* (figure 2.1), illustrating a southern portion of the Pacific Lowlands.

south, additional rivers are included. While D'Anville's map is more complete than Gerritsz's, it does not accurately reflect the level of habitation and settlement along the Pacific coast at this time. By the mid-eighteenth century, several small towns had been established along the coast. These included Lloró (not pictured), to the southeast of Zitará, as well as La Cruz, Raposo, and San Francisco de Naya (not pictured), south of Buenaventura. In addition to these small towns, there were dozens of reales de minas.[26] So, while D'Anville provided more data on his 1756 map than Gerritsz did on his 1625 map, D'Anville still omitted a great deal of information relating to the Pacific Lowlands. Interestingly, D'Anville had produced a more detailed map of New Granada nearly a decade earlier. His printed *Amérique Méridionale* (South America), from 1748 (figure 2.9), indicates that omissions on his later 1756 map were a conscious choice.[27]

One of the first detailed and internally produced maps of New Granada was the *Plan geográfico del virreynato de Santafé de Bogotá*, mentioned at the beginning of this chapter (see figure 2.1). Created by Moreno y Escandón for the king of Spain

in 1772, this map was not the result of extensive travel, land measurement, or astronomical observation, despite being produced within the viceroyalty. Instead, it was created in the cartographer's study, relying on information then available in Santa Fé.[28] This large and detailed work aimed to provide the most up-to-date and comprehensive view of the viceroyalty, yet it remained silent about the stretch of coast south of Buenaventura.

If we zoom in to the section depicting the southern portion of the Pacific Lowlands (figure 2.10), we find a few places that do not appear

on D'Anville's 1756 map.[29] For example, Moreno y Escandón included the Atrato and San Juan Rivers in the Chocó and identified both by name.[30] He conveyed Nóvita as a sizeable city through a cartographic emblem denoting a cathedral, and he presented information about towns along the Cauca River. Moreno y Escandón's map identifies nine settlements between Anserma and Popayán, while D'Anville's 1756 map (see detail in figure 2.8) identifies only three.[31] This "new" information presented on Moreno y Escandón's 1772 map may have come from local informants or perhaps from his own travels down the Cauca River, which (together with the Magdalena River) served as one of New Granada's principal fluvial highways.

Nevertheless, if we glance southward on Moreno y Escandón's map, a great void appears. Near and below the bay of Buenaventura, only the bay itself and the towns of Raposo and Cali are identified. The settlement of Buenaventura, which supported one of the few Pacific ports in New Granada, is not shown.[32] The map is also silent about mining regions further south. Some of the rivers below Buenaventura are suggested through the presence of squiggly lines, but none are named, not even significant ones such as the Dagua or the Yurumanguí, the subjects of chapters 5 and 6.[33] Do these omissions on Moreno y Escandón's map reflect a lack of intelligence about the Pacific Lowlands or an attempt to safeguard proprietary information?[34]

If we consult the official report that accompanied this map, we get closer to answering this question. Moreno y Escandón's *Plan geográfico del virreynato de Santafé de Bogotá* was appended to his *Estado del virreinato de Santa Fé, Nuevo Reino de Granada* [. . .], which accompanied the outgoing viceroy Pedro Mesía de la Cerda's *Relación del estado del virreinato de Santa Fé* [. . .].[35] These missives provided an official overview of the current state of the viceroyalty and offered guidance to the viceroy's successor. Ultimately, these reports traveled to the king of Spain. In his relación, Moreno y Escandón explicitly mentioned the Dagua and Yurumanguí Rivers, describing both as important gold-mining areas.[36] Yet he elected to omit both rivers from his comprehensive map of the viceroyalty. His report reveals that he possessed more geographic knowledge than he shared on his map. We should wonder what led him to withhold this information.[37]

Despite the omissions discussed, detailed cartographic images of the Pacific coast were produced. Navigators created, kept, edited, and exchanged comprehensive coastal charts, which identified landmarks, natural harbors, and places where sailors could resupply.[38] Threats posed by foreign as well as internal enemies, however, forced cosmographers to treat all information concerning geography, cartography, and navigation to the Americas as state secrets. Accordingly, the Spanish monarchy found it necessary to censor and prohibit the circulation of geographical information, including maps, descriptions of the terrain and coasts, and historical accounts.[39]

Navigators and ship captains, while dependent on accurate coastal charts, were keenly aware of the danger posed by cartographic information falling into the wrong hands. Both charts and pilots were at risk of being seized by pirates or enemy warships.[40] A collection of maps known colloquially as the Hacke atlas offers an example of what could happen if Spanish cartographic "secrets" were commandeered by non-Spaniards. One of these coastal charts presents a detailed section of New Granada's Pacific coast, stretching from Cape Corrientes at left to the Isle of Gorgona at right. Hacke created this manuscript map, *Good Adventur Bay* (figure 2.11), using information from a corpus of Spanish charts that had been seized by the English privateer, or buccaneer, Captain Bartholomew Sharp in 1681 when he and his crew overtook and captured the Spanish ship the *Santo Rosario* shortly after they crossed the Isthmus of Panama on foot.[41] The sensitive nature of these charts and the information they contained is further indicated by the fact that sailors aboard the Spanish vessel reportedly rushed to throw the charts overboard at the time of the ship's capture.[42] Hacke, who copied this and other maps seized by Sharp, never published this atlas because the intelligence it proffered was considered too valuable to disseminate.[43] This and other attempts by ships' crews to destroy detailed nautical charts to keep them from entering enemy hands demonstrate that information about the coastal shores of the Pacific Lowlands was, in fact, known but jealously guarded.

Two decades after Moreno y Escandón produced his *Plan geográfico*, another comprehensive and internally created map was assembled, this one by New Granada's native son Francisco José de Caldas.[44] The 1796 manuscript map, *Carta del vireynato de Santafé de Bogotá copia de la de Mr.*

FIGURE 2.11 William Hacke's manuscript map, *Good Adventur Bay*, after 1698, 16 × 13 in. (53.5 × 41.4 cm). Oriented with north at lower left, this chart of the bay of Buenaventura includes the Isle of Gorgona, the Dagua River, and the small fort at Buenaventura. From Hacke, *An Accurate Description of All the Harbours, Rivers, Ports, Islands . . . in the South Sea of America . . .,* © John Carter Brown Library, accession no. 66-304, Codex Z 6/3-size, leaf 74.

D'Anville (figure 2.12), as the title indicates, drew heavily from a map by D'Anville.[45] While Caldas did not specify which of D'Anville's maps he had copied, a careful comparison suggests it was the 1748 *Amérique Méridionale* (see figure 2.9), which may have been unavailable in the viceroyalty until the end of the eighteenth century.

To get a sense of how faithful Caldas's copy was to D'Anville's map, we can compare and contrast map sections depicting the Pacific Lowlands. Caldas's map (figure 2.13), while more visually crowded, includes only those places documented on D'Anville's map (figure 2.14). Both renderings include the arrastradero de San Pablo, a road that bridged the gap between the Atrato and Noanamá

(San Juan) Rivers in the Chocó. Both maps depict the towns of Nóvita, Noanamá, and Zitará, as well as Bebará. The spellings of certain town names differ from map to map. For example, Bebará is noted on D'Anville's map as "Oevara" and on Caldas's map as "Vebará." While the two maps are stylistically distinct—D'Anville's a print and Caldas's an ink-on-paper rendering—they appear to be informationally the same.

In the following year, 1797, Caldas made corrections and additions to his copy of D'Anville's map. These revisions may have been informed by his own travel and exploration in New Granada. The resulting manuscript map, which combined D'Anville's armchair cartography with Caldas's

FIGURE 2.12 Francisco José de Caldas's manuscript *Carta del vireynato de Santafé de Bogotá copia de la de Mr. D'Anville*, 1796. España. Ministerio de Defensa. Archivo Cartográfico y de Estudios Geográficos del Centro Geográfico del Ejército, Sig. Ar.J-T.7-C.1_9.

FIGURE 2.13 Detail of Caldas's 1796 map (figure 2.12), illustrating the area of the Pacific Lowlands.

FIGURE 2.14 Detail of D'Anville's *Amérique Méridionale*, 1748 (figure 2.9), illustrating the area of the Pacific Lowlands.

on-the-ground reconnaissance, was *Carta esférica del vireynato de Santafé de Bogotá por Mr. D'Anville, corregida en algunas partes según las últimas observaciones por D. Francisco Joseph de Caldas* (Spherical chart of the viceroyalty of Santa Fé de Bogotá by Mr. D'Anville, corrected in places following the recent observations of D. Francisco Joseph de Caldas, figure 2.15). Additions include the port of Cupica and the Napipi River, which, when travelers used a short stretch of road from Cupica, connected the Pacific Ocean to the Atrato (see detail, figure 2.16). On Caldas's 1797 map, the San Juan River in the Chocó (noted as the Noanamá River in his 1796 map) is clearly delineated and identified as such for the first time. Meanwhile, Zitará has been labeled with its new name, Quibdó, and the town of Buga appears between Cartago and Cali. Curiously, Caldas's 1797 map is silent about rivers along the Pacific coast (from Buenaventura to Barbacoas). While the Dagua River is delineated and identified

by name, the areas along the Dagua and just south of it are blank.

Despite these omissions, Caldas did include remote yet culturally significant spaces in the country's interior that had not yet been committed to paper on other maps of the viceroyalty. One of these additions was the pre-Hispanic site of San Agustín (seen at the bottom of figure 2.16, southeast of Popayán), home to over five hundred monolithic statues carved during the first millennium CE.[46] In the late eighteenth century, San Agustín was largely unknown, but Caldas had recently visited the site. He waxed poetic about the statues' creators, whom he described as an artistic and industrious nation no longer in existence.[47] The inclusion of San Agustín, absent on D'Anville's map, suggests that Caldas's mapmaking methods combined two distinctive approaches: armchair cartography and geographical reconnaissance. Caldas's on-the-ground exploration, which resulted in new cartographic information, underscores the importance of this method in the creation of maps that edge closer to a more complete picture of New Granada.

On both of his maps, Caldas omitted details about the Pacific Lowlands, suggesting he had little understanding of this remote periphery. An undated field map attributed to Caldas, however,

FIGURE 2.15 Francisco José de Caldas's manuscript *Carta esférica del vireynato de Santafé de Bogotá por Mr. D'Anville, corregida en algunas partes según las últimas observaciones por D. Francisco Joseph de Caldas*, 1797. España. Ministerio de Defensa. Archivo Cartográfico y de Estudios Geográficos del Centro Geográfico del Ejército, Sig. Ar.J-T.7-C.1_13.

FIGURE 2.16 Detail of Caldas's 1797 map (figure 2.15), illustrating the Pacific Lowlands.

Lowlands produced by cartographers and functionaries in the Netherlands, France, and New Granada between 1610 and 1772, reveals that neither the maps produced outside the viceroyalty nor those created within it offered much information about a Pacific coastal region of decided economic importance to the Spanish Crown. While interest in this region was documented cartographically as early as 1610, the area remained nebulously defined during the Spanish colonial period. These conspicuous absences on maps suggest attempts to keep the locations of Pacific coastal mining areas secret. However, the area's topography, geography, and lack of colonial investment and oversight also played a role in preserving the Pacific Lowlands as terra incognita.

Manuscript Maps of the Pacific Lowlands

On internally produced manuscript maps of the Pacific Lowlands, remote corners of the empire become immediate and tangible. These works were especially useful for administrators and officials who would never experience these areas firsthand. These maps, which lack an internally consistent scale, use text to communicate this missing dimension. Interestingly, Laura Hostetler, writing on the ethnography and cartography of early modern China, notes that the overwhelming majority of maps from the Qing Empire (1636–1911) also relied on text, rather than scale, to convey distance.[51]

Charting a route from Buenaventura to Cali, the map *Croquis del curso del río Dagua* [. . .] (Sketch of the course of the Dagua River, figure 2.18) is concerned with regional topography and road conditions that impact distance as it relates to time.[52] The itinerary at right on the map details a journey requiring weeks of travel. Above it, a short

indicates that he acquired familiarity with this area at some point. The manuscript map *Pedernales jurisdicción de Guayaquil y conclusion de la de Popayán*, oriented with south at top, covers an area of just under 620 miles (1,000 kilometers), from Buenaventura to Ecuador (figure 2.17).[48] Along the inked line that separates land from sea, dozens of rivers are identified.[49] The explanatory text at the top decodes the map's cartographic signs, informing the reader that cities (*ciudades*) are identified with an emblem of a cathedral, towns (*pueblos*) are marked with a circle topped by a "t," and reales de minas are indicated with an "x."

This map identifies only two cities, Iscuandé (population 2,751) and Barbacoas (population 6,618), and thirteen towns.[50] These settled areas are greatly outnumbered by mines, which total over thirty. The rivers shown on Caldas's field map would not appear on printed maps until the mid-nineteenth century. To learn more about them and the mining activity along their shores, we must turn to manuscript maps.

My examination of maps depicting the Pacific

FIGURE 2.17 (*left*) *Pedernales jurisdicción de Guayaquil y conclusión de la de Popayán*, undated, oriented with south at top. This manuscript map, attributed to Francisco José de Caldas, depicts the area from Guayaquil, Ecuador (*at top*), to the bay of Buenaventura (*at bottom*). The map's purpose is unclear but seems to be the identification of mines (*reales de minas*), each marked with an "x." Archivo Histórico Restrepo Fondo XII, vol. 2: "Francisco José de Caldas sus cartas y opúsculos," microfilm 43.

43

Pedernales Jurisd.n de Guayaq.l y conclusion de la de Popayan

Las Ciudades estan anotadas con esta 🏛

Los Pueblos con esta ○

Los Reales de Minas con esta . . . X

C. S. Fran.co

Morro de Sua

Tacames

Esmeraldas

Rio Verde

La Tola P.to

S. Rosa

S. Pedro P.

Ancon de Sardinas

C. Manglares

Desag.de Mira

Boca Grande

Chuchal

J. Tumaco

J. Biciosa

J. Vimal

Morro Tumaco

Guapilpi

Amarradero

de Chimbusa

Rosario

Laguna chimbusa

J. del Gallo

Salaonda

Mataiana

Caballos

Indiermiro

Guirepa

Amaralos P.to

Japape

Caxaso P.to Gorgonilla

Iscuande

Guapí P.

J. Gorgona

Guasuí

Tambiqui

Saija

Macay

Tambor

Naisa

Yurmanaguí

Calambre

Morro de Tortugas

Mallorquin

Mapes

Xarxapatas

Chuchas

Joloas

S.P.o y P.to

Culo de Barco

Rio de Anchicaya

La Buinaventura

Cascajal

La Cruz

Dagua

J. de Palmas

Blanco

Las Juntas

Mar

del

Sur

PERU

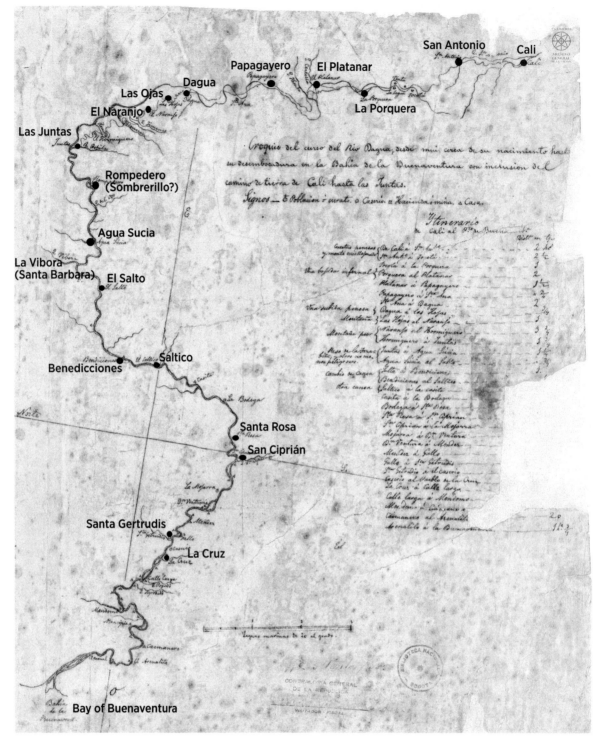

FIGURE 2.18 Detail of the manuscript *Croquis del curso del río Dagua* [. . .], undated, 15.4 x 24.4 in. (39 x 62 cm), oriented with east at top, with glosses and location dots added by author. The thick meandering line depicts the Dagua River from Cali to Buenaventura, and the dotted line charts the land route along part of the river. The annotations at right reference the route's challenging conditions. Meanwhile, the explanatory text identifies symbols for poblaciones and curatos (indicated by a cross atop a circle with a dot in the center); caseríos (identified by a circle with a dot in the center), including Las Ojas, El Naranjo, Benedicciones, and Saltico; haciendas and minas (identified by a square), which include San Antonio, El Platanar, Papagayero, Dagua, Aguasucia, and Santa Gertrudis; and casas (identified by a triangle). Santa Rosa, San Ciprian, and La Vibora are noted as casas but had formerly been mining sites. The place identified as Rompedero was likely the former location of Sombrerillo. Archivo General de la Nación, Bogotá, Sección: Mapas y Planos, Mapoteca 6, Ref. 72.

explanatory text provides symbols that identify *poblaciones* or *curatos* (towns or curates), *caseríos* (villages), *haciendas* (ranches) or *minas* (mines), and *casas* (houses).[53] On this map, only Cali and La Cruz are identified as *poblaciones*. The notations of villages, haciendas, mines, and houses indicate points along the route where travelers might rest, refuel, and exchange news along the journey.

The itinerary at right provides a log of legs and corresponding travel times, where two contiguous stops represent one leg of the trip. Each is annotated with comments about the local terrain. From Cali (at top right) to San Antonio, one is confronted with "cuestas penosas y monte encallejonado" (painful ascents and narrow mountain paths). From Porquera to Platanar, the traveler is subjected to "una bajada infernal" (a hellish descent). At the beginning of the leg from Dagua to Las Ojas, one awaits a "subida penosa" (painful ascent). Meanwhile, from Las Ojas to El Naranjo, there is "montaña" (mountainous terrain), while from El Naranjo to Las Juntas, one finds "montaña peor" (even worse mountainous terrain). In addition to these vivid descriptions, the explanatory text alerts readers that they must travel by canoe beginning at Las Juntas. Dangerous river conditions here require taking the canoe out of the river, walking it to a calmer section, and then entering the water once again. This happens at El Salto, at Benedicciones, and again at Saltico. As much as this text-based itinerary communicates information about distance, it also flashes a warning: expect discomfort, delays, and worsening conditions. Working from topographic and geographic illustrations alone, it would be impossible for someone with little knowledge of the area to gauge the distance, the travel time, or the differing modes of travel required to move from Cali to the bay of Buenaventura, at the bottom of the map. Because distances in the Pacific Lowlands were dictated by the local terrain and were adversely affected by heavy rains and rising rivers, textual descriptions in legends were an indispensable element of manuscript maps of the region. While many parts of Spanish America were measured in linear distance, the most relevant unit in the Greater Chocó was time.

Some of the internally produced manuscript maps examined in this book lack explanatory texts. Instead, explications are embedded in associated letters and documents. The Map of the Yurumanguí Indians (plate 1; discussed in the introduction

and chapter 6) provides one such example. Oriented with west at the bottom, this map renders the stretch of coast from Buenaventura to the Naya River (roughly fifty miles [eighty kilometers], as the crow flies). Thin serpentine lines represent paths or roads (*caminos*) that connected Indigenous dwellings to one another. This map, like the others discussed, does not employ an internally consistent scale. The explanatory text, framed in three linked cartouches at bottom (see appendix A), is of little help. To understand the spatial distance of the area on the map, we must consult the letter written to accompany it.[54] Without this letter, there is no way to know that Cerro Naya (2), at far right, lies roughly three days (on foot) from the Yurumanguí River (23). Meanwhile, a visually shorter distance on the map—that between structure 20 and structure 22—requires two full days of travel along an Indigenous road (21). Maps, by themselves, do not contain all the information we need to interpret them. In order to accurately understand space and distance in manuscript maps, in addition to the events that led to their creation, it is necessary to first locate the historical documents that most clearly illuminate the maps' meaning.[55]

In addition to providing information about topography, terrain, and distance, manuscript maps of the Pacific Lowlands also argued for needed investment and infrastructure: the construction of roads, the development of ports, and the establishment of reducciones. With roads and ports, residents hoped to bring in—with greater frequency and at lower cost—a more diverse array of goods. Reducciones, meanwhile, promised a local supply of labor. Manuscript maps identify the location of gold mines and tracts of arable land and provide information about routes of access into remote regions of New Granada. Maps also provided visual testimony for inspections (*visitas*), lawsuits (*pleitos*), and claims (*reclamaciones*) and supported the proposed relocation of *resguardos* (communal agricultural lands) and reducciones.[56] All the maps examined here, ultimately, served economic ends.[57]

Conclusions

This chapter has established that as late as the eighteenth century, many areas of the Pacific Lowlands were, cartographically speaking, terra incognita. While many maps from this period suggest New

Granada as an ordered, controlled viceroyalty, locally produced manuscript maps from the Pacific Lowlands illuminate how isolated and disconnected many regions were from economic and political centers. Master cartographers in Europe, such as Gerritsz and D'Anville, mapped the continent but provided little information on the Pacific Lowlands. Cartographic voids are also found on printed maps produced within the viceroyalty. Because many parts of the Greater Chocó did not appear on printed or circulating maps, these areas remained unfamiliar and unknown to anyone who lived outside of them. Those who advocated for infrastructure or who fought over land had no choice but to produce hand-drawn maps of these areas to make them visible and knowable to outsiders. It is through these hand-drawn maps that New Granada's Pacific periphery comes into view.

The manuscript maps discussed in the following chapters emerged from specific local conditions and circumstances and captured fixed moments on the space-time continuum. None of this information, however, is immediately evident from the maps alone. If we are to resurrect forgotten places of economic possibility and unlock as yet untold narratives about individuals, ethnicities, provincial industries, and local politics in this peripheral area of the Spanish Empire, we must examine these maps in conjunction with their associated historical documents.

3

THE MAP OF THE ATRATO RIVER AND PUEBLOS OF CUNA INDIANS

The Atrato Vigía and the Short-Lived Cuna Reducción of Murindo, 1759–1778

In this chapter, we turn to the Atrato River in the Chocó and the map *El río Atrato y pueblos de indios Cunacunas* (plate 2), or the Map of the Atrato River and Pueblos of Cuna Indians, c. 1759, which highlights Cuna presence near the Gulf of Urabá. Past scholarship has used this map to discuss autonomous Cuna Indians near the gulf. A closer look at this hand-drawn work, however, reveals that it is primarily concerned with Spanish attempts to settle Cuna Indians at the short-lived reducción of Murindo.

This deceptively simple map draws our attention to a contested zone of Spanish and Cuna entanglement, illuminating the precarious nature of Spanish conquest and colonization in a peripheral region of New Granada in the mid-eighteenth century. This same map sheds light on a story about the Atrato River, the unconquered Cuna Indians who inhabited the mouth of this important fluvial corridor, and the Spanish colonists who worked to establish a reducción on a remote frontier. Like

other cartographic works examined in subsequent chapters, this map provides the setting for this story. For information about the characters, the plot, the conflict, and the resolution, it is necessary to unite the map with the archival documents that contextualize this time and place in Spanish colonial history.[1]

Past scholarship has used this map to discuss the region's independent Cuna inhabitants and Spain's failed attempts to pacify and settle them.[2] An integrated analysis of the map and its large case file (*legajo*, *expediente*, or *signatura*), however, reveals that the Map of the Atrato River and Pueblos of Cuna Indians, in the past understood by scholars to be concerned with Cuna settlements generally, is instead focused on one Cuna settlement in particular: Murindo. The map visually emphasizes autonomous Cuna, underscoring Spanish vulnerability in this area. But it also directs attention to Murindo, a short-lived pueblo de indios whose inhabitants—Cuna Indians—had, according to

Spanish documents, actively sought their *reducción* and worked with Spaniards to draw up the terms of their settlement. In this chapter, I will visually unpack this map, seeking out the arguments it makes and the story it tells. Then I will reconstruct a preliminary history for Murindo, proposing that Murindo was envisioned by the Spanish as a second line of defense to support an ill-equipped *vigía* (watchtower and defensive post) on the Atrato River. Before we arrive at Murindo, however, there is another story to tell, one of the Spanish Crown's attempts to close the Atrato River to travel and commerce for roughly a century.

The Atrato, a Great but Prohibited River

For those living in the Chocó in the Spanish colonial period, the most important road was a river. While not as long as the Nile, nor as trafficked as the Mississippi, the Atrato was nonetheless the primary "highway" through the region, connecting the Caribbean Sea to the Chocó interior (see figure I.5).[3] As the shortest distance between two points, the Atrato was vital to those living, working, and mining along the river's shores.

The Atrato initiates in the Farallones de Zitará and flows north for 400 miles (650 kilometers) through the Chocó, emptying into the Gulf of Urabá. After the Magdalena and the Cauca, the Atrato is the third most navigable river in Colombia.

In addition to its rich placer deposits, the Atrato's roughly 150 tributaries fed the cultivation of *maíz* (corn), *plátanos* (plantains), *caña de azúcar* (sugar cane), *algodón* (cotton), and cacao. These waterways also offered numerous routes of entry into the Chocó and Antioquia regions and the Cauca Valley. As significantly, the Atrato formed part of an interoceanic waterway connecting the Caribbean Sea to the Pacific Ocean.[4]

During the eighteenth century, the shores of the Atrato were inhabited by independent and unpacified Cuna Indians.[5] The Atrato was also frequented by people from foreign nations who were not subject to Spanish laws and thus freely engaged in illicit trade and contraband, rendering this river a threat to Spain's economic interests as well as to its sovereignty.[6] Further complicating matters, the Cuna (who fiercely resisted Spanish subjugation) made allies of Spain's foreign enemies. The

Indians' strategic partnerships with Spain's rival colonial powers (Dutch, English, and French) left this region incompletely settled and unsuccessfully conquered.[7] To borrow from Andrew Lipman's characterization of Dutch and English attempts to colonize New England and New Netherlands in the seventeenth century, the Atrato was not a settled shore, but an unsettled one.[8] Given these factors, the Atrato River—a vital route into the Chocó interior—became a watery wild west.

For the Chocó's inhabitants, the Atrato River represented a source of sustenance and a means of locomotion. For the Spanish Crown, however, it became an Achilles's heel. Rather than undertake concerted efforts to fortify the river and the region, the Spanish opted for a radically different approach. They "closed" the Atrato—the region's principal fluvial artery—to travel and commerce from 1698 to 1784. The discussion that follows examines the strategy of "closure" adopted by the Crown and efforts by high-ranking colonial officials to lift these restrictions.[9]

River closure, as Matt Nielsen observes, was a popular defense strategy in the Spanish Empire, aimed at preventing the flow of contraband and impeding enemy advances.[10] On some rivers, such as the Guadalquivir in Spain, closure was carried out using enormous iron chains. A sense of what this might have looked like survives in an illustration from 1591, *Traza de la manera como se ha de poner la cadena en la entrada del puerto de la Havana* (A sketch of how chains are to be placed at the entrance to Havana's port), by Bautista Antonelli, showing the heavy links that blocked entry to the port of Havana near the fortress of El Morro (figure 3.1).[11] For other rivers, such as New Granada's lower Orinoco, whose incredible widths defied the use of chains, different measures were deployed. Nielsen discusses two initiatives that sought to prohibit entry into the lower Orinoco, effectively "closing" it to foreign enemies. One of these measures aimed to construct an artillery-equipped fortress in the middle of the river that would regulate river passage. When the river itself worked against the fortress's construction, colonial authorities and military officers explored ways of transforming the region's timber reserves into a fleet of war ships, or floating fortresses.[12]

This strategy of restricting access to key areas for extended periods of time was not limited to aquatic spaces, nor was it the sole prerogative of the

FIGURE 3.1 Bautista Antonelli, *Traza de la manera como se ha de poner la cadena en la entrada del puerto de la Havana*, 1591. This chart depicts the entrance to Havana's port and its early system of fortification, showing chains anchored near the fortress of El Morro that aimed to restrict access. Ministerio de Cultura y Deporte. Archivo General de Indias, MP-Santo Domingo, 12.

Spanish Empire. Hal Langfur examines a Portuguese Crown policy that forbade access to unsettled mining zones in Brazil's Eastern Sertão, areas that came to be designated "forbidden lands." In prohibiting access to these areas, the Crown aimed to stop the unsupervised (and untaxed) prospecting of gold and to minimize contraband. As part of this policy to restrict access, road projects that would have facilitated entry into these zones were abruptly suspended. Meanwhile, anyone who ventured into these forbidden lands was imprisoned and had their possessions seized. The restrictions on Brazil's Eastern Sertão remained in place for a full century, a period that roughly coincided with Spain's "closure" of the Atrato.[13]

These examples, from different parts of the Iberian Americas, reveal that, as extreme and as impractical as forbidding travel and commerce on the Atrato River may have been, such a measure had not only a precedent but also a following. This strategy of prohibiting access as a means of safeguarding a territory and its economic resources reflected, as Langfur notes, "a different type of jurisdictional authority—that of enforced absence."[14] Nielsen, meanwhile, calls this centuries-old tactic "calculated inactivity" and discusses

its efficacy on the lower Orinoco.[15] Because the Spanish state had only a finite amount of resources to devote to its vast empire, it chose not to invest in regions it viewed to be marginal or beyond colonial control.

The Real Audiencia of Santa Fé de Bogotá, the highest court presiding over the territory of New Granada, first declared the Atrato closed to maritime commerce in 1698. In restricting trade and travel along the Atrato, the Spanish Crown hoped to impede the flow of contraband and illicit commerce.[16] Similar decrees were passed in 1705, 1717, and 1718. *Real cedulas* (royal decrees) issued in 1730, 1733, 1734, 1736, and 1774 gave royal sanction to earlier decrees.[17] As scholars have noted, these periodic renewals only highlighted the depth and persistence of the problem and underscored the lack of local compliance with royal decrees and cedulas. The need to consistently renew prohibitions on the Atrato only confirmed the ineffectiveness of colonial authorities in the region, as well as their complicity in the contraband.[18] In 1732, unauthorized travel on the Atrato was punishable with fines of up to five hundred pesos in gold.[19] Later documents indicate that such abuses were punishable by death (*pena de muerte* or *pena de la*

vida).[20] However, there is little evidence to suggest that the death penalty was actually enforced.[21] Contrary to the Crown's intent, Atrato prohibitions only abetted the illicit traffic of gold, goods, and enslaved laborers.[22]

Repeated and extended prohibitions on the Atrato also hindered legal commerce and contact between Atlantic maritime routes and the mining regions in the Chocó. As a result, the Chocó was partially supplied by the domestic economy.[23] Merchants in Cauca and Cartagena profited from Atrato closures and, accordingly, did little to oppose them. In 1717, Cauca merchants (who relied on the Magdalena and Cauca Rivers, not the Atrato, to move their products through the interior of the country) went as far as to push the audiencia to enforce restrictions on the Atrato.[24] Meanwhile, merchants in Cartagena, when consulted in 1774 about the possibility of reopening the Atrato to maritime commerce from the Caribbean, firmly opposed the idea.[25]

A paradox of the Crown prohibitions on the Atrato was that navigation was forbidden only to Spaniards (los españoles). Atrato restrictions hamstringed Spanish miners, merchants, and free people in the region. Meanwhile, non-subjects such as the English and the Dutch could—and did—make great use of the Atrato without consequence.[26] During decades of restrictions, foreigners conducted illicit commerce on the Atrato with impunity (a su salvo), taking from the Chocó quantities of cacao, tortoiseshell, resin, and exquisite wood, not to mention precious minerals, especially gold.[27]

Prohibitions on Spanish travel and commerce along the Atrato did not go unchallenged. High-ranking regional officials and New Granada's viceroys lobbied for the restrictions to be lifted.[28] Viceroy Pedro Mesía de la Cerda (1761–1772), in his 1772 Relación del estado del virreinato de Santa Fé [. . .], stated that to provide those in the Chocó with the supplies they needed, the most expedient route was, without a doubt, from the Gulf of Darién (which led to the Gulf of Urabá) along the Atrato River. Because navigation on the Atrato was prohibited by royal decree, Mesía de la Cerda urged his successor to undertake a diligent investigation for Charles III in the hope that, once presented with the facts, the Bourbon monarch would reverse these crippling restrictions.[29]

Francisco Antonio Moreno y Escandón, in his Estado del virreinato de Santa Fé [. . .] (1772), stressed that prohibitions on the Atrato had forced those in the Chocó to live with scarcity. Everything cost the miners dearly, and rarely did one find a miner who was not burdened by debt. Forbidding navigation on the Atrato, he noted, served only to punish Spaniards, while it gave free license to the rebellious Indians and foreigners who continued to use the Atrato for commercial purposes.[30]

Manuel de Guirior, after serving four years as viceroy of New Granada (1772–1776), arrived at similar conclusions. In his 1776 Instrucción que deja a su sucesor [. . .], Guirior remarked that reason and experience revealed that if vecinos were not permitted to obtain licit goods produced within the country, they would inevitably conduct business with foreigners because foreigners offered them what they needed and wanted, namely, mules, tallow, cotton, dyewoods, and fruit. Furthermore, he noted, illicit commerce enabled gold to slip out of the viceroyalty undetected.[31] Guirior presented his successor with a detailed analysis of the benefits of reopening navigation on the Atrato, arguing that such measures would increase productivity in the mines and stimulate commerce while also aiding in the settlement (reducción) of Cuna in the Darién.[32]

A lengthy and pointed discourse in favor of opening the Atrato to trade and commerce was also written by the Spanish military engineer Juan Jiménez Donoso under the direction of Viceroy Manuel Antonio Flores (1776–1781), Guirior's successor.[33] Detailed maps accompanying Donoso's 1780 report visually strengthened his argument.[34] Opening the river would enable Spanish colonists to take advantage of the area's rich resources, including gold, cacao, hardwoods, and dyewoods.[35] These offerings would attract more people to the area, helping to fortify the region and bring about an increase in agricultural production, which would augment mining activity and corresponding revenues. With a larger population and thriving industries, the region would become more secure and easier to defend from its enemies.[36] Essentially, Donoso argued for the importance of settling the region but understood that settlement was unlikely unless the restrictions on the Atrato were lifted.

Two years after Guirior had submitted his relación and two years before the ink had dried on Donoso's report, the Reglamento para el comercio libre (Regulation on free trade) of 12 October

1778 was instituted under Charles III. As John Fisher explains, free trade implemented across Spain's dominions aimed to promote the settlement of territories (like New Granada) that had been largely neglected. Free trade was also intended to undermine and undercut the rampant contraband trade, increase revenues, and, above all, develop the empire as a market for Spanish agricultural and manufactured goods and as a source of raw materials for Spanish industry.[37] Despite the implementation of comercio libre in the rest of the empire, another six years would pass before travel and commercial restrictions were finally lifted on the Atrato in 1784.

The Map of the Atrato River and Pueblos of Cuna Indians

A near century of Crown-imposed restrictions on the Atrato did little to strengthen Spain's sovereignty in the region. Instead, closures on the Atrato encouraged inhabitants, merchants, and miners to identify new routes through the Chocó, which led to the emergence of newly settled places on the landscape. One such place was Murindo, a short-lived Cuna reducción founded on the border of Spanish and Cuna territory.

Reducción was part of a Crown policy begun in the mid-sixteenth century that aimed to centralize native inhabitants in pueblos de indios to isolate them from outside influences, more efficiently collect tribute from them, teach them Christian doctrine, and benefit from their labor.[38] General parameters about who should be targeted for reducción and what reducciones should consist of are found in the *Recopilación de leyes de los reynos de las Indias* (Collection of the laws of the kingdoms of the Indies), published in 1681.[39] No guidelines are provided, however, for people who resisted reducción or for those who chose to return to their native settlements or places of origin after being settled in a reducción.

The Map of the Atrato River and Pueblos of Cuna Indians (plate 2) is perhaps the only known map to document Murindo's emergence as a reducción. While this cartographic work calls attention to Murindo, it also places great visual emphasis on nearby autonomous Cuna pueblos, underscoring Spanish vulnerability in this area. As the Spanish

envisioned it, a successful pacification of Cuna at Murindo would benefit the Crown in several ways: Cuna in Murindo would become tribute payers, loyal vassals, and would monitor access into the region, protecting Spanish settlements and mining sites farther south.

"Cunacuna," "Cuna," or "Kuna" (autodenomination Tule) were catchall terms used by the Spanish to refer to the large, decentralized, and dispersed Indigenous populations that occupied great swaths of territory in and around the Darién and the Gulf of Urabá.[40] All spoke a common language and followed a single law, yet each Cuna group operated independently.[41] Cuna did not consider themselves vassals of the Spanish Crown, they did not abide by Spanish laws, they did not pay tribute, they did not convert to Catholicism, and they successfully operated outside the system of Spanish commercial exchange.[42] Contrasting with David J. Weber's observation that independent Indians in the colonial period often occupied lands with little economic value, Cuna controlled the most strategic areas along the Caribbean coast and the Gulf of Urabá (see map with autonomous Cuna pueblos identified, plate 3).[43]

During the eighteenth century, Cuna were not a single homogenous nation but instead comprised many independent groups differentiated by their places of origin. In an essay examining cultural and economic interaction between Europeans, Cuna, and Chocó Indians in the Darién between 1739 and 1789, Daniela Vásquez Pino writes of a northern Cuna group and a southern Cuna group, as well as other Cuna groups who inhabited the dense tropical forest (*monte*) near the cordillera of the Darién.[44] It was the southern Cuna, Vásquez Pino notes, who were open to ideas of reducción by the Spanish.[45]

The Map of the Atrato River and Pueblos of Cuna Indians, oriented with south at left and covering a stretch of some 370 miles (600 kilometers), draws our attention to areas inhabited by southern Cuna. It presents a selective, subjective, and greatly simplified representation of the Atrato River as it flows from Quibdó to the Gulf of Urabá. Any reference to the northern Cuna is omitted from this map (plates 2 and 3).[46] At top right, the eastern portion of the Caribbean coast (labeled "Costa de Cartagena" on the map) is indicated by a thin curved line. The continuation of this line, at

left beyond the Gulf of Urabá ("Golfo del Darién"), delineates the western part of the Caribbean coast ("Costa de Portovelo"). Along the Atrato River (at left) are the Spanish town of Quibdó and the Indian reducciones of Murrí and Bebará. The pueblos of autonomous Cuna appear on the right side of the map, numbered 1 through 11 (marked with red dots in plate 3). At bottom center, a cartouche contains the names of these Cuna pueblos: Cacarica (1), Humaquia (2), Arquia (3), Tiguere or Tigre (4), Tarena (5), Acandia (6), Caiman (7), Banana (8), Truxi or Trujillo (9), Cue (10), and Canepa (11).[47] A dotted line on the map marks the area separating "controlled" Spanish settlements, where the new reducción of Murindo and the Spanish vigía are, and "uncontrolled" autonomous Cuna pueblos (see figure 3.2).

On the Map of the Atrato River and Pueblos of Cuna Indians, autonomous Cuna pueblos inhabit most of the cartographic space and occupy the most desirable and strategic locations along the shores of the gulf. Is this map an approximately accurate rendering of the Atrato River, or does it intentionally distort space? If we compare the map in plate 3 to a chronologically later, scaled map, the *Plano del curso del río Atrato* [. . .] (Map of the course of the Atrato River [. . .], plate 6), created in 1780 by Donoso, the military engineer discussed earlier, decided spatial distortions emerge.

Donoso's map presents the same span of territory, from Quibdó to the Gulf of Urabá; it shares the same orientation (with south at left); and it includes the same locations as the Map of the Atrato River and Pueblos of Cuna Indians (plates 2 and 3). Nevertheless, on Donoso's scaled map, the Spanish pueblos, the pueblos de indios, and the vigía occupy more than seven-eighths of the cartographic space, while independent Cuna pueblos inhabit only one-eighth of this space (plate 6). Through this comparison, we see that the Map of the Atrato River and Pueblos of Cuna Indians expands autonomous Cuna territory while simultaneously compressing Spanish territory.[48] By visually amplifying Cuna presence, the unknown mapmaker communicates the ever-present threat posed by autonomous Cuna Indians in the Chocó and underscores the challenges Spain faced in fortifying and defending its interests along the Atrato.

The loose, perhaps hasty, style of the Map of the Atrato River and Pueblos of Cuna Indians might suggest that it lacked planning or organization.

A closer look reveals an underlying structure where text (glosses), numerals, and symbols work together to convey the state of Spanish settlement along the Atrato. The map's unknown author codifies two types of aggregations or settlements: Spanish pueblos (which include Quibdó, Murrí, Bebará, and Murindo) and independent Cuna enclaves. Spanish pueblos (which, on the map, include administrative centers like Quibdó as well as reducciones like Murrí, Bebará, and Murindo) are located to the left of the vigía and are glossed *on the map itself*, identified with a symbol. Conversely, the eleven autonomous Cuna pueblos, located to the right of the vigía, are *not* glossed but are indicated with a number and a symbol.

Significantly, the names of the autonomous Cuna pueblos are encapsulated within the cartouche at bottom, alongside their corresponding numbers, in a symbolic attempt to contain them. Through this carefully codified system of communication, the map formally acknowledges—through glosses on the cartographic portion of the map—only those settlements under Spanish control. This convention of textually labeling Spanish spaces on the depicted geography while confining the names of unconquered Cuna settlements to the cartouche allows the mapmaker to create a clear distinction between towns settled by the Spanish and unconquered Cuna pueblos. Through these cartographic conventions, the mapmaker conveys the idea that autonomous Cuna enclaves—prominently presented on this map—are unsettled spaces in the Spanish Empire, places of Spanish vulnerability, and areas that pose a threat to Spanish sovereignty. The faint dotted line to the right of the vigía and to the left of the first Cuna pueblo, Cacarica, further emphasizes the divide between Spanish-settled towns and unconquered Cuna pueblos. At first glance, this line suggests a road. I would argue, instead, that it refers to the imagined boundary separating "civilized" Spanish settlements from "barbarous" Cuna territory.

In addition to space subjectively construed, the Map of the Atrato River and Pueblos of Cuna Indians (plates 2 and 3) conveys a sense of what it might have *felt* like to be a Spaniard living along the Atrato at this time. On the map, Spanish "controlled" areas are constricted to the left-hand margin, suggesting geographical confinement. Meanwhile, the lower Atrato, which offers direct access to the Gulf of Urabá and the Caribbean, is

FIGURE 3.2 Detail of the Map of the Atrato River and Pueblos of Cuna Indians (plate 2), depicting Quibdó and the reducciones of Murrí, Bebará, and Murindo. Spanish-occupied towns are glossed and identified by symbols. Murindo is noted as "Pueblo de Murindo donde están los Cunacunas conquistados . . ." The dotted boundary line differentiates Spanish-occupied areas (*at left*) from Cuna-occupied ones (not seen in this detail). The vigía sits at the river, to the immediate left of this dotted line.

Plano que demuestra la immediacion de Quibdò ultimo Pueblo de Chocó con los Indios Barbaros nombrados Cunacunas entre los que se hallan mescladas diferentes Naciones como son Ingleses, Franceses &ª

Advertencia

Todas las Poblaciones toman el nombre del Rio immediato que las baña

FIGURE 3.3 *Plano que demuestra la inmediación de Quibdó último pueblo de Chocó con los indios bárbaros nombrados Cunacunas* [. . .], 1753, 9 x 5.5 in. (23 x 14 cm), oriented with north at right. Quibdó (*at far left*) is the only town glossed on the map. Places inhabited by Cuna Indians are indicated by shapes denoting habitation. For these, the river is named but the settlement is not. Ministerio de Cultura y Deporte. Archivo General de Indias, MP-Panama, 151.

guarded by unconquered and often hostile Cuna pueblos. The fact that the mapmaker did not include the Pacific Ocean or routes to it makes the Spaniards' limited options for mobility and escape even more palpable.

Cuna omnipresence along the Atrato is similarly articulated in an earlier map, from 1753, the *Plano que demuestra la immediación de Quibdó último pueblo de Chocó con los indios bárbaros nombrados Cunacunas* [. . .] (Map demonstrating the proximity of Quibdó, the last town in the Chocó, to the barbarous Indians known as Cuna [. . .], figure 3.3). This map depicts the same geographical extent (Quibdó to the Gulf of Urubá) and shares the same orientation (with the Atrato flowing from left to right) as the Map of the Atrato River and Pueblos of Cuna Indians, suggesting the 1753 map may

have informed the c. 1759 map.[49] On the 1753 map, the mapmaker identifies the same eleven Cuna-inhabited rivers seen in plates 2 and 3: Cacarica, Humaquia, Arquia, Tigre, Tarena, Acandia, Caiman, Banana, Truxi/Truji(llo), Cue, and Canepa.[50] Likewise, the 1753 map engages in similar distortions of scale (where Cuna pueblos occupy nearly all the represented space) and employs similar visual and textual conventions. Both the Map of the Atrato River and Pueblos of Cuna Indians and this 1753 map textually label Spanish-occupied spaces (e.g., Quibdó) while leaving adversaries' settlements unnamed. Both maps emphasize that much of the lower Atrato was occupied by unconquered Cuna. (Murindo is notably absent from this map. It would not form part of the local landscape until 1760.)

Murindo and the Atrato Vigía

Two lines of evidence support Murindo as the subject of the Map of the Atrato River and Pueblos of Cuna Indians (plate 2). The first is the way Murindo is textually singled out by its detailed gloss, which reads, "Pueblo de Murindo donde están los Cunacunas conquistados" (pueblo of Murindo, where the conquered Cuna are). Other pueblos—Quibdó, Murrí, and Bebará—are identified on this same map simply as "pueblo de . . ." A second line of evidence supporting Murindo as the map's subject is the map's inclusion in a large Caciques e Indios case file whose single focus is the reducción of Cuna Indians at Murindo.[51]

Murindo's founding was tied to the autonomous Cuna enclaves enumerated on the map (plate 2). Its exact siting, however, was influenced by the location of the Atrato vigía, which was in place when Murindo was founded. On the map, both Murindo and the vigía exist in a buffer zone dividing the Spanish settled areas from autonomous Cuna enclaves. As a minimally equipped defensive post, the vigía shouldered the oversized burden of protecting Spanish settlements and mines from Indigenous and foreign attack. Archival documents suggest that Murindo was envisioned by Spanish colonial officials as a way to shore up defense in the region. Murindo's Indigenous inhabitants could be called upon to protect Spanish settlements farther south should defensive efforts at the vigía fail.[52]

The Atrato vigía was tasked with defending and securing a minimally fortified Chocó. Accordingly, the vigía occupies an important place on the map and in the story of Murindo. On the map, the vigía is the largest emblem on the Spanish side (see figure 3.2). It is represented by a tiered cylindrical watchtower, similar in style to towers constructed on the coast of Granada, Spain, from the sixteenth to the eighteenth century.[53] The vigía's depiction as an impenetrable fortress, however, belies its decidedly modest form.[54] Contemporary accounts repeatedly describe the Atrato vigía (which doubled as the residence of the cabo [captain]) as a place that was architecturally modest, inadequately manned, and poorly armed.[55] A detailed inventory dating from 1761 reveals that this defensive structure was built of straw and had a palm-frond roof. Its only furnishings were an old wooden table and an aged leather chair. Meanwhile, its munitions consisted of seven muskets, two of which were spent and one of which was housed several days away in Quibdó.[56] These contemporary descriptions and reports stress that the Atrato vigía was little more than a rudimentary outpost made of ephemeral materials.[57] The robust portrayal of the vigía on the map as a towering fortress reflects wishful projections of Spanish organization, order, and fortification in the Chocó. As was the case in the Darién and other parts of the Spanish Empire, there was a need and a desire for adequate military defense, but this did not always translate to the construction of actual defensive sites.

Other areas of New Granada saw more committed attempts to defend Spain's interests. One example is the much more adequately equipped fortress of San Fernando on the lower Orinoco. Like the Atrato vigía, the San Fernando fortress was envisioned as a defensive structure that would safeguard a peripheral region of Spanish America. Before construction of San Fernando was abandoned in 1761, the project had received sixteen thousand pesos of support from the viceroyalty of New Granada. A portion of this was earmarked for its concrete footings, foundation walls, and ramparts, while an even larger sum was slated to cover the cost of heavy artillery in the form of fourteen cannons of varying sizes.[58] The Atrato vigía, conversely, made of straw and possessing just four working rifles, appears to have received no such viceregal subvention.

In the neighboring Darién, plans for defense occurred mostly on paper. A 1778 sketch of a fuerte (fort) proposed for the alluvial-rich site of Caná presents a two-story building, fifteen varas (yards [about fifteen meters]) square, whose walls were to be made of timber and mamposteria (masonry) and whose roof was to be tiled (figure 3.4). Contemporary correspondence, however, indicates that this fort was merely a projection. In a letter to Viceroy Flores, Andrés de Ariza, governor of the Province of the Darién, noted that the materials required to build Caná's fort—namely, bricks—were unavailable in the region. Before construction could begin, a lumber mill and a brick kiln would first need to be established.[59] The imposing stature of the suggested frontal elevation of Caná's fort—like the sketched emblem of the Atrato vigía on the map— hid an inconvenient truth: the Crown lacked the means, the manpower, and the materials to build critical defensive structures in the region.

318

Vista Exterior dela casa Fuerte de Caná. Ariza

FIGURE 3.4 Andrés de Ariza, *Exterior view of the projected fort at Caná*, 1778. Archivo General de la Nación, Bogotá, Sección: Colonia, Fondo: Caciques e Indios, tomo 34, doc. 12, fol. 318r.

Other defensive projects envisioned for the Darién and the Chocó at this time were exponentially more ambitious but equally unrealized. The fort of San Carlos provides one such example. In 1761, Spanish military engineer Antonio de Arévalo was dispatched to the Darién to identify the most opportune place to build a defensive fort.[60] Arévalo ultimately chose a site on the Caiman River, near the mouth of the gulf. This site appears on the Map of the Atrato River and Pueblos of Cuna Indians, in the vicinity of the Cuna enclave marked with a 7 (plate 2). It was here that Arévalo hoped to build a formidable Spanish fort in Cuna territory.[61] Arévalo's report and accompanying maps, which included plan and profile views of the fort itself (plate 7), offer a glimpse of what idealized military defense along the Atrato might have looked like had the Crown's resources matched its ambitions.[62]

Arévalo depicts the fort of San Carlos as part

formidable fortress, part miniature city. Surrounded by a substantial outer wall, the installation boasted areas for weapon storage and defense, including stations for twelve cannons and twelve *pedreros* (an older style of cannon that launched stones). There was also a chapel, a hospital, and space to accommodate up to fifty men. By Arévalo's estimate, the fort of San Carlos would have cost a staggering 34,125 pesos. Lack of funds prevented this ambitious project from taking its proposed form, and soon interest in this defensive redoubt along the Caiman River waned.[63]

Particularly illustrative of the chasm that separated Spanish colonial desires from realities in this imperial periphery was the Atrato *vigía*. The previous examples demonstrate that, along the Atrato, ambitious plans to defend the region were realized only two-dimensionally. Given the mineral wealth of the area and the demonstrated need for defense, why was it that Spanish-occupied

zones along the Atrato received so little Crown support? As J. R. McNeill notes, save for Cartagena and Havana, very few ports or coastal points of entry received Crown investment.[64] Even Portobelo, in Panama, lacked substantial fortification until the 1770s.[65] Most of Spain's resources went into shoring up defenses at these two ports, and, as time would reveal, Cartagena and Havana proved challenging to defend even with this spending.[66] Despite the influx of New World silver, Spain, from 1580 forward, was in perpetual danger of bankruptcy owing to its military ambitions in Europe.[67] Its ongoing wars with England were a significant drain on its resources, and its entry, in 1762, into the Seven Years' War (1756–1763) and the toll this took on its financial reserves greatly altered the defensive plans of peninsular authorities. As a result, the Darién and the Chocó lost their strategic importance. Fortification projects such as Arévalo's proposed fort of San Carlos on the Caiman River were abandoned and would not see renewed interest until after 1783.[68]

In addition to being under-fortified architecturally, the Atrato vigía was also under-manned. Because Spaniards were reluctant to risk life and limb defending this inadequate fort, the task of guarding the Atrato vigía fell mostly to the Indians of Murrí, who lived in relative proximity to the defensive site (see figure 3.2).[69] Guarding the vigía, which was hot, humid, and overrun with flies, mosquitos, and snakes, presented a hardship to the Murrí Indians. The vigía was also several days distant from Murrí.[70] The map provides no sense of scale, but archival documents state that a trip downriver from Murrí to the vigía required two or three days, while the return trip, upriver, took five or six.[71] At the vigía, Murrí Indians were required to stand guard for an entire month, a significant amount of time away from their families, their homes, and their crops. Resultantly and understandably, they frequently abandoned their posts, leaving the vigía and areas farther south vulnerable to attack.[72]

The Murrí Indians' absence at the vigía stemmed from other causes. Frequently they were co-opted by the vigía captain to undertake labor expeditions, where they felled trees, carved canoes, and collected honey, fibers, and medicinal plants, the proceeds of which likely benefited the captain. These trips took Murrí Indians to places along the Atrato that were two days distant from the vigía, leaving

this defensive site unprotected.[73] In one remarkable instance, eleven days passed before the vigía was again fully manned.[74]

The Murrí Indians' *mita*, "obligatory," labor at the Atrato vigía has interesting parallels in the compulsory forest-collecting expeditions in Brazil's Sertão, along the remote waterways of the Amazon River.[75] Heather Flynn Roller notes that these expeditions, which lasted six to eight months, posed grave hardship for the men who undertook them but also offered a range of economic and material opportunities that other state-sponsored labor did not. Like the captains at the Atrato vigía, the expedition leaders (*cabos*) in the Sertão also routinely exploited crewmen, sending them to undertake errands that benefited the cabo. Some of the Sertão crewmen fled the expeditions either before they began or after they had ended, echoing forms of resistance employed by Murrí Indians. And yet, as Roller demonstrates, many of the Indians on the Brazilian expeditions found ways to make this cumbersome system work in their favor.[76] For the Murrí Indians, tasked to guard the Atrato vigía, there seem to have been few advantages to their compulsory labor. Decades of their flight from and abandonment of the vigía would lead to the eventual proposal that the lookout post be guarded by anyone but Indians from Murrí.[77]

The Atrato vigía, which largely failed as a defensive post, served other, more successful functions. It operated as a neutral space where those from all nations could find temporary sanctuary or engage in negotiations with colonial authorities.[78] It was at the Atrato vigía that Cuna leaders and the governor of the Chocó, Francisco Martínez (one of our story's protagonists), hashed out terms for the reducción of Murindo in 1758.[79] A decade later, the vigía remained a space of safety and asylum, where Indians who were threatened by enemy groups could take refuge.[80] Spanish lookout posts and forts functioned as safe havens for non-Spanish Europeans as well. Viceroy José Solís Folch de Cardona (1753–1761), in his *Relación del estado del virreinato de Santa Fé* [...] (1760), wrote of orders to build a fort on the coast of the Darién where the French could be received under royal protection.[81] These spaces of Spanish diplomacy were also found outside the viceroyalty of New Granada. The fort of Nogales (today's Vicksburg, Mississippi) was a place where Spanish agents and representatives of the Cherokee, Chickasaw, Choctaw, and Creek

nations met to forge alliances aimed at preserving Spain's dominion throughout the provinces of Louisiana and both Floridas.[82] In addition to functioning as a territorial claim and a defensive post, the vigía represented a safe zone on the frontier. With a better understanding of the Map of the Atrato River and Pueblos of Cuna Indians and the important and multifunctional role of the Atrato vigía, we now shift to the historical documents on Murindó.

Historical Context of the Map of the Atrato River and Pueblos of Cuna Indians

One advantage of a graphic, as opposed to textual, approach is the ability to quickly identify overlooked places on the space-time continuum. That said, textual documents relay important details that graphic ones do not. The Map of the Atrato River and Pueblos of Cuna Indians (plate 2) directs our attention to Murindó, while archival documents fill in the important historical context for how and why Murindó came into existence. The large case file "Autos sobre la reducción de los indios Cunacunas y mejor establecimiento" (Decrees concerning the settlement of the Cuna Indians), housed at the Archivo General de la Nación in Bogotá, is the most detailed surviving textual source for this short-lived pueblo de indios.[83] The title of the case file suggests it is concerned with the Cuna, but all the documents in it refer specifically to the establishment of Murindó and the ongoing challenges in maintaining a reducción on the Atrato so close to Cuna territory. Working from this case file and other related historical documents, it is possible to learn about the map's objectives and construct a preliminary history for the Cuna reducción at Murindó.

The date 1759 has been ascribed by the AGN to the Map of the Atrato River and Pueblos of Cuna Indians (plate 2); this year corresponds with records of ongoing discussion between Cuna leaders, Governor Francisco Martínez, and Spanish administrators regarding the founding of a pueblo de indios that would take the name San Bartolomé de Murindó. The map provides important spatial and geographic context for the events chronicled in the case file. Meanwhile, many of the places identified on the map are mentioned in the documents.[84]

Nevertheless, there is no clear reference to this map in any document in the case file. Instead, Martínez conceded in a letter to Viceroy Solís Folch de Cardona dated 6 February 1759 that he had been *unable* to make the map as the viceroy asked him to do.[85] As a result, the identity of the author and the exact date of this map remain open questions.

Nevertheless, documents in the case file do indicate who likely informed the contents of the map. In this same letter to the viceroy, Martínez acknowledged that because few people had detailed knowledge of the area, he would have to rely on those who did: the manatee fishermen (*manatieros*) who doubled as local guides (*baquianos*). The manatieros are mentioned throughout the case file. The Spanish depended on them to keep an eye on the vigía as they fished along the Atrato. In other instances, the manatieros were noted as profiteers, overcharging Cuna residents in Murindó for basic supplies and staples.[86] Nevertheless, the manatieros' livelihoods required them to travel up and down the Atrato, so it seems likely they provided important intelligence for this and other maps of the area.[87]

According to information included on the map and in the case file, this cartographic sketch was likely created in either 1759 or 1760. Murindó, in the map's gloss, is described as "conquistado," suggesting that the pueblo de indios had already been established by the time the map was produced. ("Conquistado" is an interesting choice of words, given that all correspondence in the case file suggests that the settlement of Murindó was a peaceful process and one that the Cuna had themselves initiated.) Documents in the case file, as we will see, indicate Murindó was founded in 1760, so, if the map presents a fait accompli, it could date to 1760 or later. If the map instead dates to 1759, it may be that this cartographic sketch and the language it employs actively project Spanish desires to establish Murindó as a reducción.[88]

In discussing the Cuna at Murindó, it is important to remember that Cuna Indians, who inhabited the Darién and the northern Chocó near the Gulf of Urabá, comprised groups that were culturally similar but politically and militarily independent from one another. The Cuna had long resisted Spanish colonization but were opportunistic when it came to foreign interlopers with whom they traded, allied, and even settled. Beginning in the mid-seventeenth century and continuing through

the end of the eighteenth, debilitating trade laws combined with minimal Spanish presence led to regular incursions by foreign powers—Dutch, English, French, and Scottish—creating a space for intense colonial interaction between Indians and Europeans.[89] As Ignacio Gallup-Diaz notes, a single Cuna leader might find himself engaged in complicated exchanges with several European rivals of different nationalities on the very same day.[90] These various and simultaneous alliances were possible in part because the Cuna were not a united chiefdom but were made up of many small, autonomous groups. In their autonomy, they chose to pursue and cultivate the alliances that proved most advantageous to them. One such alliance emerged between Francisco Martínez and the Cuna caciques who would settle in Murindo.

One of the earliest events relating to this alliance documented in the case file transpired in 1752. The then governor of the Chocó, Alfonso de Aronja (1751–1756), dispatched Martínez, described as a vecino of Quibdó, to track down and reincorporate a group of fugitive Indians who had fled their corregimiento of Murrí.[91] Martínez, whose apparently pacific and diplomatic tactics resulted in the return of the Indians to Murrí, would succeed Aronja as governor of the Chocó. From his position as governor (1756–1761), Martínez negotiated and oversaw the reducción at Murindo of a group of Cuna who (according to the documents) had expressed their desire to become Spanish subjects.[92] The case file ends in 1764, when Martínez, who had by then been named *corregidor* (administrator of a reducción or district magistrate) of Lloró, was summoned by the new Chocó governor to track down and reincorporate the same Cuna Indians that he, Martínez, had worked so hard to settle in Murindo just a few years earlier.[93]

Elsewhere in the Darién and the Chocó, attempts to resettle native inhabitants into Spanish reducciones happened only after efforts to conquer them had failed.[94] Murindo is an interesting case where Cuna Indians allegedly sought reducción rather than having it forced upon them. They negotiated the terms of settlement with Spanish officials and worked with Spanish colonists to build their new pueblo de indios. The Cuna remained for a time and then, as the disadvantages of settlement mounted, they abandoned Murindo.[95]

Constructing the History of Murindo, a Short-Lived Cuna Reducción

In April 1758, a Cuna delegation of caciques and other Cuna from the pueblos of Tarena, Banana, Tigre, and Caiman arrived at the Atrato vigía hoping to speak with Governor Martínez about their interest in settlement.[96] All four of these Cuna pueblos appear on the map, located at strategic points on either side of the Gulf of Darién (plate 2). Tarena (5) and Tigre (4) appear on the Portobelo side of the gulf, while Caiman (7) and Banana (8) are on the Cartagena side. Caiman occupied a particularly strategic site, along the same river where the Spanish military engineer Antonio de Arévalo later hoped to construct the fort of San Carlos (plate 7). At the vigía, the Cuna caciques allegedly expressed their desire to become vassals of the Crown, learn the mysteries of the Catholic faith, and abide by Spanish laws. In exchange, Martínez would establish, for these Cuna leaders and their families, a new settlement along the Atrato.[97] The Cuna volunteered to manage a vigía (at the time, nonexistent) at the mouth of the Atrato River and to pay their tribute with money raised through the sale of cotton hammocks.[98] A few months later, in late August 1758, the same Cuna leaders, accompanied by other Cuna Indians, returned to the vigía, where they worked with Martínez to finalize the terms of their settlement (*capitulaciones*).

Martínez outlined the parameters of this accord in a ten-point plan drafted on 25 August 1758, signed by Cuna leaders.[99] The location of this reducción, and the areas designated for work and crop cultivation, would be determined by Martínez. As part of this accord, the Cuna agreed to intermarry with their sometimes enemy, the Chocoes, to keep the peace in this often-hostile region. In exchange, it was agreed that Cuna living in Murindo would govern themselves through appointed Cuna caciques, captains, and *alcaldes* (magistrates). Cuna self-governing in reducciones was not entirely without precedent or, for that matter, completely without Spanish intervention. It was common for Spanish officials to select or approve the Cuna leaders who would head reducciones and negotiate Cuna-Spanish treaties. These Indigenous leaders would also be recognized as decision makers and figures of authority by their fellow Cuna. Accordingly, Cuna caciques worked with the Spanish in establishing new settlements.[100]

In addition to being governed by their own leaders, the Cuna agreed that Marcos de la Peña, a seventy-year-old *mulato* (person of mixed African and European heritage) from the Canary Islands who led the Cuna to the vigía for the negotiations, would reside in the new pueblo de indios of Murindo, teaching the Cuna the customs and lifeways (*buenas costumbres*) of the Spanish.[101] The Cuna were reportedly comfortable with this arrangement as de la Peña had already lived among them for some thirty years.[102] De la Peña, who spoke the Cuna language and was trusted and respected by Martínez, also acted as translator.[103] Cuna leaders, meanwhile, were tasked with populating Murindo with their own family members and other Cuna Indians. One of the ten stipulations for settlement was that all who came to reside in Murindo would do so voluntarily.[104]

What prompted this voluntary Cuna reducción? The primary reason given in the documents—God (*dios*), referencing baptism and conversion—can be viewed with some skepticism. Jeffrey Erbig raises a similar question in his book *Where Caciques and Mapmakers Met: Border Making in Eighteenth-Century South America*: why did *tolderías* (mobile native communities and their encampments) in Río de la Plata briefly entertain, from 1749 to 1751, the idea of settlement under the Spanish after years of resistance?[105] Erbig suggests this sudden interest in reducción may have been due to the Spanish military campaigns underway at this time in Río de la Plata. These coordinated efforts aimed to capture or kill entire tolderías and would force survivors to live in reducciones. Another reason for toldería compliance at this time, Erbig posits, may have been wartime duress and fear of neighboring enemies. Tolderías, like Cuna enclaves, were in competition with one another for resources. Reducciones—in Río de la Plata as well as in the Chocó—offered protection and sustenance, which may have been appealing when faced with threats of violence and starvation. Erbig concludes that the tolderías' interest in reducción was driven more by fear of Indigenous neighbors than by the actions of the imperial interlopers, the Spanish and the Portuguese.[106] A similar fear of hostile Indigenous neighbors, including Caledonian Indians (northern Cuna) and Chocó Indians, may have prompted Cuna interest in reducción at Murindo at this particular moment.[107]

Another explanation for Cuna openness to reducción at this time seems to have been their trust in the Chocó governor, Francisco Martínez.[108] This rapport likely began sometime after Cuna leaders were first introduced to Martínez in 1752. It was at this time that Governor Aronja sent Martínez into Cuna lands to locate—and ultimately return and resettle—fugitive Indians from the pueblo of Murrí.[109] During this 1752 visit, Martínez was ill received by Cuna, who threatened him with fire, sticks, and arrows.[110] Undeterred, Martínez continued traveling along the Atrato, stopping at places that appear prominently on the Map of the Atrato River and Pueblos of Cuna Indians (plate 2). He arrived by canoe to Truxi (marked 9 on the map) with two French and three Indigenous companions. At the pueblo of Banana (8), some Cuna reminded Martínez that the viceroy had authorized them to tie up or kill any Spaniard who came into their province.[111] The Cuna initially had misgivings about this Spaniard from Quibdó, but Martínez's methods of negotiating with Murrí's fugitive Indians seem to have eventually won their trust.[112]

There was some discussion as to where, precisely, Murindo would be built. The Cuna lobbied for a place to the right (north) of the map's dotted "boundary line" (see figure 3.2), which separated the Spanish-controlled area from autonomous-Cuna territory, in a zone where traffic along the Atrato was forbidden.[113] Martínez, meanwhile, successfully pushed for a site on the opposite side of the boundary line.[114] The Map of the Atrato River and Pueblos of Cuna Indians is helpful in understanding the significance of this location (plate 2). Had Murindo been founded to the north (right) of the boundary, as the Cuna had wanted, this new reducción would have been closer to Cuna places of origin (Tarena, Tigre, Banana, Caiman) and squarely *within* Cuna territory. Murindo's eventual siting (to the left of the boundary line) placed it one day downriver of the vigía, a spot that was more conducive to crop cultivation, safer from attack, and closer to Spanish settlements.[115]

The reducción of Murindo and its location met several Spanish needs. Its proximity to the vigía and the invisible boundary line separating Cuna lands from Spanish ones would enable Murindo's inhabitants to protect Spanish settled areas in the direction of Quibdó. The newly settled Cuna in Murindo would warn about impending threats to

the region and guard against illicit traffic on the Atrato, acting as surrogate Spanish settlers defending Spanish interests.[116] By establishing a Spanish settlement of Cuna Indians near the Atrato vigía, the colonizers also hoped to build alliances with Cuna pueblos closer to the mouth of the gulf and the Caribbean coast. Such alliances would enable the Spanish to strengthen their position in the region.[117]

Murindo's establishment, according to Martínez, transpired without incident. On 9 October 1760, Martínez had been in the new reducción for more than a week, overseeing areas to be cleared for labor and planting. On this visit, he was accompanied by Murrí's priest (Pedro de Salazar), the vigía's captain (Juan Diaz Portillo), and Beté's corregidor (Antonio Rico). One of their first tasks was to map out the boundary lines for Murindo.[118] Three weeks later, the fledgling reducción had 119 baptized residents, dwellings to house them, a church to save their souls, planted fields to nourish their bodies, and canoes to transport them up and down the Atrato.[119]

As Martínez's reporting makes clear, reducción projects required time, patience, clear communication, and labor, but they also demanded considerable financial investment. A critical and costly piece of the Murindo initiative was the incentivizing gifts for the Cuna. These included axes (hachas), adzes (azuelas), knives (navajas), beads (chaquiras), clothing (ropa de vestir), machetes, tobacco, salt, beef, and manatee meat, as well as a crucifix made of silver.[120] These lavish gifts, some of which were difficult to acquire in the region, had been valued at the sizeable sum of twelve hundred pesos, or castellanos, in gold.[121] This practice of gift giving, which was underway in the seventeenth century, had by the mid-eighteenth century become an integral component of Spanish-Cuna relations and was an accepted facet of the colonial relationship.[122] In totaling up all Murindo-related expenses, Martínez estimated that some three thousand castellanos had been spent, not counting the incentivizing gifts. All funds had come from Martínez's own pocket.[123] In 1761, Martínez wrote to the viceroy, reminding him that he, Martínez, had invested a large amount of effort and money in this venture, for which he hoped to be compensated.[124]

On 9 May 1761, Martínez reported that he had successfully completed the settling of Cuna in Murindo.[125] The names of Murindo's first 147 inhabitants are preserved in the case file. This detailed population tally is divided into two separate groups: those with governing authority (mandones) and those without (particulares).[126] Nearly a fifth of Murindo's new residents were mandones and their families.[127] Organized by family unit, this list provides the names and ages of parents and offspring. It also reveals that a family unit could include cousins (sobrinos), mothers-in-law (suegras), and orphaned children (huerfanos) who had been adopted into a family. Shortly after this list was compiled, two Cuna leaders, Baltasar and Bartolomé, were permitted to return to their native lands to identify additional Cuna willing to reside in Murindo.[128] Martínez predicted that within a year Murindo's population would double in size, growing to some 300 souls.[129] All aspects of Murindo's settlement suggest that the process was voluntary, not coerced.

Martínez was vociferous about his success, but he was also clear-eyed about future challenges. In his correspondence with the viceroy, Martínez managed expectations and cautioned that, while the Cuna in Murindo were presently content (sumamente gustosos), he himself had witnessed their abject poverty and scarcity (inopia). They lacked clothing, tools, salt, and other things essential for their well-being. Martínez empathized with the misery that these Cuna, as recent transplants in strange lands, would endure. In hopes of minimizing future despair, Martínez reportedly brought to Murindo everything he could think of to support them.[130] While Martínez did not anticipate that the Cuna in Murindo would become discontent, he alerted the viceroy that the situation was tenuous and depended on their good treatment. One corrupt corregidor or imprudent cura (priest) could put at risk, and even negate, all the progress Martínez had made.[131]

By the end of May 1761, Martínez's tenure as Chocó governor had ended, and he was replaced by Luís Maraver Ponce de León (1761–1765). In a report to the viceroy from his new position as governor, Maraver Ponce de León summarized the events that had led to the successful founding of Murindo and restated the reasons Cuna had wished to be reduced, which differed somewhat from the reasons Martínez had given.[132] He emphasized that Martínez, who had overseen the Cuna reducción

at Murindo, had done so in the service of God and king. Martínez did not expect to be repaid, but his efforts, the new governor stressed, should nonetheless be recognized. Maraver Ponce de León also mentioned in his letter that the Cuna in Murindo held great affection for Martínez.[133]

Abandoning Murindo

Early in 1763, roughly two years after completing his term as governor of the Chocó and just three years after settling the Cuna in Murindo, Martínez received dispiriting news. The Cuna Indians he had so earnestly established in Murindo had fled, abandoning the reducción.[134] This potential outcome had loomed large from the beginning. In an earlier letter to the viceroy, Martínez had raised the possibility that, once he was no longer governor of the Chocó, tending to the well-being of Cuna he had settled in Murindo, there was no guarantee they would stay.[135] From Martínez's perspective, Murindo's success was tied to his amicable relationship with Cuna leaders and was situationally dependent on his oversight.

According to recorded testimonies, Murindo had been completely abandoned.[136] Some Cuna had returned to Caledonia, some to Tigre, and others to Tarena. In sum, Cuna had returned to their native territories.[137] What had led the Cuna to desert Murindo? The documents are silent on this matter. However, before abandoning Murindo, a few of the leaders (including Juan Antonio, the son of Marcos de la Peña) had traveled to Lloró to consult with Martínez, ostensibly to discuss their plans to leave the settlement.[138] The record does not reflect how or whether Martínez advised these leaders in their flight, but such a visit hints at the bond that Martínez and the Cuna had cultivated over the course of many years.

The new Chocó governor, Maraver Ponce de León, attributed the Cuna's flight from Murindo to Indian fickleness (*beleidad*). He also faulted the way Murindo had been established. The very location of Murindo—so close to the Atrato and to Cuna territory—had made it easy for the Cuna to flee. Equally problematic was the decision to allow the Cuna to govern themselves.[139] Maraver Ponce de León went on to note that the mulato captain, Marcos de la Peña, who had lived with the Cuna in Murindo, had died shortly before the end of

Martínez's term as governor. Because de la Peña was never replaced, Murindo suffered a lack of oversight.[140] Replacing de la Peña would have been challenging, Maraver Ponce de León conceded, as it was unlikely that another Spaniard would have taken de la Peña's place, choosing to live in remote Murindo, subject to "barbarous Indians and the unfortunate events that were known to occur."[141] Murindo had experienced other early setbacks as well. The cura assigned to Murindo, Juan Lorenzo de Candia, had drowned on his way there, and his replacement (Pablo de León) had been delayed owing to lack of funds.[142]

Months later, Martínez, who was then serving as corregidor of Lloró, was temporarily relieved of his duties and dispatched to locate the Cuna Indians who had abandoned Murindo. He was instructed to employ all means at his disposal to convince them to return.[143] On 24 March 1764, Martínez left his house in Lloró, accompanied by six Indians, arriving at Quibdó later that day. From Quibdó, he devised a plan and acquired the necessary permissions, arms, and traveling companions. Days later, Martínez set out for the vigía accompanied by thirteen Indians, traveling in three canoes. Once the party had reached the vigía, Martínez contemplated the approach he would take. Rather than seeking out the Cuna himself, he sent his translator, who assured the Cuna that Martínez had come in peace to return them to Murindo.[144] The translator's venture met with success. Soon after, a delegation of Cuna arrived to the vigía to confer with Martínez. Leading the delegation was the cacique of Tarena and another Cuna who had settled in Murindo.[145] Upon hearing the Spaniard's promise that they would not be punished, the Cuna agreed to return to the reducción.[146]

Martínez's journey to locate the fugitive Cuna was, by his account, seamless, but the return trip to Murindo was fraught with challenges. There were more willing Cuna than there were canoes to transport them. Most of the space in the canoes was given to Cuna belongings such as cooking pans, baskets, arrows, dogs, and aromatics or spices (*ollas, casuelas, canastas, flechas, perros*, and *drogas*).[147] In the end, the canoes could accommodate only fifty-three people. Cuna who did not find space in the designated canoes chose to travel through the gulf in the more dangerous piraguas, with grave repercussions. One woman died from heavy sea surge and others became very ill.[148] Despite

the setbacks, Martínez arrived to Murindo on 14 April 1764 with fifty-three Cuna Indians in tow. Once again, efforts to settle Cuna at Murindo were undertaken at Martínez's expense.[149] Additionally, in leaving his home in Lloró to seek out and negotiate renewed peace with the Cuna Indians, Martínez had left his mines and fields unattended and his wife alone with their newborn child.[150]

It is not clear how long Cuna resided in Murindo after their resettlement. The case file documenting the reducción ends in 1764. Martínez and the then Chocó governor, Nicolás Díaz de Perea (1765–1771?), beseeched the viceroy to compensate Martínez for his efforts. The viceroy's benevolence extended to a mere six hundred castellanos. This was to be given to Martínez, but not as repayment for his time or expenses; it was earmarked for Cuna in Murindo in the form of clothing, food, tools, ornaments, and other things necessary to celebrate mass. Given that the initial gifts of this type, which Martínez brought to Murindo in 1760, totaled twelve hundred castellanos, it seems unlikely the six hundred designated by the viceroy would have stretched very far. Furthermore, these funds were not supplied by Santa Fé but were to be taken from the coffers (cajas) of the province of Zitará. Should those coffers be lacking, the money was to be drawn from the cajas of Nóvita.[151] The lack of viceregal support for a small and relatively modest undertaking like Murindo reflects the Crown's divestment in the region. In this periphery, months distant from Santa Fé, pacification and stability were left to local actors—Cuna Indians and Spanish officials—who negotiated (and renegotiated) their terms of cohabitation along the Atrato's shores.

The Atrato Vigía: An Epilogue

Murindo ceased to be a central focus of archived Spanish colonial case files after 1764.[152] The opposite is true for the Atrato vigía, whose infamy only grew with time. Both Murindo and the vigía appear on a 1781 map created by Antonio de Arévalo.[153] On this map, the vigía has moved from the Sucio River farther south to the site of Curbaradó, even more distant from autonomous Cuna territory than it had been before. One explanation for the vigía's change of place may be the erosion of Murindo and the loss of security that came from this nearby

reducción. There were, however, other events that led to the vigía's relocation, including a Cuna attack in 1766, which prompted the vigía's move to Curbaradó that same year.[154]

As a structure that symbolized Spanish territorial claims in the region, the vigía had long been a target of Cuna aggression. In 1766, northern Cuna made incursions into Chocó territory, attacking this defensive post and killing its interim captain (the former corregidor of Beté, Antonio Rico, who had helped Martínez establish the boundary lines for Murindo) and others who were serving as sentinels.[155] In addition to slaying Indians and Spaniards and burning their bodies, the Cuna attackers looted the vigía and set it on fire. During this same attack, these northern Cuna succeeded in abducting a Spanish woman and her daughters.[156] This particular event made an indelible impression on Charles III, who referenced it in a real cedula written in 1774, mentioning the woman by name as Antonia Borja.[157]

The devastating 1766 attack and the vigía's resultant destruction prompted its relocation.[158] In a letter to the viceroy, Governor Díaz de Perea stated that he was willing to sacrifice for his regent and his own honor, but there was nothing at the vigía—not military force, nor people, nor arms—to sustain or defend any type of empire.[159] Díaz de Perea asked the viceroy to send munitions,[160] but these requests appear to have gone unanswered.

The newly located vigía at Curbaradó was as under-resourced and as understaffed as its predecessor had been. An undated and anonymous descripción portrayed the vigía at Curbaradó as poorly constructed, not unlike the tambos (humble inns for travelers) of the Indians. The vigía captain was a veteran soldier and yet even he was unable to fend off the smallest attack. The descripción went on to note that the new vigía's building materials—straw and palm—were the most likely to catch fire; it took only a single flaming arrow to ignite them. In terms of arms, there were only seven or eight muskets, only half of which were functional.[161]

Just a year after the vigía had been relocated to Curbaradó, the Spanish learned that the Caledonian Indians planned to burn the new vigía and kill Cuna living in Murindo.[162] In a letter written a few months later, Díaz de Perea underscored the ongoing dangers. There were only six Murrí Indians to serve as sentinels, and none knew how to operate the muskets at the vigía. Díaz de Perea ordered

that the vigía be adequately manned in all months of the year. Without these crucial reinforcements, this important post would be compromised, and the province would be invaded. Given the historically poor defense at the vigía, Díaz de Perea proposed that it be guarded not by Murrí Indians but instead by free men (*libres*) from the region.[163] The Curbaradó vigía continued to be a target of Cuna attack. In 1771, Cuna Indians and unnamed foreigners attempted to invade the province of Zitará. The Zitará attack was thwarted, but on their retreat, this marauding group burned the vigía and killed the cabo. A report to the viceroy noted that two men ("dos negros") were also missing, possibly killed or abducted in the assault.[164]

A particularly devastating attack on the vigía occurred in 1776. The details were recounted in a letter to Nicolás Antonio Clasens, then governor of the Chocó (1776–1778), from Francisco Antonio Romero, who served as both the captain of the vigía and the corregidor of Murrí. After the Cuna attack, Romero scoured the vigía for clues, discovering the body of Salvador Cobo, who had died from several blows to the skull from the butt of a shotgun (*culata de escopeta*), which was found near his corpse. Romero looked for, but did not find, any trace of the cabo, Calderon, so ordered that the river be searched. At a place called La Larga, on the Atrato, the search party encountered evidence: two pieces of paper with cryptic and ominous messages scrawled in charcoal by the hand of Calderon. One of the notes warned that Indians sent to the vigía to stand guard would be beaten and killed. Another scrap of paper alluded to those killed in the recent attack, while a third scrap contained a message suggesting that Cuna Indians would soon return.[165] Through written notes and mutilated bodies, Cuna visually demonstrated the lethal threat they posed to the Spanish and their Indigenous allies. Romero, together with libres, Indians from Murrí, and some manatieros, worked quickly to rebuild the vigía, all the while fearing the next Cuna invasion.[166]

The brutal 1776 attack led to some introspection about the vigía's many shortcomings and to proposals about how future calamities at this defensive post might be avoided.[167] One of the problems with the vigía was its location. This siting was not conducive to defense, an issue that, as Governor Clasens emphasized, was counter to the most basic requirement of a lookout post.[168] The

area was also prone to flooding, facilitating the entry of enemy canoes.[169] And despite having long ago confirmed the ineffectiveness of Murrí Indians as watchmen, the task of guarding the Atrato vigía still fell to them. Clasens concluded that despite the vigía's many drawbacks, there was no better place for it, so it should remain at Curbaradó but should be manned by someone other than Indians from Murrí.[170]

In Clasens's view, the vigía would be better guarded by *gente libre* (free people) from the province, such as mulatos and *zambos* (those of mixed Indigenous and African ancestry), who were agile and skilled in the water, faithful to the king and to the motherland, willing to serve, and brave.[171] Clasens emphasized that, given the vigía's remoteness, six guards were simply insufficient. To adequately protect the vigía, twelve or more were needed.[172] In the same case file, there are contracts for six libres identified for the post of custodian and guard of the Atrato vigía. In each of these six contracts, the freemen committed to the job, and did so voluntarily, for the term of one year.[173] All six came from different parts of the province: one was from Toro, one from Buga, one from Cartago, one from Roldanillo, one from Antioquia, and one from Llano Grande.[174] The only mention of payment came from Clasens, who stressed to the viceroy that these individuals must be salaried, as nothing would have an effect without monetary compensation.[175]

Decades of archival documents reveal that the Atrato vigía was a crucial, yet ineffective, Spanish defensive structure. Made of flammable materials and inadequately armed, it was half-heartedly patrolled by Murrí Indians who, when threatened by attack, chose flight instead of deploying the outdated weapons at their disposal. The history of this unfortified and understaffed defensive post along a major transit route linking the Caribbean to the country's interior helps to illustrate the tenuous and ephemeral nature of Spanish conquest and colonization in this peripheral region of Spanish America.

Despite its failure as a defensive post, the Atrato vigía served other, more successful, functions, such as providing a space for dialogue and mediation between Spanish, Cuna, and other nations. It is through the vigía and its various roles that we gain a better sense of Spanish-Cuna interactions and

Cuna strategies of resistance and diplomacy at this time. It was from the vigía that Cuna sought an audience with the governor of Chocó and negotiated the terms of their future settlement. The vigía also provided a place where Cuna and French could negotiate with the Spanish. It was a "safe" zone in an otherwise contested area where Spaniards traveling through the Chocó could stop to rest and gather information (though in reality often at their peril) before continuing their journey. The vigía also posted a territorial claim, indicating the northernmost extent of Spanish settlement along the Atrato. Precisely because the vigía represented Spanish presence and incursion in Cuna territory, it remained a target of Cuna attack. Cuna ambushes and other factors forced the Spanish to relocate the vigía at least three times. These forced relocations of a Spanish defensive structure along the Atrato underscore Cuna ability to limit Spanish incursions into their territory.

Conclusions

This chapter began with a map (plate 2) that led to the discovery of an overlooked place on the space-time continuum: the Cuna reducción of San Bartolomé de Murindo. A critical examination of the map and its associated case file made it possible to sketch out key elements of the overlooked history of this Cuna reducción. Archival documents reveal that the Spanish reducción of Murindo came into existence in 1760 at the behest of Cuna Indians from Tarena, Banana, Tigre, and Caiman who voluntarily sought settlement by the Spanish. Cuna negotiated the terms of their reducción and were permitted to govern themselves. When conditions at Murindo ceased to be favorable to them, the Cuna collectively left. There were no apparent consequences.

The map and archival documents also direct us to another overlooked element of colonization in this periphery: the Atrato vigía (see figure 3.2). A modest defensive structure situated near the imagined boundary line denoting the Cuna-Spanish frontier, the vigía marked the northernmost border

of Spanish occupation in Cuna territory. The vigía's primary function was to defend Spanish-settled areas farther south and protect the Crown's interests in the region. And yet, as the story of Murindo demonstrates, the vigía wore many hats. In addition to serving the purposes of boundary marking and defense, it was a space of refuge, mediation, and dialogue.

Murindo provides a concrete example of the tenuous and ephemeral nature of Spanish colonization in the Chocó. In particular, this mid-eighteenth-century episode sheds light on the various strategies employed by Cuna to control Spanish expansion along the Atrato. The Cuna lived in independent groups led by different caciques and acted independently of one another. Some Cuna violently frustrated Spanish territorial claims through relentless attacks on the Atrato vigía, ultimately forcing the Spanish to relocate their defensive position closer to Spanish settlements. Other Cuna, meanwhile, chose an equally strategic but more pacific path, entering into dialogue with Spanish authorities, soliciting and negotiating a reducción that would, at least for a time, satisfy both parties. In comparison to their tactics of violence and negotiation with Spaniards, the Cuna engaged in mutually beneficial alliances with the French and the English, who supplied them with the weapons they needed to keep the Spanish in check. In sum, Murindo reveals that Cuna strategies against the Spanish were offensive, not defensive. Furthermore, the story of Murindo highlights Cuna Indians as opportunists, as well as skilled diplomats, adept at negotiating and cooperating with Spanish officials and other foreigners. As Gallup-Diaz demonstrates, the Cuna did not simply confront and resist European expansion into their territory, they effectively *managed* it.[176] This was the case in the seventeenth-century Darién and appears to have been true also in the eighteenth-century Chocó. Additional examples of Cuna Indians as wily actors on an international stage can be found in the many treaties the Cuna entered into with the Spanish over the course of decades.[177] These varied strategies of coexistence are concretized in the story of Murindo.

4

THE MAP OF THE CHOCÓ, PANAMA, AND CUPICA

The Unrealized Potential of a Pacific Port, 1777–1808

Oriented with east at top, the Map of the Chocó, Panama, and Cupica is visually reminiscent of a color-field painting, exhibiting zones of orange and indigo that are disorienting because, on this map, counterintuitively, indigo represents land, while orange denotes water (plate 4). Similar to works by Helen Frankenthaler or Mark Rothko, the map appears to lack a single focal point. However, a closer look reveals that rivers, streams, and seas direct our attention to a heart-shaped form at the bottom center of the composition, which is marked with a compass rose that looks much like an asterisk. The heart-shaped form, labeled with a large "6," represents the bay of Cupica, which, as I will argue in this chapter, is the subject of this cartographic work. Similar to the Map of the Atrato River and Pueblos of Cuna Indians (plate 2), the Map of the Chocó, Panama, and Cupica omits information about the physical landscape and focuses our attention on the aquatic environment. Cupica, as it is depicted on this map, is a vital element in an aqueous network. The bay's size (which has been amplified by the mapmaker) and its position (at bottom center) underscore its centrality in this cartographic composition. A close read of map and

associated historical documents reveals Cupica as a key node along a Pacific corridor and a viable point of entry into the Chocó interior.

In this chapter, the Map of the Province of the Chocó and the southern part of Panama with new establishments in Cupica (*Mapa de la provincia del Chocó y parte meridional de Panamá con fundaciones hechas en Cúpica*), shortened to the Map of the Chocó, Panama, and Cupica (plate 4), directs our attention to this little-known port. Located on the Pacific Ocean roughly 300 miles (480 kilometers) south of Panama, Cupica was one of several places to emerge as a result of Crown prohibitions on travel and commerce along the Atrato. Just six days by watercraft from Panama, Cupica was—geographically speaking—an unlikely periphery. As a port and a town, Cupica engaged in coastal trade and commerce with Panama, Tumaco, Guayaquil, and Lima. It was also an entry point to an interoceanic waterway connecting the Pacific to the Caribbean via the Atrato River. The map of Cupica provides a glimpse of Spanish aspirations for Cupica as a port of promise. The act of uniting this cartographic work with relevant historical documents illuminates local attempts to

use Cupica in overcoming the region's defensive and economic shortcomings. Map and documents, considered together, preserve episodes of competing local interests, thwarted Spanish colonization, and Indigenous agency in a peripheral area of the Greater Chocó.

In the late eighteenth and early nineteenth centuries, the Pacific port of Cupica enjoyed the attention of Spanish officials for three decades but then fell away from prominence. Since then, it has represented a missed opportunity. Working from the Map of the Chocó, Panama, and Cupica (plate 4) and archival documents from its case file, we resurrect the port of Cupica from obscurity.[1] This 1783 map by Lorenzo Alarcón anchors our story in space-time, setting the scene on the Pacific coast between today's Panama City and Bahía Solano.[2] Relevant archival documents allow the story's central protagonists—and antagonists—to emerge. The map highlights the bay of Cupica's excellent location on the Pacific Ocean, yet archival documents spanning three decades reveal how local politics and Cupica's revolving door of *corregidores* undermined Cupica's development. The historic episode of Cupica complicates the very notion of periphery, suggesting that this designation—"periphery"—had as much to do with politics as it did with geography.

The story of Cupica explored in this chapter foregrounds Spanish efforts to develop its port. In the background are Indigenous actors who moved from one reducción to another. Even if the documents elide their importance, reduced Indigenous inhabitants were key to Cupica's development: they were the workforce that moved goods to and from the port and on to other areas of the Spanish Empire. The inhabitants of the reducción of Cupica and their role as active agents will be the focus of the final section of this chapter. The seeming inability of Cupica's successive corregidores to construct and maintain a church on this remote frontier, discussed at the end of this chapter, may help to explain the ultimate failure of Cupica (the reducción) and along with it, Cupica's port. Regardless of the circumstances leading to its demise, Cupica's thirty-year Spanish colonial history makes it worthy of scholarly attention.

The Map of the Chocó, Panama, and Cupica (plate 4) makes two visual arguments, one geographic and one economic. Both arguments center on the great potential of Cupica and the importance of developing it as a Pacific port. The first argument the map illustrates is that Cupica provides a logical access point from the Pacific Ocean and has connections (via the Atrato River) to the Caribbean Sea. For those seeking ways to unite the two seas—an undertaking that held advantages for the Chocó, its mining operations, the viceroyalty, and the Spanish Crown—the map provides visual evidence that Cupica is a feasible starting point. The second, and perhaps more salient, argument highlights Cupica's economic potential. Cupica (6 in the bottom half of the map) appears in visual dialogue with the "plaza de Panama" (37, toward the bottom left corner of figure 4.1),[3] underscoring their proximity to one another. Cupica's location relative to ports to the south—Chirambirá, Buenaventura, Tumaco, Guayaquil, and Lima's port of Callao—makes it a central nexus on a trade network linking the Chocó to both Panama and the viceroyalty of Peru. In directing our attention to Cupica, the mapmaker posits that this underutilized Pacific port could, with substantial investment, commercially benefit the Chocó, the viceroyalty, and the Spanish Crown.

Created in 1783, a year before the Crown lifted a near century of restrictions on travel and commerce along the Atrato, this map reflects a shift in supply networks, from the Caribbean/Atlantic to the Pacific.[4] Focusing attention on the port of Cupica, the map reveals that this Pacific bay was part of an interaction sphere that extended far beyond its province, Zitará (in the viceroyalty of New Granada), and brought advantages to local populations as well as profits to merchants in Panama, Guayaquil, and Peru. Cupica's location made it central for those living and operating along the Pacific coast. Nevertheless, its great distance from New Granada's capital of Santa Fé doomed Cupica from the start.

The Map of the Chocó, Panama, and Cupica (plate 4) has been published in recent years and its legend text transcribed, but, to date, it has received no significant analysis.[5] Academic scholarship has been equally silent on the settlement and port of Cupica in Spanish colonial history, save for a mention by William Sharp in his foundational *Slavery on the Spanish Frontier: The Colombian Chocó, 1680–1810*. As Sharp relays, Cupica functioned as a port in the 1770s but began fading from view once navigation was again permitted on the Atrato a decade later. Not finding additional

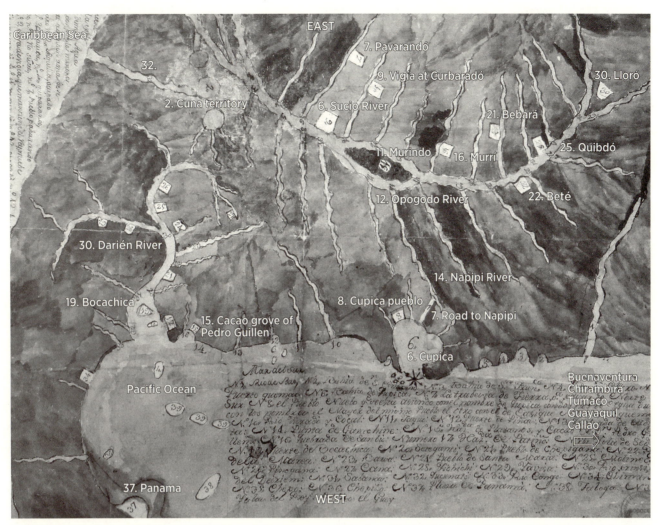

FIGURE 4.1 Detail of the Map of the Chocó, Panama, and Cupica, 1783 (plate 4), with numbers and text (added by author) denoting places of importance to the discussion.

mention of Cupica in archival documents after 1791, Sharp logically assumed that the port had been abandoned.[6] My aim in this chapter, building upon Sharp's tantalizing mention of Cupica, is to demonstrate that Cupica remained an active Pacific port for at least another decade past 1791. Much of Cupica's late eighteenth-century history can be culled from the Map of the Chocó, Panama, and Cupica and surviving archival documents.[7]

Despite Cupica's relative omission from late Spanish colonial history, this Pacific port is critical for our understanding of New Granada and Spanish America because it raises questions about the nature of peripheries. As the crow flies, Cupica lay 280 miles (450 kilometers) from New Granada's capital. However, in physicogeographical terms, Santa Fé and Cupica were separated by all three cordilleras of present-day Colombia—the

Occidental, Central, and Oriental—and by its two largest rivers—the Magdalena and the Cauca (see figures I.1 and I.5). The most direct route from the viceregal capital to the port of Cupica required several months of fluvial and overland travel.[8] The Map of the Chocó, Panama, and Cupica illustrates Cupica as a logical and central Pacific port, despite the fact that, in the eyes of Spanish colonial administrators, Cupica was little more than a remote frontier. In undertaking a textual journey through Cupica's history, we come to understand that labels like "periphery" are wholly dependent on and relative to the defined center.

Cupica was viewed by Santa Fé as peripheral because it was more easily connected to areas *outside* its province of Zitará than to areas within it. Travel from Cupica (6) to Quibdó (marked 25 in the top half of the map), a town located within the

province of Zitará, required up to nine days. Meanwhile, travel from Cupica to Panama (37), which belonged to a different province, that of Panama, took just six days.[9] Cupica's geographical position, therefore, placed it *outside* of *internal* geopolitical networks, yet squarely *within* politically defined *external* trade networks.[10] For residents of Panama and Cupica, this connection was seamless and had been for at least a millennium. Archaeological findings reveal that pre-Hispanic populations near Cupica had frequent contact with those in Panama and the Caribbean. Based on 1961 excavations at Cupica, Gerardo and Alicia Reichel-Dolmatoff determined that Cupica's interaction sphere from 735 to 1000 CE had a northwesterly and coastal orientation and included Panama and the Pearl Islands.[11] Meanwhile, Warwick Bray, during his excavations at Cupica in the 1980s, identified evidence for pre-Hispanic contact and exchange between Cupica and the Gulf of Urabá and the Caribbean coast.[12] These geographical spheres of contact and exchange remained in evidence during the eighteenth century. For example, vecinos of Panama owned and maintained plantain and cacao groves near Cupica (discussed later in this chapter). Imports to Cupica came not from Santa Fé or from Popayán, but from Panama.[13] Cupica may have been seen as a periphery relative to the capital of Santa Fé, but it was part of a long-established Pacific coastal interaction sphere. A closer look at maps and archival documents focused on late eighteenth-century Cupica reveals that the perception and designation of Cupica as a periphery was the result of political boundaries, not geophysical ones. In other words, visual and textual material suggests that it was geopolitics, not geography, that led to Cupica's peripheral status throughout the Spanish colonial period.[14]

Cupica: A Port of Potential

Cupica's potential as a Pacific port was never in doubt. Military engineers and viceroys in the late eighteenth century, intrepid explorers and geographers in the nineteenth century, and a Colombian president in the late twentieth century all saw Cupica as a port of promise.[15] Cupica facilitated commerce with other ports along the Pacific and was long viewed as a viable entry point to an interoceanic waterway connecting the Pacific and the

Atlantic. This passageway would, in 1914, take the form of the Panama Canal. In the century preceding the canal's construction, however, Cupica was seen as a likely contender for the coastal start of an aqueous route uniting these oceans.[16]

Many distinguished individuals identified the importance of Cupica. Alexander von Humboldt, in the early nineteenth century, saw in Cupica the possibility for an opening to an Atlantic-Pacific channel. One of the nine potential routes Humboldt proposed in his *Political Essay on the Kingdom of New Spain* (1811) utilized the bay of Cupica.[17] Around this time, the Colombian polymath Francisco José de Caldas also expounded on Cupica's strengths as a Pacific port with connections to the Caribbean via the Napipi and Atrato Rivers.[18] The explorer Charles Friend, who traveled to Cupica in 1827, described the bay as beautiful, with an expanse that stretched for seven miles. Its shores were full of timber, Friend noted, facilitating an industry where local Indians carved canoes that were sold in Panama.[19] In 1834, Cupica was still being discussed as a port that—using the Napipi, the Atrato, and the Gulf of Urabá—could grant access to the Atlantic.[20] Jean-Baptiste Boussingault, a French scientist and colonel under Simón Bolívar, in the 1850s proposed Cupica as part of an interoceanic canal.[21] Meanwhile, Agustín Codazzi, undertaking reconnaissance in the Chocó as director of the ambitious Comisión Corográfica in the 1850s, viewed the use of Cupica as a way to connect the Atrato valley with other ports along the Pacific.[22]

Aspirational dreams for Cupica carried into the twentieth century, championed by Colombian president Virgilio Barco Vargas (1986–1990). In Barco's view, Cupica possessed the potential to become, with substantial government investment, a world-class maritime port.[23] Transforming Cupica from a sleepy village into a global coastal hub would stimulate economic and cultural development in the Pacific Lowlands and would link the Pacific Ocean to the rest of the country through a proposed ferry line to the Gulf of Urabá.[24] As history reveals, none of these grand projections for Cupica were realized.[25]

Spanish colonial documents show, however, that ambitious plans for Cupica were in place by the final decades of the eighteenth century. As discussed in chapter 3, the Spanish military engineer Juan Jiménez Donoso, an early proponent of

Cupica's development, recognized Cupica's proximity to Panama and to the Chocó interior and identified it as an excellent source for timber.[26] Viceroy Antonio Caballero y Góngora (1782–1788) was keen to find a route that could link the Atlantic and the Pacific.[27] Cupica presented one such option. Neither engineers nor viceroys, however, can be credited with on-the-ground attempts to exploit Cupica's potential. This thankless task would fall to other, less powerful Spaniards. Those ambitious but thwarted few will be our focus later in this chapter.

The Map of the Chocó, Panama, and Cupica is concerned with aquatic routes of access into and out of the region and the ways that rivers and oceans connect (see figure 4.1). Topographic features are omitted, as are most roads, giving visual primacy to waterways. Territory claimed by the Spanish is indicated in white. Even at this late date, 1783, these areas are few in number. Guiding the map's orientation is the Atrato River (marked with a nearly illegible 1 in the top half of the map), which flows from right to left (from south to north). Below the Atrato, to the left, is the Darién River (30 in the bottom half of the map), which flows west, toward the Pacific Ocean. The Atrato's tributaries, in the top half of the map, host places discussed in the previous chapter, including Murindo (11), Murrí (16), Bebará (21), Quibdó (25), and Lloró (30).[28] Also identified is the Atrato vigía (9 in the top half of the map), which occupied a prominent place in our discussion of Murindo.[29] Nevertheless, the map's subject is Cupica.

The map highlights two fluvial routes—the Atrato and the Darién—which, through a series of connections, unite the Caribbean and the Pacific. Additionally, both river systems offer avenues for travel and commerce inside and outside the region. The Atrato system (in the top half of the map) connects the Caribbean Sea to the Pacific Ocean via the Atrato and the bay of Cupica (bottom half of map). This Atrato route moves from the upper left to the lower right quadrant of the map. Meanwhile, the second system utilizes the Darién River (30), which flows to the Pacific and links to the Caribbean through small tributaries near three circular features found in Cuna territory (2). From these circular features, one waterway leads to the Atrato while another river (32), marked but unnamed, flows to the Caribbean.[30] In sum, the map outlines two aquatic routes that connect the Pacific and Atlantic coasts.

A closer look at both fluvial trajectories reveals that these routes are not equal. The Darién route, which begins in the lower left quadrant near the fort of Bocachica (19), relies on the Darién River but forces travelers to pass through the circular features in the upper left quadrant of the map. These circles are identified in the legend as lands of *indios rebeldes*, or autonomous Cuna.[31] Significantly, no portion of this area is identified as Spanish-settled territory (shown in white squares). Vast areas near the Caribbean were, at this time, still controlled by independent Cuna who posed grave danger to any Spaniard who dared enter their lands. The mapmaker indicates that the Darién route, while an option, is less than ideal.

The second, less perilous, option used the Atrato River. This route began farther south, in the bay of Cupica (6). Its itinerary was longer but arguably safer because it avoided Cuna territory. Since the Spanish had been unable to subjugate autonomous Cuna in this region, Spanish colonists had little choice but to work around Cuna presence on the landscape. The most advisable strategy was to avoid encounters with autonomous Cuna whenever possible. This map highlights that travel into Cupica and down the Atrato, while longer, was the better choice.

The notion that the shortest route, especially if it passed through Cuna territory, was not always the best one is corroborated on a later chart. An 1807 map created by Andrés de Ariza, *Ruta de Antioquia a Panamá por una parte de la provincia del Chocó* [. . .] (Route from Antioquia to Panama through a part of the province of the Chocó [. . .], plate 8), illustrates two possible itineraries from Antioquia to Panama.[32] Both began in Antioquia and moved to the confluence of the Atrato and the Napipi (see plate 8, blue line). At this juncture, there were two options. The shorter but much riskier of Ariza's two itineraries moved from the Atrato to the Arquia River to the Darién River (plate 8, red line). From the nearby Ensenada del Darién (Darién Cove), one could sail to Panama in a matter of days. However, because a critical piece of this shorter trajectory moved through perilous Cuna territory (an area Ariza glossed on the map as "Indios Cunas"), Ariza cautioned against it in the map's explanatory text. The maritime passage from the Ensenada del Darién was, Ariza confessed, shorter, but there was the *inconveniente* (drawback) of the Cuna.[33] Instead, his map highlights the longer, but safer,

route that turned onto the Napipi River and went to Cupica, and from there to Panama (plate 8, green line). In other words, while a route that involved the Ensenada del Darién was theoretically possible, it was, in practice, fraught with peril. Travel through Cupica offered a safer alternative. Ariza's 1807 map reinforces the claim made in the 1783 Map of the Chocó, Panama, and Cupica: Cupica offered the most viable option for entering and exiting the Chocó via the Pacific.

Despite their stylistic differences, the two maps make the same argument. Ariza's map emphasizes Cupica as a secure route that avoided Cuna-occupied territory. Meanwhile, the Map of the Chocó, Panama, and Cupica underscores Cupica's proximity to Panama and to ports farther south while highlighting Cupica as an entry point to the interior (plate 4). Both maps indicate that colonial and provincial officials, from 1783 until 1807, saw Cupica as a viable Pacific port.

Cupica's Late Eighteenth-Century Emergence as a Port and Reducción

Of the many remote places discussed in this book, Cupica is the one that most challenges the notion of periphery. A protected bay on the Pacific, with deep water conducive to the entry of large ships, Cupica was an optimal node that facilitated regular and reliable commerce with Panama and other Pacific ports, including Guayaquil in Ecuador and Callao in Peru.[34]

An important motivation for establishing Cupica as a port was to encourage commerce with Panama. Information on this trans-Pacific trade route is preserved in the case file. An example of what came into Cupica's port from Panama at this time appears in the discussion of the maritime vessel *La Deseada*, which sailed into the port of Cupica in 1779, two years after Cupica was founded in 1777.[35] An inventory of the ship's cargo reveals that *La Deseada* carried an array of goods likely originating from several ports: meat, salt, leather, sugar, cacao, leather bags full of animal fat for candles and soap, material for candlewicks (*pábilo*), cooking pans (*pailas*), green earthenware jars (*botijas*), glass jars (*frasqueras*), bales of wool and fine cloth (*fardos de bayeta y ruan*), and wine transported in short, wide bottles with long necks

(*limetas de vino*). Also listed on the ship's manifest are iron (*fierro*), steel (*acero*), and lead (*plomo*), as well as rifles (*escopetas*) and a writing desk (*escritorio*).[36] From other case files, we learn that building materials for Cupica's church, including bells and ornaments, also came from Panama.[37] All of this indicates that much of what was needed to supply Cupica and the Chocó could be obtained with relative ease from nearby Panama.

These same documents reveal that Cupica generated its own trade goods. One of Cupica's main exports, timber, was locally harvested, loaded onto canoes crafted by Indigenous inhabitants, and transported to Panama's port.[38] Cacao was another commodity sent from Cupica to Panama. Pedro Guillem, a vecino of Panama and captain of *La Deseada*, owned a large cacao grove just north of Cupica and likely shipped his cacao to Panama to be sold (see 15 on figure 4.2).[39]

Trade between Cupica and Panama was seamless; however, Cupica's commerce was not limited to Panama. Cupica's merchants also traded with the Darién, Guayaquil, Tumaco, and Lima.[40] Evidence of Cupica's extensive Pacific trade, some of which was illicit, came from one of Cupica's corregidores, José Fernández. In a letter to the viceroy, Fernández relayed that his rival, Nicolás Gutiérrez, was in Cupica contracting two vessels loaded with merchandise, including enslaved Africans, from Cartagena. These vessels would sail to Peru and Guayaquil and would then return to Cartagena loaded with goods from those ports.[41] As archival documents attest, Cupica formed part of an extensive Pacific trade network that extended beyond the Chocó and the viceroyalty of New Granada.

Cupica's geophysical location made it a central node in a larger sphere of interaction. As the Map of the Chocó, Panama, and Cupica illustrates, Cupica was connected to several Pacific ports. It was also linked, via the Atrato, to the Caribbean, and from there, to the Atlantic. These trade networks put Cupica in contact with people and goods from outside its province, Zitará, and from viceroyalties other than New Granada. Trade through Cupica also meant that provisions and merchandise from the Caribbean and beyond arrived at more regular intervals and at more competitive prices.[42] Its proximity to Panama and ports to the south made Cupica an ideally situated Pacific port.

Still, decades of attempts to develop Cupica

FIGURE 4.2 Detail of lower left portion of the Map of the Chocó, Panama, and Cupica (plate 4), showing Cupica (6), the Plaza de Panama (37), and the cacao groves of Pedro Guillem (15). Guillem was a vecino of Panama and the captain of the maritime vessel *La Deseada*.

came to naught. Which factors kept this geographically central, adequately sized, and well-connected bay from becoming a port of consequence during the late Spanish colonial period? Answers to this question emerge from a rigorous examination of the 246-folio case file archived with the Map of the Chocó, Panama, and Cupica.[43] The documents in this file bring to light thirty years of initiatives aimed at transforming the quiet bay of Cupica into a bustling port. The surviving correspondence, involving corregidores, governors, and viceroys, affirms Cupica's place as a Pacific port of promise. These same documents, meanwhile, confirm that local rivalries and Cupica's distance from New Granada's center thwarted its ultimate success.

Cupica's Corregidores

Cupica's First Corregidor, Lucas de Alarcón

The Map of the Chocó, Panama, and Cupica (plate 4) was produced in 1783 under the direction of Lucas de Alarcón, a vecino of the Chocó and an owner of mines and enslaved laborers.[44] Cupica's late eighteenth-century history is closely tied to Alarcón, who was Cupica's "discoverer" and its first corregidor. Alarcón did not commission the Map of the Chocó, Panama, and Cupica to advocate that he be *appointed* corregidor of Cupica. Instead, he used it in his campaign to *retain* his post. A signature and date on the back of the map identifies Lorenzo Alarcón as its creator and 15 January 1783 as its date (figure 4.3).[45]

To better understand the events that ushered in Lucas de Alarcón's appointment as Cupica's first corregidor, as well as those that led to his ousting, it is necessary to travel back in time. In 1776, the Chocó governor, Nicolás Antonio Clasens (1776–1778), sent Alarcón, who was then serving as corregidor of Beté, to undertake reconnaissance along the Atrato River.[46] Alarcón, it appears, first learned of Cupica and came to see its great potential during this expedition. During his reconnaissance, Alarcón identified the Napipi (14) and the Opogodó (or Opogadó) (12) Rivers as opportune points of connection, as both flowed to the Atrato and provided easy access to the Pacific through Cupica (figure 4.4).[47] Alarcón's "discovery" of this

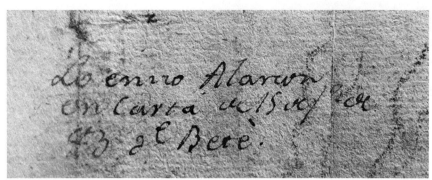

FIGURE 4.3 On the back side of the Map of the Chocó, Panama, and Cupica (plate 4), the text "Lorenzo Alarcón en carta de 15 de 1º de 83 de Beté" provides a date for the map (15 January 1783) as well as the likely author and the location of its creation.

quiet bay in 1776 set in motion the future course of Cupica.

Reconnaissance behind him, Alarcón, though still serving as the corregidor of Beté, received orders from Governor Clasens to establish Cupica's port, which would facilitate more streamlined correspondence with the Darién, permit trade with Panama, and supply mining operations in the Chocó.[48] The founding of Cupica as a port was closely tied to establishing a reducción of Indigenous inhabitants, whose labor would fuel port operations. The closest Indigenous population at Alarcón's disposal was the one in his corregimiento of Beté (22). To facilitate the foundation of Cupica's reducción, Alarcón was granted two additional years as corregidor of Beté, with the possibility of extending if necessary. Additionally, in 1777, he was appointed the first corregidor of Cupica for a ten-year term.[49] The building blocks for Cupica's development as a port and reducción were now in place.

Critical to developing Cupica as a port was first establishing it as a reducción, a project that Alarcón undertook with gusto. In his first three years, Alarcón founded the pueblo, settled approximately a hundred Indians, and oversaw the construction of ten large houses.[50] A church and a residence for the corregidor and another for the priest (who had yet to be named) were also underway. Alarcón reported that Cupica's population was sustained by local groves of plantains, cacao, sugar cane, and fruit trees, and the soil and climate were conducive to the growing of corn.[51] By 19 February 1781, Cupica's church was reportedly complete.[52] On 12 June 1782, Alarcón recorded the names, ages, and family units of those residing in Cupica. In addition to 144 Indigenous inhabitants, there were 7 gente libre.[53] From these accounts, it appears that Alarcón's designs for Cupica, both port and

reducción, were advancing according to plan. Unbeknownst to Alarcón, various forces were at work to upend his progress.

From the very beginning, Alarcón's efforts were undermined by competing factions. One faction consisted of merchants from Cartago, Buga, and Cali who had long supplied—at exorbitant prices—the remote gold-mining regions of the Chocó. As Alarcón complained in a letter to the viceroy, the founding of Cupica as a port that facilitated trade with Panama and Guayaquil was opposed by merchants from Cartago, Buga, and Cali (and also by the lieutenant governor of Zitará). In their eyes, Cupica and its trade with Panama and Guayaquil supplied the Chocó with the same goods at better prices, threatening the profitable internal monopoly that merchants from Cartago, Buga, and Cali had held on commerce with the Chocó.[54] Other threats to Alarcón's position as Cupica's corregidor came from jealous rivals who coveted the perks of this lucrative remote port. These challengers would ultimately unseat Alarcón as corregidor of Cupica. Halfway into Alarcón's ten-year appointment, and despite his documented progress, his position as corregidor of Cupica came under fire.

In a letter to Viceroy Caballero y Góngora, Alarcón addressed accusations made against him and relayed that, as corregidor of Cupica, he had fulfilled his mandate.[55] Other correspondence describes how Alarcón had successfully founded the new reducción of Cupica, which boasted a settled Indigenous population, a good church, a variety of crops, and livestock.[56] Cupica's reducción supported its port, which, before Alarcón's arrival, had been entirely unknown and consisted of little more than a dangerous and deserted coast inhabited by barbarous Indians.[57] Alarcón's undertakings at Cupica had facilitated transport between the Pacific and the Darién, permitted commerce

(*franquicia de comercio*) with Panama, and enabled trade with Guayaquil.[58] Goods coming into Cupica's port also supplied the province of Zitará and its pueblos with merchandise at regular intervals and at more competitive prices.[59] If further validation of Cupica's merits was needed, the military engineer Juan Jiménez Donoso had corroborated the importance of Cupica, noting its excellent timber.[60] The establishment of Cupica's port and reducción had, Alarcón argued, been successfully carried out.

Documents indicate that accusations against Alarcón were not leveled at the quality of Cupica's port nor at its commerce, but at Alarcón's methods of populating Cupica. The bishop of Popayán had hinted to the viceroy that Alarcón, who took credit for populating Cupica, had merely moved Indians from his corregimiento of Beté to the new reducción of Cupica, an act that the bishop equated to "disrobing one saint to clothe another."[61] Early correspondence discussing the project of "populating and opening the port on the Pacific" indicates that, from the beginning, the *naturales* (Indigenous inhabitants) of Beté were envisioned as key to the port's success, as they could provide needed labor in Cupica.[62] While it was never explicitly stated that Cupica's initial inhabitants would be Beté Indians, their temporary relocation to Cupica must have been assumed, given that Beté was the nearest pueblo de indios to Cupica.[63] It is important to note that Indians from Beté made up only a portion of Cupica's population. A list of Cupica's inhabitants, drafted on 12 June 1782, indicates that one-third, or thirty-six, were Indian tribute payers from Beté. However, another thirty-one were *cimarrones* (Indians who had fled reducciones elsewhere). There were also seventeen Indian tribute payers from Lloró, five Indian tribute payers from Quibdó, and five Indians from Murrí who had, according to documents, come to Cupica voluntarily.[64] Alarcón had in fact brought Indians from Beté, but they accounted for only a portion of Cupica's population. Cupica had been settled primarily with runaway Indians and others from Lloró, Quibdó, and Murrí.

The relocation of Indians from Beté to Cupica appears to have been the central point of contention in archived correspondence, but Alarcón understood that the real issue was Cupica itself. Cupica—a port that facilitated trade with other provinces and other viceroyalties—was not supported by the lieutenant governor of Zitará or by merchants in Cartago, Buga, or Cali precisely

FIGURE 4.4 Detail of bottom center section of the Map of the Chocó, Panama, and Cupica (plate 4), showing Cupica (6) and the road (7) that led from the bay of Cupica to the Napipi River (14), which connected to the Atrato. The Opogodó River (12) also lay in proximity to Cupica and to a waterway flowing from there.

because commerce into and out of Cupica threatened their own trade with the Chocó. The fact that these men, Alarcón wrote, put such energy into impeding coastal commerce simply to maintain their own positions both then and in the future should not surprise anyone. To serve their own interests, they would gladly see Cupica destroyed, despite the fact that without Cupica, trade with Panama would not exist.[65] Alarcón's comments foreshadow an observation made several decades later by Agustín Codazzi about local interests often winning out over the greater prosperity of the region. Mentioning Cali specifically, Codazzi

noted then that a handful of wealthy *especuladores* (speculators), who held a monopoly on mules and shipments, opposed any road construction that might threaten their own livelihoods.[66]

Faced with the possibility of losing his position as corregidor of Cupica and its associated benefits before the end of his ten-year term, Alarcón presented his arguments to the viceroy both textually and visually.[67] It was at this time, in 1783, with much at stake, that Alarcón oversaw the creation of the Map of the Chocó, Panama, and Cupica (plate 4). On this map, Alarcón highlighted Cupica's ideal position on the Pacific coast, which clearly facilitated trade with Panama (37) as well as with Guayaquil and Callao. Alarcón emphasized Cupica as a gateway to the Caribbean by depicting the road (7) that led from Cupica to the Napipi River (14), which led to the Atrato (1), which flowed to the Caribbean. In his accompanying letter, he drew attention to the newly created map, stating that from Cupica, the province of Panama was just forty-eight leagues away and could be reached in about six days, with other provinces equally accessible.[68] Alarcón apologized for the map's geographical defects but emphasized that it was accurate in *la práctica* (in practice).[69] This statement, together with the map's detailed coastline and vaguely formulated interior, suggests that, in addition to arguing for the importance of Cupica and his own continued role as its corregidor, the map may have visually informed navigation on this stretch of coast.[70] On the Map of the Chocó, Panama, and Cupica, Alarcón made immediate and apparent the advantages Cupica held for Pacific trade.[71]

If the map made an impact on the viceroy, it had little effect on the course of future events. Allegations against Alarcón continued to surface. The new Chocó governor, Carlos Smith (1786-c. 1787), in a letter to the viceroy, noted that while he understood the benefits of Cupica (with its excellent location, rich soils, and exquisite wood) and the positive outcomes Cupica had brought for Panama, it was harder for him to see the advantages that Cupica's establishment had created for the Spanish Crown.[72] In Smith's view, Alarcón had not fulfilled his obligations.[73] In his years as Cupica's corregidor, Alarcón had not regularly submitted tribute to the Real Hacienda (Royal Treasury), a failure that decidedly worked against him.[74] By 2 October 1790, Alarcón had been replaced by a new corregidor of Cupica, José Fernández.

Cupica's Second and Third Corregidores, José Fernández and Nicolás Gutiérrez

José Fernández was the second of Cupica's four corregidores, but his time in this post would be brief.[75] During Fernández's visit to Cupica on 15 December 1790, he recorded a total of 131 Indigenous inhabitants but relayed that there was no one in Cupica who knew how to write. He went on to state that Cupica was, and had always been, without a priest, a church, and church ornaments.[76] This observation—that Cupica lacked a church—is somewhat perplexing given that Alarcón reported completing Cupica's church in 1781 and requested that ornaments from Panama be sent for its decoration.[77] An undated letter from Alarcón to Chocó's governor noted Cupica's church as *competente*, by which one assumes operational.[78] Fernández, aware that his present fortune was due in part to his predecessor's failure to submit timely tribute payments, was quick to tend to this duty. In a letter from 1791, Fernández relayed that he was the first person in sixteen years to submit tribute from Cupica Indians to the *reales cajas* (royal coffers).[79] Although Fernández apparently made efforts to please those in Santa Fé—paying tribute, resettling Indians, and (re)building Cupica's church—doubts soon surfaced about his abilities.[80]

Despite documentation to the contrary, it was determined that Fernández had not accomplished the goals he had set for himself.[81] Fernández retained his post as corregidor of Beté and Bebará but was stripped of his title as Cupica's corregidor after serving less than three years.[82] The reasons for Fernández's premature removal are not clear.[83] A 1793 report suggests that Cupica, under Fernández, was quite functional. Its inhabitants were sustained by local plantain trees and supplied by vessels coming from Panama. There was also, under Fernández, an operational road from Cupica to the Napipi River. The reducción of Cupica reportedly had a plaza, streets, houses, and Indian dwellings, as well as a residence for the corregidor.[84] What could Fernández have done to bring about his abrupt dismissal? Less than a year into his post, as documents reveal, a plot to unseat Fernández as Cupica's corregidor was underway, led by an aspirant to the post, Nicolás Gutiérrez.[85]

Gutiérrez, a vecino of Zitará, a miner, and a *comerciante* (merchant), would become Cupica's third corregidor.[86] Gutiérrez had proposed the establishment of a new pueblo de indios along the

Opogodó River (figure 4.1).[87] The Opogodó was strategic: it could be connected (as the Napipi River [14] had been) by road to Cupica (6), and it flowed into the Atrato. Gutiérrez provided a list of justifications for building this new settlement along the Opogodó River. The location's advantages included its rich soils, which were amenable to growing corn and plantains; its grassy pastures for raising livestock; and the fact that it was an area already frequented by the very Indians Gutiérrez hoped to settle there. When Indians in the area fled their reducciones, Gutiérrez noted, they often sought refuge on the Opogodó River.[88] The thrust of Gutiérrez's proposal was about populating Opogodó, but his future designs on Cupica were clear. He emphasized that the Opogodó was geographically proximate to Cupica, meaning that a road could be built to connect the two. This road, according to Gutiérrez, would be even more efficient than the road (7) that presently connected Cupica (6) to the Napipi River (14).[89] Gutiérrez, in his proposal, engaged in a clever bait and switch, vying openly for control of Opogodó and covertly for control of Cupica.

The establishment of a pueblo de indios along the Opogodó River, as proposed by Gutiérrez, progressed quickly, as did his surreptitious plans for control of Cupica. In a letter to the Chocó governor dated 18 July 1791, Gutiérrez laid out his designs, citing eight stipulations or conditions.[90] Gutiérrez would populate the reducción of San Ignacio de Opogodó with a hundred Indians from the monte, establish plantain and cacao groves, and raise cerdos and vacas (pigs and cattle). Once he had laid out his intentions for Opogodó, Gutiérrez deftly turned his focus to Cupica. Because livestock would be taken to Cupica for export, Gutiérrez proposed that Cupica be placed under the jurisdiction of Opogodó, which he had been granted permission to oversee.[91] This jurisdictional change, giving him control of both Opogodó and Cupica, could begin, Gutiérrez benevolently suggested, after the term of Fernández (Cupica's current corregidor) had ended.[92]

In a March 1793 letter, Gutiérrez pointed out that Cupica was presently underutilized, little known, and decrepit, and its Indigenous residents lacked a parish priest, a church, and religion.[93] The point that Cupica had no church is striking for several reasons. This same trope had been employed by Fernández to suggest an unsettled Cupica under

Alarcón, despite the fact that Alarcón had reportedly built a church. Furthermore, archived documents suggest that *two* churches had already been constructed in Cupica.[94] The suggestion that a new reducción, replete with inhabitants who required ecclesiastical teaching, was without a church was anathema to Spanish colonial sensibilities. A completed and functional church was, in their eyes, fundamental to the success of Cupica's reducción as well as its port. Suggesting that this structure—and this institution—was absent was to present a problem that required immediate resolution.

With the aim of rehabilitating the potentially profitable but allegedly decrepit port of Cupica, Gutiérrez requested in 1791 that he be named corregidor of Opogodó and Cupica for a ten-year term.[95] Hoping to make a case for Cupica's importance and the need for his oversight, Gutiérrez proposed a new road—from Cupica to Opogodó—which, he argued, would permit more expeditious correspondence with Santa Fé. Gutiérrez also emphasized that Cupica—which lay only eight or nine days from Quibdó, where the lieutenant governor of Zitará resided—was within the realm of colonial supervision and control.[96] In his letter to the viceroy of 20 March 1793, Gutiérrez included a map (which had been copied from an earlier map) to illustrate the proximity of the Opogodó River to both the Napipi River and Cupica, *Plan que representa el Golfo de Darien. Según el original del senor Tomas Jefferis, geógrafo de SM Británica año de 1775* (Map of the Gulf of Darién. According to the original by Tomas Jefferis [sic], geographer of His English Majesty, 1775).[97] The fact that the original map served a different function may explain why places central to Gutiérrez's argument—namely, the Opogodó River and Quibdó—are curiously absent. A detail of this map (figure 4.5) shows Cupica's proximity to the Napipi River and its connection to the Atrato but makes a stronger visual case for settlement along the Napipi than along the Opogodó, which was not Gutiérrez's intention.[98] Despite Gutiérrez's confusing map, viceregal officials were enthusiastic about his proposal. Their primary concern was the obvious conflict of appointing Gutiérrez to a post (corregidor of Cupica) that was currently held by someone else (Fernández). Officials were also apprehensive about Gutiérrez's proposed term length—ten years—which struck them as excessive.[99] Misgivings aside, in April 1793 it was recommended that Gutiérrez be granted

FIGURE 4.5 Detail of *Plan que representa el Golfo de Darien. Según el original del señor Tomas Jefferis, geógrafo de SM Británica año de 1775*, 1793. Archivo General de la Nación, Bogotá, Sección: Mapas y Planos, Mapoteca 4, Ref. 140A.

permission to establish the *reducción* of Opogodó and serve as *corregidor* of Cupica, which—at Gutiérrez's request—had been aggregated to the *corregimiento* of Opogodó.[100]

News of Gutiérrez's pending appointment as the third *corregidor* of Cupica was met with understandable defiance by José Fernández. In a letter dated 10 October 1793, Fernández—referring to himself as the *corregidor* of Beté, Bebará, and Cupica—argued that he had fulfilled his mandate: he had constructed a church, adorned it, and provided it with a bell. The only thing missing was the main door.[101] A 1793 report had relayed that the *reducción* of Cupica was, in fact, functional, as earlier noted. Indians were settled, goods were coming in from Panama, and the road from Cupica to the Napipi River was operational. There was no sound reason, in Fernández's mind, for his removal. In an attempt to cast aspersions on his rival, Fernández stated that Gutiérrez's appointment was not warranted: Gutiérrez was using Cupica to move contraband (merchandise that included enslaved Africans) from Cartagena to Peru and Guayaquil.[102] Fernández's searing accusations against Gutiérrez, however, appear to have fallen on deaf ears.

The new Chocó governor, José Michaeli (1791–c. 1798), was emphatic in his disapproval of Fernández. In a November 1793 letter to Viceroy José Manuel de Ezpeleta (1789–1797), Michaeli reported that Fernández, as *corregidor* of Cupica, had failed to deliver. Furthermore, Fernández's permanence in "these provinces" was of no further use.[103] In Michaeli's eyes, Fernández was insufficiently ambitious. He would neither populate Opogodó nor facilitate trade with Panama, leaving Cupica to fall into ruin.[104] Citing these reasons,

Michaeli justified his decision to remove Fernández as *corregidor* of Cupica and replace him with Gutiérrez.[105]

On 5 February 1794, Gutiérrez was appointed *corregidor* of Cupica for a term of five years, only half the time he had requested,[106] although in the end he held the office for seven years. As we might by now anticipate, efforts to undermine Gutiérrez would soon be underway. In a letter to the viceroy in August 1800, the lieutenant governor of Zitará, Martín de Mutuverría, reported that Gutiérrez, in his years as *corregidor* of Cupica and Opogodó, had accomplished little. There was no indication that Gutiérrez would carry out his plans for either *reducción*.[107] Furthermore, despite Gutiérrez's promises to make the *reducción* along the Napipi prosperous, that situation seemed hopeless because—as Mutuverría saw it—Gutiérrez lacked the (presumably financial) means to populate it. Gutiérrez, who had succeeded in unseating the former Cupica *corregidor*, would himself be unseated.

Documents indicate that Gutiérrez's movements at this point had become somewhat restricted. A royal decree on 1 October 1800 forbade Gutiérrez from leaving Cupica or Opogodó for Cartagena or for any port on the Pacific.[108] Roughly a year later, Gutiérrez renounced his post as *corregidor* of Cupica and left for the province of Chiriquí in Panama.[109] Despite Mutuverría's unfavorable assessment, a report drafted shortly after Gutiérrez's departure indicated that the populations in Cupica and along the Napipi were large and in good shape. Gutiérrez was later credited with meeting his mandate and was recorded as solvent with the Real Hacienda.[110]

Cupica's Fourth Corregidor, Carlos María de Andrade

In 1806, after Cupica apparently had gone five years without a corregidor, the businessman (*empresario*) Carlos María de Andrade was appointed as the reducción's fourth and likely final corregidor.[111] Andrade was keen to reopen discussions concerning a road connecting Cupica to the Napipi River, which would stimulate commerce both inside and outside of the region.[112] In a letter to the viceroy, Andrade focused on the advantages Cupica had for commerce with the Darién and proposed a mail route (*correo ordinario*) that would carry correspondence from the Chocó through Cupica and on to Panama.[113]

New plans for Cupica as a stop along a mail route to Panama likely held some appeal to viceregal administrators. In New Granada, the official mail system (*correos*) was much slower to take shape than it had been in the viceroyalties of New Spain or Peru. It was not until roughly 1750, under Viceroy José Alfonso Pizarro (1749–1753), that New Granada had a functioning state-supported mail service.[114] More problematic were the maritime routes, including those between Panama and Guayaquil. In 1765, a mail route was initiated under the governor of Panama and the viceroy of Peru. The shortest reported time to move mail from Panama to Guayaquil (in the viceroyalty of Peru) was twenty-eight days. Another attempt took forty-four days, while others took up to three months. In 1766, one ship reportedly spent six months trying to get to Guayaquil before being forced to return to the port of Panama.[115] These inordinate delays led viceregal administrators to seek other options.[116] Given that Cupica was just six days from Panama, it was precisely this route that Andrade hoped to introduce. The route would move through the Chocó, out of Cupica, and on to Panama by *falucho* (a coastal vessel with a sail). The only missing piece was the vessel itself, which had not yet been procured.[117]

In 1808, Andrade requested a license to further develop Cupica and to establish a reducción along the Napipi River.[118] The tenor of the response from the *fiscal* (legal representative; prosecutor) in Santa Fé indicated the viceregal government had at last become wary of new ideas involving Cupica. The fiscal observed that Andrade's proposal had come on the heels of Gutiérrez's project, which, despite *auxilios* (support), not to mention the means

Gutiérrez had at his disposal, still had come to little. How could Andrade, he asked, with even fewer resources, succeed? In a telling passage, the fiscal noted that the *ministerio* (viceregal government) did not seem to understand that there were few advantages to developing Cupica and that little or nothing would come from founding a new reducción along the Napipi. Official resistance to Andrade's proposal stemmed, in part, from the informal nature of the request. If Andrade aspired to establish a reducción, it was expected he do so through a formal contract, according to prescribed laws.[119] By this point in time, however, viceregal interest in Cupica had waned. Governing officials saw Cupica as a distant port, one that had benefited only the Chocó and areas outside the viceroyalty. They had seen little advantage in Cupica for New Granada and even less for Spain. A formal reply from Santa Fé on 28 March 1808 relayed that Andrade's proposal to grow Cupica and establish a new reducción along the Napipi had been denied.[120] Documentation relating to Cupica tapers off at this point, and any remaining hopes for Cupica as an important Pacific port under the Spanish fade from view.

Considerable efforts to develop Cupica into a viable commercial port—starting in 1777 and ending in 1808—illuminate Cupica's potential but simultaneously expose the various factors that worked against its successful development. Merchants from Cartago, Buga, and Cali opposed Cupica, while competing aspirants to the post of corregidor of Cupica sabotaged the port's progress at the same time that they undermined their rivals. It seems that distance also played a role in Cupica's ultimate failure. Cupica was months away from Santa Fé and even farther from Spain. While there were benefits for Cupica's corregidores, Chocó's colonists, and merchants in Panama, Guayaquil, and Peru, less clear were the benefits to the Spanish Crown—as Chocó governor Carlos Smith had indicated in 1787.[121] This hesitancy to invest energy and resources into an isolated port calls to mind the tactical strategy of underdevelopment, discussed by Matt Nielsen as "calculated inactivity."[122] Spanish leaders employed this time-tested approach of under-fortifying or under-developing Spanish America's remote dominions from the late sixteenth century forward. Nielsen succinctly summarizes these views on under-development as espoused by renowned military engineer Juan

Bautista Antonelli: "Where there were no riches, there was no booty to be raided by corsairs or pirates; where there were no forts, there were no strongholds to be overthrown and occupied by enemy forces; and where there were no ports or infrastructure, there was no political economy to be usurped by adversarial sovereigns."[123] Calculated inactivity was, as Nielsen demonstrates, an early and effective strategy for the Orinoco River. It was also successfully employed along the Atrato, as we saw in chapter 3. Calculated inactivity coupled with competing provincial factions (merchants whose livelihoods were threatened by commerce in and out of Cupica) proved effective in ensuring that Cupica never reached its full potential.[124]

Cupica's Inhabitants and from Whence They Came

If three decades of effort failed to transform Cupica from a sleepy bay to a bustling port, it did succeed in creating a lengthy paper trail. Folios from the case file preserve detailed population tallies recorded by the reducción's respective corregidores. The most detailed of these lists, which documents information about Cupica's Indigenous inhabitants, was taken in 1782 under Cupica's first corregidor, Lucas de Alarcón.[125] Conversely, the most abbreviated list was made in 1790 under José Fernández, Cupica's second corregidor.[126] Alarcón's list, drafted on 14 June 1782, identifies ninety-four Indians residing in Cupica at that time, including women, men, children, and infants.[127] One representative entry reads, in translation: "Toribio Paychagama, 30 years of age, his wife Rosalia who is said to be a cimarrona, 20 years of age, their two children, Juana who is 6 years old and Juan who is one year old."[128] Preserved for posterity are details about an Indigenous family: a father, mother, and their two young children. The mother had come to Cupica as a fugitive, ostensibly from another reducción.

Alarcón's list also records the diverse places from whence Cupica's Indigenous residents came, shedding light on the movement—both voluntary and involuntary—of Indigenous people in the southwestern Chocó. One-third of Cupica's inhabitants at that time were relocated Indian tribute payers who had come from Beté.[129] Spouses, children, and infants are included in this list. Apparently not originally from Beté, they were noted as

"agregados," and this status may have enabled them to reside in Cupica short term.[130] Another third of Cupica's inhabitants were cimarrones. Before coming to Cupica, they had come to Beté from other reducciones, possibly to escape an unreasonable corregidor or an unhealthy climate. Just under a third of Cupica's population was made up of Indian tribute payers from Murrí, Quibdó, and Lloró, with the five tribute payers from Lloró noted as having come voluntarily. The relocation of Indians from Beté, Murrí, Quibdó, and Lloró provided Cupica's port with an immediate labor force, one that could transport merchandise and supplies from Cupica to towns and mining sites in the Chocó, benefiting Spanish colonists. But relocation may also have held advantages for Indigenous inhabitants, who used these moves to seek out more favorable living conditions. In these population lists there is evidence of family units migrating from larger pueblos, which had greater colonial oversight, to smaller ones, with less oversight. This shifting landscape of inhabitants also suggests that the creation of new reducciones in the Chocó did not always equate to an increase in subjugated Indians. Instead, the creation of a new pueblo de indios meant "borrowing" Indigenous families from one settlement to "populate" another. Some Indians moved voluntarily, and others were forced, but the list from Cupica indicates that those who were involuntarily brought to a new reducción often ran away.[131] Migration here, forced or chosen, happened for different reasons but was not uncommon.

The relocation of Indigenous populations in the Greater Chocó was not unique to Cupica. A quarter of a century earlier, around 1754, Indians from the more southern areas of Naya, Cajambre, Anchicayá, Calima, and Raposo had been forcibly relocated to La Cruz, along the Dagua River near Buenaventura.[132] Various justifications for this move were provided by colonial authorities, indicating that this relocation was not voluntary, as it had been at Murindó (see chapter 3). One of the driving factors for the La Cruz relocation was the port of Buenaventura's need of a local workforce to meet merchant ships. Indigenous people were moved from Raposo to La Cruz for this purpose.[133] A similar justification—laborers needed to meet vessels at port and distribute cargo to the interior— was used to support the relocation of Indians from Beté to Cupica in 1782.

Further insight into these peripatetic Indigenous

populations in the Chocó is provided through tallies of inhabitants noted as *ausente*, "absent," indicating people who had left one place, often for another. Depending on the place, the number of absentee residents could be low or high. Based on a visita undertaken in the Chocó in 1784, the pueblo of Pavarandó reported no ausentes.[134] Meanwhile, Lloró reported the highest number—eighty-four— an observation that quickly shifted the visitador's focus to the corregidor's treatment of Indians in Lloró.[135] The new whereabouts of Lloró's absentee inhabitants was rarely mentioned, but in the few cases where it was, annotations reflect relocations to the Sucio River, Quibdó, and Antioquia, as well as to Cupica.[136] These population tallies reflect Indigenous movement through the Chocó, where people abandoned one settlement to inhabit another.

Heather Flynn Roller explores absentee movement of colonial Indians in Brazil's northern Amazon in her book *Amazonian Routes: Indigenous Mobility and Colonial Communities in Northern Brazil*. Documents provide the names, ages, family status (widow, son, etc.), and place or town where each person or family had absented to. One town's loss, as Roller observes, was another's gain. "Those who migrated from one village to another were not the aimless wanderers depicted by many contemporaries and some historians," Roller writes. Various factors shaped their trajectories, including family or ethnic connections, gender, labor preferences, relationships with local officials, the reputation of certain villages, geographical proximity, and cultural imperatives, among others.[137]

As with instances of population movement in Brazil's northern Amazon, reasons for voluntary relocation in the Chocó were situationally distinct. In the case of Murindo, the focus of the last chapter, a few Cuna groups were amenable to reducción, so they left their places of origin (albeit temporarily) for a newly established Spanish pueblo de indios. For Murindo, Cuna willingness seems to have been due, in part, to Cuna rapport with Francisco Martínez, the Chocó governor. Cuna interest in reducción at Murindo may also have been motivated by incentivizing gifts or by the safety and security the reducción offered at a time of crisis or scarcity. In the case of Cupica, those who willingly relocated from Beté, Murrí, Quibdó, and Lloró might have found greater opportunities in moving to a port settlement. Cupica's remote location—far

from colonial authorities—likely resulted in less oversight and more autonomy. Their labor obligations, moving cargo from port to province, would have regularly taken them out of Cupica and away from the watchful eye of administrators. With both Murindo and Cupica, the voluntary relocations of Indigenous people provide evidence of native agency in an unsettled area of the Chocó.

Population lists also preserve information about Cupica's non-Indigenous residents, including the *maestro de campo* of Beté (presumably a Spaniard), his wife and three children, and seven gente libre.[138] The term "gente libre" in New Granada most often referred to free people of mixed ethnicities (*gente libre de todos colores*). In this case, however, "gente libre" seems to be used to denote any inhabitants who were not constrained by the same rules that bound Cupica's Indigenous residents. One of these seven libres was Josef de Alarcón, the brother of Lucas de Alarcón, Cupica's first corregidor.[139] Juan Reyes, another libre, served as a sentinel, and lived in Cupica along with his brother, Manuel. Diego Bonilla, noted as an official of Herrera (possibly referring to Manuel Antonio de Herrera, the cura of Beté and Bebará), was a libre resident of Cupica along with his son, Salvador. The final two libres were André Martínez and Javier Trujillo, the latter a *platero*, "silversmith."[140] No libres are listed in Cupica's later population lists.[141]

Conflicting Accounts about Cupica's Church

Archived documents for Cupica also shed light on conflicting reports about the state of Cupica's church. The statements in the case files, taken at face value, suggest that Cupica's church was in a state of perpetual construction for decades. In 1780, Cupica's church was being built by four Indian families working under Alarcón's supervision.[142] The following year, 1781, the church was reportedly complete, measuring thirty-six varas square and boasting bells and ornaments Alarcón had ordered from Panama.[143] By 1784, the church was documented as *competente*, "operational."[144] A missive from Cupica's second corregidor, José Fernández, written in 1790, however, negates this progress: Fernández wrote that Cupica had neither a church nor ornaments for its decoration.[145] To remedy this, Fernández wrote that he had

invested nine hundred *patacones* (pesos) of his own money on ornamentation and two bells.[146] Realizing that his post as corregidor of Cupica was threatened, Fernández delayed in installing these items.[147] Instead, he informed officials in Santa Fé that, until official orders came directing him to do so, he would cease all efforts to populate Cupica and would halt all work on its church. This might explain why Cupica's third corregidor, Nicolás Gutiérrez, on a visit to Cupica in 1793, relayed that the Indians in Cupica had neither *párroco* (parish priest), nor *iglesia* (church), nor *religión* (Catholicism).[148] These issues notwithstanding, later the following year, Fernández sent word that the church was complete and had been adorned with ornaments and bells.[149] These contradictory reports concerning Cupica's church, penned by Cupica's various corregidores, indicate that no viceregal administrator with any authority ever ventured to Cupica to verify progress there; Santa Fé's knowledge of Cupica and its pueblo de indios was all secondhand.

Conflicting accounts about Cupica's church also raise questions about what qualified, in Spanish colonial parlance, as a church. A physical building earmarked for its cause was, by itself, insufficient. The *Recopilación de leyes de los reynos de las Indias* (1681) stipulated that a church where a decent mass could be held was a mandatory element for every reducción. This requirement extended even to reducciones with small Indigenous populations, like Cupica.[150] To merit categorization as a proper church, a structure needed interior ornamentation, requisite objects for mass and confession, bells, and a door.[151]

Concern over the state of Cupica's church illuminates the important symbolic place of spaces of conversion, confession, and worship for remote regions of the viceroyalty. To be without a church was to be without God, which was akin to barbarity. For peripheral areas of the Greater Chocó, a church represented not just a completed building but the presence of a vital Spanish institution. If a reducción was to be considered successfully pacified and settled, it needed to have a functional church. For this reason, a commitment—from a prospective corregidor—to construct a church, and thereby to introduce a spiritual and civilizing element to the frontier, was central to any proposal that aimed to establish Cupica as a viable reducción. All four of Cupica's corregidores were aware

of this. Accordingly, church construction was one of the first tasks they promised to undertake upon arrival in Cupica. To insinuate that this important civilizing element was absent highlighted the urgent need for new oversight. Despite the seemingly ambiguous state of Cupica's church, a detailed inventory of its holdings, drafted on 25 July 1802, confirms its existence at that point. This three-page inventory includes a door with two windows (or *ojos*), metal bells, and a copper bell. There are also several items for mass, veneration, procession, and confession: an altar, a cross for the altar, a silver chalice, a chasuble, a crucifix, a large wooden cross, a silver and copper incense burner, a confessional, and an elaborate standard with an engraved image of the Virgin Mary.[152] No religious paintings or sculptures are listed, but the notation of three prints in wooden frames (*tres estampas con marcos de madera*) suggests two-dimensional images of saints or other religious imagery.[153] It is not clear when or under whom these items were procured, but this inventory indicates that by 1802, a quarter century after Cupica's founding, this pueblo de indios did in fact have a proper church.

Conclusions

A critical look at the Map of the Chocó, Panama, and Cupica (plate 4) draws our attention to the port of Cupica. Documents in the map's associated case file, meanwhile, enable us to resurrect the late Spanish colonial history of this little-known port and Indigenous reducción on the Pacific coast of today's Colombia. The map visually argues for Cupica as a viable port, one that could promote commerce with Panama and also with ports to the south; connect the Pacific Ocean to the Caribbean Sea; and supply mining regions in the Chocó's interior. Additional points in Cupica's favor brought up in the documents included its hospitable climate and fertile soil, which were conducive to the cultivation of crops and the raising of livestock, and its deep water. All these reasons justified investment in Cupica. And yet, this geographically central and adequately sized bay never became a port of any consequence during the Spanish colonial period.

Map and case file shine a light on the role local politics and competing provincial interests played in Cupica's history. Cupica, port and reducción, had its supporters. Archival documents chronicle

the handful of men who hoped to benefit from developing Cupica. Between 1777 and 1808, the pueblo de indios of Cupica saw a revolving door of four corregidores, each of the last three instrumental in the ousting of his predecessor. The efforts and activities of Cupica's corregidores reveal that while attempts to further the development of Cupica happened at the hands—and at the expense—of provincial authorities and vecinos, these efforts did not result in a thriving port.

Cupica also had its detractors. These included merchants in Cartago, Buga, and Cali whose profits and livelihoods were imperiled by Cupica's trade with areas outside the Chocó. Viceregal officials were reluctant to establish a port at Cupica. New Granada already had a major port, Cartagena, which had proven, on multiple occasions, challenging enough to defend.[154] Providing protection for yet another port, and one on a less accessible coast, presented an unnecessary strain on already limited Crown resources. From the perspective of officials in Santa Fé, Cupica was a distant port that benefited the Chocó and other viceroyalties but offered no clear advantages to New Granada or Spain.

The story of Cupica is important because it complicates our understanding of periphery and illustrates that notions of center and periphery are relative. A place that is seen as peripheral to one center of power might simultaneously be a nexus, or center, for a different region and its networks. A look at any map—including the Map of the Chocó, Panama, and Cupica—identifies Cupica as an advantageously situated Pacific port, one with easy maritime access to Panama, Guayaquil, and Peru. Cupica's location solidified it as a central node within an external trade network. Nevertheless, Cupica was weeks away from settlements within its own province of Zitará and months distant from New Granada's capital, Santa Fé de Bogotá. Cupica—geographically proximate to other viceroyalties—was peripheral to New Granada's center.

Furthermore, the Map of the Chocó, Panama, and Cupica and its associated case file indicate that people living in late eighteenth-century Chocó saw beyond geopolitical boundaries. Because Spain's policies restricted the most logical routes of travel and commerce (the Atrato and the Pacific), inhabitants in these areas sought alternative avenues. Rather than depending on supplies from within their own province or their own viceroyalty, those who vied for control of Cupica understood that opportunities lay beyond established political borders.

PLATE 1 Created by or under the direction of Manuel de Caicedo, *Mapa de la costa del Pacífico des-de Buenaventura hasta el río Naya, con mención de todos los otros ríos*, or Map of the Yurumanguí Indians, 1770, 22.8 x 48.8 in. (58 x 124 cm). Oriented with west at bottom, this map depicts a stretch of Colombia's Pacific coast from the Dagua River (*at left*) to the Naya River (*at right*). It appears to have once formed part of the case file "Misioneros de Yurumanguí," AGN Curas y Obispos 21 44 D 2 (1742–1780), fols. 14r–312v. For transcribed map text, see appendix A. Archivo General de la Nación, Bogotá, Sección: Mapas y Planos, Mapoteca 3, Ref. 125.

PLATE 2 Unknown author (but likely created under the direction of Francisco Martínez), *El río Atrato y pueblos de indios Cunacunas*, or Map of the Atrato River and Pueblos of Cuna Indians, c. 1759, 12.2 x 16.5 in. (31 x 42 cm). Oriented with south at left, this map features the Gulf of Urabá (*just right of center*), the Atrato River flowing from left to right, and a cartouche (*at bottom*) with the names of eleven autonomous Cuna pueblos. Murindo and the vigía appear below the Atrato (*at left*), and the autonomous Cuna pueblos take up most of the upper central part of the map. This map's associated case file is AGN Caciques e Indios 58 D 19, fols. 435r–741v; it appears on fol. 559v. For transcribed map text, see appendix A. Archivo General de la Nación, Bogotá, Sección: Mapas y Planos, Mapoteca 4, Ref. 103A.

PLATE 3 Unknown author (but likely created under the direction of Francisco Martínez), *El río Atrato y pueblos de indios Cunacunas*, or Map of the Atrato River and Pueblos of Cuna Indians, c. 1759, 12.2 x 16.5 in. (31 x 42 cm). Autonomous Cuna settlements (indicated by red dots) occupy most of the map's space. Purple indicates the Spanish town of Quibdó; yellow the pueblos de indios of Bebará and Murrí; blue the new reducción of Murindo; and white the vigía, on the Sucio River. Archivo General de la Nación, Bogotá, Sección: Mapas y Planos, Mapoteca 4, Ref. 103A, adapted by author.

PLATE 4 (*right*) Lorenzo Alarcón, *Mapa de la provincia del Chocó y parte meridional de Panamá con fundaciones hechas en Cúpica*, or Map of the Chocó, Panama, and Cupica, 1783, 15 x 18.9 in. (38 x 48 cm). A central focus of this map (oriented with west at bottom) is Cupica, a port that facilitated coastal trade and commerce with Panama, Tumaco, Guayaquil, and Lima. Cupica was also an entry point for an interoceanic waterway connecting the Pacific to the Atlantic via the Atrato River. This map's associated case file is AGN Aduanas 2 2 D 17, fols. 470r–716v; it appears on fol. 617. For transcribed map text, see appendix A. Archivo General de la Nación, Bogotá, Sección: Mapas y Planos, Mapoteca 4, Ref. 136A.

PLATE 6 (*below*) Juan Jiménez Donoso, *Plano del curso del río Atrato* [. . .], 1780. This map shows locations that also appear on the Map of the Atrato River and Pueblos of Cuna Indians (see plate 3). Purple indicates the Spanish towns of Quibdó and Lloró; yellow the pueblos de indios of Bebará (*left*) and Murrí; blue Murindo; green the relocated vigía at Curbaradó; white the Atrato vigía's former location on the Sucio River; and red the autonomous Cuna pueblos. España. Ministerio de Defensa, AGMM-COL-11/10, adapted by author.

PLATE 5 Unknown author, *Manuscript Map of Dagua River Region, Colombia*, or Map of the Dagua River Region, 1764, 23.6 x 33.9 in. (60 x 86 cm). This map, oriented with west at right, depicts the Dagua River as it flows west, emptying into the port of Buenaventura. At center is Las Juntas (letter I), a central node in the region and one of few places in the area where crops could be cultivated. Just downriver (*to the right*) is the free settlement, or sitio, of Sombrerillo (number 11). The mines of Manuel Pérez de Montoya are located to the right of Sombrerillo. For transcribed map text, see appendix A. Geography and Map Division, Library of Congress, G5292.D2 1764 .M2.

PLATE 7 Antonio de Arévalo, *Plano del fuerte de San Carlos*, 31 March 1761, 20.1 x 23 in. (51 x 59 cm). Provided are plan views and various elevations for the proposed fort of San Carlos, to be built along the Caiman River. Ministerio de Cultura y Deporte. Archivo General de Indias, MP-Panama, 165.

PLATE 8 Andrés de Ariza, *Ruta de Antioquia a Panamá por una parte de la provincia del Chocó* [. . .], 1807, 11.1 x 18.5 in. (28.2 x 47 cm), with colored lines added to differentiate alternate routes. This map proposed two routes; both began in Antioquia and followed the same trajectory (in blue) to the confluence of the Atrato and Napipi Rivers. At that point, there were two choices. The shorter but riskier route (in red) traversed Cuna territory. The longer, more assured route (in green) moved from the Atrato to the Napipi to Antadó, then traveled by land to a tambo on the south side of the bay of Cupica. From Cupica, one traveled to Panama by sea. Ministerio de Cultura y Deporte. Archivo General de Indias, MP-Panama, 309, adapted by author.

PLATE 9 Edward Walhouse Mark, *In the River Dagua*, Colección de arte del Banco de República, AP0038.

PLATE 10 Detail of *Mapa de la costa del Pacífico desde Buenaventura hasta el río Naya* [. . .], or Map of the Yurumanguí Indians, 1770 (plate 1). A Spanish ship sails in the Pacific Ocean past the mouth of the Cajambre River.

5

THE MAP OF THE DAGUA RIVER REGION

Las Juntas, Sombrerillo, and African Agency in the Pacific Lowlands, 1739–1786

In this chapter, we move southward to the Dagua River, an important fluvial corridor connecting the Cauca Valley in the interior to the port of Buenaventura on the Pacific. The Dagua River and its gold-rich streambeds lured Spanish colonists to seek their fortunes on the backs of enslaved Africans who were brought to the area to mine. Those imported from Africa adapted to the region's isolation, its tropical climate, and its riparian environment, and found opportunities in the *gran distancia* that separated the Pacific Lowlands from New Granada's capital. With time, Africans and their descendants would become the primary labor force in the region and would comprise a large percentage of the area's population.[1] Africans' great numbers proved advantageous in achieving their autonomy and, ultimately, their freedom.[2]

The visually sumptuous *Manuscript Map of Dagua River Region, Colombia* (plate 5), which I will refer to as the Map of the Dagua River Region, dated 1764, introduces us to another periphery in New Granada. In addition to capturing the area's remoteness, this map shines a light on competing colonial interests in the Pacific Lowlands and draws our attention to understudied places of fleeting importance on the space-time continuum. One such place, Las Juntas, was a central node in the region (see figures 5.1 and 5.2, letter l). Another, Sombrerillo (number 11 on the map, figure 5.2), was a space of refuge for Africans and their descendants. A closer examination of this map enables us to resurrect stories about African mobility, autonomy, and resistance along the Dagua.

The Map of the Dagua River Region was produced with a concrete objective and a specific audience in mind. The expansive map and lengthy legend—which occupy eight sheets of paper adhered together—was likely created as visual testimony for a land dispute between two vecinos of Cali who fought over rights to Las Juntas, placed at the center of the map.[3] Because the area in dispute had not been formally mapped by colonial cartographers or engineers and was unfamiliar to the colonial administrators in Santa Fé who would need to adjudicate the case, it was necessary to make a hand-drawn map depicting this contested

FIGURE 5.1 (*right*) Detail of the *Manuscript Map of Dagua River Region, Colombia* (plate 5), showing Las Juntas (letter I) and surrounding cultivation areas where each cultigen is pictorially differentiated. An area of chontaduro palms (n) is indicated with palm trees depicted frontally. Areas of plantain (4, 5) and cacao cultivation (m, n), meanwhile, are depicted from an aerial perspective. In the Dagua just below Las Juntas is a canoe and two figures. The figure at left navigates using a pole, and the one at right uses an oar.

FIGURE 5.2 (*below*) Detail of the *Manuscript Map of Dagua River Region, Colombia* (plate 5), showing roads (depicted as thin, dark, squiggly lines) into Las Juntas and Sombrerillo. The road at left (h, i, j) was a steep descent that was dramatically illustrated in nineteenth-century travel accounts (see figure 5.4). Another route (u, r) accommodated mule traffic but required travelers to cross the Pepita River (p) before descending a road (x, z) into Las Juntas. The road (s) to Sombrerillo was equally fraught and, as the map indicates, led to the Dagua River (A), not to Sombrerillo proper.

area and its larger context. This newly created map would be key in making this little-known corner of the viceroyalty visible and tangible. This map (like others discussed in this book) sacrifices geographical accuracy in order to better communicate the map commissioner's ulterior motives.

Despite the map serving to support the land dispute at Las Juntas, the Map of the Dagua River Region opens a window to other stories. A closer, across-the-grain reading of this visual document

introduces us to Africans forcibly brought to the Pacific Lowlands through the transatlantic slave trade in the late seventeenth and early eighteenth centuries.[4] Africans quickly adapted to riparian conditions along the Dagua and, within decades of their arrival, controlled overland and fluvial transport in the region.[5] Elements on the map—sites of gold mining, a canoe and its two polers, and the free settlement of Sombrerillo (see figure 5.2)—allude to African agency in this region.

The Map of the Dagua River Region: Some Context

Differing from other maps I discuss in this book, which reside in historical repositories in Colombia or Spain, the Map of the Dagua River Region is held in the Geography and Map Division at the Library of Congress in Washington, DC. It was acquired in 2000 from the Philadelphia Print Shop, a rare-books store in Pennsylvania.[6] Details of its journey from Cali, Colombia, to the Philadelphia area remain a mystery. The fact that the map was at some point severed from its original archival documents complicates our ability to determine by whom, for whom, and why it was made. Nevertheless, because this map is held in a repository with state-of-the-art imaging equipment, it is possible to answer questions about *how* the map was made. A technical investigation by the Library of Congress's Preservation Research and Testing Division identified the map's paper, inks, pigments, and watermarks.[7] The results of this analysis are presented in appendix B.

There is a limited amount of information on the Dagua River region in secondary scholarship.[8] Fortunately, a trove of primary source documents for this region exists in Colombian archives. While I have not yet identified *the* documents that definitively explain this cartographic work, I have uncovered other documents that lend historical context to this map.[9] Through archived case files at the Archivo General de la Nación (AGN) in Bogotá, the Archivo Central del Cauca (ACC) in Popayán, the Archivo Histórico de Cali (AHC), and the Biblioteca Nacional de Colombia in Bogotá (BNC), I have been able to tease a handful of stories from this colorful cartographic image.[10]

A Look at the Map, the River, and the Region

The Map of the Dagua River Region (plate 5) presents us with a vast, densely forested, sparsely inhabited landscape in a remote corner of the Pacific Lowlands. This cartographic work depicts rivers aerially and the surrounding valley topographically. Vibrant blue denotes mountain ridges, forest green represents *monte*, and mottled brown characterizes steep escarpments. Oriented with west at right, the map's central focus is the Dagua River, which snakes from left to right, flowing from the Farallones de Cali (the mountains to the west of Cali, part of the Cordillera Occidental) to the bay of Buenaventura. This map covers an expanse of over 620 miles (1,000 kilometers), yet nowhere do we see a Spanish town, a pueblo de indios, or a church. These absences underscore the Dagua River's great distance from administrative centers such as Cartagena, Tunja, and Santa Fé. Even Cali, the Spanish colonial town nearest to the Dagua River region, lies beyond the parameters of this cartographic watercolor.

The mapmaker draws attention to two *sitios* (informal settlements) placed in the center of the map. The first of these is Las Juntas (see figure 5.2), which lies at the fork of the Dagua and Pepita Rivers. The other is Sombrerillo, depicted as an island along the Dagua to the right of Las Juntas. Las Juntas was a critical nexus for the region and the first place at which the treacherous Dagua River could be navigated. Sombrerillo, portrayed as the most densely inhabited locale along this river, had its own distinction as an outpost for free Africans and escaped enslaved laborers who cohabitated with white outsiders.[11] Africans at Sombrerillo, at Las Juntas, and at mining sites along the Dagua were critical to mobility within the region. Working as canoe polers (*bogas*) and overland porters (*cargueros*), they brought goods and travelers into the area. As the roads and rivers on the map indicate, Las Juntas and Sombrerillo were the two principal nodes for people and things entering and exiting the region.

The Dagua River, with its strong currents, sharp turns, and myriad waterfalls, was one of the fastest and most dangerous rivers in Colombia. Differing from the Magdalena and Cauca Rivers, which were traveled comfortably in *champanes*, the Dagua River was so narrow, so serpentine, so swift, and so steep in places that only the final third of its 90 miles (150 kilometers) could be traveled in the Spanish colonial period, and only then in small canoes guided by expert polers.[12] Difficult and dangerous in equal degrees, the Dagua was described by nineteenth-century explorers as more of a torrent than a river, where one's survival hinged upon a scream, a gesture, or a glance given by the poler guiding the canoe.[13] Navigating its currents left the traveler drenched from rain and waves that entered the canoe.[14] Charles Saffray, a passenger in a small craft headed down the Dagua in 1869, lost a friend

FIGURE 5.3 Detail of the *Manuscript Map of Dagua River Region, Colombia* (plate 5), with key places identified. Roads are shown as thin, dark, squiggly lines.

to the whims of the river, despite the fact that they were traveling only fifteen minutes apart. Reflecting on his journey, Saffray ruminated that, given what he had seen of the Dagua—which forced a canoe to descend 1,300 feet (400 meters) in just 25 miles (40 kilometers)—someone would need to explain to him precisely how such a river was considered navigable.[15]

Despite its dangers, the Dagua formed part of a vital corridor connecting the Cauca interior to the bay of Buenaventura.[16] Travelers and supplies came into the region, as the map reveals (see figure 5.3), from places like Cali, Zabaletas, the gold-mining areas around Raposo, and the Chocó. The Dagua corridor was especially crucial for those in the colonial town of Cali, which fell within the gobernación de Popayán. An important agricultural and

ranching center, Cali was home to wealthy and powerful families such as the Caicedos, as well as *comerciantes* (merchants), *hacendados* (plantation proprietors), and *dueños de minas* (mine owners).[17] Cali's colonial elite had long claimed the bay of Buenaventura as their own, making them especially dependent upon the Dagua River.[18]

Today, travel from the city of Cali to the port of Buenaventura takes roughly five hours along a twisting, paved two-lane highway. In the Spanish colonial period, however, this trip took up to twelve days and transpired along the Dagua and some of the worst roads in Spanish America.[19] Many of these roads (noted as *caminos* in archival documents and on this map) were mere footpaths that washed away in the rainy season. A visitador dispatched to the Dagua region in 1762 blamed

s. road to Sombrerillo

11. Sombrerillo

A. Dagua River

6, 7, 8, 9. cacao groves

14. mines at Aguasucia

13. quebrada of Aguasucia

Port of Buenaventura

his inability to visit all areas of the province on the abominable condition of the roads.[20] These fragile, ephemeral paths are discernible on the map, depicted as thin, dark brown lines. All lead to one of two places: Las Juntas (letter l) or Sombrerillo (number 11, see plate 5).

In addition to facilitating access to the Pacific coast, the Dagua River corridor was of interest for its rich placer deposits. By 1579, gold had been discovered in the neighboring mountains of Raposo (to the south), a find that led to mining expansion along the Pacific. By the mid-seventeenth century, several mines had been established along the Dagua River.[21] Because Indigenous populations along the Dagua had been decimated by disease and overwork, the Spanish brought in Africans, who, grouped into *cuadrillas* (enslaved labor gangs), mined for gold along the Dagua.[22] Africans'

arrival to the area made it possible for Spaniards to begin exploiting the Dagua River region's rich mineral resources in earnest.[23]

The Land Dispute at Las Juntas

African gold mining along the Dagua River provides a segue to one of the stories this map tells. One of the Spaniards who exploited the rich mineral deposits along this river was Manuel Pérez de Montoya, a powerful businessman, a vecino of Cali, a member of its *cabildo* (municipal government), and an owner of mines and enslaved laborers.[24] In 1763, a year before the Map of the Dagua River Region was made, Pérez de Montoya initiated a land grab against a wealthy landholder and fellow Cali vecino, Manuel de la Puente.[25]

FIGURE 5.4 Francois Louis Niederhausern-Koechlin, *Vista de las Juntas*. This engraving is based on a watercolor by Charles Saffray, who wrote of his travels along the Dagua. The romanticized image conveys the steepness of the zig-zag road that dropped into Las Juntas. In the foreground, the engraver relays the perils of canoe travel along the Dagua and suggests that, even in the mid-nineteenth century, Las Juntas was more of an outpost than a town. Published in Eduardo Acevedo Latorre, *Geografía pintoresca de Colombia: Nueva Granada vista por dos viajeros franceses del siglo XIX, Charles Saffray y Edouard André*, 1968: 45.

The corresponding case file, entitled, in translation, "Don Manuel Pérez de Montoya against don Manuel de la Puente regarding [de la Puente's] planting of cacao and plantain groves on the area of [Pérez de Montoya's] mines," held in the AGN in Bogotá, provides historical context for the 1764 map housed in Washington, DC.[26]

Details about Las Juntas's importance to the region are preserved in the case file. Las Juntas was where goods such as tobacco, meat, and *aguardiente* (cane brandy) entered from places including Cali and Zabaletas and were redirected to neighboring mining zones.[27] Las Juntas's centrality is illustrated on the map through its location at the confluence of the Dagua and Pepita Rivers (see figure 5.2). Its significance for the area is also laid bare through the representation of roads, several of which led to Las Juntas. One of these roads, which came from Cali (O, see figure 5.3), reached a point where travel was possible only by foot (h, i, j). Another route (u, r) accommodated mule traffic but required travelers to cross the Pepita River (p) before descending a road (x, z) into Las Juntas. The dramatic descent into Las Juntas (along the route notated with h, i, and j on the map) is rendered in a nineteenth-century engraving where the road—shown as a forebodingly steep zigzag trail—can be seen in the background (figure 5.4). Sitting 1,250 feet (380 meters) above sea level, Las Juntas was described by one nineteenth-century traveler as "a type of abyss" (*un especie de abismo*): suffocatingly hot, saturated with vapor, and blocked from air currents by the steep mountains that encircled it. No one, it was noted, lived in Las Juntas for pleasure (*por su gusto*).[28]

In addition to being an important nexus, Las Juntas was one of few cultivable zones in this 620-mile (1,000-kilometer) expanse. The mapmaker illustrates this, visually distinguishing the various crops grown at Las Juntas. Chontaduro palms, or peach palms, are depicted frontally (see n, figure 5.1), while areas of *plátano* (plantain, rendered a light green) and cacao (shown as a dark green) are shown from an aerial perspective. Pérez de Montoya had designs on these crops, as they would enable him to sustain his cuadrillas who were mining downriver at Aguasucia (13 and 14, see figure 5.3).

Las Juntas was critical to Pérez de Montoya's mining operations. Nevertheless, the map's legend, along with documents held in another archive, indicate that the *estancia* (estate or house and grounds) of Las Juntas was owned by Manuel de la Puente.[29] His claim included groves of cacao and plantain as well as *aguacates* (avocados), *caimitos* (star apple), *guayabos* (guava), *zapotes* (sapodilla), and chontaduros, which de la Puente had planted.[30] These planted zones along the Dagua, which boasted a quantity and variety of agricultural products uncommon for the area, rightfully belonged to de la Puente.

FIGURE 5.5 Detail of the *Manuscript Map of Dagua River Region, Colombia* (plate 5), showing the signatures and rubrics of three witnesses, located at bottom right of the map's explanatory panel: Manuel Pérez de Montoya, Antonio Garcés y Saá, and the notary, Joseph Vernaza.

Undeterred and with an eye to controlling this fertile patch along the Dagua, Pérez de Montoya exaggerated the size of his claim, alleging that he had rights to territory that stretched from Las Juntas to Santa Barbara del Salto (also known as La Vibora), not indicated on the map but located just downriver from the mines at Aguasucia (see figure 5.3).[31] In making these territorial claims, Pérez de Montoya implied that he had rights not only to the land and crops at Las Juntas but also to most of the navigable parts of the Dagua River, from Las Juntas to Santa Barbara del Salto and beyond.

Because Pérez de Montoya likely understood that his territorial claims stood on shaky ground, he provided other justifications for why Las Juntas should fall within his purview. He argued that de la Puente's commercial operations at Las Juntas impeded Pérez de Montoya's mining efforts, making it difficult for his cuadrillas to *catear* (seek out) new sources of gold along the river. Pérez de Montoya went on to note that, in addition to managing groves and orchards at Las Juntas, de la Puente also ran a bodega catering to travelers coming into the region. The aguardiente and other products sold at this bodega had proven a distraction for Pérez de Montoya's cuadrillas, which resultantly had a negative impact on his mining operations. This, Pérez de Montoya alleged, made it difficult to pay his *quintos* (royal mining tax).[32] At a time when the royal coffers were depleted and the Spanish Crown was in desperate need of sources of revenue, an inability to pay the royal fifth was often a winning argument. Nevertheless, later documents suggest the case was decided in de la Puente's favor.[33]

The Map of the Dagua River Region (plate 5) can be connected to this 1763 land dispute through two primary lines of evidence. Places like Las Juntas, depicted on the map and labeled in the legend, factor prominently in the land dispute.

The signatures and corresponding rubrics of three witnesses in the map's bottom right-hand corner (figure 5.5), meanwhile, reference individuals (members of Cali's cabildo) who are repeatedly mentioned in the case file.[34]

One of these signatories was Pérez de Montoya, who initiated the dispute against de la Puente in 1763. Another was Joseph Vernaza, the *escríbano público* (notary) for Cali and its cabildo. Vernaza's signature notarized many documents concerned with the land dispute.[35] The third signature on the map belonged to Antonio Garcés y Saá, the son of a criollo merchant who owned property and mines along the Dagua River.[36] The map's legend identifies Garcés y Saá, under the name "Garcia," as the owner of the house and hacienda de Dagua (P). Both were stops along the river between Cali and Las Juntas (see figure 5.3).[37] Manuel de la Puente, who is described in the map's legend as the owner of Las Juntas, was not a signatory of the map, suggesting that this arresting cartographic work was created to support Pérez de Montoya's claims and not de la Puente's. While the land dispute between Pérez de Montoya and de la Puente provides historical context and a possible explanation for the creation of the Map of the Dagua River Region, nowhere in this 1763 case file is the 1764 map mentioned or alluded to.

Africans along the Dagua

In addition to the land dispute, another narrative emerges from a close reading of the Map of the Dagua River Region (plate 5): one of African adaptation, agency, and autonomy along this remote gold-mining frontier in New Granada's Pacific Lowlands. Mining areas on the map imply African labor in extractive economies. Rivers evoke aquatic

travel and transport in canoes navigated by skilled *bogas* (canoe polers), also called *canoeros*, whom archival documents refer to as "negro," indicating people of African descent. Roads, or paths, meanwhile, point to overland transport undertaken by *cargueros* (overland porters), many of whom were African. The inclusion of Sombrerillo (figures 5.2 and 5.3), inhabited by free and formerly enslaved Africans, provides additional evidence that Africans successfully leveraged the local landscape and benefited from the dearth of Spanish authorities.

In the early eighteenth century, Spaniards brought Africans to the Dagua River region to extract gold from quebradas.[38] By the end of the first quarter of the eighteenth century, dozens of mines were in operation along the Dagua River, each worked by fifty to a hundred enslaved Africans.[39] These mines were prosperous by 1719, which increased traffic in enslaved Africans.[40] Mining inventories from the first half of the eighteenth century show a preponderance of African ethnonyms, or approximate ethnic-geographic designations, suggesting enslaved members of cuadrillas were recent arrivals to the Americas.[41] By the second half of the century, however, most African slaves in these inventories were designated as "criollo/a," indicating they had been born in the Americas.[42] Descendants of these early African arrivals from West and Central Africa continued to inhabit the area until the early twentieth century.[43]

The Map of the Dagua River Region identifies just one mining operation—the real de minas of Aguasucia (13, 14 in figure 5.3)—located downriver from Las Juntas and owned by Manuel Pérez de Montoya.[44] Nevertheless, archival documents reveal that many other mines were in operation along the Dagua River. These included Santa Barbara del Salto, San Josep, San Geronimo de las Benedicciones, and the earlier mines of San Ciprián and Santa Gertrudis.[45] Most were owned by families in Cali, who, given the frontier conditions in the Dagua region, preferred to remain in the interior, leaving an administrator to oversee their mining operations in the periphery.[46]

Because the Map of the Dagua River Region is concerned only with Pérez de Montoya's mines of Aguasucia, it omits all others. To gain a better sense of where other mines along the Dagua were located, it is necessary to look to other maps. One such map is the *Croquis del curso del río Dagua* [. . .] (figure 2.18), created in the later eighteenth or

early nineteenth century and oriented with southeast at top. Cali appears at the far upper right, while Las Juntas lies at upper left. Between Las Juntas and Buenaventura (at bottom) are several mining sites. Two are identified as such, including Aguasucia (seen on the Dagua map) and Santa Gertrudis. Several others are identified on this map (figure 2.18) as *casas* but were actively mined in the eighteenth century. These include La Vibora (Santa Barbara del Salto), El Salto, Benedicciones, Santa Rosa, and San Ciprián.[47] These numerous mining sites remind us that Africans were ever present in this gold-rich region.

African adaptation and autonomy can also be read from the Map of the Dagua River Region by focusing our attention on rivers. Bogas, or canoeros, of African descent (both enslaved and free) had mastered navigation along the perilous Dagua by the early eighteenth century[48] and were paid top dollar, earning between eight and ten *reales* per day.[49] Attempting to justify this exorbitant rate in 1780, more than a decade after this map was made, Pérez de Montoya explained that canoe travel here was not simply a matter of crossing a river from one side to the other. It required negotiating a steep torrent, where large boulders imperiled travelers and cargo.[50] A canoe poler's job was dangerous, requiring skill as well as nerves of steel. As a result, enslaved Africans who worked as bogas were highly valued and well compensated. Evaluations in mining inventories reveal that a boga's assessed value could be nearly equal to or higher than that of a cuadrilla captain.[51] These evaluations underscore the critical place of Africans along the Dagua who knew how to skillfully navigate its currents. The pivotal role of African bogas in this region can be inferred by the inclusion on the map, just below Las Juntas, of a canoe in the river with two canoe polers, one at the bow and the other at the stern (see figure 5.1). These bogas, it merits mentioning, are the only two figures depicted anywhere on the map.

Many Africans in the Dagua region came from lands where river and sea navigation in small and large canoes was a way of life. Many lines of evidence support that Africans had mastered the canoe (both its construction and its navigation) in West Africa long before their arrival in New Granada.[52] Discussing the canoe in West African history, Robert Smith observes its role in political and economic life, where it was central to trade and commerce.[53] Its importance for coastal, lagoon,

and riparian peoples has been equated to that of the horse for the history of the savannah states.[54] Kevin Dawson, in his engaging book *Undercurrents of Power: Aquatic Culture in the African Diaspora*, writes of water as a defining feature for African-descended people living along seas, rivers, lakes, and estuaries. Many Africans were adept and experienced swimmers, underwater divers, and canoeists.[55] Immersionary traditions in Africa allowed its inhabitants to merge water and land into unified culturescapes.[56] In Africa, as in New Granada's Pacific Lowlands, the aquatic space connected people living on the coast and littoral areas to those in the interior. In places like the Niger Delta, overland travel was often impossible, echoing conditions in the Greater Chocó.[57] As a result, canoeing in both regions provided an essential means of locomotion.[58] In addition to canoe navigation, fishing and gold extraction were key survival skills for the watery peripheries, or aquatic spaces, of the Pacific Lowlands. For Africans in the Greater Chocó, aquatic spaces like the Dagua River provided an avenue for autonomy and, for some, a path to freedom.[59]

Afro-Colombian bogas on the Dagua were a source of endless fascination for nineteenth-century explorers to the region. These polers—described as shirtless, with pants rolled up to their knees, and wearing wide-brimmed straw hats—were lauded as intrepid boatsmen, expert pilots, and true athletes.[60] The canoes, guided at times by an oar and at other times by a long pole, spiraled through the water, glided above it, and sank beneath it. The bogas were imperturbable and united with their canoes.[61] The Dagua's canoe polers also captured the attention and imagination of Edward Walhouse Mark, an English diplomat and painter who, from 1843 to 1856, traveled through what is now Colombia. In his watercolor rendering of the Dagua, two bogas pull a canoe from the river's swift currents while another team of bogas maneuver around rocks using long poles (plate 9). From these examples, we gain a sense of how Africans' mastery of this riparian environment paved the way to their autonomy along the Dagua.

African mobility in this periphery can also be inferred in the map's depiction of roads, or paths, represented by thin brown lines. The legend relays that many were in poor condition, while others were so steep, narrow, and slippery that they could be traversed only on foot. In the Dagua River region, roads were the domain of cargueros, who hauled supplies on their backs into and out of the region from places like Cali and Zabaletas (see figure 5.3).[62] Documents suggest that cargueros enjoyed decent wages as well as some independence. For example, libres living in Cali preferred to take paid work as cargueros to Sombrerillo rather than remain in Cali to work on plantations or ply a trade.[63] Because cargueros (and bogas) controlled the flow of goods into and out of the region, they also possessed the power to stop the flow of supplies. In 1766, two years after the Map of the Dagua River Region was signed, porters in this region went on strike, refusing to transport aguardiente or basic staples to the cuadrillas working the mines along the Dagua. Without food or sustenance, the cuadrillas could not actively mine, which impaired mine owners' profits and their ability to pay the royal mining tax. The cargueros' strike impacted local Spaniards in other ways as well. Because cargueros had successfully interrupted the supply chain, a colonial official complained that he had been without meat for four or five days.[64]

The Free Settlement of Sombrerillo

Some of the strongest evidence for African adaptation and autonomy along the Dagua River survives in the sitio of Sombrerillo. Despite its relative absence in historical scholarship, Sombrerillo occupies a prominent place on the Map of the Dagua River Region (see figure 5.3).[65] Located between Las Juntas and Pérez de Montoya's mines at Aguasucia and completely surrounded by water, Sombrerillo is the largest settlement on the map. A road leading nearly into Sombrerillo indicates it as an important stop in the region. Sombrerillo was, additionally, one of few places from which canoes could be put into the Dagua to travel downstream to Buenaventura.

The map's legend relays that Sombrerillo was home to cargueros who transported on their shoulders supplies and merchandise brought into the area by canoe.[66] As early as 1739, Sombrerillo was home to over 150 cargueros, in addition to "indio[s], negros, mulatos, mestizos, y aún blancos" (Indians, Blacks, mulattos, mestizos, and even whites); some of Sombrerillo's residents came from remote regions, some were native to Cali, and

some were outlaws and runaway slaves.[67] In 1739, Sombrerillo was described by members of Cali's cabildo as a hedonistic place where residents did not participate in mass, drank to excess, committed robberies and attacks, and lived scandalously.[68]

Documents indicate that Sombrerillo sustained a population of a few hundred people for a number of decades. Nevertheless, Sombrerillo is never referred to in documents as a *pueblo de libres* (free town).[69] Instead, as the map's legend indicates at number 11, Sombrerillo was a *sitio*.[70] In the eighteenth century, a sitio was not simply a "place" or an "informal settlement," but carried a more precise meaning. As Marta Herrera Ángel explains, sitios were inhabited by ethnically mixed populations, including Spaniards, mestizos, and others of multi-ethnic heritage who were referred to as "free" so as to distinguish them from tribute-paying Indians. As places that were not cities, or villas, or towns, sitios had neither a priest (resident or visiting) nor a church.[71]

During much of the eighteenth century, Sombrerillo's inhabitants dominated all means of transport linking the Cauca Valley and Buenaventura.[72] And yet, there is no evidence that Sombrerillo was ever formally established or incorporated.[73] There is also no documentation to suggest that Sombrerillo was intentionally destroyed.[74] If Sombrerillo was a town populated by free people but was not a pueblo de libres, how might we come to understand this regionally important settlement along the Dagua?

A Brief Discussion of Free Towns in Eighteenth-Century America

In North American colonies, free towns were inhabited by former slaves who had, in some instances, been manumitted by their masters and given title to land they would settle as free people. Gum Springs, for example, was a small, free Black community that had formerly been part of the Mount Vernon estate. Gum Springs was settled in the 1830s by West Ford, a former slave of George Washington's nephew Bushrod Washington, on land that had been willed to Ford by the younger Washington.[75]

In Spanish colonies, pueblos de libres had their own set of traits. They were places that had been formally constituted and officially recognized by Spanish authorities. Members of these free towns enjoyed some legal protections, but these protections came with certain obligations. One example is the eighteenth-century free town of Gracia Real de Santa Teresa de Mose, or Mose, located in Spanish Florida, which was royally sanctioned in the eighteenth century. Mose's inhabitants included former slaves, many of West African origin, who had escaped British plantations and were granted religious sanctuary by the Spanish Crown.[76] In exchange for their freedom and a place to settle, these *cimarrones* (runaway slaves) and their descendants were expected to farm and provide defense for the Spanish.[77]

In the viceroyalty of New Spain, Nuestra Señora de Guadalupe de los Morenos de Amapa, or Amapa, was a pueblo de libres founded in 1769 that resulted from negotiations between runaway slaves and Spanish authorities.[78] These runaway slaves—who roamed the mountainous areas of the political jurisdiction of Teutila—robbed travelers on the road to Córdoba, terrorized nearby valley settlements and sugar mills, sowed rebellion among other slaves, and posed a threat to public safety. After punitive expeditions failed to quell them, the Spanish were forced to engage in conciliation and negotiation, brokering treaties similar to those made between Cuna and Spanish in the Darién.[79] The Spanish agreed to grant the Amapa cimarrones legal freedom if they agreed to defend the Spanish king and his dominions, capture runaway slaves, and prevent the formation of new cimarron colonies. Those living in Crown-sanctioned pueblos de libres were also expected to name local leaders (*alcaldes* [magistrates] and *regidores* [people who govern]) and live obedient Christian lives.[80] In these examples from Spanish America, pueblos de libres were the result of formal negotiations between runaways, freed slaves, and colonial authorities. In the cases of Mose and Amapa, residents were given land and granted their freedom as part of a two-way agreement that came with expectations and obligations to the Spanish Crown.

In New Granada, this type of accord was struck between residents of *palenques* (palisaded camps formed and inhabited by runaway slaves) and Spanish colonial authorities, sometimes resulting in formally sanctioned "pueblos de libres." Palenques, in New Granada, existed from the late sixteenth century forward.[81] One of the largest palenques in the Pacific Lowlands was El Castigo, created sometime after 1635.[82] By 1726, El Castigo was inhabited

by some three hundred people occupying two settlements, each with its own church. Inhabitants sustained themselves through seasonal farming and gold mining. In 1732, seeking a more official status, residents entered into negotiations with Jesuit priests, expressing an interest in living *como cristianos*, "like Christians."[83] Over time, many palenques acquired legitimacy and legality through agreements with Spanish civil and ecclesiastical authorities, allowing them formal integration into colonial society.[84]

Sombrerillo, a refuge for runaway slaves and a home to free Blacks, is never described in historical documents as a palenque or a *cimarronaje*. There is equally no evidence to suggest that Sombrerillo had been brought into the Spanish colonial fold through a treaty or formal agreement. Such an agreement would bring with it certain protections.[85] In the case of Sombrerillo, however, there is no indication that such protections were ever sought or needed. Sombrerillo, situated on an island, protected on all sides by the Dagua's swift currents, had its own form of defense. Equally, there is little to suggest that Sombrerillo was burdened by obligations to the viceroyalty or to the Spanish Crown. While never a pueblo de libres in an official sense, Sombrerillo appears to have been a free town in the truest sense of the term, a town operating independently from the rules and regulations of Spanish colonial society. Furthermore, despite reports that Sombrerillo harbored runaway slaves and fugitives, it does not appear to have been targeted or disbanded by Spanish authorities. On the contrary, it seems to have thrived for many decades. Those residing in Sombrerillo provided services critical to the regional economy and were depended on by Spaniards inside and outside the Dagua River corridor. Continued demand for cargueros and bogas assured Sombrerillo's survival, at least for a time.

Not all informally established towns of free and enslaved people in New Granada were able to operate with the same impunity. The palenque of Cartago is a case in point.[86] In 1785, thirteen enslaved and three free people fled to the mountains, having worked on haciendas and in domestic service in Cartago, where a large number of blancos resided. After their capture, the runaways testified that in the Spanish colonial town of Cartago they saw few avenues for self-purchase and were unable to live the conjugal lives they wanted. To escape this fate,

they had risked everything and tried to establish a new, less restrictive society on the margins. Through this case study, explored in detail by Pablo Rodríguez, we learn that the formation of a palenque was not an impulsive act, but one planned carefully in advance. Those who fled their masters in Cartago had a clear-eyed sense of the task before them. They brought tools, weapons, and seeds, as well as a pig and a calf for their future sustenance. Helped by Indigenous allies, these runaways identified a site that was defensible and difficult to reach. Their short-lived settlement, far from being lawless or hedonistic, replicated aspects of orderly Spanish colonial society, including the designation of a leader and an agreed-upon distribution of labor. They even established a makeshift altar, where they prayed to Christian saints using images that they had brought with them. But because slaves in Cartago were few and blancos were many, this small group of cimarrones, totaling sixteen, was pursued in earnest by a party of thirty Spaniards. Their hopes for a life free from the constraints of enslavement lasted only three short weeks.[87]

The fact that Sombrerillo, conversely, existed for decades merits further contemplation. Unlike Cartago, Sombrerillo does not appear to have been targeted for destruction. Differing from the palenque of El Castigo, there is no evidence that its inhabitants embraced Christianity or ever built a church. Instead, Sombrerillo seems to have existed informally, a sitio crucial to the local and regional economy whose inhabitants moved supplies and people through the region. Gaspard-Théodore Mollien, who traveled along the Dagua in 1823, approximately sixty years after the map was made, offered up an observation that might help to explain Sombrerillo's survival and longevity. Writing of the canoe polers on the Dagua generally, Mollien noted that the bogas were so vital to the transport of goods in the region that government agents respected them and left them alone, opting not to anger them by making them abide by laws or regulations. Someday, when the roads were in a better state of repair and river navigation was less treacherous, one might, Mollien mused, finally be able to make these bogas obey.[88] Descendants of enslaved Africans, bogas had become masters of the river, mining its minerals and maneuvering down its currents. The Map of the Dagua River Region is a testament to their adaptation, agency, and autonomy in the Pacific Lowlands.

Conclusions

This chapter began with the large watercolor Map of the Dagua River Region (plate 5), which introduced us to the Dagua River and enabled us to uncover new narratives about this remote periphery in the mid-eighteenth century. At the center of the cartographic composition are two places of fleeting significance on the space-time continuum: the estancia of Las Juntas and the free settlement of Sombrerillo. Las Juntas and Sombrerillo emerged at this time and came to thrive as sitios. Las Juntas was important as a commercial node for the region and was one of few agricultural cornucopias along the Dagua River. These factors placed Las Juntas at the center of a 1763 land dispute. Sombrerillo, meanwhile, an island on the Dagua protected by the river's swift currents, became a place of refuge and ultimately home to a multiethnic population who lived outside the bounds and confines of Spanish colonial society. Many of Sombrerillo's residents were Africans, who, as cargueros and bogas, dominated transport and trade in the region. Through Sombrerillo, we reclaim stories of African adaptation, agency, and autonomy. As the only known cartographic image that verifies the existence, confirms the location, and suggests the centrality of the free settlement of Sombrerillo, the Map of the Dagua River Region importantly calls our attention to the critical role that Africans played in this eighteenth-century periphery.

6

THE MAP OF THE YURUMANGUÍ INDIANS

The "Discovery" and Decimation of the Pacific Lowlands'
Indigenous Inhabitants, 1742–1780

In this chapter, I connect a large manuscript map, the Map of the Yurumanguí Indians, 1770 (plate 1), to a lengthy case file concerned with the "discovery," attempted settlement, and inadvertent decimation of Indigenous inhabitants who lived dispersed along the shores of the Naya and Yurumanguí Rivers from at least 1742 until 1770.[1] These rivers, which were weeks distant from the nearest urban center, represented a gold-mining area of great potential that attracted powerful and wealthy individuals from both Cali and Popayán.[2] The map's corresponding case file, "Misioneros de Yurumanguí" (Missionaries of Yurumanguí), documents Spanish attempts to subjugate and settle the Indigenous inhabitants in this area, "saving" their souls and exploiting their labor.[3] The case file reveals what the map obfuscates: Spanish efforts to colonize this native population led to its swift decimation. As the Spanish inadvertently killed off the Indigenous inhabitants they aimed to subjugate, they simultaneously doomed their own prospects

of Christianizing and exploiting this native group. The act of reuniting this map with its case file makes it possible to reconstruct a history that neither map nor documents could tell by themselves.

Embedded within the case file are tales of peripheries and distance, failed *entradas* (expeditions of trade, raid, exploration, or conquest) by miners and by Franciscan missionaries, competing interests of individuals and entities in Popayán and Cali, and the apparently insurmountable task of connecting a remote frontier on the Pacific to urban centers in the interior. Colonial authorities, while motivated by the prospect of increased mineral wealth, were hesitant to provide the needed infrastructure, fearing that easier access to this distant shore would only foment illicit trade and contraband. Documents in the case file indicate that four decades of Spanish intervention in this periphery resulted not in the conquest or colonization of these recently discovered Indigenous inhabitants but only in their apparent extinction.[4]

FIGURE 6.1 Detail of the Map of the Yurumanguí Indians, 1770 (plate 1), with key rivers identified. Also indicated are the quebradas of San Vicente and San Nicolás, mined by Otorola. At right is Cerro Naya, where another nation of Indians was rumored to live, and a cross at top right indicates Las Cruces.

FIGURE 6.2 Detail of the Map of the Yurumanguí Indians, 1770 (plate 1). A long, slender, two-person canoe enters the Naya River (4) from the Pacific Ocean. The figure at front guides the canoe with a long pole, while the one at back rows with an oar.

The Map of the Yurumanguí Indians

The Map of the Yurumanguí Indians (plate 1) returns us to the place—and to the map—where we began our cartographic journey in the book's introduction. This large watercolor work, oriented with west at bottom, depicts a 70-mile (110-kilometer), sparsely populated stretch of Colombia's Pacific Lowlands from the Dagua River at far left to the Naya River at far right (figure 6.1). At top is the Cordillera Occidental, indicated by undulating blue peaks, and at bottom is the Pacific Ocean. Between mountain and sea are green riparian zones, yellow escarpments, and ocher bluffs. The mapmaker

Las Cruces

Cerro Naya

NAIA

Quebrada San Vicente

Quebrada San Nicolás

Naya River

Micay River →

presents the Pacific coast as it might have been seen by Spanish navigators, English pirates, or maritime merchants: from the vantage point of the sea. As a viewer, we peer upward from the Pacific Ocean toward the mountainous ridgeline in the distance. From these high peaks, rivers flow from their origins down into the sea. The map's lower register presents three linked cartouches that contain information on twenty-nine features, including rivers, paths, and the isolated dwellings of the Indigenous inhabitants (plate 1).

At first glance, this map seems concerned with a vast uninhabited landscape, but as we focus our gaze, signs of human presence come into view. A Spanish ship (plate 10) trolls the coastline near the Cajambre River (figure 6.1), and a canoe maneuvered by two figures, one wielding a long pole and the other an oar, enters the mouth of the Naya River (figure 6.2). The implication is that aquatic

travel happens here on both large and small scales, but interior regions can be reached only by small watercraft, not large ones. Along the ridgeline at top right, a cross marks the summit of Las Cruces (figure 6.1). Concentrated in the centermost portion of the cartographic space is a smattering of simple buildings (see plate 1 and figure I.3). These structures, situated along rivers and smaller tributaries and connected to each other through sinuous footpaths, represent the dispersed *casas* (dwellings) of the Yurumanguí Indians. The Map of the Yurumanguí Indians documents the existence of this Indigenous group at the same time that it chronicles its demise.

Contained in this map is detailed geographic, hydrographic, and topographic information for a remote region in the Pacific Lowlands. This intermediate area north of the Micay River (which lies beyond the right edge of the map), as Claudia Leal

FIGURE 6.3 Signature of Manuel de Caicedo on the lower right corner of the Map of the Yurumanguí Indians.

observes, is often overlooked by historical scholarship.[5] The map is especially valuable given the area's isolation. Because this landscape was infrequently visited by colonial administrators, geographers, and cartographers, the Map of the Yurumanguí Indians is one of few surviving visual documents that preserve detailed information about this region.

This spectacular and alluring map is housed today in the Archivo General de la Nación in Bogotá (plate 1). Rendered across twelve sheets of paper with an overall size of 22.8 x 48.8 inches (58 x 124 centimeters), it is one of the larger maps in the AGN's collection. At some point in its history, this map was separated from the Spanish colonial documents that once accompanied it. As a result, its date and the circumstances regarding its creation have long been unknown.[6] Nevertheless, the explanatory text at bottom provides textual clues, including the names of rivers, which help to narrow the geographical focus. Meanwhile, the inclusion and mention of *indios infieles* (unchristianized Indians) offers additional information, as does the signature and rubric at bottom right, which may indicate the name of a possible author or commissioner (figure 6.3). These lines of investigation will be explored in the following pages.

I began searching for the map's case file during a trip to Colombia in March 2017 but, despite hints the map provided, was unsuccessful. A second opportunity presented itself two years later. I had traveled to Popayán to initiate research on a different map. While I was there, Indigenous communities united under the Consejo Regional Indígena del Cauca (CRIC) launched large-scale protests against the Colombian government.[7] These protests involved tens of thousands of Indigenous people who opposed the exploitation of their land as well as the lack of government support. As a form of protest, they closed the Panamerican highway between Cali and Popayán, effectively blocking the entry of food, gasoline, and other key supplies.

Protests soon erupted in the town of Popayán, leading many stores and public offices to close their doors. Included among these was the Archivo Central del Cauca, meaning my days in Popayán would not be spent at the archive as planned. In fact, skirmishes on Popayán's streets made it difficult to leave the hotel. With days of forced confinement and a good internet connection, I began efforts to track down the "missing" case file for the Map of the Yurumanguí Indians. At the time, I did not realize that Indigenous resistance and resilience would also be a sub-theme of this map (plate 1).

Initially, I had been searching historical archives for documents related to the Naya River. Having turned up little, in 2019 I shifted my focus to the Yurumanguí River, which led me to a large case file—"Misioneros de Yurumanguí."[8] Spanning four decades and over three hundred folios, the documents in the case file chronicle the Spanish "discovery" of an Indigenous group that lived beyond the colonial system in an area of rich placer mines. The remote Yurumanguí region, which colonizing Spaniards envisioned as a prime gold-mining area and the focus of a new missionary enterprise, was quickly targeted for *reducción*. This case file records the failed Spanish attempts to Christianize and colonize the Yurumanguí Indians, as well as the Yurumanguí's resistance and ultimate decimation as a result of European disease and other factors.

Contained in the case file is a letter that presents a map. This letter, written on 12 December 1770 to Viceroy Pedro Mesía de la Cerda by Manuel de Caicedo (a vecino of Cali, member of its cabildo, and member of one of its prominent families), describes the map and provides details of Caicedo's entrada to the region.[9] The incredible correspondence between the content of Caicedo's letter and the information on the Map of the Yurumanguí Indians presents strong evidence that this letter and this map had, in fact, been created as a set.

FIGURE 6.4 Signature of Manuel de Caicedo on his letter to Viceroy Pedro Mesía de la Cerda dated 12 December 1770, in which he presents and describes the map. AGN Curas y Obispos 21 44 D 2, fol. 200v.

Caicedo's letter makes it possible to ascribe a date, 1770, and to propose an author or commissioner for this stately cartographic work (plate 1).[10] That Caicedo's signature and rubric on his letter to the viceroy (figure 6.4) match the signature and rubric on the bottom right portion of the map (see figure 6.3) provides additional support that map and letter were the product and project of the same hand.

In the map, we are given geographical context for the places, people, routes, and events discussed in the case file. Meanwhile, the case file offers details about the discovery of Indigenous inhabitants—*indios barbaros, jamás conocido*, and *de idioma incognito* (barbarous, as yet unknown, and of an unknown language)—who lived along the Naya and Yurumanguí Rivers between 1742 and 1780. Documents in the case file reveal that these inhabitants, the Yurumanguí Indians, had managed to evade Spanish detection and resist Spanish conquest and colonization.[11] The case file also preserves linguistic information (through a two-hundred-word Yurumanguí *vocabulario*, "dictionary," recorded by a Franciscan missionary) and detailed ethnographic information for the Yurumanguí found nowhere else.[12] The Map of the Yurumanguí Indians serves as a beacon, calling us to this largely overlooked history.

This previously unmoored map once formed part of the ethnohistorically and ethnographically significant case file "Misioneros de Yurumanguí." The map is a visual reference for much of the information in the case file, making this region and its rivers, paths, and terrain accessible and tangible. I posit that the map is not just *a* referent, but *the* referent, created to accompany Caicedo's 12 December 1770 letter, preserved in the case file.[13] In addition to ascribing a date and an author to this map, the contents of the case file make it possible to situate the map, and the letter, in a larger historical context. Map and case file together present failed Spanish attempts to settle an Indigenous population in New Granada's periphery. These attempts were undertaken by powerful vecinos of

Cali and Popayán as well as by Franciscan missionaries. Advances were hampered—as other maps and case files have shown—by the decisions of colonial authorities, intra-elite rivalries, the local environment, and the actions of subaltern actors, in this case Indigenous inhabitants. This scholarship is the first to link the Map of the Yurumanguí Indians to the previously known and partially published case file. In reconnecting the map to the documents that once accompanied it, I also link the map to twentieth-century scholarship on the Yurumanguí Indians.[14] None of the previous scholarship includes or references the manuscript map presented here.

Geographical Context

The Yurumanguí River in the Pacific Lowlands of today's Colombia was one of many isolated regions in the already peripheral viceroyalty of New Granada. As I have emphasized in earlier chapters, each periphery was rendered distinct through its geography, topography, and distance from colonial authorities. These diverse landscapes, in turn, gave rise to distinct demographics, economies, and lived experiences. Marta Herrera Ángel has examined how, in New Granada, key features of landscape—elevation and climate, including temperature and humidity—result in different types of vegetation and differentiate one region from the next. Changes in elevation create valleys, cliffs, peaks, and abrupt ruptures, while rivers produce narrow canyons, rapid currents, waterfalls, and slower-moving streams. Rivers can be obstacles to movement across the landscape, but rivers can facilitate movement as well. Many areas in the Pacific Lowlands were covered in thick vegetation, making them ideal places for refuge and escape.[15] Such an area is depicted on the Map of the Yurumanguí Indians (figure 6.5). As a result of geographical factors, and possibly also political ones, this area has long been a frontier.

FIGURE 6.5 The Yurumanguí River today. The dense jungle cover here, which is typical of this river area, makes it clear why river travel was the most common mode of travel in this area in the eighteenth century. Photo by David Fayad Sanz. Published in Lorenzo Morales, "Custodios del Yurumanguí," *Semana*, 17 November 2018.

The expanse depicted on the Map of the Yurumanguí Indians (plate 1) reflects an area of neotropical jungle, an ecosystem that is home to some of the greatest biodiversity on the planet. The zone's challenging geography and topography have made it largely inaccessible to Europeans, allowing a plethora of flora and fauna to thrive. Today, as in the Spanish colonial period, there are no highways or roads that connect this region to the closest urban center, Cali.[16] In 2017, Isabella Bernal, a journalist investigating narco-trafficking, undertook the trek from Cali to Puerto Merizalde, which is located on the Naya River about six miles (ten kilometers) from the Pacific Ocean. The overland journey, which she describes as "infernal," took forty-four days. As Bernal notes, even in the twenty-first century, this area is still considered the "frontier of the frontier."[17]

In the eighteenth century, as today, New Granada's varied topography partitioned it into many isolated regions, meaning that distance was measured not by kilometers, miles, or leagues but by weeks or months. Traveling from Cali to the mines of Yurumanguí took two to three weeks, with an additional five days needed for provisioning.[18] The journey was broken up into legs, with each necessitating its own mode of transport. Pedro Agustín de Valencia wrote, in a letter to the viceroy, that from Cali to the base of the Farallones de Cali, four days were spent, facilitated by mules and cargueros. From El Naranjo to Las Juntas, through rough mountainous terrain, one undertook another two days of travel, again relying on mules and cargueros. Things became even more challenging upon reaching Las Juntas. From there, the three-day trip to El Salto unfolded along paths that accommodated only cargueros. Moving from El Salto to Buenaventura took only one day but required a harrowing canoe ride down the Dagua River (figure 6.6). From Buenaventura, one traveled south along the Pacific coast in a large canoe for four days, braving the treacherous Gulf of Tortugas, to finally arrive at the mouth of the Yurumanguí River.[19] To reach the mines required an additional three days in a small

Navegación en el río Dagua.—Dib. de A. de Neuville

FIGURE 6.6 Alphonse de Neuville, *Navegación en el río Dagua*, engraving based on a nineteenth-century sketch by Charles Saffray. This romanticized image provides a sense of the dense and mountainous riparian landscape and the dangers inherent in river travel in this region. Published in Eduardo Acevedo Latorre, *Geografía pintoresca de Colombia: Nueva Granada vista por dos viajeros franceses del siglo XIX, Charles Saffray y Edouard André*, 1968: 31.

canoe.[20] These eighteenth-century challenges of topography presage problems of isolation that, in the late twentieth century, gave rise to a thriving cocaine trade in this same region.

Historical Contexts, Past Scholarship, and the Case File "Misioneros de Yurumanguí"

Before examining the map and case file, it is worth briefly touching upon the eighteenth-century contexts that brought Spaniards to this region. An important period of change in New Granada was ushered in with Pedro Mesía de la Cerda, whose tenure as viceroy, from 1761 to 1772, coincided with the beginning of the ambitious reform under Charles III (r. 1759–1788). At this time, initiatives were launched to increase both government efficiency and revenues in Spain's colonies abroad.[21] These decades of imposed reform overlap with the second half of the period chronicled in the case file "Misioneros de Yurumanguí." In this strained economic climate—with the Crown eager to boost revenues in any way possible—the discovery of a potential revenue stream (placer mines) and a labor force (unincorporated Indigenous inhabitants) represented a golden opportunity. The authorities dispatched Franciscan missionaries to the Yurumanguí River region to Christianize its Indigenous inhabitants and settle them into a reducción. Spanish mine owners in the region, meanwhile, were given permission to build a road that would connect the lucrative but isolated Pacific coast to the colonial centers of Popayán and Cali.

Scholars first happened upon the case file,

housed at the AGN, in the 1940s. Initial publications focused on the file's linguistic and ethnographic information about the Yurumanguí Indians. Of particular interest was a dictionary that had been assembled in 1768 by the Franciscan friar tasked with evangelizing these Indians, Cristóbal Romero.[22] Gregorio Arcila Robledo published this dictionary as "Vocabulario de los indios Yurumanguies" in 1940.[23] A few years later, Sergio Elias Ortíz looked to the case file "Misioneros de Yurumanguí" for ethnographic descriptions of the Indians and drew from the 1768 diary of Sebastian Lanchas de Estrada, the mine administrator entrusted with overseeing the planned reducción.[24] These publications spawned more investigations. Around this time, E. Aubert de la Rue and Edmond Bruet undertook a geological and mineralogical study of the area.[25] Meanwhile, ethnologist Paul Rivet led an expedition to the region, hoping to find evidence of a connection between Yurumanguí and the Hokan language family.[26] Geographer Ernesto Guhl, who accompanied Rivet, published a comprehensive description of the area's topography and climate.[27] In a later interview, Guhl said that an aim of this three-month expedition was to find vestiges of this lost Indian nation but lamented that, in the end, "we did not find a single Yurumanguí."[28] Since then, linguists have worked to categorize Yurumanguí, which today is considered a language isolate with no known relatives.[29] Most recently, documents in the case file have been used to examine the crisis facing the Franciscan missionary system in the second half of the eighteenth century owing to economic challenges and the limited number of friars qualified to carry out evangelizing programs.[30]

In all of this scholarship, there has been no inclusion of or reference to this large map, likely because, at some point, the map was separated from its case file.[31] If the map had been known to scholars beginning in 1940, it would have been of incalculable value to Rivet and Guhl in their efforts to track down this lost Indigenous group. With the map, they would have known where to look for traces of Indigenous roads, cultivation areas, trade routes, and dwellings.[32] Lanchas de Estrada's ethnographic writings are also helpful in this regard, as they describe house materials and floor plans, and mention portable objects that might be preserved in the archaeological record. These include items endemic to the Yurumanguí (stone tools) as well as artifacts brought by Spaniards and Franciscans, including beads, bells, metal axes, and machetes.[33]

The case file, which begins in 1742 and ends in 1780, outlines two principal objectives: (1) to pacify and settle the Indigenous inhabitants of the Yurumanguí and Naya Rivers, and (2) to construct a road connecting these new Spanish subjects to the urban areas of Cali and Popayán. The road, which would be wide enough to accommodate mules and mule trains, would allow for the importation of needed supplies and people, and it would permit gold extracted from local quebradas to be transported to the reales cajas in Popayán.[34] The road would also be instrumental in facilitating the reducción of the Yurumanguí Indians.

Proponents of the Road: Juan Ventura de Otorola and Pedro Agustín de Valencia

The story preserved in the case file "Misioneros de Yurumanguí" begins with the prospector Juan Ventura de Otorola, a Spaniard, a general, and a vecino of Popayán.[35] In 1742, he petitioned for the rights to mine sections of the Naya River and received permission the same year.[36] Otorola disclosed that some of the naturales of the province had volunteered to help him mine. If given authorization to employ their labor, he would in turn pay their royal tribute.[37] By 1748, Otorola had been mining along the Naya River for six years, working profitable quebradas that he had discovered—namely, those of San Miguel, San Vicente, and San Nicolás, all of which flowed to the Naya River.[38] On the map, the quebrada of San Vicente is located just above that of San Nicolás, to the left of the Naya River (figure 6.1). Otorola reported that he had relocated himself and his family from Popayán to the Naya River, where, in addition to extracting gold from his registered mines, he was planting *sembrerias* (crops).[39] In a letter, he mentioned a faction of indios infieles whom he had attempted to pacify and assured Raposo's lieutenant governor that, under his care, these unincorporated Indigenous people would be instructed in the Christian faith.[40] In a 1748 decree, Otorola was given permission to continue his work, as long as he adhered to the guidelines laid out in the royal ordinances.[41]

In 1751, Otorola was still actively mining along the Naya River. Given the difficulty of importing

víveres (provisions) to supply his operations, he had proposed the construction, at his own expense, of a road that would connect his mines to his native city of Popayán.[42] Otorola argued that such a road—which would accommodate mule trains and allow for the import of supplies—would benefit people in Popayán as well as those in the Chocó, Barbacoas, and Iscuandé. This road would also shorten travel times and mitigate risks posed by existing routes.[43] To aid in the road's construction, Otorola asked that Indigenous laborers and porters, as well as translators, be made available to him. He also requested that those who might use and benefit from this proposed road (merchants, travelers) contribute to the project, as he had already spent more than two thousand pesos toward this end, relying on his enslaved laborers to undertake much of this work.[44]

A road linking the placer-rich region of the Yurumanguí and Naya Rivers to the urban center of Popayán seemed a winning proposition for everyone, especially considering Otorola was footing the bill. Nevertheless, in 1751, viceregal authorities suspended the road's construction, citing the *inconvenientes* that could result from an increased ease of communication between Popayán and the Pacific Ocean.[45] Colonial authorities in Santa Fé were convinced that such a road would surely pave the way for the illicit exodus of gold.[46] Soon after receiving the unexpected news of the road's suspension, Otorola disappeared from both the documents and the Naya area. In 1760, his wife reported that for the previous two years he had been "missing or dead in the kingdom of Peru."[47] Assuming he would not return and needing to pay her husband's creditors, as well as her own, she oversaw the *remate* (sale) of his assets, including the mines along the Naya River.[48] Otorola's road would not be constructed, at least not by Otorola.

The next chapter of this story begins with Pedro Agustín de Valencia, a vecino of Popayán and a formidable character of immeasurable means. One of the richest men in Popayán, Valencia had acquired a considerable fortune from mines, haciendas, and real estate.[49] In 1749, after overcoming numerous obstacles, he established the Casa de Moneda (mint) in Popayán.[50] Some of his wealth, undoubtedly, stemmed from mines along the Yurumanguí, Naya, and Cajambre Rivers.[51] Keen to shorten the travel time between his home and his mining operations—two weeks if all went smoothly—Valencia,

too, petitioned to build a road that would connect the Naya and Yurumanguí region with the urban center of Popayán.[52] In proposing this road in 1756, Valencia referenced Otorola's earlier petition and reiterated previous arguments that supported this initiative.[53] The road would enable the import of tools and supplies and the export of gold to Popayán. It would also mitigate dangers and shorten travel time.[54] A year later, in 1757, Valencia was granted a license to undertake the construction of this road.[55]

The Franciscan Reducción and the Yurumanguí Indians

Under Valencia, the road became inextricably linked with the reducción of the Yurumanguí Indians.[56] For both the missionaries and the viceregal authorities, the road was imperative to the success of the reducción. Without a road, the project was doomed. In a letter to Viceroy José Solís Folch de Cardona dated 10 December 1759, Valencia wrote of his plans to complete the road within the coming month so that a missionary with tools and other things that would win over the good will of the Indigenous people (bells, beads, axes, machetes, and cloth) could enter the region.[57] In an act of good faith, Valencia appointed his mine administrator, Sebastian Lanchas de Estrada, to oversee the pacification and reducción of the Yurumanguí Indians.[58] Lanchas de Estrada, in his capacity as captain of the reducción, would earn himself an important place in history, creating the only ethnographic description we have of this Indigenous group.[59] Lanchas de Estrada was slated to work with Friar Bonifacio de San Agustín Castillo, a Franciscan from the Colegio of Popayán, whose stipend was to be paid by Valencia. Despite the fact that a decree had authorized the pacification and reducción of the Yurumanguí Indians, the friar was recalled to Popayán shortly after arriving at the Yurumanguí River.[60] From the outset, efforts for both the road and the reducción were thwarted by colonial authorities. In addition to the many challenges of topography and isolation that hampered the project, the road and reducción received little support from those in Santa Fé who held the authority and means to provide it.

It had been Valencia's hope that Franciscans from the Colegio de Popayán would undertake the

missionizing efforts on the Yurumanguí River.[61] His preference, however, was quickly contested. In a letter to Viceroy Mesía de la Cerda, Friar Fernando de Jesús Larrea (an influential Franciscan who had come to Popayán in 1739 from Quito) suggested that the Colegio de Cali—rather than the Colegio de Popayán—be tasked with the mission of pacifying the Indians.[62] According to Larrea, friars in the Colegio de Popayán were overcommitted with conversion initiatives in Caquetá and Putumayo. Meanwhile, those in the Colegio de Cali had no missions and were geographically closer to the Indians in question.[63] The Franciscans viewed their involvement in the reducción as a way to maintain a foothold in Spanish colonial projects in the periphery. For the newly founded Franciscan Colegio de Cali, whose friars would ultimately be tasked with evangelizing the Yurumanguí Indians, the reducción was a way to prove their worth.[64]

As momentum increased for both the road and the reducción, more people began to take an interest in the area. One such individual was Pedro Tamayo, who had undertaken an entrada into Yurumanguí territory without official permission.[65] Tamayo was actively scheming to replace Lanchas de Estrada as captain of the reducción with Gregorio Domínguez de Tejada, the lieutenant governor of Raposo.[66] Valencia and Lanchas de Estrada moved quickly to defend their positions, their interests, and their investments. The viceroy, responding favorably and supportively to a letter written by Lanchas de Estrada, forbade further entradas by Tamayo or Tejada.[67]

Through all of this, colonial authorities in Santa Fé demonstrated tepid interest in both the reducción and the road. They did not want to incur the expense of establishing and maintaining another Indigenous settlement on the frontier. Furthermore, they feared a road would be costly and would only create opportunities for illicit commerce and contraband. The lack of governmental support indicates that establishing and maintaining economic interests in the periphery was not a priority. Reforms, as sweeping and as all-encompassing as they pretended to be, were focused on areas within their reach.

A second missionary, Cristóbal Romero, the Franciscan friar who recorded the Yurumanguí dictionary, was sent to the Yurumanguí River in 1768.[68] Upon his arrival, Romero set out to evangelize the Yurumanguí Indians. It was his urgent need to communicate with his charges that pushed him to learn their language, and through the process, he recorded more than two hundred terms of the Yurumanguí tongue, believed by linguists today to be extinct.[69] The settlement itself, however, experienced continual setbacks. A suitable place to establish the reducción was never identified, and there were no funds to create or sustain it.[70] The Indians, uninterested in abandoning their way of life, were resistant. By custom and by choice, the Yurumanguí lived days apart from one another in an area that already presented significant challenges of travel.[71] Making matters worse for all parties, Indigenous inhabitants were dying. By Romero's estimate, by July 1768 only sixty-four Indians remained.[72] In October of that same year, Romero informed Lanchas de Estrada in a letter that twenty-one Indian *almas* (souls) had perished from *peste* (disease), referred to later in the case file as *viruela* (smallpox).[73]

The rapid decline of the Yurumanguí population posed a serious threat to the reducción. Without Indigenous people to reduce, the project lacked a raison d'être. In a sobering letter to the viceroy written in February 1770, Larrea relayed that the Colegio de Cali did not have the resources to subsidize the missionizing efforts, meaning the mission had little hope of succeeding. Fewer than ten Indians remained in the sitio of San Vicente; the rest had retreated to the mountains.[74] Larrea also commented on the dire demographic situation: the majority of the Indians were old and without children. He had heard that the few women who remained had killed their infants when they were born because there was little optimism the children would survive the conversions.[75] The diminishing number of Yurumanguí led to discussions about how to bring more Indigenous people into the area.[76]

Frantic attempts to revive the reducción project brought new urgency to the construction of a road.[77] In his February 1770 letter to the viceroy, Larrea put forth the name of Cali's *alférez real* (municipal standard-bearer), Manuel de Caicedo, presenting him as the ideal person to oversee the road's construction. Larrea was convinced that with five hundred pesos supplied by the royal treasury to cover necessary costs, Caicedo could open the road, given his knack for such things. Without the road, the colegio would be unable to continue

conversions.[78] Nine months later, Caicedo was again recommended to the viceroy, this time by a different official, Joseph Ignacio Ortega.[79] The fact that two individuals recommended Caicedo's involvement suggests that Caicedo had put a bug in both men's ears.

Within a matter of months, Manuel de Caicedo, a vecino of Cali, a member of its cabildo, and one of its elite, became involved in the pacification and reducción of the Yurumanguí Indians. Caicedo was a member of one of the most illustrious Cali families; their wealth derived from haciendas in the Cauca Valley and mines in the Chocó, as well as the province of Raposo, including the Dagua and Naya River regions.[80] The Caicedos had long maintained high-ranking positions on Cali's cabildo. For more than a century, most of it uninterrupted, five Caicedo family members held the distinguished and influential position of alférez real. Manuel de Caicedo held this post for five decades, from 1758 to 1808.[81]

Caicedo's interest in the Naya River was tied to gold extraction. His interest can be traced back to 1760, when, at the sale of Juan Ventura de Otorola's assets, he attempted to buy rights to Otorola's mines, his enslaved workers, and his mining tools. A document in another case file, housed in a different archive, reveals that Caicedo was denied these assets because he failed to submit payment within the set time frame.[82] Nevertheless, Caicedo maintained his plan to mine gold along the Naya River. His optimism (buoyed by his assertion that the viceroy had granted him mining rights) may explain why, in 1770, Caicedo agreed to oversee the construction of a road that would connect the Naya region to his hometown of Cali, despite the undesirable nature of the work involved.[83] The outcome of a later *pleito*, from 1775 to 1776, which determined that Caicedo did not have legal claims to the mines of Naya, may explain why the road was never completed on his watch.[84] Denied the opportunity to extract gold from the Naya River, Caicedo ultimately lost interest in a road that would only serve to make others rich. Despite pressure put on Caicedo to complete the road "as he promised," there was no progress toward this end.[85] In 1780, the viceroy was informed that all efforts to establish the mission had been futile. There were no longer Indians with whom to populate the desired reducción.[86]

Logistics of a Road in the Remote Pacific Lowlands

With a better sense of what was at stake with the road and the reducción, we return to the Map of the Yurumanguí Indians to examine the more practical aspects of this road project. The map insists on the area's riparian nature (plate 1). Predominant features—the Pacific coast and the many rivers that flow to it—are aquatic. Further emphasizing this aquatic space are a ship and a canoe (plate 10 and figure 6.2). From Valencia's account, preserved in the case file, we understand that roughly half the time he spent traveling from Cali to his Yurumanguí mines was by canoe.[87]

Despite the fact that the map emphasizes the omnipresence of rivers and sea, much of the case file is concerned with the construction of a road. The precise route said road would take and the stops that would define it—while of decided logistical importance—were slow to take shape. It was not until 1770 that Lanchas de Estrada, in a letter to the viceroy, proposed that the projected road should follow the existing Indigenous paths.[88] A slightly more detailed trajectory was proposed in 1771 by Caicedo in a letter to the viceroy. Caicedo suggested that the path or track (*senda*) could begin between the Jamundí and Claro Rivers and exit near the Indigenous groups living on the Cajambre River.[89]

There is no eighteenth-century map that illustrates the trajectory of Caicedo's proposed road. It is therefore necessary to look to a later map, *Mapa Geográfico de la provincia de Buenaventura en el departamento del Cauca* [. . .] (Geographic Map of the Province of Buenaventura in the Department of Cauca [. . .]), created in 1825 under Tomás Cipriano de Mosquera (see figure 6.7). This map reveals that a considerable obstacle in connecting Cali (or Popayán, farther south, off the map) to the Pacific was the Farallones de Cali, the formidable cordillera west of the Cauca River. The map helps to clarify that Caicedo's proposed "road" relied on rivers: travelers leaving from Cali would take the Cauca River to the Claro River and from there pass over the cordillera. On the west side of this mountain range, slightly to the south, a traveler could then use the Cajambre River to get to the Pacific Ocean. Mosquera's map reveals that most of the distance separating Cali and the Yurumanguí area could be

FIGURE 6.7 Detail of *Mapa geográfico de la provincia de Buenaventura en el departamento del Cauca* [. . .], 1825, adapted to show proposed road from Cali to the Pacific Ocean. The fluvial route from Cali to the Pacific is indicated with a line along the Cauca and then the Claro and Cajambre Rivers, and an approximation of Caicedo's proposed road is shown as a thick line going over the cordillera. Archivo General de la Nación, Bogotá, Sección: Mapas y Planos, Mapoteca 6, Ref. 89, adapted by author.

bridged using fluvial, not overland, highways. The geography presented on Mosquera's map suggests that Caicedo's proposed road would have served merely to connect two disparate rivers, the Claro and the Cajambre.

Indigenous Spaces, Practices, and Lifeways

The Map of the Yurumanguí Indians (plate 1) and the case file that I argue it is associated with preserve stories of reducciones and roads but also contain narratives about Indigenous spaces and lifeways. The map represents the most granular attempt to depict the space and settlement patterns of the area's Indigenous inhabitants. Information in the case file, meanwhile, preserves rich detail on this Indigenous group. By mining the map and focusing on select documents from the case file, it is possible to retrieve knowledge about an Indigenous population that managed to elude Spaniards until the mid-eighteenth century. The paragraphs that follow use observations from Lanchas de Estrada's diary, Romero's dictionary, and Caicedo's December 1770 letter to enrich the reading of the map.[90]

Twelve Indigenous structures are depicted, the majority of them clustered near the center of the map (see figures 6.1 and I.3). Three are situated near the Yurumanguí and Cajambre Rivers (23 and 24, figure 6.8), at a distance from the others. The map depicts all the dwellings in the same schematic way, as simple roofed structures with one or two doors. Lanchas de Estrada, however, described these Indigenous dwellings as built upon wooden piers (*sobre unos maderos*) with open sides and four-sided roofs.[91] A sense of what these structures might actually have looked like survives in photos of Indigenous houses taken by Robert C. West in the 1950s (figure 6.9). In these images, dwellings are rectangular in plan with open sides. They sit atop wooden piers and are covered by four-sided thatched roofs reminiscent of those described by Lanchas de Estrada.[92]

For the Yurumanguí Indians, a dwelling housed a family unit, with one husband and one wife. Furthermore, as the Yurumanguí Indians did not have a single chief, each household functioned as its own governing unit.[93] This seems especially logical given the distances that separated these dwellings. Yurumanguí houses were spaces for the living as well as for the dead: Indians were buried in the

FIGURE 6.8 Detail of the Map of the Yurumanguí Indians, 1770 (plate 1), showing the structure identified as a bodega (20) along the Cajambre River (24). To go from this bodega to the dwelling indicated by the number 22, a traveler would have spent two full days on the Indigenous road marked 21. Note the small figure to the left of 22. To the right of the Yurumanguí River (23) is a trail (16), described as a mining road, which likely led to the mines of Pedro Agustín de Valencia.

FIGURE 6.9 Indigenous dwelling at the Chocó village of Nazareño, on the Patía del Norte River. Note the rectangular house raised on poles and with open sides, accessed by a notched-log ladder. Photo by Robert C. West. Published in West, *The Pacific Lowlands of Colombia: A Negroid Area of the American Tropics*, 1957: 117. Robert C. West Latin American Photograph Collection, Cartographic Information Center, Department of Geography and Anthropology, Louisiana State University.

houses where they died, their things burned on a sepulchre, and the houses abandoned.[94]

One of the structures on the map (20) is identified in a cartouche as a *bodega* or *troje* (barn or granary, figure 6.8). It is not clear whether this was a collective site for food storage or a private one. Nevertheless, Lanchas de Estrada wrote that the Yurumanguí cultivated a variety of crops, including *maíz* (corn), *chontaduro* (peach palm), *plátanos* (plantains), *frijoles* (beans), and *yucca* (tubers).[95] They grew tobacco, but they picked it early and consumed it cooked.[96] They also cultivated honey and domesticated various birds, including *pavos* (turkeys), *guacamayos* (macaws), and *papagayos* (parrots).[97] Despite the local abundance of wild game, the Yurumanguí did not eat *saíno* (hog) or *tatabro* (wild boar, peccary) but instead relied on fish they caught from nearby streams.[98] They prepared food in clay pots, stored fruit and corn

in baskets, and prepared *chicha* (fermented corn beverage) in canoes 7 feet (2.13 meters) in length, 3 feet (0.91 meters) tall, and 3 feet wide.[99] It is likely that Yurumanguí cultivation areas were spread horizontally and vertically across the landscape to take advantage of multiple biomes.[100] Lanchas de Estrada, in his description of Indigenous land management, paints a veritable cornucopia of flora and fauna, illustrating local and sustainable practices employed by the region's Indigenous inhabitants. Here, in a place considered a barren wasteland by most Spaniards, the Yurumanguí Indians built their homes and carved their canoes, fermented chicha, and maintained a diverse diet.

Another prominent feature on this map are roads. As elsewhere in the Pacific Lowlands, roads in this region were more akin to footpaths and served as the connective tissue that united a widely dispersed community. Nearly all paths on the map

lead to houses; in one instance, though, a very long path leads to a site called Las Cruces, referring to the cross at the top of the mountain (figure 6.1). The map suggests that Yurumanguí structures were distant from one another; Caicedo's letter helps to concretize these vague notions of space and distance. Caicedo wrote that the dwellings numbered 9, 10, and 11 (see figures 6.1 and I.3) were within a few hours of each other. Meanwhile, the bodega (20) was two full days from its nearest neighbor (22), and was reached by an Indigenous path (21, figure 6.8).[101] Incidentally, Lanchas de Estrada recorded that the word "day" in the native language was expressed by the term "sicona," which also meant "sun." "Sicona" conveyed a destination that was one day away, while "sicona, sicona, sicona" indicated a place that was three days distant. To discuss a larger unit of time, such as a month, the term "digia" was used, which also meant "moon."[102]

Paths, in addition to their intended use of connecting inhabitants to one another, provide information about settlement patterns. Places where paths intersect indicate nexus points, or nodes. There are only a few places on this map where two paths intersect; one such spot is marked by a group of three structures (9, figure I.3). This inhabited area seems to mark a southern boundary for this territory and may indicate the place where Indians heading to Las Cruces (7, figure 6.1) or returning from there would stop to rest, resupply, and share news. From 9, moving to the left (to the north), paths follow rivers that connect dwellings and lead ultimately to the northernmost part of this settlement (22).[103]

Caicedo wrote that all the paths were Indigenous, or maintained by the Indians, save for one. The outlier (16), a mining road, is the only path on the map that initiates from a river (see 23, figure 6.8).[104] It is worth noting that, while the path is clearly indicated on the map, no information is provided about the locations of any associated mining sites. It is likely that the mines implied by a mining road would have been those of Pedro Agustín de Valencia, which were accessed by small canoe from the Pacific Ocean.[105] It is not clear whether Caicedo intended to be secretive about these mining locations.

Only three human figures are represented on this cartographic work. Two guide a canoe into the Naya River (see figure 6.2). A third figure is found at the top left portion of the map, to the left of the dwelling labeled 22 (see figure 6.8). Rendered as a stick figure, this may represent Caicedo completing his survey work.[106] It might also be one of the Yurumanguí Indians who aided Caicedo in his reconnaissance. From Lanchas de Estrada's description, we understand that men native to this area were corpulent, with mustaches like dragons and long beards. They plucked their eyebrows and had little body hair; their heads were round, and they had bowl-style haircuts. Lanchas also noted that they practiced cranial reformation. Women, meanwhile, wore their hair long, with bangs. Both men and women used the bark of the *damajagua* tree as a form of bodily covering.[107] The Yurumanguí Indians reportedly consumed a good deal of chicha (which they made from maíz and flavored with plantain), drinking until they fell down or worse. Lanchas de Estrada recorded that four Indians died from excessive consumption while he was there.[108]

Another interesting bit of information Lanchas de Estrada noted is that, up until the time of the Spanish entradas in the mid-eighteenth century, the Yurumanguí Indians had known only stone tools.[109] Accordingly, they became fascinated by the metal implements—machetes, axes—that the Spanish brought as colonizing incentives. Their want of metal tools may have led to their initial and continued exchange with Spaniards. Interestingly, as Lanchas de Estrada wrote, the Yurumanguí held no desire for the gold or minerals that were so abundant in the region.[110] Pre-Hispanic groups around Calima had developed technologies for mining and working gold as early as the second millennium BCE.[111] Nevertheless, Lanchas de Estrada gives no indication that the Yurumanguí Indians mined or manipulated any form of metal.

Up to this point, we have focused on areas of the map that are referenced in the legend. From Caicedo's letter, however, we learn that another Indigenous group ("copia de esta nación") was rumored to inhabit the slopes or the headwaters of the Digua River (27), just east of the Anchicayá River (26) at the far left of the map (see figures 6.1 and 6.10).[112] During his reconnaissance in other parts of this region, Caicedo also found evidence of deserted habitation sites near Cerro Naya (2), south of the Naya River (see figure 6.1). These sites had formerly been occupied by a warring nation, but in a recent skirmish many had died, houses had been

FIGURE 6.10 Detail of the map showing one of the areas that Caicedo identified as inhabited by *poblaciónes ocultas,* "hidden populations." An extension of the Indigenous group occupying the dwellings marked on the map (*copia de esta nación*) was rumored to inhabit the slopes of the Digua River (27, *at right*) and the San Juan de Caloto River (28) areas, above the Anchicayá River (26).

destroyed, and Indians had been taken as slaves by other Indians.[113] The existence of a rival group is corroborated in the diary of Lanchas de Estrada, who noted that the Yurumanguí Indians warred with those three days to the south of them.[114] Is there more to be read from Caicedo's mention of other Indigenous groups?

Lies That Maps Tell

As Mark Monmonier has demonstrated, maps can lie, mislead, and obscure the truth.[115] If we return to the case file "Misioneros de Yurumanguí" and, in particular, to the 10 October 1768 letter written by Romero to Lanchas de Estrada, we are reminded that by that date, twenty-one Indians had perished from a smallpox epidemic.[116] By 27 February 1770, Friar Fernando de Jesús Larrea wrote to tell the viceroy that only ten Indians remained.[117] Nevertheless, months later, on 12 December 1770,

Caicedo completed his map and his six-page letter to the viceroy outlining his reconnaissance of the area.[118] Less than a year later, in a letter dated 25 October 1771, Caicedo laid out his plans for the construction of a road from Cali.[119] At this time, Caicedo still had reason to believe he would be given permission to mine in the area and assumed that the road he was tasked to build would benefit him personally. Caicedo's challenge in reviving the road project hinged upon being able to demonstrate that there were still enough Indians to justify missionizing efforts. In his 1770 letter, Caicedo referred to the many Indians he had seen—numbering over sixty—even more, he wrote, than Friar Romero had witnessed. Caicedo also mentioned "poblaciones ocultas," implying that more Indians might be hidden.[120] And, if need be, there were always the rival Indian groups, living in the direction of Cerro Naya, who could become a new focus of reducción.[121] With a better understanding of Caicedo's economic interests in this region, his reasons for exaggerating the number of Indigenous people remaining in this area become clear. In many ways, Caicedo's map and letter contradict what was reported by the Franciscans—that by 1770 few Indians remained. But how would the viceroy or his advisors, who had never traveled to this Pacific coastal frontier, know that there were no Indians remaining to reduce?

By the time the map was completed and its accompanying letter signed, sealed, and sent to the viceroy in 1770, the once-sizeable population of Indigenous inhabitants living along this stretch of Pacific coast had been significantly compromised by Spanish entradas, Franciscan missionizing efforts, disease, and duress. While the map identifies the locations of Indigenous houses, these houses would have been, by 1770, quite empty, given that the majority of their inhabitants had become casualties of European disease. In many ways, before it ever reached its intended recipient, the Map of the Yurumanguí Indians had been rendered obsolete.

Similar to maps, documents can also distort and mislead. In Francisco Antonio Moreno y Escandón's 1772 report on the state of the viceroyalty of New Granada (marking the end of Mesía de la Cerda's term as viceroy), the high-ranking criollo functionary conceded that little progress had been made on missionizing efforts in the Yurumanguí

FIGURE 6.11 Detail of Moreno y Escandón's *Plan geográfico del virreynato de Santafé de Bogotá*, 1772 (figure 2.1), with the stretch of the Pacific coast that coincides with the Map of the Yurumanguí Indians enclosed in a rectangle. Some of the rivers in this area are indicated by lines, but none are named, suggesting that very little information was publicly circulated about this section of the coast.

area. Nevertheless, Moreno y Escandón indicated, Manuel de Caicedo was hard at work on a road that would connect this rich mining area to Cali and Popayán.[122] Moreno y Escandón's simple statement obfuscated decades of challenges to the road's construction and ignored the lack of support received from colonial administrators in Santa Fé. While both the Yurumanguí and Naya Rivers are mentioned by name in Moreno y Escandón's report, and despite the fact that Caicedo had recently submitted a detailed map of this area to the viceroy, neither the Yurumanguí River nor the Naya River appears on Moreno y Escandón's detailed map of the viceroyalty (figure 2.1).[123] Instead, the area south of Buenaventura is completely blank (figure 6.11). The fact that this area, home to rich placer mines as well as agricultural and human capital, is not represented on the most recent cartographic iteration of the viceroyalty of New Granada underscores the historical importance of the Map of the Yurumanguí Indians. As I have argued throughout this book, manuscript maps provide the most detailed—and sometimes the only—cartographic

reference for geographically remote frontiers in the Pacific Lowlands during the eighteenth century.

Indigenous Agency, Resistance, and Knowledge Contribution

In addition to unearthing information about Spanish colonial initiatives in the periphery, the Map of the Yurumanguí Indians (plate 1) and its associated case file provide evidence for Indigenous agency, resistance, and knowledge contribution in the region. Lanchas de Estrada wrote of intentionally dispersed Indigenous settlement patterns, which seem to have aided the Yurumanguí in avoiding Spanish detection. Larrea, meanwhile, relayed that Indian women resorted to infanticide as a means of sparing their children from Spanish *reducción*. Contained within Caicedo's 1770 letter to the viceroy are hints of how Indigenous inhabitants both helped and hindered his reconnaissance of their territory. He wrote of being in constant contact with local Indians, whom he depended on as guides.[124] Yurumanguí Indians provided Caicedo with information about the distances between houses and the existence of other Indigenous groups living near the Digua River and Cerro Naya. Indigenous inhabitants established and maintained the very paths Caicedo traveled along, and they likely accompanied him on most if not all of his journey. Indians of the Naya and Yurumanguí Rivers had also introduced Caicedo to their principal source of sustenance, the chontaduro, a staple that probably sustained him as he undertook his reconnaissance. That the Yurumanguí shared their food with Caicedo is inferred from his descriptions of local food preparation. Indigenous benevolence, however, came at a price. Indians relayed to Caicedo that the tools, bells, and clothes he gave in exchange for their knowledge were insufficient. They wanted more, leaving him "casi desnudo" (nearly naked) as he departed along the Cajambre River.[125] The Yurumanguí fiercely resisted Spanish efforts at subjugation, communicating to Caicedo that they had no intention of transporting him or his things. It was impossible, he complained, to get them to carry even a single plantain.[126] For these *naturales*, knowledge of one's environment equated to power, and, as Herrera Ángel points out, was its own form of defense.[127] Emerging from

these Spanish documents of attempted reducción are voices and actions of Indigenous protest and resistance.

Conclusions

An examination of the Map of the Yurumanguí Indians (plate 1) helps to concretize the geography, hydrography, and topography of an understudied Pacific coastal region lying between the Dagua and Naya Rivers. As an area rich in placer mines, it attracted wealthy and illustrious vecinos from Cali and Popayán but was also the last bastion for an Indigenous group, the so-named Yurumanguí Indians, who inhabited the shores of the Naya and Yurumanguí Rivers and managed—until the mid-eighteenth century—to evade Spanish detection. The map, long severed from its historical documents until now, provides the setting for this story of failed Spanish colonial entradas and Indigenous resistance in New Granada's Pacific periphery. For information about the protagonists, the plot, and the conflict, it was necessary to track down historical documents that could elucidate this large cartographic watercolor. The fortuitous discovery of a case file—"Misioneros de Yurumanguí"—and within it, a letter, made it possible to assign a date, an author or commissioner, and a raison d'être to this stately manuscript map. In addition to documenting the existence of an autonomous Indigenous group living between the Naya and Yurumanguí Rivers, this map pinpoints the locations of their dwellings and roads, which, in turn, charts the extent of their territory. This case file also preserves valuable historic, linguistic, and ethnographic information about the Yurumanguí. Together, map and case file represent some of the best information we have for this Indigenous nation and this little-studied region.

This cartographic work also encapsulates Spanish projections and desires about land and territory. The map was created to argue for the importance of a road that would support mining in the region. The ability to build this road and mine the area's alluvial deposits was dependent upon a local Indigenous population whose labor Spanish colonists could exploit. Spanish efforts to reduce native Indians led to their disappearance, a fact elided by the presence of their dwellings on the map. Like other cartography discussed in this book, the Map of the Yurumanguí Indians makes an argument that is not encumbered by on-the-ground realities.

This map and its associated case file also highlight a paradox of conquest and colonization in Spanish America: Spanish colonizers looked to Indigenous populations as a source of labor and revenue. However, the act of subjugating and settling Indigenous people often led to their decimation. This episode also demonstrates that colonization in remote gold-mining regions of the Pacific Lowlands was undertaken by colonists and local officials who were tasked with building and funding their own infrastructure at the same time that they sought ways to carve out economic prosperity. Progress made in these frontier areas happened at the hands and at the expense of vecinos, not viceroys.

The Map of the Yurumanguí Indians and its associated case file preserve for posterity the important role of subaltern actors in the periphery. The very project that led to the demise of the Yurumanguí ironically conserved their legacy, aspects of their lifeways, and a portion of their language. Colonizers' accounts portray Indigenous people on the Naya and Yurumanguí Rivers as informants, guides, and hosts to trespassing Spaniards. The Yurumanguí Indians, in ways that echo the Cuna at Murindo, identified ways to benefit materially from Spanish entradas. And like the Murrí Indians who were obligated to guard the vigía along the Atrato, the Yurumanguí found ways to resist. The Map of the Yurumanguí Indians, when informed by its relevant documents, is an example of how manuscript cartography can help to recover native history and native agency.

Finally, the Map of the Yurumanguí Indians prompts further reflection about the forces and factors that shaped peripheries. For the Naya and Yurumanguí Rivers, viceregal neglect, distance from the center, and local geography and topography all played a role. Soon after this potentially lucrative area along the Pacific coast had been discovered, vecinos of Popayán and Cali petitioned for a road that would connect it to interior urban centers. Despite potential financial benefits to the Crown and the viceroyalty, officials in Santa Fé impeded these efforts, aware that easier access to this lucrative but distant extractive economy

held benefits for vecinos of Cali and Popayán, as well as for those engaging in illicit trade, but none for Santa Fé or Spain. The landscape, meanwhile, which fed, clothed, and sheltered native inhabitants, presented insurmountable challenges to outsiders. As journalist Isabella Bernal reaffirmed in 2017, this stretch of the Pacific Lowlands represents, even today, the frontier of the frontier, a place where outsiders are completely vanquished by nature and the environment.

CONCLUSIONS

What Manuscript Maps Contribute to the Study of Colonial Latin America

As I have demonstrated in this book, eighteenth-century manuscript maps of Colombia's Pacific Lowlands present detailed yet subjective geographic, hydrographic, and topographic information for peripheral areas in the Spanish Empire that were rarely visited by colonial administrators and were not included on printed maps until the nineteenth century. These manuscript maps recorded ephemeral places that occupied but a brief instant on the space-time continuum and documented areas of resource extraction—namely, gold—signaling their economic importance to the Spanish crown.

These same maps, which insist on the centrality of rivers and the challenges of terrain, enable us to resurrect stories about the people who inhabited these tropical lowlands. Preserved in map legends are the names of landholders, mines and mine owners, provincial notaries, and routes of commerce and communication. Manuscript maps of the Pacific Lowlands also point us toward local histories about short-lived Cuna reducciones and *sitios*, provide information about autonomous Indigenous populations who resisted Spanish colonization, and preserve stories of Africans whose adaptation led to their autonomy. Meanwhile, the absence of cities, plazas, and churches on these maps exposes the fact that Spanish colonial presence in these peripheries was minimal. A careful reading of these maps, together with the original, often extensive archival documentation that contextualizes them, enables us to unearth untold narratives about adaptation, environment, and multicultural entanglement along the margins of a beleaguered viceroyalty during the final century of Spain's empire in South America. For students and scholars of art history, history, cartography, anthropology, and archaeology, these manuscript maps provide a rich and largely untapped resource.

What Manuscript Maps Reveal about Maps and Mapmaking

Throughout this book, I have presented manuscript maps from the Pacific Lowlands as artifacts that were created for different purposes, arose from distinct circumstances, and were produced by diverse hands. As a result, each map exhibits its own objective and aesthetic. These maps were made to support petitions for roads, ports, land acquisition, and the founding of reducciones. Evidence for this is documented in the case files. Mapmakers were selective and purposeful in terms of what they chose to include and omit. These maps were not intended to represent accurate geographical space or topographical features. Instead, these manuscript maps, sent to royal officials in positions of power, were meant to be persuasive. Accordingly, some spaces on the maps were intentionally

exaggerated or minimized to support a claim or a position. Furthermore, these manuscript maps did not always reflect the present they were produced in; some of them looked forward, projecting Spanish colonial objectives or desires (see chapter 3), while others looked backward, presenting an actuality that once had been, but no longer was (see chapter 6). By engaging in these cartographic transgressions, manuscript maps—and their creators—presented visual arguments centered on the "periphery of the periphery." These rendered landscapes enabled distant corners of the Spanish Empire to be "seen" and "understood" by the decision makers in the center (Santa Fé) who would never experience the Greater Chocó for themselves.

The cases examined in this book underscore that manuscript maps of the Pacific Lowlands were not meant to be self-evident. To fully grasp their content and their objectives, one must consider these cartographic works in conjunction with the historical textual documentation that explains them. Maps point us to forgotten places; meanwhile, associated archival documents preserve local narratives and histories and expose the agendas of the actors behind the maps. Strategies of Indigenous resistance and adaptation, as well as African perseverance and placemaking, are readily found in these documents as well. Scholars' ability to derive rich information from a careful examination of image and text underscores the importance of studying these manuscript maps in context rather than in isolation.

This study has brought to light not only the names and identities of a handful of manuscript mapmakers but also the significant contributions of native informants. Chocó governor Francisco Martínez depended on local manatieros for the geographic information contained in the Map of the Atrato River and Pueblos of Cuna Indians (plate 2). Lorenzo Alarcón signed and dated the Map of the Chocó, Panama, and Cupica (plate 4), but it seems likely that Indigenous knowledge informed the map's geography. The Map of the Dagua River Region (plate 5), meanwhile, may have been commissioned by Manuel Pérez de Montoya, but the detailed intelligence about the area's trails, roads, and rivers likely stemmed from inhabitants of African descent. And the Map of the Yurumanguí Indians, while produced by or under the direction of Manuel de Caicedo (plate 1), seems to have depended upon the local knowledge

of Yurumanguí Indians who hosted and guided Caicedo during his reconnaissance through their lands.

What Manuscript Maps Reveal about Peripheries

Manuscript maps of the Pacific Lowlands call into question the relative nature of peripheries in Spanish America. In the case of New Granada, a label like "periphery" was wholly dependent on the defined center. Places examined in this book were situated along the Pacific coast or were connected to it (or to the Caribbean) by fluvial highways. Areas in the Greater Chocó had their own communication networks and interaction spheres. These networks often existed outside the jurisdictional province or viceroyalty they found themselves in, so the peripherality of these regions was dictated as much by political circumstances as it was by geographical ones. This becomes especially apparent in the case of Cupica (chapter 4), a Pacific port that was geographically distant from the political center of Santa Fé but proximal to Panama and the Pacific coastal network farther south.

Manuscript maps reveal that peripheries were underdeveloped and under-defended. Some historians have argued that this was a conscious strategy employed in isolated areas of Spanish America from the late sixteenth century forward.[1] This approach favored *not* fortifying or developing Spanish America's more remote domains because in not providing or even permitting an infrastructure, governing authorities gave potential interlopers fewer incentives to invade. Nevertheless, nature and the environment, not to mention Indigenous resistance, also played an important role in leaving this lucrative but remote corner of the empire unsuccessfully conquered and colonized.

A close study of manuscript maps along with their archival contexts reveals these peripheries to be dynamic, multiethnic spaces of entanglement, adaptation, resistance, and placemaking. Maps and case files from the Greater Chocó bring to light the strategies of both subjugated and unconquered Indians (chapters 3, 4, and 6), the adaptation and opportunism of Africans and their descendants and those of mixed ancestry (chapter 5), and the dogged determination of Spanish colonists (chapters 3, 4, 5, and 6), whose efforts and expenditures

were seemingly in vain. Along the Atrato River, Cuna Indians negotiated a coexistence with Spanish settler-colonizers while cohabitating with the French and trading with the Dutch and English (chapter 3). From the port of Cupica, Spanish and Indigenous engaged in regular commerce with Panama, as Indians before them had done for at least a millennium (chapter 4). Along the Dagua River, people from West and Central Africa, brought against their will to a densely tropical riparian environment, adapted and went on to create communities, control aquatic and overland commerce as cargueros and bogas, and coexist in sitios with Indians, Europeans, and those of mixed ancestry (chapter 5). Meanwhile, farther south, people native to the Naya and Yurumanguí River region managed, until the 1740s, to evade discovery and subjugation by Spanish miners and missionaries.

What Manuscript Maps Reveal about the Spanish Empire

Manuscript maps of the eighteenth-century Pacific Lowlands privilege spaces of economic promise. The Atrato, Dagua, Naya, and Yurumanguí Rivers and their tributaries represented important sources of gold. Spain's unquenchable desire for this precious metal led to the forced colonization of Indigenous people early in the Spanish colonial period and later brought large numbers of enslaved Africans into these areas. Gold mined in parts of the Greater Chocó linked the highlands to the coast in new ways and ensured New Granada's connection to the global economy. The creation of the maps I have discussed coincided with a period of concerted economic reform under the Bourbon monarch Charles III. With Spain's finances in a precarious state after financially devastating wars, Charles III and his ministers looked to their American colonies for remedies.[2] Gold extracted from New Granada, while nowhere near as plentiful as the silver mined from Potosí in the viceroyalty of Peru, was nevertheless one of New Granada's most viable exports.[3] By the eighteenth century, the most dependable source of this gold was the Pacific Lowlands. And yet, attempts by vecinos and provincial officials to create an infrastructure that would connect this periphery and its resources to the rest of the viceroyalty and the empire were frustrated

by viceregal and Crown authorities' agendas, intra-elite rivalries, Indigenous resistance, African autonomy, and the space itself.

What Manuscript Maps Reveal about Landscape

The manuscript maps in this book collectively tell of the triumph of landscape. The Greater Chocó, from an imperial perspective, remained unmappable, representing a geography that was impossible to explain or represent adequately to anyone who did not experience the space for themselves. And while the Greater Chocó still remains one of the world's most bewildering and little-studied ecosystems, this aqueous landscape has long been inhabited by people who have developed novel adaptive strategies. For European settler-colonizers and explorers, though, this ecosystem was threatening, treacherous, and sterile. Nineteenth- and twentieth-century visitors to the Greater Chocó blamed the region's sparse settlement and lack of development on the climate. Agustín Codazzi, director of the Comisión Corográfica (1850–1859), wrote that, despite its favorable geographical position, its extensive river systems, its natural bounty, and its mineral riches, the region had never been exploited to its full potential nor colonized in a way that was commensurate with its great riches because of its deadly (deletéreo) climate, characterized by scorching heat, inescapable humidity, and incessant rain. Such conditions were not conducive to the cultivation of agriculture, nor were they favorable to human health.[4]

Non-Europeans, in contrast, perceived this ecosystem quite differently. Cuna along the lower Atrato and Africans along the Dagua saw advantages, not obstacles, in the environment that enveloped them. The Yurumanguí, meanwhile, maximized the offerings of their territory, cultivating a variety of crops, domesticating birds, and fishing from streams. The same dense forest that presented a confounding maze for Europeans provided refuge for those who wished to escape the confines and controls of the colonial system. This adaptation was due in part to the fact that non-Europeans possessed survival skills and orientation techniques that were environmentally, as opposed to cartographically, dependent. While Europeans looked to maps for direction, native people and

Africans from similarly tropical environments looked to nature. A knowledge of and a symbiosis with one's environment was its own form of enlightenment and defense.[5] The manuscript maps explored in this book shed light on landscape but also concretize perceptions about that landscape. Through their inclusions and omissions, exaggerations and minimizations, these manuscript maps attempted to tame an otherwise wild space that existed on the outer edge of empire, the "periphery of the periphery."

APPENDIX A

Transcribed Text from Manuscript Map Legends

Manuel de Caicedo, author or commissioner, *Mapa de la costa del Pacífico desde Buenaventura hasta el río Naya, con mención de todos los otros ríos* (Map of the Yurumanguí Indians), 1770 (plate 1). Archivo General de la Nación, Bogotá, Sección: Mapas y Planos, Mapoteca 3, Ref. 125.

The transcriptions that follow work from the original maps and are my own. To aid the reader, I have used current Spanish spelling and have spelled out abbreviations. Words that are partial or illegible in the original are indicated with a [?].

[Left cartouche]

1. Cuchilla cuyas aguas invierten al río que se manifiesta u otras a otro que llamen Micai =
2. Sitio de Naya
3. Mar de Sur
4. Río de Naya
5. Quebrada de San Vicente
6. Quebrada de San Nicolás
7. Alto que llamen de Las Cruces del cual cuyas aguas vienen al cañón de esta ciudad y otra a la parte de Naya ya como se muestra

[Middle cartouche]

8. Camino que corre a las casas de los indios infieles
9. Primera casa que se encuentra en la quebrada de San Vicente
10. Segunda casa en dicho río
11. Tercera casa
12. Cuarta casa
13. Camino al río de San Nicolás
14. Casa primera que hay en este río
15. Segunda casa
16. Camino que corre a las minas del río Yurumanguí
17. Camino que corre a los indios infieles de dicho río
18. Única casa que en este río se conoce
19. Camino que sigue a los indios al río del Cajambre
20. Casa que sirve de bodega o troje

[Right cartouche]

21. Camino que corre a la última casa descubierta por este parte
22. Casa en el río del Cajambre
23. Río de Yurumanguí
24. Río de Cajambre
25. Río de Raposo
26. Río de Anchicayá
27. Río de Digua
28. Río de San Juan Chaloto [*sic*]
29. Río de Dagua el cual es conocido desde sus cabeceras que se forman partiéndose el farallón por la parte que acaba y sigue por tierra útil y limpia mucha parte y luego se introduce en montañas y desemboca en el Puerto de San Buenaventura [?]

Unknown author, *El río Atrato y pueblos de indios Cunacunas* (Map of the Atrato River and Pueblos of Cuna Indians), c. 1759 (plate 2). Archivo General de la Nación, Bogotá, Sección: Mapas y Planos, Mapoteca 4, Ref. 103A.

[Top left margin]

Costa de Portobelo

El río de Atrato corre al sur del norte, y bajando de la provincia de Zitará, queda esta costa de Portobelo a mano izquierda y esta es una cordillera de donde bajan varios ríos a desaguar en el Atrato y juntos a estos ríos que van figurados y nombrados, por sus nombres están situados los pueblos de los Cunacuna y van figurados con esta señal [] y número correspondiente según aparece en la tarjeta=

Cordillera de la costa de Portobelo

[Far right margin]

Norte

Costa de Cartagena

Ríos que desembocan en el golfo del Darién y están al lado de la costa de Cartagena, que van figurados y con sus nombres y los de varios pueblos de los Cunacuna que están situados a las cabezas de dichos ríos con esta señal [] y sus números como se ve en la tarjeta y todos están a la derecha bajando el golfo hacia la mar . . .

Cordillera de la costa de Cartagena

[Cartouche at bottom center]

Pueblo de los Indios Cunacunas
Pueblo de Cacarica número 1
Pueblo de Humaquia número 2
Pueblo de Arquia número 3
Pueblo de Tiguere número 4
Pueblo de Tarena número 5
Pueblo de Acandia número 6
Pueblo de Caiman número 7
Pueblo de la Banana número 8
Pueblo de Truxy número 9
Pueblo de Cué número 10
Pueblo de Canepa número 11

[Named rivers and pueblos (reading from left to right of map)]

[Above Atrato]

Río y Pueblo de Bebará []
Río [and pueblo] de Cacarica 1 []
Río [and pueblo] de Humaquia 2 []
Río [and pueblo] de Arquia 3 []
Río [and pueblo] de Tiguere 4 []
Río [and pueblo] de Tarena 5 []
Río [and pueblo] de Acandia 6 []

[Below Atrato]

Pueblo de Quibdó []
Río de Arquía
Río Bebarama/Pueblo de Murrí []
Río de Bebará
Río de Arquía
[] Río de Murindo/Pueblo de Murindo donde están los Cunacunas conquistados
Río Sucio
Casa de la vigía de Atrato []
Río de Tumaradó
Brazo de Atrato, tiene siete que pueden entrar embarcaciones

Golfo del Darién tiene 20 leguas de largo y su boca 7 de ancho que es lo más angosto

[Bottom left]

Sur
Provincia del Zitará

[Right of Atrato]

Río [and pueblo] de Caiman 7 []
Río [and pueblo] de la Banana 8 []
Río [and pueblo] de Truxy 9 []
Río [and pueblo] de Cué 10 []
Río [and pueblo] de Canepa 11 []
Río cuio nombre se ignora

[In Atrato]

Boca de Atrato
Boca del Golfo

Lorenzo Alarcón, *Mapa de la provincia del Chocó y parte meridional de Panamá con fundaciones hechas en Cúpica* (Map of the Chocó, Panama, and Cupica), 1783 (plate 4). Archivo General de la Nación, Bogotá, Sección: Mapas y Planos, Mapoteca 4, Ref. 136A.

[Left side]
Mar del norte en que va explicado todo lo contenido en lo figurado con la explicación de solo los ríos demás agua que estén y los ocupados por los mineros están en el río Atrato ascienden a más de sesenta.

no. 1. Río Atrato
no. 2. Alquilla, ocupado por indios rebeldes
no. 3. Cacarica
no. 4. Guiparando
no. 5. Terremiguando
no. 6. Río Sucio
no. 7. Pueblo Pavarandó
no. 8. Domingodo
no. 9. Casa de vigía que mantiene el rey nueve hombres
no. 10. Tiguamiando
no. 11. Morindo [Murindo]
no. 12. Opogado [Opogodo]
no. 13. Baxé
no. 14. Napipi
no. 15. Isla de montaño
no. 16. Pueblo de Morrí [Murrí]
no. 17. Boxalla
no. 18. Pacurucundó
no. 19. Tagachi
no. 20. Buey
no. 21. Bebará
no. 22. Pueblo de Beté
no. 23. Río de Beté
no. 24. Negua
no. 25. Pueblo de Quibdó
no. 26. Quito[?]
no. 27. Caxi
no. 28. Tanandó
no. 29. Andagra
no. 30. Pueblo de Lloró = lo que no va figurado de ríos en esta costa son depoblaciones, de indios rebeldes que confina hasta el palenque de negros de la parte de Portobello, el número de quebradas que tienen los dichos son 53 y se entienden por el lado derecho poniéndose a la boca de los ríos de Atrato y por la izquierda comprehende [la parte?] de estos hasta el desemboque del río de la provincia de Lorica de la parte de Cartagena con el número de 22 quebradas
no. 31. Río Domingodo

no. 32. [? (paper torn)]

[Bottom right]
Mar del sur

No. 1. Río de Bao
No. 2. Bahía de San Antonio
No. 3. Bahía de San Francisco
No. 4. Puerto Claro
No. 5. Puerto Quemado
No. 6. Bahía de Cupica
No. 7. La travesía de tierra para pasar de Norte a Sur
No. 8. El Pueblo Nuevo que se está haciendo con el nombre de Cupica con dos ríos de agua dulce con los nombres el mayor del mismo Pueblo el otro con el de Cacique
No. 9. Morro quemado
No. 10. Río Jurado y Cocal
No. 11. Taque
No. 12. Puerto de Pinas
No. 13. Quebrada de Motata [?]
No. 14. Punta de Garachine
No. 15. Hacienda de platanares [?] y cacao de don Pedro Guillem
No. 16. Quebrada de Sanbú
No. 17. Hacienda de Patiño
No. 18. Isla de Cedro
No. 19. Fuerte de Bocachica
No. 20. Seteganti
No. 21. Pueblo de Chepigana
No. 22. Río de la Marea
No. 23. Barva [?]
No. 24. Pueblo de Santa María
No. 25. Molineca
No. 26. Pinogama
No. 27. Caná
No. 28. Fichichi
No. 29. Yavisa
No. 30. Río principal del Darién
No. 31. Sabana
No. 32. Qucunati [?]
No. 33. Río Congo
No. 34. Chiman
No. 35. Chepo
No. 36. Chepillo
No. 37. Plaza de Panamá
No. 38. Taboga
No. 39. Islas del Rey
No. 40. El Guey

Unknown author, *Manuscript Map of Dagua River Region, Colombia*, 1764 (plate 5). Geography and Map Division, Library of Congress, G5292.D2 1764 .M2.

Explicación.

AAA. Río de Dagua

BBB. Río de Bitaco, cuyas aguas internan en el de Dagua

CCC. Camino Real antiguo de el río de Bitaco, que pasando por Zabaletas, vaya por el Potrero de los Chancos, hasta el río de Dagua

DD. Desecho que baja costeando el río de Bitaco, y pasa dicho río de Dagua

E. Paso antiguo de dicho río de Bitaco; en este paso se concluyeron de Don Bernardo Alfonso de Saá las medidas que practicó y se expresan en el Titulo de Merced librado a favor de Francisco de Roa

FF. Río Dagua que en el intermedio de estas letras toma el nombre de los Chancos

G. Montaña de la derechera de Calima, cuyas faldas se elevan sobre el Potrero de los Chancos

H. Potrero de los Chancos

Y. Aguada que está sobre una meseta que hace dicho Potrero de los Chancos

J. Potrero de Zabaletas

LL. Quebrada de Zabaletas

M. Río grande que hace su entrada en el de Bitaco sobre cuyas juntas se halla demarcado el paso del camino real antiguo, como se demuestra en su correspondiente lugar

NN. Camino Real y nuevo de las Simmaronas que toma unión en la hacienda de Dagua con el que va de esta ciudad y pasan en uno, haciendo su internación hasta la estancia de Don Manuel de la Puente en cuyo paraje hacen los arrieros descarga de los víveres y ropas que conducen a las provincias de Raposo y el Chocó

OO. Camino Real antiguo que sale de esta ciudad y pasando por dicha hacienda de Dagua se abraza con el nuevo de dichas Simarronas y sigue el rumbo como se demuestra

PP. Casas y hacienda de Don Antonio y Doña Petrona García llamada de Dagua

QQ. Potrero de Dagua

R. Bajada del Camino Real antiguo del Potrero de Dagua, y es el mismo que unido con el que baja de las Simarronas forma su marcha en la conformidad que va explicado

SS. Quebrada seca, cuya derrota, atravesando por el camino Real que se dice de la bajada del Potrero de Dagua, sigue arrojando sus aguas, cuando las tiene, al frente de los Chancos. Esta quebrada es, donde dijeron los testigos terminaron las medidas que por este lado practico don Bernardo Alphonso de Saá, y sirve de lindero a la Hacienda de Dagua que posee don Antonio García, que fue uno de los testigos para este acto

T. Sitio de las Ojas

V. Sitio del Naranjo

a. Casa que se nombra rancho, y pertenece al que se halla agregado en el Naranjo, el cual sirve de guarda o centinela a un corto cañaduzal que tiene este en la vega del río de Dagua, según se halla delineado

b.c. Quebrado cuyo nombre no se pudo averiguar, y desciende a dicho río de Dagua por entre las asperezas de las elevadas montañas que en este mapa de demuestran

d. Casa de la Peñita, que sirve de estanquillo al arrendador de aguardiente de esta ciudad

e.f. Quebradas de Giménez, cuyas aguas en breve instante se pierden de visita, por la aspereza relacionada, hasta que hacen su entrada en el denominado río de Dagua

g. El chorrito, sigue el mismo curso en todo, como las antecedentes quebradas

h.i.j. Camino o desecho moderno, que apartándose del antiguo de mulas, que hasta hoy existe, baja la pendiente, espesa montaña de Pepita, y transitando sobre la playa del referido río de Dagua, llega a descansar a Las Juntas con las gentes que solo de a pie le pueden traficar

l. Casa de la estancia de Las Juntas que posee Don Manuel de la Puente, las que se hallan situadas, entre los dos ríos de Dagua y Pepita, según se manifiesta en este lugar

mm. Vegas que se hallan ocupadas de cacahual, cuya longitud será poco más o menos de mil pasos comunes, y están situadas entre el río de Pepita y las vertientes o faldas de las montañas que se ven figuradas, entre el camino Real antiguo de mulas, y desecho de Pepita, que se tiene hecho mención

n. Cacahual, en cuya circunferencia se encierren variedad de árboles frutales, como caymitos, zapotes, aguacates, guayabas, y chontaduros: estos últimos están la mayor parte situados a la orilla del

río de Pepita, y en la inmediación de las casas de dicha estancia de las Juntas

pp. Río de Pepita

q. Juntas, de los dos ríos de Dagua y Pepita

rr. Camino antiguo que seguía su destino a Sabaletas; dejado ya por causa de los muchos derrumbos que lo han cegado

ss. Camino más moderno que el antecedente, nombrado palo grande que se transitaba a mula, como el de Sabaletas y por él se conducían las respectivas cargazones hasta Sombrerillo, y no se trafica por su mucha fragosidad

Camino Real que hasta el río de Pepita ha estado siempre corriente y es el mismo que va anotado con el renombre de antiguo, el cual pasa por la hacienda y bajada del Potrero de Dagua, O.P.Q.R. Las Ojas, el Naranjo, la Peñita, Quebradas de Giménez, y Chorrito; y tomando su descenso al expresado río de Pepita desde la letra t. lo pasa en u. olvidándose en este paraje de los otros dos caminos que caballeros se demuestran sobre la aspereza de las correspondientes montañas, y costeando dicho río de Pepita abajo desde X. se interna en Z. prosiguiendo su derrota hasta las casas de las Juntas, ya nominadas; paraje hasta donde llegan a mula, y dejan las cargazones, como se ha explicado

1. Cacahual que mezclado de platanar se halla situado al otro lado del río de Pepita; en este expreso Pedro Roso, mayordomo de dicho Puente se habían resembrado algunas plantas, por otras ya perdidas

2. Platanar que existe en dicho lado y dijo el mayordomo pertenecer a la ya mencionada estancia de Las Juntas

3. Casa que se halla situada al otro lado del río de Dagua y hace frente a la de las Juntas; en este sitio está la estancia que era de Don Francisco Laviano y se remató por cuenta de Real Hacienda

4.5. Dos platanares que inmediatos a esta dicha casa se encuentran los que dijeron los testigos ser de los rematados por dicha Real Hacienda.

6.7.8.9. Cuatro platanares que igualmente dijeron pertenecer a esta estancia, entre los cuales hay algunas matas de cacao

10. Casa donde habita Juan de Guzmán con las respectivas canoas que conducen las cargazones a Sombrerillo, desde el paraje que se figura una, dentro del río, y el arrendamiento pertenece a su Majestad

11. Sitio de Sombrerillo: en este residen los cargueros que conducen a hombros, las cargazones que dejan estas canoas, y se internan para las provincias dichas

12. Quebrada de Sombrerillo

13. Quebrada de Aguasucia

14. Real de Minas de Santa Rosa de Aguasucia

15. Quebrada del Colorado

Nota

Que desde las Juntas de los dos ríos Dagua y Pepita hasta las mareas o Puerto de Santa Buenaventura, se compone el río de Dagua, por uno y otro lado de minerales de oro corrido que se hallan en labor, siendo todo el continente de tierra que se demuestra en esta mapa compuesta de lomas peladas, altas quebradas, montañas ásperas, y cuasi intransibles, que empiezan a elevarse desde las orillas de los respectivos ríos y quebradas, a cuyas márgenes no se hallan otros llanos que las cortas vegas donde están situados los cacahuales, y platanares que van anotados; y separado de estos, otros que mantiene la cuadrilla del Real de Minas y Aguasucia; y de esta para abajo en otros Reales, se ven algunas playas y tierra desmontada que sirve de pasto al ganado vacuno que algunos mineros tienen en estos parajes y también para sementeras y platanares que los dueños de las minas tienen para mantener sus cuadrillas. Cali y diciembre 19 de 1764.

Manuel Pérez de Montoya
Antonio Garces y Saa
Joseph Vernaza

APPENDIX B

Technical Study of the Manuscript Map of Dagua River Region, Colombia

Meghan Wilson, Tana Villafana, and Hadley Johnson, Scientists in the Preservation Research and Testing Division, Library of Congress, in collaboration with Mike Klein, Curator, Geography and Map Division, Library of Congress

In April 2022, a technical study of the *Manuscript Map of Dagua River Region, Colombia* (LCCN 2001622517, Call Number G5292.D2 1764 .M2) was undertaken by scientists in the Preservation Research and Testing Division at the Library of Congress. The noninvasive instrumentation used for analysis included multispectral imaging (MSI), fiber optic reflectance spectroscopy (FORS), and Fourier transform infrared (FTIR) spectroscopy. For the regions of interest (ROI) analyzed by FORS and FTIR, see figure B.1. For the full technical report, see Wilson et al., unpublished ms., Library of Congress.

Research Outcomes
- FTIR indicated that the map is comprised of a rag-based paper, or a combination of rag and wood-pulp fibers.
- Four of the map's eight sheets contained two distinct watermarks. The two watermarks within the illustrated map matched each other, and the two within the legend matched each other (see figure B.2).
- There was no indication of an underdrawing; however, infrared illumination revealed that two of the river names had been rewritten in a slightly shifted position from the original layout (see figure B.3).
- An infrared image of the legend revealed ruled lines and drawn margins.
- Infrared imaging and false-color infrared processed images revealed that the ink (including that used for the rubrics on the reverse) was identified as iron gall.
- FORS and FTIR identified the blue pigment as azurite. FORS identified the green pigment as verdigris or a copper-resinate, and the red pigment on the ship was identified as vermilion. The yellow and brown pigments suggest the presence of iron but were inconclusive with the techniques used.
- A spectra of the adhesive could not be collected and preserve stability, so this option was not pursued.

Recommendations
X-ray fluorescence spectroscopy of the yellow and brown pigments could confirm the presence of iron if more conclusive evidence is desired.

FIGURE B.1 Regions of interest on map analyzed by FORS and FTIR, with FORS sites indicated with circles and FTIR sites with squares. Image created by Meghan Wilson.

FIGURE B.2 "CAB" watermark and "GC" watermark. Photos by Meghan Wilson.

FIGURE B.3 Map detail with rewritten river names "R. de Dagua" and "R. de Vitaco," from far left side of map. Infrared images (940 nm), photos by Meghan Wilson.

NOTES

Introduction

1. Colombia is today divided geographically into five regions—the Pacific, Atlantic, Amazonian, Orinocan, and Andean—and politically into thirty-two departments. The area called the Pacific Lowlands stretches from the eastern border of Panama to the northern border of Ecuador and includes sections of the departments of Chocó, Antioquia, Valle del Cauca (including Buenaventura), Cauca (extending from the Micay River to the Guapi River), and Nariño (including Barbacoas and Tumaco).

2. By the eighteenth century, the Pacific Lowlands was an important source of both gold and platinum, see Lane 1996, 2011. For scholarship on the Pacific Lowlands, see Barona et al. 2002; Murphy 1939; Friedemann 1971; Giraldo Herrera 2009; Herrera Ángel 2016; Lane and Romero 2001; Leal 2018; Martínez Capote 2005; Offen 2003; Oslender 2016; Romero 1991, 1995, 1997, 2002, 2017; Tubb 2020; West 1952, 1955, 1957; Whitten and Friedemann 1974. On Buenaventura specifically, see Correa Restrepo 2012; Romoli 1962; Valencia Llano 2014.

3. Nevertheless, the Pacific coast was thoroughly documented by Spanish navigators and English pirates, see Howse and Thrower 1992.

4. Caldas 1942: 24.

5. See Barona et al. 2002: 105–106. It was not until the mid-nineteenth century (after New Granada won its independence from Spain) that New Granada's disparate territories were "officially" recorded (by the Comisión Corográfica), at last making visible a vast nation that had for centuries been vaguely understood, see Appelbaum 2016.

6. The concept of space-time provides a useful framework for thinking about manuscript maps. For more on the space-time continuum, see Sten Odenwald, "Special and General Relativity Questions and Answers: What Is a Space Time Continuum?," Gravity Probe B: Testing Einstein's Universe, NASA Astronomy Cafe, einstein .stanford.edu/content/relativity/q411.html; see also Kveladz 2019.

7. Spanish colonial documents discuss the decimation, annihilation, and extinction of Indigenous groups. But archival, ethnographic, linguistic, and cartographic research on, for example, the Sindagua in Barbacoas indicates that census documents and numbers tell a different story, see Herrera Ángel 2016: 222, 296–297; 2017. The situation for the Yurumanguí may have been similar.

8. Another analogy exists in time-lapse photography, where each frame captures—but also suspends—a single instant.

9. Hundreds of these manuscript maps have been digitized and are searchable and downloadable from the ArchiDoc database on the AGN's website, http:// consulta.archivogeneral.gov.co/ConsultaWeb. Created in the 1960s, the AGN Mapoteca united two cartographic collections: maps previously held in Bogotá's Biblioteca Nacional de Colombia and maps held in the AGN's collection. Maps from the Biblioteca Nacional are believed to correspond with case files housed at the AGN, Cortés 1967: 11. Another important source for eighteenth-century maps of New Granada is the Archivo General de Indias in Seville, where maps of places in New Granada are filed under "Panama," "Venezuela," and "Peru/Chile" rather than under "New Granada"; see Buisseret 2007: 1144.

10. There are 118 maps with dates between 1800 and 1819; 268 with eighteenth-century dates; 48 with seventeenth-century dates; and 1 with a sixteenth-century date, Cortés 1967: 57–223. In the collection are more

than 100 architectural plans for cathedrals, churches, cabildo houses, bridges, ports, and factories, among other things, Cortés 1967: 10–11, 276–320.

11. See Cortés 1967: 18–52.

12. Cortés 1967: 17.

13. Today, when consulting a map in the AGN, a researcher must also identify and request its corresponding case file to fully understand the map's context. In instances where a map has no known associated case file, researchers must undertake detective work to track it down.

14. See Cortés 1967: 51. This study has drawn from maps and archival documents in the Archivo Central del Cauca in Popayán (ACC), the Archivo Histórico de Cali (AHC), the Archivo General de la Nación in Bogotá (AGN), the Biblioteca Nacional de Colombia in Bogotá (BNC), the Archivo General de Indias in Seville (AGI), and the Archivo General Militar de Madrid (AGMM).

15. Cortés 1967. The few studies on manuscript maps from the AGN include Mancera Medina 2005; Martínez Rubiano and Bautista Estupiñán 2003; Muñoz Arbeláez 2007; Tovar Pinzón 2009; Velandia 1999; Wiersema 2020b.

16. Studies on cartography of New Granada and Gran Colombia, as it became known after its independence from Spain in 1819, have largely been published in Spanish. For early studies, see Acevedo Latorre 1986; "Primeros mapas" 1905; Rozo 1952; Torres Lanzas 1906, 1985; Vergara 1939. More recent studies include Aprile-Gniset 2016; Diaz Ángel, Muñoz Arbeláez, and Nieto Olarte 2010; Fuentes Crispín 2015, 2016; Nieto Olarte and Diaz Ángel 2016; Orlando Melo 1992; Wiesner Gracia 2008. For the handful of studies focused on eighteenth-century maps and mapping projects, see Mejía 2016; Peña-Ortega 2020; Rodríguez Hernández 2014a, 2014b. For maps of the Chocó, see González Escobar 1996. For discussion of cartographic routes and itineraries in the mid-eighteenth to the mid-nineteenth century, see Duque Muñoz 2013a. For large mapping expeditions in South America in the later eighteenth century, see Erbig 2016, 2020; Safier 2008. For an examination of written reports on New Granada's geography and territory, see Afanador-Llach 2016. For nineteenth-century studies that illuminate the place of cartography in statecraft and nation building, see del Castillo 2017, 2018, forthcoming; del Castillo, Díaz Ángel, and Duque Muñoz 2014; Díaz Ángel and Duque Muñoz forthcoming a and b; Díaz Ángel, Muñoz Arbeláez, and Nieto Olarte 2013; Duque Muñoz 2006, 2009, 2012. For investigations on large state-sponsored or commissioned cartographic projects from the nineteenth century, most notably that of the Comisión Corográfica, see Appelbaum 2016; Barona et al. 2002; del Castillo 2006; Duque Muñoz 2013a, 2013b; Sánchez 1998. For the comisión's voluminous watercolors, see Ponce de León 1986. For the cartographic oeuvre of Francisco José de Caldas, a friend and disciple of Alexander von Humboldt's, see Nieto Olarte et al. 2006. For scholarship on the atlas of José Manuel Restrepo, see Diaz Ángel, Muñoz Arbeláez, and Nieto Olarte 2013.

17. For discussion on cartography and the economy, see Hoppit and Morieux 2019: 362.

18. For maps as complex systems of visual communication, see Harley 1987: 2–3; 1968: 74.

19. Being on "the margins" of empire in Spanish America was likely a more normative experience than being at its center, see Cromwell 2018: 13n4.

20. Lane 2002: xv.

21. Cartographic studies of Latin America stand on the shoulders of early cartography pioneers such as Casey (2002), Edney (2009, 2019), Harley (1968, 1988, 2002), Monmonier (1991), Pickles (2004), Turnbull (1996), and Woodward (1987, 2007). The ongoing *History of Cartography* project provides a multivolume examination of cartography across space and time, while online digitized projects and databases make this material accessible to a wider audience. See, for example, the World Digital Library and David Rumsey Historical Map Collection, as well as the map repositories of the AGI, AGN, and BNC. A handful of anthologies examine maps across the Spanish Empire, providing multiple perspectives from various authors. These include Arias and Meléndez 2002; Dym and Offen 2011; Nieto Olarte and Diaz Angel 2016; and Portuondo 2009. For critical commentary on the state of the field, see Bockelman and Erbig 2020; Prado 2012.

22. Harley 1987: xvi.

23. See, for example, Safier 2008.

24. See discussion in Nieto Olarte et al. 2006: 24–25, 32.

25. See Haguet 2011; Safier 2008: chap. 4. The final printed version was produced by engravers, under time constraints, who were unfamiliar with the place they were re-imaging, see Haguet 2011.

26. Safier shows how "cartographic information was transferred from manuscript travel narrative to proof, from proof to copperplate, and from copperplate back to proof again for additional corrections," often leading to errors, omissions, and unexpected outcomes, 2008: 136.

27. The *gobernación* (governing body) and the *audiencia* (highest judicial tribunal) had their own archives. In the case of Lima, what remained of both ended up in the Archivo General de la Nación in Lima. *Pleitos* (lawsuits) were officially dispatched to the audiencia and transported in the royal mail. I thank José Carlos de la Puente for this information.

28. Blond 2019: 25–26, 27–29.

29. Dym 2019: 82–83. The creation of these maps spared decision makers laborious travel, thereby accelerating the decision-making process, Blond 2019: 25–26, 27–29.

30. See Sandman 2008.

31. Blond 2019: 25–26, 27–29.

32. These reforms were driven by the financially

devastating wars that followed the reign of Charles II (r. 1665–1700). Such costly wars included Spain's participation (1762–1763) in the Seven Years' War (1756–1763). Reforms aimed to fill the depleted royal coffers but also included efforts to curb smuggling, lessen the power of the church, modernize state finances, establish firmer political control of the empire, and end the sale of bureaucratic appointments, Kuethe and Andrien 2014: 1–5.

33. See Bleichmar 2006: 82; 2015; Lafuente and Valverde 2005: 136; Puig Samper 2001; Sagredo Baeza and Gonzales Leiva 2004.

34. De Granda 1977.

35. Mosquera 2006: 60–61.

36. Whitehead 1998: 319. For examples of this in Intertropical Africa, see Bassett 1998: 33–37.

37. Whitehead 1998: 322.

38. Humboldt 2005; see Herrera Ángel 2010: 97–99, 102. In this same essay, Herrera Ángel notes the important role of Indigenous information, perceptions of environment, and world views for foreign travelers of the period.

39. Some are planimetric, topographic, geographic, hydrographic, or hypsometric, and some can be considered land-use maps.

40. Laid paper, made from linen pulp from the flax plant, was in use from the twelfth century to the nineteenth.

41. Iron gall ink has been confirmed in the *Manuscript Map of Dagua River Region, Colombia* (plate 5); see appendix B. Other inks may also have been employed. For example, a 1780 report by Juan Jiménez Donoso observed that writing ink was produced from the smoke of "embil" mixed with wine or aguardiente, see Donoso (1780) 1954b.

42. See appendix B and plate 5.

43. These maps, while sent to a governor or a viceroy, were individually commissioned.

44. Monmonier 1991: 1.

45. See Harley 1988.

46. Maps represent spatial relationships, but they do so in culturally specific ways using culturally specific conventions, Gronim 2001: 373.

47. See Woodward and Lewis 1998: 537–538 for examples.

48. Smith 2013.

49. Whitehead 1998: 303.

50. Oslender 2016: 8.

51. West 1957: 3. To put this into perspective, Seattle receives roughly 40 inches (100 centimeters) of rain annually.

52. Oslender 2016: 8, 93. For further discussion on the Chocó's diversity, see Leal 2018: 5–8; Offen 2003: 52; Tubb 2020.

53. André 1884: 702–703.

54. Oslender 2016: 8; Proyecto Biopacífico 1998.

55. Mollien (1823) 1944: 305–306.

56. Saffray (1869) 1948: 333.

57. Codazzi in Barona et al. 2002: 145.

58. Álvarez Lleras 1923: 9.

59. Oslender 2016: 11–12. I am grateful to Matt Nielsen for pointing me to Oslender's book.

60. For an enlightening view of navigation and adaptation in the Pacific Lowlands, see Giraldo Herrera 2009.

61. Oslender 2016: 52. Charles Cochrane, guided by a Black *canoero* (canoe poler) and his daughter while traveling through the Pacific Lowlands in 1823–1824, took note of the daughter's great strength and agility, 1825: 429.

62. Oslender 2016: 119.

63. Oslender 2016: 10, 22, 47–48.

64. Oslender 2016: 12.

65. André 1884: 702.

66. Empson 1836: 99.

67. Travel by silla is documented from the sixteenth to the nineteenth century. For early discussion, see Escobar (1582) 1992: 346. Many explorers opted to travel by silla because they were not physically well enough to travel by foot, Cochrane 1825: 2:397–401.

68. Oslender 2016: 52.

69. *Cambridge Dictionary*, s.v. "periphery," https://dictionary.cambridge.org/us/dictionary/english/periphery.

70. Shils 1961: 124.

71. Azaryahu 2008: 305.

72. Azaryahu 2008: 305.

73. Azaryahu 2008: 305–306.

74. See Jaramillo Uribe 1987: 49 and chart on 51. Chocó, Popayán, and Antioquia were the main areas of gold extraction during the eighteenth century.

75. Sellers-García 2014: 5–9.

76. Sellers-García 2014: 9, 100.

77. Prado 2012: 319.

78. See Prado 2012. For frontiers as zones of unequal interaction between cultures, see Langfur 2002: 220.

79. Prado 2012: 320–322.

80. See Weber and Rausch 1994: xxiii.

81. Weber and Rausch 1994: xiv–xv.

82. In arguing for the importance, or centrality, of peripheries to the Spanish Empire, John Jay TePaske notes that many peripheries were transfer or reception points for precious metals and enslaved Africans, 2002: 37–38.

83. Lane and Romero 2001.

Chapter 1: New Granada

1. Romoli 1953: 55–56.

2. Romoli 1953: 122–128, 152–175.

3. McFarlane 1993: chap. 1.

4. McFarlane 1993: 26–28.

5. McFarlane 1993: 192.

6. McFarlane 1993: 194–195.

7. See McFarlane 1993: 194–195.

8. McFarlane 1993: 198.

9. McFarlane 1993: 198–199. The viceroyalty lasted from 1739 to 1810, with thirteen viceroys overseeing its governance in that time.

10. The Cordillera Occidental is 15,630 feet (4,764 meters), the Cordillera Central is 17,598 feet (5,364 meters), and the Cordillera Oriental is 17,749 feet (5,410 meters).

11. See discussion in West 1952, esp. chap. 5.

12. For Mutis's diaries, which discuss this travel in detail, see Mutis 1957.

13. Mutis accompanied Viceroy Pedro Mesía de la Cerda as his physician and surgeon on this journey; see Mutis 1957; Villegas 1992: 82. For descriptions of similar travel times, see Helg 2004: 49; McFarlane 1993: 40.

14. McFarlane 1993: 32–34; Miño Grijalva 2002: xiv.

15. For discussion of the 1778–1780 census, see McFarlane 1993: 32–34. A breakdown by province is found in his app. A, 353 (table 1).

16. For discussions of ethnicities, ethnic terminology, and ethnic percentages, which varied across the Spanish Empire, see Bethencourt 2013: 171.

17. See McFarlane 1993: 32–38, 353 (table 1).

18. In this catchall category were *negros, mulatos, zambos, pardos, montañeses,* and *mestizos,* Garrido 2005: 167–168. For discussion of mulatos in New Granada, see Rappaport 2011: 603–604. Kathleen Romoli discusses *montañeses* as Indigenous people inhabiting the mountainous areas near the Anchicayá, Bitaco, Pepita, and Dagua Rivers, 1974: 458–459. *Montañeses* are also mentioned in Escobar (1582) 1992 and by Jorge Isaacs in his novel *Maria,* 1867.

19. Garrido 2005: 167–168.

20. McFarlane 1993: 38.

21. Santiesteban (1740–1741) in Robinson 1992: 189; McFarlane 1993: 53–54.

22. Silvestre (1789) 1950: 222.

23. Barona 1986: 65; Jaramillo Uribe 1987: 49; Lane forthcoming. Gold quantities extracted here paled in comparison to the silver mined in New Spain and Peru; see McFarlane 1993: 71–73; Kalmanovitz 2008: 34; and Lane's detailed discussion of Potosí, 2021. Under Viceroy Pedro Mesía de la Cerda (1761–1772), New Granada's treasury collected only one-fifth of what Peru's treasury brought in and only one-tenth the amount collected from New Spain, Kuethe 1990: 30.

24. For example, the 1773 last will and testament of Manuela Quintero, a free mulata from Cali, affirmed that she owned plates from China and a black hat from Paris, AHC Fondo Escribanos, Notaria Primera, libro 4, fols. 74v–75v.

25. McFarlane 1993: chap. 1; Twinam 1982; West 1952: 1; Williams 2005: 17.

26. Jaramillo Uribe 1987: 49. For extractive economies in the Pacific Lowlands, see Leal 2018: 11, chap. 2; Tubb 2020.

27. "El nervio principal y casi único, para la subsistencia de este vasto Reino, y su comercio con España, quien los vivifica y alienta es el oro que se saca de las muchas minas que de este precioso metal se trabajan en los Gobiernos de Popayán, Chocó, y Antioquia," "Proyecto de Hurtado" 1920: 183, cited in West 1952: 112; see also chart in Jaramillo Uribe 1987: 51.

28. For free trade, see Fisher 1981. Agricultural goods included cotton, cacao, sugar, horns, and dyewoods; the dearth of good roads hampered the export of agricultural products and led to their putrefaction before they could reach their destination, Jaramillo Uribe 1987: 49, 75.

29. West 1952: 112.

30. See Colmenares 1989: 1:178. Ironically, most of New Granada's gold was exported to Europe, while some went on to the Middle East and India. Very little remained in New Granada; see Lane forthcoming.

31. McFarlane 1993: 39–40.

32. Nevertheless, interregional trade also suffered from poor internal transport and communication; see McFarlane 1993: 39–40.

33. See Moreno y Escandón (1772) in Colmenares 1989: 1:179.

34. McFarlane 1993: 72. Robert C. West identifies several mining regions, including Anserma-Cartago, Popayán, Almaguer, Antioquia, and the Pacific Lowlands; exploitation was underway in most of these areas by the mid-sixteenth century, 1952: 9–34. In Antioquia, where both vein and placer mining were undertaken, the Indigenous population was tapped for their mining knowledge, skill, and labor, West 1952: 22–25. By the late sixteenth century, Zaragoza had become the leading gold producer in Antioquia and was rumored to be the richest source of gold in the Indies, West 1952: 26, 26n106. Antioquia was an important mining region from the early seventeenth century until roughly 1670; it was replaced by Popayán, which continued to be a major producer of gold until the end of the Spanish colonial period, Jaramillo Uribe 1987: 51.

35. Placer mining was the main technique used in the early years of many gold rushes, including California's.

36. See West 1952: 54–63. For an interesting description of Spanish mining techniques in the Darién, observed by English pirates from the cover of a tree, see Wafer 1729: 286–287.

37. Williams 2005: 17.

38. Williams 2005: 17. Another metal mined in the Pacific Lowlands, at first accidentally, was platinum (*platino*). The Chocó was the sole producer of this precious metal until the 1820s, when it was discovered in Russia, West 1952: 63–64. Completely unknown until the late seventeenth century, platino was first publicized in 1748 by Jorge Juan and Antonio de Ulloa in their widely translated *Relación histórica del viaje a la América Meridional.* Ulloa is still commonly credited with its "discovery," discussed in Lane 2011.

39. Jaramillo Uribe 1987: 51; West 1952: 15. The Chocó was the first area in the Pacific Lowlands to be

exploited. By 1583 it was important enough to be made a province. It would be incorporated into Popayán a decade later, in 1594, West 1952: 16–17.

40. Antonio Manso Maldonado, president of the Audiencia of Santa Fé de Bogotá (1724–1731), reported on the mines of Chocó in 1729, noting that gold there was not extracted by the *arroba* (a unit of weight of approximately 25 pounds [11.5 kilograms]) but by the *carga* (load); nevertheless, the people living there were extremely poor, Colmenares 1989: 1:28–31. Nearly a half century later, Moreno y Escandón wrote that a lack of roads to major centers restricted commerce in the Chocó, which economically strangled the population. People there lived in scarcity, costs were excessively high, and miners were deep in debt; see Colmenares 1989: 1:153–270.

41. Jaramillo Uribe 1987: 53. Stanley J. Stein and Barbara H. Stein demonstrate that smuggling in New Granada occurred at a much higher rate than it did in New Spain or Peru; between 1747 and 1761, smuggling accounted for three million of New Granada's five and a half million pesos of annual exports, 2003: 72.

42. Kuethe 1990: 33. Juan José Ponce Vázquez shows that this was also the case for seventeenth-century Hispaniola, 2020: 59, 96; see also Cromwell 2018: 12–13, 20, 30; Grahn 1997.

43. McFarlane 1993: 34–38; Escobar (1582) 1992. For a similar sixteenth-century demographic collapse in Quito's mining districts of Zamora, Zaruma, and Yaguarsongo, see Newson 1995: 347. For a similar decline in Pasto's mining areas from the time of the conquest through the end of the seventeenth century, see Calero 1997: 186, which is discussed in Lane forthcoming. The introduction of falciparum malaria to New Granada by people from West Africa (who often had strong resistance to infection) contributed significantly to the further decline of the Indigenous population, see Carney 2017: 446; McNeill 2010: 53–54.

44. Sandoval (1627) 1956: 196, bk. 2, chap. 2; see also West 1952: 83; Barona 1986: 61–66. In Brazil's Eastern Sertão, Hal Langfur notes that what some scholars have attributed to decimation was in fact relocation, as Indians sought refuge in isolated forests and river valleys, 2002: 255.

45. Africans who had acquired their freedom fell into the "libres de todos colores" category, see McFarlane 1993: 32–38, 353.

46. Wheat 2011: 12; 2009; see also Colmenares 1979: 40–46; Curtin 1969: 128–130; del Castillo Mathieu 1982: 160–161; Vila Vilar 1977, 1982.

47. Borucki, Eltis, and Wheat 2015: 446.

48. Colmenares 1979: 47, 52, 60; see also McFarlane 1993: 75–76; Souldore-La France 2001: 89.

49. Chandler 1972: chap. 4. Working from port entry records, David Wheat found that 463 slave ships had come into Cartagena between 1573 and 1640 carrying more than seventy-three thousand enslaved Africans,

2009: chap. 3. See also the transatlantic slave trade database at www.slavevoyages.org. Africans arrived through back channels, such as Buenaventura, as well; see Valencia Llano 2014: 240.

50. Researchers have estimated that from the sixteenth through the eighteenth centuries, more than 30 percent of Africans aboard ships perished, a number in line with estimates provided by Sandoval in his 1627 *De instauranda Aethiopum salute*, the earliest known book-length study of African slavery in the colonial Americas, Sandoval (1627) 1956; Chandler 1972: 18–19. The *cabildo* (municipal government) of Santa Fé in 1730 estimated that 15 to 20 percent of newly arrived Africans died within their first two years in the country, Chandler 1972: 138–139. For slave health in the early seventeenth century, see Newson and Minchin 2007.

51. Smallpox inoculations were available after the 1760s, reducing this danger. Scurvy and yaws led to the deaths of many as well. Until the quarantine act was established in Jamaica in 1735, there was no general understanding that sick people needed to be separated from healthy ones, Chandler 1972: 29–39, 52, 77.

52. See Chandler 1972: chap. 2.

53. Chandler 1972: 46.

54. See Sidbury and Cañizares-Esguerra 2011: 185.

55. Chandler 1972: 46. See also Smallwood 2007: 30, which discusses the social death these individuals endured.

56. Chandler estimates that roughly three-quarters of the Africans' time on board was spent in this confined, stifling space, 1972: 46.

57. Chandler 1972: 46.

58. Chandler 1972: 97–106.

59. See Atrato River discussion in chap. 3.

60. Chandler 1972: 107–108.

61. Chandler 1972: 107–119.

62. See Leal's discussion of racialized landscapes and stereotypes about Blacks being better equipped to survive conditions in the Chocó, 2018: chap. 5.

63. McNeill 1999; see also Curtin 1968. For a comparison to African mining camps in Brazil, see Karasch 2016: 22–23; see also Almario García 2009. West Africans and those of West African descent carry an inherited partial immunity to yellow fever, McNeill 1999: 178–179. Others, meanwhile, carry a conferred immunity, having survived a bout of the disease. For populations that lacked immunity, yellow fever was much more lethal than malaria, McNeill 2010: 3–4. Meanwhile, victims of malaria built up a hard-won resistance through repeated bouts; see McNeill 2010: chap. 2.

64. Judith Carney notes these places as rich in natural resources, including fish, shellfish, firewood, honey, salt, and medicinals, as well as soils conducive to wet-rice and oil-palm cultivation. These same areas were lethal for Europeans, who had little genetic resistance to diseases endemic to the mangrove swamps, 2017: 433–436.

65. Carney 2017: 436. Carney suggests that

epidemiology presents a plausible explanation for Afro-Colombian dominance of the Pacific Lowlands, 2017: 446.

66. See, for example, Chandler 1981: 119; 1982: 315; Klein 2012: 208; Leal 2018: 45–51; Meiklejohn 1974: 179. In the Pacific Lowlands, enslaved people were given designated days off to provide their own sustenance through fishing, hunting, and the planting of crops, see Fermín de Vargas 1953: 53; Sharp 1976: 134. Enslaved workers could also use days off to work an enslaver's mine for their own profit, although a percentage of pay earned on days off would go to the master, see ACC Sig. 11501 Col. C IV-11 g (1773), fol. 99v.

67. Colmenares 1979: 98; discussion in Leal 2018: 45–51; Meiklejohn 1974: 179; Chandler 1981: 119; 1982: 315.

68. Leal 2018: 45; see also Meiklejohn 1974: 179; Chandler 1981: 119; 1982: 315.

69. Pit placering utilized simple technology and tools; see Colmenares 1979: 140–142. Many of these same tools are used today in artisanal mining in the Chocó; see Tubb 2020.

70. West 1952: 55–62.

71. See West 1952: 56–58; McFarlane 1993: 72.

72. Lane forthcoming.

73. These reservoirs, known as *entables*, required months to construct and were the component that made the mines lucrative as well as valuable, Leal 2018: 42–43; Colmenares 1979: 137.

74. Leal 2018: 27; see also Tubb 2020.

75. See, for example, ACC Sig. 11392 Col. J I-17 mn (1760), fol. 20r–v, where eight *barras*, four *almocafres*, three *hachas* (axes), three *barretones*, and two machetes were valued at eighty-one patacones and were noted as weighing over 5 arrobas (148 pounds [about 67 kilograms]).

76. The term "mazamorrero" is derived from *mazamorra*, which in Spanish refers to the sand and gravel sluice tailings, West 1952: 90.

77. Jaramillo Uribe 1987: 52. William Frederick Sharp indicates that enslaved laborers in the largest cuadrillas were split up and sent to work at different mining sites, 1976: 115–116.

78. AGN Negros y Esclavos 43 4 D 38 (1758–1759), fols. 558r–563r. Roughly one-third of the slaves from this mine were identified as nonproductive (*chusma*).

79. This mine was at Río de la Concepción, AGN Negros y Esclavos 43 4 D 38, fol. 584v.

80. ACC Sig. 8806 Col. J I-17 mn (1762–1766), fols. 58–62.

81. This mine was at Río Ycho, AGN Negros y Esclavos 43 4 D 38, fol. 585r. For more on Miguel de Velasco y Solimán, see Wiersema 2023.

82. West 1952: 102–103.

83. McFarlane 1993: 72; see also West 1952: 103.

84. This is based on 1778–1780 census numbers from the provinces of Chocó, Raposo, and Barbacoas;

see McFarlane 1993: 353 (table 1). Today, the Pacific Lowlands is home to a large Afro-Colombian population, which comprises roughly 90 percent of the area's inhabitants. Indigenous groups, including Embera, Wounaan, Zenu, Tule (Cuna), and Awa, comprise about 5 percent of the region's residents who support themselves through subsistence agriculture as well as gold panning, timber extraction, *palmito* (palm-heart) harvesting, and the acquisition of marine resources; see Offen 2003: 54. For a more recent perspective on livelihoods, see Tubb 2020. For discussion of society in the Pacific Lowlands post-emancipation, see Leal 2018.

Chapter 2: Coming into View

1. Moreno y Escandón's original map is no longer extant. For a rich discussion of this map—the surviving contemporary copy and the reduced printed copy—see Mejía 2016: 35–37.

2. See Dampier 1729.

3. See Howse and Thrower 1992.

4. See Bleichmar 2015: 239.

5. The Spanish Crown had designated New Granada an exporter of gold. Meanwhile, Cuba and Puerto Rico were deemed sugar producers, Venezuela was designated a main exporter of cacao, Río de la Plata exported hides (leather) and meat, Chile was a major exporter of wheat, and Mexico and Peru were designated important exporters of silver, Jaramillo Uribe 1987: 67.

6. Conspicuous cartographic voids reflect the need to withhold or restrict knowledge, keeping sensitive information out of foreign hands; see Sandman 2008: 33.

7. Contrary to Maldonado's intent, however, the final printed version of the map retained this information, Safier 2008: 132.

8. Juan and Ulloa 1748: 338. Juan and Ulloa spent time in Popayán, where they commented on the large number of inhabitants that had resulted from unions of Europeans and Africans, in contrast to very few Indian castes, see bk. 6, chap. 3. They also observed that wealthy people in Popayán, despite the prohibitive cost, danger, and inconvenience of transport, owned European furniture, which, after being transported by sea, was moved overland and on rivers into the interior, 336. For Juan and Ulloa, see also Andrien 1998.

9. Mary Louise Pratt notes that Juan and Ulloa were also silent about mines, military installations, and other strategic information, 2008: 20.

10. See expedition itinerary in Villegas 1992: 86.

11. Starting on Colombia's north coast (the Sinu River), Humboldt and Bonpland traveled to Cartagena, Turbaco, Honda, Mariquita, Bogotá, Ibague, Cartago, Popayán, Almaguer, and Pasto; see Sprague 1926: 23–25.

12. See discussion in Mosquera 2006: 60–62.

13. The viceroyalty gained independence from Spain between 1819 and 1822, resulting in a republic known as Gran Colombia. The states of Ecuador, Venezuela, and the Republic of New Granada were created later, with

the Republic of New Granada lasting from 1831 to 1856. In 1850, twenty years after dividing Gran Colombia into three new republics, New Granada possessed only a vague notion of the territory within it, Barona et al. 2002: 39.

14. See Appelbaum 2016; Barona et al. 2002; Ponce de León 1986; Sánchez 1998. Appelbaum notes that the comisión's work was far from straightforward. It was challenging to survey a mountainous interior with no real roads, never mind the lowland frontiers, where the state had little effective presence, 2013: 352–353.

15. Spain's American territories were strictly off limits to any type of official travel by foreigners for most of the colonial period, Pratt 2008: 16.

16. There is a notation on Isla Gorgona of the presence of cacique Jundigua. The river labeled San Juan River on this map refers to the Micay River, see Romoli 1962: 113–114. There was also a San Juan River north of Buenaventura, in the Chocó.

17. Díaz Ángel, Muñoz Arbeláez, and Nieto Olarte 2010: 14. Gerritsz, viewed by many as the foremost Dutch cartographer of the seventeenth century, was also a publisher, printer, bookseller, bookbinder, and portraitist, see Kuening 1949. In 1617, Gerritsz was appointed as the first official cartographer of the Dutch East India Company, one of the most enviable posts for an ambitious cartographer, Keuning 1949: 56. While Gerritsz did undertake a voyage to the New World in 1628, it is not clear that he ever visited New Granada or sailed along its coasts, Keuning 1949: 61–64.

18. Gerritsz's map of New Granada was published in Joannes de Laet's *Nieuwe Wereldt ofte Beschrijvinghe van West-Indien, wt veelderhande schriften ende aen-teeckeninghen van verscheyden natien by een versamelt* [. . .] (Leiden, 1625), along with nine other maps projected and delineated by Gerritsz, including additional maps of today's South America as well as some of Mexico and Florida, Keuning 1949: 61.

19. See Herrera Ángel's discussion of coastal contours presented on maps, 2016: 75–80.

20. Toro (near Nóvita), settled in 1573, was one of the earliest places in the Chocó where gold was exploited, West 1952: 15–16.

21. For the discovery and early history of Buenaventura, see Romoli 1962: 114; West 1952: 15; Valencia Llano 2014.

22. See Howse and Thrower 1992, as well as the Hacke atlases held in the British Library, the John Carter Brown Library, and elsewhere.

23. Hacke, a tradesman chart maker of the Thames School (see David Quinn's foreword in Howse and Thrower 1992: ix) and one of the most prolific of his era, produced over three hundred navigational charts from 1682 to 1702; see Smith 2020.

24. See the narratives of English pirates responsible for this seizure, including William Funnell (1729), Bartholomew Sharp (1729), Lionel Wafer (1729), and Basil Ringrose (Howse and Thrower 1992).

25. Haguet 2011: 90; Díaz Ángel, Muñoz Arbeláez, and Nieto Olarte 2010: 18.

26. See mining settlement map in West 1952: 21.

27. This map, printed in Paris under the auspices of the Duke of Orleans, was drawn by artist Hubert-Francois Gravelot and engraved by Guillaume-Nicolas Delahaye. For more on D'Anville, see Haguet 2011.

28. The original version of Escandón's map accompanied his report *Estado del virreinato de Santa Fé, Nuevo Reino de Granada* [. . .], which was annexed to Viceroy Pedro Mesía de la Cerda's own account of his viceroyalty (his *Relación del estado del virreinato de Santa Fé* [. . .]). The map's draftsman was José Aparicio Morata. The original was destroyed in a fire in Bogotá in 1948, but a coeval copy exists in the Museo Naval in Madrid, see Mejía 2016: 35–36, 38.

29. D'Anville's omissions seem to have been by choice, as he included many more places in his earlier map, *Amérique Méridionale*, of 1748.

30. The San Juan River is not identified on either D'Anville's 1748 or his 1756 map, but D'Anville's 1748 map does label the Atrato and the arrastradero de San Pablo, which connected the San Juan and Atrato Rivers.

31. These nine towns on Moreno y Escandón's map are Cartago, Naranjo, Toro, Roldani, Tulua, Buga, Cali, Arroyohondo, and Caloto. D'Anville identified Cartago, Cali, and Jamundí on his 1756 map but omitted Toro, Naranjo, and Roldani on both his 1748 and 1756 maps.

32. Buenaventura's population at this time is difficult to gauge, but it fell within the province of Raposo, whose population according to the 1778 census was 3,426, see AGN Censos de Población SC EOR.22, Jurisdicción de gobernación de Popayán. John Potter Hamilton, traveling in the 1820s, described Buenaventura as "a miserable village, with a captain who commands a small detachment of the military." Despite Buenaventura's small size, considerable trade was conducted between this port town and Cali, Hamilton 1827: 2:157.

33. It is possible that, despite the date of D'Anville's *Amérique Méridionale*—1748—the map was unknown to Moreno y Escandón at the time he made his 1772 map.

34. For more on the need to safeguard geographical information from foreign and internal enemies alike, see Portuondo 2009: 6–7, chap. 3.

35. For transcriptions of these documents, see Colmenares 1989: 1:123–271.

36. Moreno y Escandón wrote of "minas en los amagamientos del río Dagua y de los nombrados Yurumanguí y Naya por lo que sería conveniente al servicio de Dios y del Rey, promover y llevar a la perfección esta idea mediante a que por experiencia se tiene reconocida la riqueza de las minas," ACC Sig. 12015 Civil IV-11 g (1772), fols. 13v–14r. See also Colmenares 1989: 1:168–169.

37. Similarly, Hal Langfur notes that, despite signs of increasing cartographic knowledge in the Spanish and Portuguese empires, large portions of the Eastern Sertão in Brazil were labeled "terra incognita" as late as 1760, 2002: 234.

38. See, for example, individual charts in William Hacke's unpublished atlas "An Accurate Description of All the Harbours, Rivers, Ports, Islands . . . in the South Sea of America . . . ," in the John Carter Brown Library, accession no. 66-304. The maps in this atlas are based on captured Spanish navigational charts.

39. The desire to protect geographic information from foreign interlopers meant that many cosmographical works were never published, Sandman 2008; see also Howse and Thrower 1992.

40. Sandman 2008; see also Portuondo 2009.

41. Hacke, "An Accurate Description of All the Harbours, Rivers, Ports, Islands . . . ," 74, manuscript in the John Carter Brown Library. See Sharp 1729; Howse and Thrower 1992.

42. Interestingly, Sharp mentions overtaking and capturing this Spanish ship (which came from Lima loaded with wine and brandy) but does not mention the maps that were confiscated by his men, Sharp 1729: 79–80. See also Williams 1993: 13.

43. John Carter Brown Library, Annual Report, 1966: 21–25, 45–52.

44. Caldas, considered by many Colombians to be their first native-born scientist and intellectual, was born in 1768 to an important family in Popayán. He led the charge in the areas of geography, astronomy, and botany.

45. In developing a map of the viceroyalty, Caldas hoped to assemble what was known about the roads, natural resources, pueblos, commerce, and the extent of New Granada, as well as its geographical position and principal areas, Nieto Olarte et al. 2006: 26–28.

46. These stone sculptures are found within a ten-mile (sixteen-kilometer) radius, making San Agustín the largest complex of megalithic statuary in Latin America. For a catalog of the 514 sculptures, see Sotomayor and Uribe 1987.

47. Caldas 1942: 42. The first known mention of the San Agustín sculptures comes from Mallorcan-born Franciscan friar Juan de Santa Gertrudis, who passed through San Agustín in 1756; see Santa Gertrudis (c. 1790) 1956. Caldas traveled to San Agustín in 1797.

48. This map, housed today in the Archivo Histórico Restrepo in Bogotá, bears no date. Caldas's *Carta esférica del vireynato de Santafé de Bogotá por Mr. D'Anville* from 1797 includes none of the detail on this map, yet his later writing suggests he was familiar with these areas of the Pacific coast; see Caldas 1942: 29, 40–41, 267.

49. Scale is absent, yet latitude is noted at right and left margins. Buenaventura, whose actual latitude is 3.8801, sits just above 4 on Caldas's map. Meanwhile Esmeraldas, whose latitude is .9592, sits just below 1.

50. For 1778–1780 census information, see McFarlane 1993: app. A, table 1; see also AGN Censos de Población SC EOR.22, Jurisdicción de gobernación de Popayán. While these community populations are large for the Pacific Lowlands, these "cities" in most other viceroyalties would be referred to as pueblos.

51. Hostetler views this use of text as more of a premodern, as opposed to early modern, convention, 2001: 17, 20.

52. While the map does provide scale in nautical leagues at bottom right, the map's author seems to understand the need for a detailed textual description of the terrain, provided at right.

53. As in the map attributed to Caldas, mines have the greatest representation and include San Antonio, La Venta, Tocotá, el Planar, Papagayero, Santa Ana, Dagua, Aguasucia, La Bodega, and Santa Gertrudis.

54. See AGN Curas y Obispos 21 44 D 2 (1742–1780), fols. 198v–200v. Map and letter are no longer archived together, and no reference, on the map or the letter, indicates there is an accompanying document. A stroke of luck led me to identify the unmoored letter that once accompanied this map. Map, letter, and case file are discussed in chapter 6 and Wiersema 2020b.

55. On this point, J. B. Harley emphasizes that a map yields only partial testimony about the circumstances under which it was created. As such, our work as scholars is to restore the original contexts to these works. Maps should be considered in a "wide spectrum of external evidence." Because many have been "plucked from their original documentary context," we must, when possible, return these works to their "correct historical stratum," 1968: 67.

56. See Martínez Rubiano and Bautista Estupiñan 2003. A visita was a royal tour or inspection, usually by an outsider, to investigate works of government. Visitas often came in response to a complaint or suspicion; see Marzahl 1978: 125.

57. Appelbaum notes this was also the case for the data and maps resulting from the Comisión Corográfica, 2016: 2.

Chapter 3: The Map of the Atrato River and Pueblos of Cuna Indians

1. This map, AGN M4, Ref. 103A, forms part of the case file AGN Caciques e Indios 58 D 19 (1758–1764), fols. 435r–741v; it appears on fol. 559v.

2. See González Escobar 1996: 4, map 3; Vásquez Pino 2015: 38.

3. The Atrato River forms part of a larger geographical, ecological, and geopolitical sphere comprising the Panamanian Isthmus, the Darién, the Gulf of Urabá, and the Atrato drainage. This region falls within the greater circum-Caribbean, whose inhabitants, as Gómez explains, "traversed imagined European imperial and commercial boundaries," 2017: 9–10; see also Gallup-Diaz 2008: chap. 3; Bray 1984.

4. Rivers that facilitated this connection included the San Juan, Peña-Ortega 2020: 93–94, and the Napipi.

5. Today, the Chocó's population is primarily Afro-Colombian, see Medina-Rivas et al. 2016: 45.

6. Illegal commerce and contraband were common in Spanish America, as well as in Spain itself. Kuethe and Andrien estimate that 50 to 90 percent of the

merchandise leaving Spain for the Indies was unregistered and hence untaxed, 2014: 71; see also Vila Vilar 1982: 309.

7. Weber notes that, in the Age of Conquest, Spain failed to conquer many parts of the Americas. Even in the late 1700s, independent Indians still held effective dominion over at least half of the actual land mass of what is today continental Latin America, Weber 2008: 12; see also Wallace and Hoebel 1952: 12.

8. Lipman 2015: 4–5.

9. For foundational work on eighteenth-century Chocó, see Sharp 1970, 1975, 1976; West 1952, 1957; Williams 1999, 2005; as well as Montoya Guzmán 2008, 2011, 2013; Peña-Ortega 2020; Vásquez Pino 2015. Many investigations, including Jiménez Meneses 2004, emphasize this region as geographically, climatically, and geopolitically inhospitable for the Spaniards who sought to conquer and colonize it. For studies on mining and slavery in the region, see Barona 1995; Barragan 2016; Bryant 2006, 2014; Colmenares 1979; Díaz López 1994; Lane 1996 and forthcoming; Leal 2018; Mosquera 1997; Peralta 2019; Restrepo 1888; Sharp 1970, 1975, 1976; West 1952, 1957. For studies on the Chocó as a space of resistance between the Spanish, other foreigners, and Indigenous people, see Cantor 2000; Friedemann 1976; Isacsson 1975; Montoya Guzmán 2008; Romoli 1975a, 1975b; Vargas 1993; Vásquez Pino 2015; Williams 1999, 2005; Hansen 1991. For transcribed and unedited historical documents pertaining to the Chocó, see Cuervo 1892; Ortega Ricaurte 1954; Urrutía, Urrutía, and Urrutía 1992; Zuluaga 1988.

10. Nielsen 2019, esp. chap. 5.

11. Chains also blocked entry to the ports of Santo Domingo and Cartagena, Nielsen 2019: 217. I thank Matt Nielsen for pointing me to this information and Jorge Galindo Díaz for confirmation that such measures were in fact taken. Chains were not necessarily permanent features but were put in place pending possible attack, Jorge Galindo Díaz personal communication, May 2021.

12. Nielsen 2019: 218, 215, 219, 233–253.

13. See Langfur 2002: 228–231.

14. Langfur 2002: 237.

15. Nielsen 2019: chap. 5. For cases in eighteenth-century Venezuela, see Cromwell 2018: 17.

16. Restrictions placed on the Atrato only fostered and encouraged smuggling by people from foreign nations and by Spaniards. Even Charles III, in a real cedula from 1774, acknowledged that closing the Atrato to Spaniards had led to an increase in illicit trade by foreigners, see Ortega Ricaurte 1954: 199. While smuggling ate away at the revenue streams of the Spanish treasury and empowered Spain's Atlantic rivals, it invigorated colonial economies, Cromwell 2018: 24.

17. Sharp 1976: 10; see also Peña-Ortega 2020: 82. For a summary of these orders, see AGN Caciques e Indios 38 D 42 (1784), fols. 724r–731v. The earliest of these real cedulas dealing with the exploitation of the "rich and abundant minerals" in the province of the Chocó was issued 22 January 1730 and prohibited communication, navigation, and commerce in an effort to mitigate the problem of enemies entering and invading the Chocó and nearby provinces, see "Real Cedula . . ." in Ortega Ricaurte 1954: 174; see also González Escobar 2011: 193–207. For a comparative in Brazil's Eastern Sertão, where royal charters in the eighteenth century prohibited opening new roads that would provide easier access to mining areas, see Langfur 2002: 229–230; 2006.

18. Marín Leoz 2008: 308–309. For cases in Venezuela and Hispaniola, see Cromwell 2018 and Ponce Vázquez 2020, respectively.

19. See "Obedicimiento, 21 April 1732 . . ." in Ortega Ricaurte 1954: 174–175.

20. See Antonio de Arévalo's descripción (31 March 1761) in Cuervo 1892: 253, as well as Mesía de la Cerda's *Relación del estado del virreinato de Santa Fé [. . .]* (1772) and Moreno y Escandón's *Estado del virreinato de Santa Fé, Nuevo Reino de Granada [. . .]* (1772) in Colmenares 1989: 1:137 and 1:180, respectively.

21. Sharp 1976: 78.

22. For discussion on the closure of the Atrato and its implications, see González Escobar 2011: 193–207; Sharp 1976: 38–40.

23. Those in Cali, Popayán, and Buga developed significant trading activities in the Chocó, selling dried and salted meat, tobacco, wheat, and sugar, all products that were not easily produced on the frontier, see Colmenares 1975: 143–149; Williams 1999: 398. Illicit trade undoubtedly played a part in provisioning the Chocó.

24. Cauca merchants also requested that maritime commerce entering the San Juan River be prohibited, as they claimed that goods trafficked on the San Juan were illicit. Sharp points out that goods entering from outside (salt, wine, aguardiente, and flour) were sold at lower prices, undercutting Cauca merchants' profits, 1976: 40–41, citing ACC Sig. 8147 Col. J I-15 cv (1717).

25. McFarlane 1993: 92–93.

26. As Antonio de Arévalo wrote in a descripción of 31 March 1761, "Pero está prohibida con pena de la vida toda navegación por este río desde el golfo . . . aunque no obstante se ha hecho por él bastante comercio ilícito con los ingleses y holandeses que han sacado de él mucha utilidad," Cuervo 1892: 253.

27. See explanatory text in *Mapa e[t]nografico del país que ocupa el río Atrato [. . .]*, 1773?, AGMM Ar.J-T.7-C.3-100, which states that "navegación de aquel río está prohibido solo a los españoles y lo trafican los extranjeros a su salvo llevándose el cacao del Darién, carey, bálsamos, y maderas exquisitas."

28. See Sharp 1976: 61; see also Mosquera 2006: 62–65. For discussion on opening the river to commerce, see Caballero y Góngora (1789) in Colmenares 1989: 1:434–435.

29. Mesía de la Cerda (1772) in Colmenares 1989: 1:137; see also Mosquera 2006: 62–63.

30. Moreno y Escandón (1772) in Colmenares 1989:

1:178–180; see also AGN Caciques e Indios 38 D 42 (1784), fol. 278v.

31. Guirior (1776) in Colmenares 1989: 1:300.

32. Guirior (1776) in Colmenares 1989: 1:271–359; see also González Escobar 1996: 15; Peña-Ortega 2020: 86.

33. Donoso (1780) 1954a; see also Donoso (1780) 1954b: 227–233.

34. See Peña-Ortega 2020: 81–82; Rodríguez Hernández 2014a: 73. Points 1 through 28 on Donoso's 1780 map are elaborated upon in Donoso (1780) 1954a: 235–239.

35. Writing later in 1869, Saffray noted that given the abundance of hardwoods in the Chocó, the Indians and Africans of this province needed only an axe and a piragua to make a fortune, (1869) 1948: 335.

36. See Donoso (1780) 1954b, with numbered arguments on pages 227–233, and Peña-Ortega 2020: 81, 95 for summarized arguments. Donoso's reasoning is very similar to Arévalo's 1761 arguments for colonizing the area, see Arévalo (1761) in Cuervo 1892: 262–264.

37. Fisher 1981: 21–23. Fisher notes that, despite its name, there were many restrictions placed on this free trade and many of the ports that sought licenses were denied. See also Stein and Stein 2003, chaps. 3, 8. The Spanish Crown did open thirteen ports in Spain, granting them direct access to trade with America, see Fisher 1981: 22.

38. See Mumford 2012: 1; Lopera Mesa 2021. For studies on one aspect of reducción, resguardos, see González 1971; Herrera Ángel 1998.

39. Recopilación de leyes de los reynos de las Indias 1681, tomo 2, libro 6, titulo 3, leyes i–xxix, fols. 198–201.

40. Adelaar and Muysken 2004: 61–66. For the complex history of pacification efforts in the Darién and the Chocó, see Montoya Guzmán 2011, 2013; Rodríguez Hernández 2014a, 2014b, 2016; Vásquez Pino 2015; Williams 1999.

41. The Cuna language forms part of the Chibchan family, where Cuna constitutes a separate branch.

42. Montoya Guzmán 2013: 30.

43. See Weber 2008: 14.

44. Vásquez Pino 2015: 16. Gallup-Diaz refers to the Darién, or San Blas, Kuna as "Tule," 2008: introduction, chap. 1; Howe 1998.

45. Both northern and southern Cuna found it advantageous to ally with foreigners, including the French and English. Some of the southern Cuna forged alliances with the French and cohabitated with them, resulting in mestizo offspring, some of whom went on to become important Cuna caciques, see Gallup-Diaz 2008: chap. 7. By 1757, an estimated 170 Frenchmen were reportedly living dispersed between the Gulf of Urabá and the Punta de San Blas, see Arévalo in Cuervo 1892: 258.

46. The map, rendered across two sheets of paper, has a vertical seam that is visible at the map's center.

47. These Spanish names may reflect toponyms characterizing specific features of the local landscape. "Tigre" may refer to a jaguar, a creature endemic to the region.

"Tigre" in the native Cuna language was achú or parpáti, see Pinart 1890: 53.

48. See discussion in Tyner 1982: 141.

49. The 1753 map formed part of a report on the Atrato River by the Chocó governor Alfonso de Aronja (1751–1756) and has been attributed to Aronja, see Torres Lanzas 1906: 92, entry 151.

50. The spellings of river and pueblo names differ slightly from map to map.

51. The Map of the Atrato River and Pueblos of Cuna Indians appears on fol. 559v, AGN Caciques e Indios 58 D 19.

52. For the use of settled Indigenous populations in securing and defending under-fortified regions in the Spanish Empire, see Chipman and Joseph 2010: 14; Deeds 2003: 109; Nielsen 2019: 217–220.

53. See Gil Albarracín 2004, 2015.

54. The gloss accompanying the emblem notes it as the house of the vigía, yet the sketched emblem depicts a fortress.

55. See AGN Caciques e Indios 58 D 19 (1761), fol. 615r, as well as "Descripción superficial" 1983: 443–444. The first documented description of the Atrato vigía references a wooden fuerte, "fort," constructed at the site of Boyajá. In establishing this modest defensive structure, the Spanish hoped to ward off threats posed by the Dutch, corsairs, pirates, and Cuna Indians, AGN Caciques e Indios 17 D 16 (1740), fol. 903v. One of the events that precipitated a need for the Atrato vigía was the arrival, in 1736, of a Dutch vessel (balandra) manned by forty-five men. While ostensibly there to conduct trade, the vessel was nevertheless equipped with several cannons and several pedreros, AGN Caciques e Indios 17 D 16 (1740), fol. 911v. The unhealthy climate along the Boyajá, however, forced Spaniards to relocate the vigía to the Sucio River in 1746, AGN Caciques e Indios 61 D 6 (1730–1748), fols. 617v, 640r.

56. This inventory was taken on 1 March 1761, AGN Caciques e Indios 58 D 19, fol. 615r.

57. Palm fronds and branches (palmas y estacas) were common materials used in this region for defensive forts, see chart compiled by Rodríguez Hernández 2016: 222, cuadro 1, based on descriptions of Andrés Ariza.

58. Nielsen 2019: 232–234, 225–227. Building materials included 68,800 cubic feet (1,948 cubic meters) of masonry components.

59. In Ariza's words, they would need to "crear laboratorio de madera, texa, y ladrillos haciendo horno formal para estos últimos materiales, cosa nunca vista ni fabricada en esta provincia," AGN Caciques e Indios 34 D 12 (1 May 1778), fols. 323r–325v.

60. See Galindo Díaz and Henao Montoya 2017; see also Morales Pamplona 2005: 165–166.

61. Rodríguez Hernández 2016: 219; see also Moncada Maya 2011; Peña-Ortega 2020.

62. This rendering was submitted to the governor of Cartagena along with a letter dated 15 April 1761 from the expedition of Antonio de Arévalo, AGI Panama, 306.

For Arévalo's 31 March 1761 report, see Cuervo 1892: 251–273, specifically 267, 270–272; see also Galindo Díaz and Henao Montoya 2017: 57–59.

63. Arévalo in Cuervo 1892: 272. Construction on a greatly scaled-down version of the fort of San Carlos did ultimately begin in 1785 but was never completed, see Galindo Díaz and Henao Montoya 2017: 57–59. The fort had been abandoned and was destroyed in 1790 by order of the king under Viceroy Francisco Gil de Taboada y Lemos, see Morales Pamplona 2005: 165.

64. McNeill 2010: 138–139. As vital stops on the trade route, Cartagena and Havana were prioritized. Cartagena, ships' first stop in Spanish America from Spain, was strategic in protecting the Isthmus of Panama, where silver coming from the Andes passed from the Pacific to the Atlantic coast. Havana, meanwhile, was the final port of call for treasure ships headed back to Spain.

65. McNeill 2010: 139.

66. McNeill 2010: 138–139, 143–144.

67. See McNeill 2010: 138.

68. Galindo Díaz and Henao Montoya 2017: 59.

69. AGN Caciques e Indios 61 D 6, fols. 620v, 705v. There is mention of changing the vigía's location in 1747 (Caciques e Indios 61 D 6, fol. 713v) and again in 1752, but it appears to have remained near the mouth of the Sucio River until 1766, AGN Miscelánea 83 D 70 (Quibdó, 13 September 1752), fol. 636r–v.

70. AGN Miscelánea 39 141 D 28, fol. 326r–v. Aronja argued that the vigía was where it was because there was no more appropriate place for it to be; its location allowed the Spanish to control the entry of Cuna, French, and others, AGN Miscelánea 39 103 D 40 (Nóvita, 20 November 1756), fols. 897v–898r; see also fol. 892v.

71. AGN Miscelánea 39 103 D 40 (20 November 1756), fol. 898r. While Aronja claimed the round-trip journey from Murrí to the vigía and back took only eight days, the priest of Murrí, Luis de la Castellana, reported the trip required twelve days, AGN Miscelánea 39 141 D 28, fol. 326r–v.

72. AGN Miscelánea 39 141 D 28, fol. 326r–v. Episodes of Indian flight had been investigated during a visita in 1755. The records of this visita provide information about the specific arrangements for manning the guard post. Each month, six Indians were sent from Murrí to the vigía. Those who served as sentinels along the Atrato were absolved of tribute obligations and also were entitled to a wage, as mandated by the viceroy, AGN Miscelánea 39 103 D 40, fol. 901r.

73. AGN Miscelánea 39 141 D 28 (1756), fol. 322r; see also AGN Miscelánea 39 103 D 40 (1756), fols. 894r–895v.

74. On 16 April 1761, Francisco Martínez arrived to find only two poorly armed Murrí Indians standing guard. The four missing Murrí Indians had been sent by the new vigía captain, Diego de Soto, to labor for him elsewhere. Martínez emphasized that Murrí Indians assigned to guard the vigía must not be taken away from this important assignment, as such disorder would result in the complete ruin of the provinces, AGN Caciques e Indios 58 D 19, fols. 612r–614v. Martínez also recommended that fishermen and others in the area (*la gente manatiera*, *pescadora*, and *demás de este distrito*) stay nearby, traveling no farther than two cannon shots (*tiros de cañon*) away.

75. Mita labor supplied workers for various projects, from sewer maintenance to church building, see Lane forthcoming.

76. Roller 2014: chap. 2.

77. See letter to Viceroy Mesía de la Cerda from Chocó governor Nicolás Díaz de Perea, 6 July 1767, AGN Caciques e Indios 26 D 9, fol. 279v.

78. Herzog discusses the use of defensive posts as places of negotiation, 2015: 99–101. For other examples, see Barr 2007.

79. Cuna leaders traveled from their settlements in hopes of meeting with the highest-ranking official in the province. They waited, sometimes for weeks, for the governor to show up. Sixty Cuna (including captains from Banana, Caiman, Tarena, and Tigre) who sought reducción in what would become Murindo reportedly camped at the vigía for more than two weeks, AGN Caciques e Indios 58 D 19 (14 May 1758), fol. 497r.

80. By this time, the vigía had been relocated to Curbaradó, Vásquez Pino 2015: 28, citing AGN Caciques e Indios 6 D 5 (1767), fol. 71r. See plate 6 for both vigía locations.

81. See Colmenares 1989: 1:118.

82. Weber 2008: 11.

83. AGN Caciques e Indios 58 D 19 (1758–1764), fols. 435r–741v. Groot discusses some events from this case file but does not cite his source, 1869: 387–391. For documents mentioning Murindo, see Donoso (1780) 1954b: 210; "*Descripción de la provincia de Zitará y el curso del río Atrato* [. . .]," in Cuervo 1892: 317–318; and "*Descripción superficial*" 1983: 442.

84. For example, Bebará, Quibdó, and Murrí are mentioned in AGN Caciques e Indios 58 D 19, fol. 638r.

85. Martínez's letter suggests he did not have enough time to produce a cartographic sketch of the area: "Cuando bajé a la vigía a caneo con los indios Cuna Cunas y volví a subir, no me fue posible hacer el mapa de el río de Atrato que VE. me ordena en carta de 19 de abril del dicho año de [17]58 por haberlo traficado de día y de noche en ida y vuelta . . . a mi regreso a la provincia del Zitará haré junta y consulta de los vecinos aunque pocos o ningunos tienen conocimiento del río y con ella y el mapa de su estado que formaré junto con el reconocimiento de los manatieros que son los baquianos," AGN Caciques e Indios 58 D 19 (Nóvita, 6 February 1759), fol. 489r–v.

86. In Martínez's letter from Murindo dated 9 May 1761, he accused the manatieros of "*extorciones, inquietudes, y engaños*," AGN Caciques e Indios 58 D 19, fol. 616r.

87. For a discussion of native map informants in other

areas of the Spanish Empire, see Roller 2012: 101; Pratt 2008; Safier 2008, 2009.

88. For more on Spanish projections, see Bassi 2016: 92–93. Langfur, in discussing Brazil's Eastern Sertão, observed that colonists' hopes, expectations, fears, and ethnocentrism were more evident on maps than was topographical accuracy. The maps capture their creators' intention of possessing "graphically a territory that remained beyond their grasp physically," 2002: 232–233.

89. Howe 1998: 10–12; Gallup-Diaz 2008: chaps. 1, 2. One of the earliest raiders was Francis Drake, Howe 1998: 11–12. Foreign pirates were drawn to the northern shore of the Darién because it was close to the route of the silver fleets and to the ports of Portobelo and Cartagena. Here foreign interlopers could provision themselves with sea turtle and manatee, take cover on islands and in coves, and befriend native inhabitants, who served as guides and allies, Howe 1998: 11. See also Dampier 1729; Wafer 1729.

90. Gallup-Diaz 2008: chap. 1.

91. AGN Caciques e Indios 58 D 19, fol. 651r–v.

92. Stories of Indian willingness to assume Spanish lifeways must be taken with a grain of salt. There were short-term benefits for Indians—Spanish gifts of food, clothing, tools—and, when advantages dwindled, the Indians often abandoned reducciones.

93. See AGN Caciques e Indios 58 D 19, fols. 723r–726v.

94. For early and unsuccessful efforts to conquer and settle the Indigenous in the Chocó and the Darién, see Montoya Guzmán 2011: 14; Rodríguez Hernández 2014a: 63n12. For similar challenges in settling Indigenous groups in mid-eighteenth-century Brazil, see Erbig 2020: 58–65, especially 62–63, table 2.

95. It was not uncommon for reduced Indians to resist reducción, voting with their feet and returning to their scattered dwellings, see Lopera Mesa 2021: 79. For short-lived reducciones in Río de la Plata, 1623–1750, see Erbig 2020: 62–63, table 2.

96. AGN Caciques e Indios 58 D 19, fols. 439r–440r; see also fol. 497r. The Cuna waited at the vigía for about five days while Martínez was summoned, fol. 449r. This Cuna entourage of roughly sixty individuals was led by a mulato man from the Canary Islands named Marcos de la Peña. I have found meager information on de la Peña, but the emigration of Canary Islanders to Spanish South America is discussed in Hernández González 1996; Morales Padrón 1952; Navarro Azcue 1992; and Parsons 1983.

97. AGN Caciques e Indios 58 D 19, fols. 439r–440r, 497r, 502v.

98. The Cuna "gustosamente pagarían el tributo a su majestad lo cual les sería fácil hacer con vender una amaca de las de algodón que tienen al modo de las mantas del reino," AGN Caciques e Indios 58 D 19, fol. 486r.

99. For this document, see AGN Caciques e Indios 58 D 19 (1758), fols. 453r–457v. Stipulations were: (1) The governor (Martínez) would lay out where the pueblo

was to be established as well as where areas of work and cultivation would be located. The town would not be north of the vigía (to the right of it on the map), as the Indians wished, but south of it, more or less one day's journey away. The place where the Indians wanted to establish their village would not be chosen because it was not viewed by the Spanish as secure. Martínez also noted that the selected siting, near the Murindo River, was preferred as it was more conducive to growing grains (granos) and fruit (frutos) and was better for fishing and hunting. Traffic north of the vigía (toward the gulf) was not permitted. (2) After the town and the cultivation areas were established, a priest (cura) would be put in place under the governor's direction. (3) Captain Marcos de la Peña would reside in the pueblo with these Indians, tasked with teaching and instructing them in the customs and lifeways of the Spanish and other related things in service of God and king. (4) Martínez would govern the Indians with love and charity, but everything else would depend on the good will of the viceroy. Here, Martínez asked that he be granted more time to govern than the amount he had been allotted. If extra time was not granted, Martínez would offer whatever help and support he could of his own. (5) The cacique and captains who had obtained titles and staffs (bastones) from the French would relinquish them. The only valid titles would be those bestowed by Martínez, who named Marcos Tarena cacique, Baltasar and Vicente captains, etc. (6) The named cacique, captains, and alcaldes were obligated to bring other Cuna to Murindo, but only those Cuna who would come willingly and not by force. (7) The six children (parvulos) who came to the vigía would be baptized; the adults would be instructed in the mysteries of the faith. (8) Marcos de la Peña, along with two Indians of his choosing, would remain in the reducción while the captains and other Cuna returned to their lands to gather their things and other Indians to incorporate into the new pueblo. (9) Once everyone was settled, all would have to agree to "las chinas cunacuna" (female Cuna Indians) marrying "los indios chocoes" (male Chocó Indians) and "las indias chocoes" marrying "los indios cunacuna," which would help ensure the peace. (10) All must be taught Christian doctrine.

100. Ignacio Gallup-Diaz convincingly argues that caciques were not part of Cuna society but instead had been created through a process of interaction and negotiation between Spanish and Cuna, see Gallup-Diaz 2008: chap. 2; see also Williams 1999: 408.

101. AGN Caciques e Indios 58 D 19, fol. 677v.

102. AGN Caciques e Indios 58 D 19, fol. 542r. Other documents in the case file note that de la Peña had lived with the Cuna for forty years, see, e.g., AGN Caciques e Indios 58 D 19, fol. 452v.

103. AGN Caciques e Indios 58 D 19, fol. 452v.

104. AGN Caciques e Indios 58 D 19, fol. 454r–v.

105. Erbig 2020: 67–69.

106. Erbig 2020: 64, 67–69; 2016: 458; see also Adelman and Aron 1999: 831.

107. For northern Cuna, see Gallup-Diaz 2008: chap. 2. The Cuna stated that they feared the Chocó Indians, with whom they were always at war, Maraver Ponce de León to the viceroy, 30 September 1761, received in Santa Fé on 27 November 1761, AGN Caciques e Indios 58 D 19, fols. 710v–711r.

108. See Maraver Ponce de León to the viceroy, 30 September 1761, AGN Caciques e Indios 58 D 19, fols. 710v–711r.

109. AGN Caciques e Indios 6 D 5 (1752), fol. 41v. Vásquez Pino discusses other reasons for Martínez's expedition into Cuna territory, 2015: 25.

110. Vásquez Pino 2015: 23.

111. AGN Caciques e Indios 6 D 5 (1752), fol. 38v.

112. When asked why they had not sought reducción when they first met Martínez in 1752, the Cuna responded that the French, who lived with them, warned them that if they did, they would be no more than slaves to the Spanish, that they would be whipped to death, *"los habían de matar a puro rigor de azote."* At the time, the Cuna figured it would be better to live among the French, who had given their leaders staffs of authority (*bastones*) and had allowed them to live as they wished, not having to pray and free to marry as many women as they wanted, AGN Caciques e Indios 58 D 19 (1758), fol. 451r.

113. AGN Caciques e Indios 58 D 19, fol. 453r. While most documents discuss the prohibition of traffic on the Atrato, it seems that, given the frequency of travel between Quibdó, Murrí, and the vigía, travel on some parts of the Atrato was tacitly permitted. Most restrictions occurred on the lower Atrato, closer to the gulf, see Cantor 1999: 68; Boyd-Bowman and Sharp 1981: 6.

114. AGN Caciques e Indios 58 D 19, fol. 453r.

115. AGN Caciques e Indios 58 D 19, fol. 453v.

116. For similar, earlier strategies, see Gallup-Diaz 2008: chap. 1.

117. The northern Cuna had made a habit of attacking sentinels from Spanish pueblos, meaning that those inhabiting settlements near tributaries of the Atrato—Murrí, Bojayá, Jiguamiandó—lived in danger, Vásquez Pino 2015: 30; see also AGN Milicias y Marinas 118 2 (1770), fol. 4r.

118. AGN Caciques e Indios 58 D 19, fol. 586r; see also 604r, 631v. For *amojonamiento*, "boundary marking," in eighteenth-century Santa Marta, see Muñoz Arbeláez 2007.

119. AGN Caciques e Indios 58 D 19, fols. 596r–605v.

120. AGN Caciques e Indios 58 D 19, fol. 639v.

121. AGN Caciques e Indios 58 D 19, fols. 597r, 639v.

122. Gallup-Diaz 2008: chap. 3; see also Vásquez Pino 2015: 18. Erbig writes of gift exchanges in Río de la Plata, noting that the Portuguese would upstage the bribes of the Spanish, offering cattle as opposed to the Spanish-supplied tobacco and yerba mate, 2016: 445–446.

123. AGN Caciques e Indios 58 D 19, fol. 606r.

124. AGN Caciques e Indios 58 D 19 (3 February 1761), fol. 704r–v.

125. AGN Caciques e Indios 58 D 19, fol. 616r.

126. AGN Caciques e Indios 58 D 19, fols. 590r–592r (and again on fols. 634r–636r). The cacique of Murindo was documented as don Marcos Tarena, where "Tarena" referred to the name of his village. It is possible that Martínez met this Cuna leader in Tarena during his 1752 visit.

127. AGN Caciques e Indios 58 D 19, fol. 590r and again on fol. 634r–v.

128. AGN Caciques e Indios 58 D 19, fol. 598r–v.

129. AGN Caciques e Indios 58 D 19, fol. 598r. News of the triumph of this reducción had already spread, prompting a leader of Cacarica—the Cuna enclave labeled with a number 1 on the map—to journey to the vigía to entreat Martínez for a reducción where he might settle his people according to the tenets of Catholicism, transforming them into faithful subjects of the Catholic monarch, AGN Caciques e Indios 58 D 19 (29 October 1760), fol. 606r–v.

130. AGN Caciques e Indios 58 D 19 (3 February 1761), fols. 698r, 701r–704v.

131. AGN Caciques e Indios 58 D 19, fol. 706r. In highlighting the tenuous nature of this new reducción, Martínez may have been seeking avenues to extend his term length as governor of the Chocó.

132. According to Maraver Ponce de León, the Cuna sought reducción in order to be baptized, become vassals of the king, and free themselves of the oppression and tyranny of the French, who had entered their lands, AGN Caciques e Indios 58 D 19, fol. 709v.

133. AGN Caciques e Indios 58 D 19, fols. 710v–711r. Gallup-Diaz notes that a similar affection between Julián Carrisoli and Tule (Cuna) Indians had facilitated their earlier reducción, 2008: chap. 2.

134. Maraver Ponce de León to the viceroy, 24 February 1763, AGN Caciques e Indios 58 D 19, fols. 723r–725r.

135. Martínez alludes to this in his letter of 3 February 1761, AGN Caciques e Indios 58 D 19, fols. 705v–706r.

136. AGN Caciques e Indios 58 D 19, fols. 717r–722v. These testimonies date from 8 February to 1 March 1763.

137. AGN Caciques e Indios 58 D 19, fol. 721v.

138. AGN Caciques e Indios 58 D 19, fol. 718v.

139. Maraver Ponce de León, report to the viceroy, 24 February 1763, AGN Caciques e Indios 58 D 19, fols. 723r–724v.

140. AGN Caciques e Indios 58 D 19, fol. 724r–v.

141. In Maraver Ponce de León's words, "No hubiera sido muy posible hallar alguna que quisiera sujetarse a vivir en tal retiro expuesto entre unos indios barbaros a los accidentes que se dejan conocer," AGN Caciques e Indios 58 D 19, fol. 724r–v.

142. AGN Caciques e Indios 58 D 19, fols. 696v, 710r.

143. AGN Caciques e Indios 58 D 19 (3 August 1763), fol. 725v.

144. AGN Caciques e Indios 58 D 19, fols. 726r–728r.

145. This may have been the same cacique of Tarena with whom Martínez negotiated the original terms of

Murindo's settlement, AGN Caciques e Indios 58 D 19, fol. 728r.

146. AGN Caciques e Indios 58 D 19, fol. 728v.

147. "Drogas" is translated as "aromatics or spices," see *Real Academia Española A 1732: s.v. "drogas."*

148. AGN Caciques e Indios 58 D 19 (22 June 1764), fol. 729r.

149. AGN Caciques e Indios 58 D 19, fols. 729r–730v.

150. This is discussed in a letter from Nicolás Díaz de Perea to Viceroy Mesía de la Cerda, Nóvita, 1 November 1764, AGN Caciques e Indios 58 D 19, fol. 734v.

151. AGN Caciques e Indios 58 D 19 (November 1764), fols. 739v–741v.

152. However, Murindo is mentioned in a 1767 document that discusses Cuna Indians in Murindo as the target of a thwarted attack by Caledonian Indians, AGN Caciques e Indios 26 D 9, fols. 277r–280r.

153. Antonio de Arévalo, *Mapa intelectual o idea formada de lo que es el río del Darién o Atrato* [. . .], 1781, AGI MP-Panama, 196. For this map, visit http://pares.mcu.es/ParesBusquedas20/catalogo/show/22249?nm.

154. Governor Nicolás Díaz de Perea to Viceroy Pedro Mesía de la Cerda, Nóvita, 19 February 1766, AGN Miscelánea 39 107 D 23, fols. 801r–804r. The vigía remained at Curbaradó until at least 1784, AGN Visitas Cauca 62 5 D 3 (9 July 1784), fol. 309r.

155. AGN Miscelánea 39 107 D 23 (19 February 1766), fols. 801r–v, 804r. The few survivors credited the canoe they hid in, from which they had earlier been hunting manatee, fol. 802v; Vásquez Pino 2015: 31n15.

156. Vásquez Pino 2015: 31n15; AGN Miscelánea 39 107 D 23 (19 February 1766), fol. 802r–v.

157. See Ortega Ricaurte 1954: 199–200.

158. AGN Miscelánea 39 107 D 23 (19 February 1766), fol. 801r.

159. In Díaz de Perea's words, "Yo me sacrificaría gustosamente por el rey y por mi honor, pero aquí no hay fuerza ni gente, ni armas para sostener ni defender ningún imperio," AGN Miscelánea 39 107 D 23 (19 February 1766), fol. 801r–v. For a similar example in Río de la Plata, see Erbig, who writes of the ill-equipped Spanish outpost Batoví, on the border with Brazil, that had only one overseer and six workers, 2020: 82–83.

160. AGN Miscelánea 39 107 D 23 (19 February 1766), fol. 801v.

161. "La vigía es de tan débil construcción como lo puede ser uno de los pobres tambos de los indios. El capitán . . . , aunque soldado veterano, . . . no puede sin embargo oponer la menor defensa a los inscritos de incendios, muertes y robos, que han solido ejecutar en este paraje los infieles enemigos cunas . . . , pues si se atiende al terreno se advierte sumamente bajo y encerrado, entre materias las más combustibles, cual es la paja y palma tan fácil de incendiarse como lo es el tirarle una sola flecha encendida; las armas son unos siete u ocho fusiles, de los cuales apenas suelen estar corrientes la mitad," *"Descripción superficial"* 1983: 443–444.

162. "Los indios enemigos Cunacuna en la presente luna, venían armados y dispuestos a atacar y quemar la vigía de San Nicolás de Curbaradó del río de Atrato, modernamente construido por mí [Díaz de Perea] y después de esta acción, pasarían al pueblo de San Bartolomé de Murindo a matar aquellos indios, sus paisanos," AGN Caciques e Indios 26 D 9 (20 May 1767), fol. 278r.

163. Díaz de Perea to Viceroy Mesía de la Cerda, Nóvita, 6 July 1767, AGN Caciques e Indios 26 D 9, fol. 279v.

164. "Dos negros" may refer to free men hired to stand guard, but the document is not clear on this point, Ignacio Renteria and Matthias Gutiérrez to Viceroy Mesía de la Cerda, 26 May 1771, AGN Miscelánea 39 141 D 43, fol. 386r–v.

165. "Dos papeles escritos con carbón de mano del dicho cabo Calderon los que a la letra dicen así = no permiten que los indios que fueron a la vigía se quedan por que (los) matan, bien golpeado . . . Calderon = Otro = uno murió o fue pozo o fue el sr cabo = hoy miércoles 1776 = Otro = Calderon va vivo y dicen que vuelven con el fin =," AGN Caciques e Indios 50 D 11, fols. 346v–347r.

166. AGN Caciques e Indios 50 D 11, fol. 347r.

167. AGN Caciques e Indios 50 D 11 (20 April 1776), fol. 348r.

168. "La vigía del Atrato distingue en su misma articulación el motivo de su establecimiento y fin a que se dirige. El paraje en que hoy se halla situado no admite norma alguna de defensa y, lo que es más, resiste o contradice en cierto modo el objeto de su destino . . . ," AGN Caciques e Indios 50 D 11, fol. 352r–v.

169. AGN Caciques e Indios 50 D 11, fol. 352v.

170. The vigía was still being habitually abandoned by Indians from Murrí, who fled each time the rebellious Cuna came, afraid of their rifles. In a letter to Viceroy Manuel Antonio Flores dated 26 November 1776 from Nóvita, Governor Clasens wrote, "Es el paraje más alto y ventajoso y que en las circunstancias en que se halla hoy la vigía no hay sitio más aparente . . . particularmente si se refuerza la guarda con gente libre, quitando o excluyendo los indios de Murrí," AGN Caciques e Indios 50 D 11, fol. 382r. Like his predecessor, Clasens blamed the vigía problems on the Murrí Indians, who had long been tasked to stand guard but to little effect. Under their watch, Clasens argued, there had been no defense, fol. 392r–v.

171. In Clasens's words, the guards should be people "como mulatos, zambos, tan agiles y diestros en el río, como aquellos, fieles en sumo grado al rey y a la patria y aventajados en ánimo y valor," AGN Caciques e Indios 50 D 11, fol. 392v.

172. Governor Clasens to Viceroy Flores, 12 November 1776 (reviewed 7 January 1777), AGN Caciques e Indios 50 D 11, fol. 392v. This same belief had been voiced earlier by Chocó governor Maraver Ponce de León, who, in a letter to Viceroy Pedro Mesía de la Cerda, noted that a guard of six Indians was insufficient for the defense that was needed, 30 September

1761 (reviewed in Santa Fé 27 November 1761), AGN Caciques e Indios 58 D 19, fol. 711r. Another problem plagued the vigía. Two very critical positions—corregidor of Murrí and captain of the vigía—had long been the purview of a single person. When wearing the cap of corregidor, said person was forced to abandon the duties of vigía captain. On the other hand, if undertaking duties of vigía captain, that same individual could not fulfill the many obligations of corregidor. These self-evident truths, therefore, made these two posts incompatible. Because, Clasens noted, the trip from the vigía at Curbaradó south to Murrí required three days of travel upriver (*río arriba*), there was nothing a person—as corregidor or as captain—could do if they found themselves in Murrí when the Cuna attacked the vigía, AGN Caciques e Indios 50 D 11, fols. 392v–393r.

173. The viceroy had wanted the vigía guards to commit to two years, but no one was willing to do so, see letter from Francisco Antonio Romero to Clasens, 17 June 1777, AGN Caciques e Indios 50 D 11, fol. 408r.

174. See contracts, AGN Caciques e Indios 50 D 11, fols. 402r, 404r, 405r, 406r, 407r, 409r. All were from the bishopric of Popayán.

175. AGN Caciques e Indios 50 D 11, fol. 410v. The contracts of these six free men are of interest for their descriptive contents: they preserve the names, ages, names of parents, and affiliated towns of the new vigía watchmen. Also recorded are meticulous physical descriptions for each individual, including color of skin, hair, and eyes, and any visible markings, scars, or injuries. Faces are described as either long or round, and some men are noted as *barbilampiño*, "beardless." AGN Caciques e Indios 50 D 11, fols. 402r, 404r, 405r, 406r, 407r, 409r.

176. Gallup-Diaz 2008: chap. 1. The Cuna, like the Indigenous living in Brazil's Eastern Sertão, kept the "territorial ambitions of colonial society in check," see Langfur 2002: 223 on the Indigenous in the Eastern Sertão.

177. Gallup-Diaz 2008: chap. 1; Bassi 2016: 86.

Chapter 4: The Map of the Chocó, Panama, and Cupica

1. The map, AGN M4, Ref. 136A, pertains to the case file AGN Aduanas 2 2 D 17 (1777–1791), fols. 470r–716v; it appears on fol. 617.

2. At this time, Panama was a province within the viceroyalty of New Granada.

3. I will refer to the location marked 37 as "Panama" throughout this chapter since that is how it is most often discussed in the documents.

4. The Spanish Crown's inability to control illicit trade and contraband led to the prohibition of travel and commerce on the lower Atrato River from 1698 to 1784. These restrictions impacted those living in the Chocó who depended on the Atrato for supplies brought into the region from outside areas. See discussion in chapter 3.

5. This map was published in González Escobar 1996: 5, map 4, and in Fuentes Crispín 2015: 92, map 24.

6. Sharp 1976: 17n25.

7. Cupica appears on maps as early as 1779, see AGI MP-Panama, 193. A 1782 map by Andrés de Ariza identifies the *nuevo puerto de Cupica*, see AGI MP-Panama, 250.

8. For approximate travel times, indicated by delivery times of correspondence, see a letter sent from Cupica on 28 January 1792, received in Santa Fé on 24 April 1792, AGN Fábrica Iglesias 26 13 D 17, fol. 656r–v, and a letter sent from Beté on 15 February 1783, received in Santa Fé on 2 May 1783, AGN Aduanas 2 2 D 17, fol. 618r.

9. As the Cupica corregidor José Fernández put it, "El lugar más inmediato al dicho Cupica es la ciudad de Panamá que haciendo brisas se arriba costa a costa en menos de seis días," AGN Aduanas 2 2 D 17 (15 January 1791), fol. 687v. For distance to Quibdó, see AGN Poblaciones Cauca 46 2 D 12 (1793), fol. 325r. Cupica was understood to be part of the province of Zitará within the gobernación of the Chocó. This is most clearly stated by the bishop of Panama, who in 1782 noted that Cupica fell within not his diocese but that of Popayán, which was part of the Chocó, AGN Aduanas 2 2 D 17, fol. 537r–v.

10. In addition to Panama, these included Guayaquil, in today's Ecuador, and Callao, Peru's port.

11. See Cooke 1998: 91, 103–104.

12. Bray 1984: 329–330; see also Pearson's discussion of littoral societies, 2006. Richard Cooke argues that the political (and geographically artificial) frontier between Panama and Colombia resulted from the desire of a nascent foreign power (Spain) to make its mark in the world. In pre-Hispanic times, the "inhospitable" and "marginal" department of the Chocó was not a frontier, Cooke 1998: 104.

13. For example, see a 1782 inventory listing church bells, AGN Aduanas 2 2 D 17, fol. 546v.

14. Colombia's Pacific ties to Panama, Peru, and the Caribbean, discussed in Leal 2018: 24, appear to have been in place in the pre-Hispanic period.

15. Cupica appears on maps of seventeenth-century Spanish navigators and English buccaneers, identified as Puerto Quemado. See, for example, William Hacke's chart 71 in the atlas "An Accurate Description of All the Harbours, Rivers, Ports, Islands . . . in the South Sea of America . . . ," dated after 1698, housed at the John Carter Brown Library, accession no. 66-304.

16. The idea of bridging the Pacific and the Atlantic began in the sixteenth century, driven by the need to move Peruvian silver and Colombian gold from the Pacific coast to ships in the Atlantic. What began as a search for a natural fluvial passage shifted to the creation of an artificial one, Keiner 2020: 18; Suárez Pinzón 2011.

17. See Keiner 2020: 20, citing Humboldt. In Humboldt's view, Cupica was the most opportune siting,

after the isthmus of Nicaragua, Keiner 2020: 21, citing Humboldt and Bonpland 1966: 245.

18. Caldas 1942: 276–277.

19. Friend 1853: 195. For evidence of this same trade in the late Spanish colonial period, see AGN Aduanas 2 2 D 17 (15 January 1791), fols. 687v–688r; AGN Fábrica Iglesias 26 13 D 17, fol. 656v.

20. See González Escobar 1996: 57. The French explorer and diplomat Gaspard-Théodore Mollien noted that, at the time of his travels in 1823, the most frequented Pacific ports were Iscuandé, El Varo, Buenaventura, Chirambirá, and Cupica. By this time, all commerce was undertaken along the Atrato, Mollien (1823) 1944: 308. The French doctor and explorer Charles Saffray, citing Humboldt, also mentioned an interoceanic route using Cupica but observed that because the upper Napipi was lamentably similar to the Dagua—a shallow torrent with a swift current, obstructed by rocks, and a place where one could not navigate piraguas—he did not see possibilities for a canal using the Napipi between the Atrato and the bay of Cupica, Saffray (1869) 1948: 338–339.

21. Boussingault 1985: 421–422.

22. Barona et al. 2002: 72. John C. Trautwine, in his detailed and beautifully illustrated volume on the subject, confessed that while he viewed the notion of an interoceanic canal for ship traffic to be a "quixotic conception," he hoped that, if proven viable, it might be realized with time, 1854: 18. See also Carvajal 1910.

23. See Barco Isakson 2017: 20. Robert Cushman Murphy noted that, in the bay of Cupica, more than anywhere else, the idea of an Atrato-Pacific ship canal at least approached the realm of reality, 1939: 9.

24. Dávila Murillo 2020. It was hoped that an interoceanic waterway accessed by ferry would internationalize the Colombian economy and aid in developing the Chocó and the northwest part of the country, Barco Isakson 2017: 20.

25. Cupica has been the site of a dramatic building project in this century, though. After a 1999 avalanche caused major destruction there, the town's 1,650 inhabitants were relocated in 2005 to a new settlement that reportedly has 235 houses (concrete structures), electricity, running water, a sewage system, and a medical clinic, as well as a wooden path that extends 2,850 feet (870 meters) toward the beach, see "Colombia: Habitantes de bahía Cupica llegan a su tierra promedita," 5 August 2005, ReliefWeb, https://reliefweb.int/report/colombia/colombia-habitantes-de-bahia-cupica-llegan-su-tierra-promedita. Today, a ramshackle tugboat, the *Bahía Cupica*, connects the town to the bustling port of Buenaventura, ferrying provisions and building materials between the two. The twenty-five-hour trip costs the occasional passenger 150,000 Colombian pesos (about 30 dollars), making it more affordable than flying and more reliable than traveling by road. Even so, weather can delay departure and complicate the journey, see Griffin 2017.

26. Donoso (1780) 1954b: 225; for Donoso's full report, see 203–241. The map that accompanied this report is *Plano del curso del río Atrato: Desde la quebrada de Yrachorra donde nace hasta su boca en el Golfo del Darién* (1780), AGMM-COL-11/10, and it is discussed in Rodríguez Hernández 2014a: 73.

27. Caballero y Góngora (1789) in Colmenares 1989: 1:456. See also Mosquera 2006: 65–66.

28. White squares identify Murrí, Bebará, Quibdó, and Lloró as Spanish settlements (pueblos) on the map. Murindo lacks a square, indicating it is merely a stop and no longer a settlement.

29. On this map, the vigía is located at Curbaradó (9), where it was moved from the Sucio River (6) in 1766.

30. The number 32 appears on the map, but its corresponding legend text is no longer extant.

31. For the dangers that unconquered Cuna presented to Spanish in the Chocó, see chapter 3.

32. See Archivo General de Indias, MP-Panama, 309.

33. The final clause of Ariza's explanatory map text is "pero hay el inconveniente de los indios Cunas."

34. The only Spanish colonial description we have of Cupica's bay was appended to a list of inhabitants (tribute payers and free people) dated 14 June 1782. As opposed to the port of Buenaventura, which is repeatedly discussed in archival documents as oppressively humid, Cupica's climate was described as temperate and healthy. The land was reportedly fertile, enabling the cultivation of plantains, corn, cacao, sugar cane, and fruit native to the area. The land was also conducive to raising livestock. Meanwhile, Cupica's coastal coves and rivers provided abundant fish and wild game, AGN Aduanas 2 2 D 17, fol. 584v.

35. AGN Aduanas 2 2 D 17, fol. 488r. *La Deseada* was the subject of years of litigation as its captain, Pedro Guillem, had tried to enter Cupica without paying the import tax (*real derecho de almojarifazgo*), fol. 493r.

36. See 1779 inventory, AGN Aduanas 2 2 D 17, fols. 491r–492v.

37. AGN Aduanas 2 2 D 17 (1782), fol. 546v; AGN Fábrica Iglesias 26 13 D 17 (1793), fol. 672r.

38. See inventory, 15 January 1791, AGN Aduanas 2 2 D 17, fols. 687v–688r.

39. Letter from Fernández to the viceroy, 18 July 1791, AGN Poblaciones Cauca 46 2 D 12, fol. 314v. For Guillem as a vecino of Panama, see AGN Aduanas 2 2 D 17, fol. 575r.

40. While trade between Cupica and Panama is documented in these case files, trade with other Pacific ports, such as Guayaquil, is only suggested. For mention of commerce with the Darién, see AGN Poblaciones Cauca 46 2 D 8 (1807), fol. 208r. For cargos arriving to Cupica from Tumaco, see AGN Aduanas 2 2 D 17 (3 January 1783), fol. 610v. For other ports, see AGN Aduanas 2 2 D 17, fols. 669v, 673v; AGN Poblaciones Cauca 46 2 D 12, fol. 326r. Permission to trade with Guayaquil was granted in

1793, AGN Poblaciones Cauca 46 2 D 12, fol. 326r.

41. AGN Fábrica Iglesias 26 13 D 17 (10 October 1793), fol. 691v. The importation of wine was forbidden by law, but records show that wine from Peru came into Cupica on a large vessel headed to Nóvita at least once, AGN Aduanas 2 2 D 17, fols. 481r–482r. The contents of this vessel were noted as so copious they could have filled thirty-two canoes. In discussing smuggling in seventeenth-century Santo Domingo, Ponce Vázquez found that illicit behavior was something social actors ascribed to people who were either their social or ethnic inferior or their social or political rival, 2020: 18.

42. AGN Aduanas 2 2 D 17, fol. 650r.

43. In reconstructing the late Spanish colonial history of Cupica, I have drawn from the principal case file to which the map pertains, AGN Aduanas 2 2 D 17 (1777–1791), fols. 470r–716v, as well as from AGN Poblaciones Cauca 46 2 D 12 (1790–1806); AGN Poblaciones Cauca 46 2 D 8 (1806–1808); AGN Fábrica Iglesias 26 13 D 17 (1792–1808); AGN Curas y Obispos 21 47 D 11 (1797); AGN Correos Cundinamarca 18 2 D 9 (1806); and AGN Historia Eclesiástica 30 6 D 12 (1808). I have also consulted eighteenth-century and early nineteenth-century manuscript maps, including AGI MP-Panama, 193 (1779); AGI MP-Panama, 250 (1782); AGN M4, Ref. 140A (1793; figure 4.5); AGI MP-Panama, 309 (1807; plate 8); AGN M4, Ref. 137A (1830); and AGN M4, Ref. 066A (1834).

44. See "Descripción de la provincia de Zitará [. . .]," in Cuervo 1892: 306–324, no. 25, where Alarcón is noted as mining with enslaved laborers near Negua, and no. 53, where Alarcón is documented as having plantain groves near the Bue River.

45. The text reads "Lorenzo Alarcón en carta de 15 de 1º de 83 de Beté," indicating Lorenzo Alarcón made this map on 15 January 1783. It is not clear who Lorenzo Alarcón was or what his relationship to Lucas de Alarcón was. Lucas had at least one brother, Josef, who is mentioned in the case file, see Aduanas 2 2 D 17, fol. 495v.

46. AGN Aduanas 2 2 D 17 (26 December 1776), fol. 510r. For additional information on Cupica at this time, see BNC RM 324, pieza 4 (1777), fols. 160–251.

47. AGN Aduanas 2 2 D 17 (26 December 1776), fol. 510r.

48. AGN Aduanas 2 2 D 17 (23 July 1776), fol. 504r. An *auto*, "decision," signed 1 September 1777 in Santa Fé by Nicolás Prieto Dávila, permitted trade (*franquicia de comercio*) between Panama and the Chocó by way of Cupica, fol. 505r.

49. Letter from Nicolás Prieto Dávila, 23 July 1777, AGN Aduanas 2 2 D 17, fol. 504r–v; see also fol. 486r.

50. Thirty of these hundred Indians were designated as tribute payers.

51. AGN Aduanas 2 2 D 17 (19 February 1780), fols. 511v–512r.

52. The church, whose roof was made of straw, was described in a different document as functional (*bastante capáz*) but lacking in the corresponding decency it required (*sin la correspondiente decencia que se require*), AGN Aduanas 2 2 D 17, fol. 523v.

53. Aduanas 2 2 D 17, fols. 582v–584r.

54. See AGN Aduanas 2 2 D 17, fol. 664v–665r, where Alarcón reported, "Debo hacer presente la justificación de VE que la fundación de este pueblo y su comercio franco con la gobernación de Panamá no fue bien admitida por el teniente de Zitara (Juan Antonio de Olea) ni por los mercaderes de Cartago, Buga, y Cali a causa de considerar se les disminuía su comercio con las provincias del Chocó las que precisamente habían de abastecen a precios más cómodos con el franco de Panamá y Guayaquil cuyo supuesto no necesita más prueba que la misma razón natural bajo el cual no es de extrañar que aplicasen todo su esfuerzo a impedir dicho comercio franco para quedar en posición de sus presentes y futuras utilidades las que seguramente afianzaban con la demolición del nuevo pueblo de Cupica sin el cual no puede subsistir el referido comercio franco con Panamá." The letter is undated but was written on *papel sellado* (a type of official paper that is stamped with a coat of arms, year, and stamp class) corresponding to 1784, 1785, and 1786.

55. AGN Aduanas 2 2 D 17 (3 January 1783), fols. 610r–611v.

56. See undated letter from Alarcón to the viceroy, fols. 662r–673v, especially fol. 670v.

57. AGN Aduanas 2 2 D 17, fol. 671v.

58. See undated letter from Alarcón to viceroy, AGN Aduanas 2 2 D 17, fols. 662r–673v, especially fols. 662v–664v; for Guayaquil, see fol. 669v. This letter is undated, but documents following it are dated 31 July 1786, fols. 673v–674r. Here, the *fiscal* (legal representative; prosecutor) noted, "Aunque por los documentos que acompaña Lucas de Alarcón se convence el beneficio que resulta a las provincias del Chocó y al comercio de Panamá, y Guayaquil con la fundación del puerto de Cupica que en él hay casi 200 moradores de ambos sexos, casas, iglesia con algunos paramentos, frutos, aves, y crías de ganados."

59. "El nuevo pueblo de Cupica sea de suma importancia para el comercio de aquella provincia y Guayaquil con la de Citará y sus pueblos por el beneficio que reciben los unos en la pronta salida de sus efectos y los otros en abastecerse de lo necesario con mucha mayor comodidad que antes como que los mercaderes ahorran mucho camino transitando por Cupica," AGN Aduanas 2 2 D 17, fol. 669v.

60. AGN Aduanas 2 2 D 17, fol. 671r–v. Around this time, Donoso was surveying the region and was involved in the construction of the fort of San Carlos at Bocachica (labeled 19 in the bottom half of Alarcón's map). In this enterprise, Donoso was capitalizing on timber exported from Cupica. To Donoso's knowledge, there was no better port on the Pacific for the procuring and transport

of such excellent wood, AGN Aduanas 2 2 D 17 (20 June 1785), fols. 656r–657r. Correspondence between Alarcón and Donoso suggests the two men were on good terms, for example, AGN Aduanas 2 2 D 17 (no date), fol. 671r–v.

61. In the bishop's words, "Que es lo mismo que desnudar a un santo para vestir a otro," AGN Aduanas 2 2 D 17 (17 November 1782), fol. 595v. A letter of 3 July 1782 from Beté's *cura* (priest), Francisco Zea, noted that most of those in Cupica's population were Indians whom Alarcón brought from Beté "con el pretexto de adelantar aquella nueva población," fol. 598r. The bishop's claims were repeated by the new corregidor of Beté and Bebará, Luis Díaz de Pizarro, who blamed Alarcón for the decrepit state of Beté and its diminished number of inhabitants, AGN Aduanas 2 2 D 17 (7 April 1783), fols. 619v–620r. This relocation of Indians from Beté to Cupica is also mentioned in the undated "Descripción superficial" 1983: 438.

62. See letter from Santa Fé (23 July 1777), AGN Aduanas 2 2 D 17, fol. 504r. Other (undated) correspondence emphasized that populating Cupica with Indigenous inhabitants was, at that time, secondary. Of primary importance was establishing trade between Panama and the Chocó, AGN Aduanas 2 2 D 17, fol. 486r.

63. "Nearest" is a relative term, as Beté was more than eight days from Cupica. AGN Aduanas 2 2 D 17, fol. 687v.

64. AGN Aduanas 2 2 D 17 (1782), fols. 582v–584r. Seven gente libre were also noted as living in Cupica.

65. AGN Aduanas 2 2 D 17, fols. 664v–673v. This comes from the same letter to the viceroy without a date cited in n. 58.

66. See Barona et al. 2002: 46.

67. See letter dated 15 February 1783, AGN Aduanas 2 2 D 17, fol. 618r–v.

68. As Alarcón put it, "Que podrá dar a V. Ex. alguna satisfacción el plano que incluyo con inteligencia que de Panamá a Cupica según los derroteros solo hay cuarenta y ocho leguas y con corta deferencia lo mismo a las demás provincias," Alarcón to Viceroy Caballero y Góngora, Beté, 15 February 1783, AGN Aduanas 2 2 D 17, fol. 618r. Beté was roughly eight days distant from Cupica. Alarcón had identified himself with the titles *capitán de la infantería española* and *corregidor* of Beté in a letter dated 7 October 1779, AGN Aduanas 2 2 D 17, fol. 486r, but by 7 April 1783, Luis Díaz de Pizarro had become corregidor of Beté, AGN Aduanas 2 2 D 17, fol. 619r.

69. In Alarcón's words, "Dicho plan carecerá de muchos defectos por no estar bien puesto de geografía, aunque si de la práctica," Alarcón to Viceroy Caballero y Góngora, Beté, 15 February 1783, AGN Aduanas 2 2 D 17, fol. 618r.

70. I thank Matt Nielsen for this observation.

71. Margin notes in this letter (made by officials in Santa Fé) recommended that both Alarcón's map and the letter be considered in any forthcoming discussions concerning Alarcón and Cupica, AGN Aduanas 2 2 D 17, fol. 618v. These same notes reveal that letter and map journeyed for nearly three months before they were reviewed by officials in Santa Fé. The letter, sent from Beté on 15 February 1783, was received in Santa Fé on 2 May 1783, AGN Aduanas 2 2 D 17, fol. 618r.

72. As Smith put it, "Considero un establecimiento en Cupica muy ventajoso tanto por la situación como por la fertilidad de las tierras y abundancia de maderas exquisita que allí se encuentran. En atención al poco tiempo que he permanecido en el Chocó y han haber visitado la provincia de Zitará, no me es dable determinar los méritos que habrá hecho Alarcón a la corona en la formalización del nuevo pueblo de Cupica pero es constante que en Panamá ha experimentado los buenos efectos de la población de esta costa," AGN Aduanas 2 2 D 17 (11 April 1787), fols. 681v–682r.

73. Nevertheless, in establishing the pueblo de indios of Cupica, Alarcón stated that he had closely followed all municipal laws regarding poblaciones and that his efforts had been undertaken in the service of God and king, AGN Aduanas 2 2 D 17, fols. 672v, 662v–664r.

74. Margin notes in a letter to Viceroy Caballero y Góngora state that Alarcón did not, for example, submit tribute payments for 1785, AGN Aduanas 2 2 D 17, fol. 675r. While Alarcón did submit tribute from the pueblo of Beté in the years 1774 to 1781, fol. 571r, he remarked that the Indians of Cupica could not be expected to pay tribute as they were far from mining operations, and while they had been told they would be paid for their labors, they never were, fol. 486r–v.

75. The case files examined here do not provide information on how Fernández came to be chosen as Alarcón's successor in Cupica. Fernández was given titles on 20 March 1790 but did not occupy his post until later that year, taking possession of Beté and Bebará on 24 August 1790 and of Cupica on 2 October 1790, AGN Aduanas 2 2 D 17, fol. 687r. Signing off on Fernández's good conduct was Manuel Antonio de Herrera, the cura of Beté and Bebará, who was also in charge of the pueblos de indios of Murrí and Pavarandó, AGN Aduanas 2 2 D 17 (18 July 1791), fols. 703v, 706r.

76. AGN Aduanas 2 2 D 17 (15 December 1790), fols. 686r–687v.

77. Discussed in Alarcón's undated letter to the governor, AGN Aduanas 2 2 D 17, fols. 543r–547v, especially fol. 546v.

78. AGN Aduanas 2 2 D 17, fol. 650r.

79. In Fernández's words, "Los primeros tributos . . . de Cupica en cajas reales son los que yo he pagado, porque, aunque de fundado tiene este pueblo más de diez y seis años . . . no se hayan pagado tributos," AGN Aduanas 2 2 D 17 (15 January 1791), fol. 687v. For full letter, see fols. 687r–689v.

80. For Fernández's commitment, see AGN Fábrica Iglesias 26 13 D 17 (Cupica, 28 January 1792, received in

Santa Fé on 24 April 1792), fol. 656r–v. For Fernández's testimony regarding his progress, see AGN Fábrica Iglesias 26 13 D 17 (4 January 1792), fol. 652r–v.

81. These goals included buying ornaments and bells for the church and bringing Indians who had fled other reducciones to Cupica, AGN Fábrica Iglesias 26 13 D 17 (13 June 1792), fols. 657v–658r. In earlier testimony, however, Fernández affirmed that he had obtained ornaments for the church, which he bought from Alarcón for 160 patacones. He had also purchased two church bells from Carlos Cuesta, AGN Fábrica Iglesias 26 13 D 17 (4 January 1792), fol. 652r–v.

82. Fernández stated that, at this point, he had held the post of corregidor of Cupica for only a year and two months, AGN Fábrica Iglesias 26 13 D 17 (30 January 1793), fol. 652r.

83. Fernández had promised to build an ornamented church in Cupica and incorporate indios cimarrones into the reducción, AGN Aduanas 2 2 D 17, fol. 697v. If these objectives were met, Fernández would be given an additional five years to administer Cupica, fol. 698v. However, if he failed, he would be out in two years' time, fols. 698v–699r.

84. This testimony citing progress in Cupica, dated 24 September 1793, was given by the subsequent corregidor, Nicolás Gutiérrez, AGN Fábrica Iglesias 26 13 D 17, fols. 672r–675v.

85. AGN Poblaciones Cauca 46 2 D 12 (12 July 1791), fol. 300r. Two years later, Gutiérrez stated that the Chocó governor, Ignacio Gould, had presented the viceroy with sufficient justifications to annul Fernández's post, AGN Poblaciones Cauca 46 2 D 12 (20 March 1793), fol. 324r–v.

86. For Gutiérrez's titles, see AGN Fábrica Iglesias 26 13 D 17 (4 September 1792), fol. 708r.

87. See proposal to lieutenant governor, AGN Poblaciones Cauca 46 2 D 12, fol. 300r–v.

88. AGN Poblaciones Cauca 46 2 D 12, 18 July 1791, fols. 312r–314r.

89. A witness, Antonio Hurtado, former *mayordomo* (steward or administrator) of the naturales of Quibdó, testified in favor of such a road just a few days after Gutiérrez wrote his first proposal, AGN Poblaciones Cauca 46 2 D 12 (15 July 1791), fols. 300v–301v. The interim cura of Quibdó attested to Gutiérrez's good character, fol. 309r.

90. Gutiérrez to the Chocó governor, 18 July 1791, AGN Poblaciones Cauca 46 2 D 12, fols. 312r–316r. Some of his proposals seem uninformed, including one that cacao be shipped from Cupica to Cartagena (via the Atrato), a much longer journey than from Cupica to Panama.

91. For this permission, see Fábrica Iglesias 26 13 D 17, 21 June 1793) fol. 664r–v.

92. AGN Poblaciones Cauca 46 2 D 12 (18 July 1791), fol. 314v.

93. In Gutiérrez's words, "No han conocido párroco, y no hay iglesia, ni religión," AGN Poblaciones Cauca 46 2 D 12 (20 March 1793), fol. 324v. In Gutiérrez's earlier letter, he had noted that, as Cupica was six or seven days distant from the priest in Bebará, many Indians died without confessing, AGN Poblaciones Cauca 46 2 D 12 (18 July 1791), fol. 314r.

94. In a letter to the lieutenant governor, Gutiérrez stated that Cupica did have a church, AGN Fábrica Iglesias 26 13 D 17, fol. 675v.

95. AGN Poblaciones Cauca 46 2 D 12 (18 July 1791), fols. 312r–316r; see also fol. 324r, where Gutiérrez suggested that Cupica and Opogodó be separate from Beté and Bebará, given the great distances from Cupica to Beté and Bebará. Gutiérrez proposed that his term begin *after* the Indians had been successfully relocated, the settlement established, crops planted, and tributes collected, a time he estimated would take a good four years.

96. Gutiérrez to the viceroy, 20 March 1793, AGN Poblaciones Cauca 46 2 D 12, fols. 324v–325r.

97. This map, AGN M4, Ref. 140A, is associated with AGN Poblaciones Cauca 46 2 D 12, fol. 323r. For full map, see http://consulta.archivogeneral .gov.co/ConsultaWeb/imagenes.jsp?id=3253352&idNod oImagen=3253353&total=1&ini=1&fin=1.

98. The Opogodó River lay just north of the Napipi River. A much stronger argument about the Opogodó River's proximity to Cupica is presented in Alarcón's 1783 map (plate 4).

99. AGN Poblaciones Cauca 46 2 D 12, 1 September 1791, fol. 319r; 23 June 1792, fol. 320r.

100. The fiscal recommended that the viceroy accept the proposal of Gutiérrez and grant him title to oversee Cupica and Opogodó, citing *Recopilación de leyes de los reynos de las Indias*, libro 4, titulo 5, ley 11; libro 3, titulo 2, ley 57; libro 4, titulo 12, ley 4; libro 4, titulo 5, ley 1; AGN Poblaciones Cauca 46 2 D 12 (25 April 1793), fols. 331r–332r.

101. AGN Fábrica Iglesias 2 13 D 17 (10 October 1793), fol. 691r.

102. AGN Fábrica Iglesias 2 13 D 17, fol. 691v. For the prevalence of illicit commerce and contraband elsewhere in the empire, see Ponce Vázquez 2020; Cromwell 2018.

103. AGN Fábrica Iglesias 26 13 D 17 (20 November 1793), fol. 709r. This statement is a bit perplexing given that, according to Fernández, he had met his mandate, see AGN Fábrica Iglesias 26 13 D 17 (4 January 1792), fol. 652r.

104. In Michaeli's words to Viceroy José Manuel de Ezpeleta, "Fernández ni se poblará Opogodo ni abrirá la útil navegación de Panamá ni dejará de destruir el pueblo de Cupica," AGN Fábrica Iglesias 26 13 D 17, 20 November 1793, fol. 709v.

105. "Nada tengo que añadir. . . . los comprobantes que la acompañen justifican sobradamente que en agregarle el pueblo de Cupica a D. Nicolás Gutiérrez resultará el mejor servicio de Dios y el Rey y conocidas ventajas del público," AGN Fábrica Iglesias 26 13 D 17, fol. 709v.

106. AGN Fábrica Iglesias 26 13 D 17 (5 February 1794), fol. 712r.

107. AGN Fábrica Iglesias 26 13 D 17 (2 August 1800), fol. 729r. While Mutuverría states Gutiérrez had served for seven years, it had been only six.

108. See AGN Fábrica Iglesias 26 13 D 17 (1 October 1800), fol. 733r, which is again referenced in a letter from Mutuverría to the viceroy (2 December 1801), fol. 736r.

109. AGN Fábrica Iglesias 26 13 D 17, fol. 736r. This comes from a letter (2 December 1801) from Mutuverría to the viceroy. A later letter (12 July 1806) suggests that Gutiérrez had gone to Panama for reasons related to his health. Before his departure, he had requested, and was denied, a license for Cartagena's port and ports along the Pacific, or "mar del sur," AGN Fábrica Iglesias 26 13 D 17 (1 October 1800), fol. 733r, and AGN Poblaciones Cauca 46 2 D 12 (12 July 1806), fol. 338r.

110. AGN Fábrica Iglesias 26 13 D 17 (9 February 1802), fol. 744r. See also AGN Poblaciones Cauca 46 2 D 12 (Santa Fé, 12 July 1806), fol. 338v.

111. AGN Poblaciones Cauca 46 2 D 8 (30 July 1806), fols. 193r–195v. Andrade had taken over the cor-regimientos of Beté and Bebará from Fernández on 16 September 1794, AGN Fábrica Iglesias 26 13 D 17, fol. 717r.

112. In an 8 May 1806 letter to the viceroy, Andrade noted that the road would facilitate a three-hour over-land connection from Napipi to Cupica, which would enable commerce with Antioquia, Panama, Quito, and other adjacent provinces, AGN Poblaciones Cauca 46 2 D 8, fol. 205v.

113. Andrade to the viceroy, 22 May 1807, AGN Poblaciones Cauca 46 2 D 8, fol. 208r.

114. Pita Pico 2015: 22; 2016: 224. The initial orga-nization of New Granada's correos had begun in 1717, see Valenzuela Acosta, 2009: 167. Kuethe and Andrien discuss a modernized mail system that started in 1764, in which small ships would leave La Coruña in Spain for Havana each month, then fan across the empire, 2014: 10.

115. Sitjà 2012: 30.

116. Maps of mail routes dating from 1774 (AGN M4, Refs. 539A, 540A) were originally part of AGN Correos Cauca 18 2 D 7 (1774–1792), fol. 711r. These appear to be newly proposed itineraries from Santa Fé to Popayán. AGN M4, Ref. 539A includes the Chocó on its itinerary but does not indicate Cupica or any Pacific port as a stop along the route.

117. AGN Correos Cundinamarca 18 2 D 9 (1806), fols. 283r–285v. Travel from Antioquia to Cupica took between eight and eleven and a half days and did not require a carrier to ford dangerous rivers or confront other obstacles that would detain the mail, AGN Correos Cauca 18 1 D 9 (1776), fol. 538r. Decades earlier, Donoso had proposed a mail route from Lima to Cartagena, a trip of approximately thirty days. Donoso's route included Cupica, the Napipi River, the Sucio River,

and Pavarandó, where a road could be taken to the Sinu River and Lorica, a town that reportedly engaged in trade (trato) with Cartagena by both land and sea. Donoso did not include the Atrato River in his proposed route as, at the time of his 1780 report, the Atrato was still closed to commerce; it was reopened in 1784. See Donoso (1780) 1954b: 234.

118. Mentioned in Carlos de Ciaurriz to Viceroy Amar y Borbón, 17 January 1808, AGN Poblaciones Cauca 46 2 D 8, fol. 203r.

119. AGN Poblaciones Cauca 46 2 D 8 (15 March 1808), fol. 210r–v.

120. AGN Poblaciones Cauca 46 2 D 8 (28 March 1808), fol. 212v.

121. See AGN Aduanas 2 2 D 17 (Murrí, 11 April 1787), fols. 681v–682r.

122. See Nielsen 2019: chap. 5.

123. See Nielsen 2019: 211–212.

124. Similar to calculated inactivity was abandonment, marginalization, and neglect, see Cromwell 2018: 12–13.

125. See AGN Aduanas 2 2 D 17, fols. 582v–584r. This list was drafted by Lucas de Alarcón's brother, Josef de Alarcón. For another detailed list, created in 1802, see AGN Fábrica Iglesias 26 13 D 17 (22 July 1802), fols. 750r–751v.

126. For Fernández's population count from 15 December 1790, see AGN Aduanas 2 2 D 17, fol. 686r. At this time, 64 Indian men and 67 Indian women (for a total of 131) were documented as residing in Cupica, but none of these individuals are named. Several are noted as having fled from pueblos in the Chocó. Many are noted as speakers of the Chocosena language.

127. Today, Cupica is home to fewer than two thou-sand people, 66 percent of whom live below the poverty line. Illegal gold and platinum mining provide income for some, but these clandestine operations have left behind polluted waterways and stagnant lakes, which serve as breeding grounds for mosquitoes, Griffin 2017.

128. AGN Aduanas 2 2 D 17, fol. 582v.

129. See Alarcón's population list in AGN Aduanas 2 2 D 17, fols. 582v–584r.

130. Indian agregados from northern Brazil who came to live in a povoação de índios (Indian village) were not obligated to undertake communal labor or pay tribute, nor were they required to live in the village permanently, Roller 2014: 160.

131. Alarcón wrote of eight Indian tribute payers and their families from Quibdó and Lloró who, for reasons unknown, hid in the monte to escape resettlement, AGN Aduanas 2 2 D 17, fol. 584r.

132. These Indians were listed as indios forasteros, indicating they were not local to Raposo but had come from elsewhere; see AGN Visitas Cauca 62 4 D 6, fols. 672r–674r, and AGN Caciques e Indios 11 D 9, fol. 664v. La Cruz, just hours from the port of Buenaventura, was a nexus where goods (cloth and provisions) entered the region and went on to Popayán and the mining regions

of the Chocó. La Cruz boasted natural resources such as wood and tar that could be cut or collected and taken to Buenaventura for sale and export, an additional industry that benefited the Spanish Crown, see AGN Caciques e Indios 11 D 9 (20 December 1754), fols. 633–663.

133. See AGN Caciques e Indios 11 D 9 (20 December 1754), fols. 633–663, especially 635r–636r.

134. AGN Visitas Cauca 62 5 D 3 (1784), fol. 291v. Pavarandó was a gold-mining site with a high number of enslaved inhabitants. Roughly one-sixth of Pavarandó's population was Indigenous and supported mining operations through food cultivation, house construction, and canoe building.

135. These 84 ausentes were out of 505 total Indigenous inhabitants in Lloró. Lloró's corregidor at this time was Isidoro Herrero Volaños de la Vega; see AGN Visitas Cauca 62 5 D 3 (1784), fols. 397r–399v for questioning; fols. 399v–407v for list of tribute payers; and fols. 408r–409v for ausentes.

136. AGN Visitas Cauca 62 5 D 3 (1784), fols. 408r–409v.

137. Roller 2014: 158–163.

138. AGN Aduanas 2 2 D 17, fol. 584r.

139. Josef is not noted as Alarcón's brother on the inventory but is identified as such elsewhere, where Alarcón reported that Josef would remain in Cupica while he (Lucas) was away, AGN Aduanas 2 2 D 17, fol. 495v.

140. AGN Aduanas 2 2 D 17, fol. 584r.

141. The presence of gente libre goes against recommendations in the *Recopilación de leyes de los reynos de las Indias* (tomo 2, libro 6, titulo 3, ley 21) about Spaniards, mulatos, mestizos, and negros residing in pueblos de indios.

142. AGN Aduanas 2 2 D 17, fol. 511v.

143. AGN Aduanas 2 2 D 17, fols. 513r–514v, 546v.

144. AGN Aduanas 2 2 D 17, fol. 650r.

145. AGN Aduanas 2 2 D 17, fol. 686r; AGN Aduanas 2 2 D 17 (15 January 1791), fols. 687r–688v.

146. See AGN Fábrica Iglesias 26 13 D 17 (4 January 1792), fol. 652r.

147. AGN Fábrica Iglesias 26 13 D 17 (28 January 1792), fols. 656r–657v; AGN Poblaciones Cauca 46 2 D 12, fol. 324v.

148. AGN Poblaciones Cauca 46 2 D 12 (20 March 1793), fol. 324v.

149. AGN Fábrica Iglesias 26 13 D 17 (10 October 1793), fol. 691r.

150. See *Recopilación de leyes*, tomo 2, libro 3, titulo 3, ley 4.

151. Church doors were required to have a key, *Recopilación de leyes*, tomo 2, libro 3, titulo 3, ley 4.

152. This last item is described as "estandarte guion de tafetán amarillo con cordones de hilo asta y cruz y una estampa de nuestra señora," AGN Fábrica Iglesias 26 13 D 17, fol. 747r.

153. AGN Fábrica Iglesias 26 13 D 17, fols. 747r–748r.

154. Cartagena was overtaken and occupied by Francis Drake in 1586 and raided by the French in 1697.

Chapter 5: The Map of the Dagua River Region

A different version of this chapter was published in 2018: "The Manuscript Map of the Dagua River: A Rare Look at a Remote Region in the Spanish Colonial Americas," *Artl@s Bulletin* 7 (2): 71–90.

1. Barona 1986. Similarly, in Barbacoas in the early colonial period Indigenous people were forced to mine, but by the later seventeenth century, Indian workers had been replaced by enslaved Africans, Navarrete 2005: 158–159; see also Lane 2000.

2. In the Dagua region, slaves could additionally contract themselves out for pay as bogas or cargueros. Through these various avenues of employment, they were able to earn money and could potentially save enough to buy their freedom or that of a family member in six to eight years' time (my estimate). For manumission transactions in Cali, see AHC Fondo Escribanos, Notaria Segunda, libro 4 (1773), fols. 222v–223v, 400r–v; AHC Fondo Escribanos, Notaria Segunda, libro 5 (1774), fols. 279v–280r.

3. It is also possible that this map, or an earlier version of it, was created as a *titulo de merced*, or land title map.

4. See Lane 2000.

5. Lane and Romero 2001.

6. Provenance from the time of sale, held in the acquisition file, notes the map had passed from an American geologist/engineer to a Spanish professor to the Philadelphia Print Shop.

7. Julie Stoner in the Library of Congress's Geography and Map Division identified two watermarks that appear on four of the eight sheets, see figure B.2 in appendix B.

8. For the Dagua River region, see Lane and Romero 2001; Martínez Capote 2005; Romero 2017. For Cali, see Arboleda 1956; Colmenares 1975; Escobar (1582) 1992. For Buenaventura, see Romoli 1962; Valencia Llano 2014.

9. For this, I am grateful to generous Colombian archivists, meticulously cataloged records, and the AGN's extensive digital database.

10. For additional discussions of this map, see Wiersema 2018, 2020a. This map has been published previously on book jackets; see Beaule and Douglass 2020; Loaiza Cano and Beltrán 2012; Romero 2017.

11. Lane and Romero 2001: 35–36; Arboleda 1956: 2:102.

12. Today, only the final twelve miles (twenty kilometers) is considered navigable, Martínez Capote 2005: 36.

13. André 1884: 701; Mollien (1823) 1944: 299; Pombo (1850) 1936: 109; Saffray (1869) 1948: 311.

14. Mollien (1823) 1944: 296–297.

15. Saffray (1869) 1948: 311–312, 338.

16. The Dagua River facilitated commerce with the Chocó, Popayán, Caloto, and Buga, as well as Isquandé,

AGN Caciques e Indios 11 D 9 (1754), fols. 634v, 646r, and for Isquande, 639v.

17. McFarlane 1993: 61–63. For foundational scholarship on Cali's elite society and its economy, see Colmenares 1975; Arboleda 1956. For Popayán, see Colmenares 1979; Marzahl 1978. I discuss the Caicedo family in chapter 6.

18. Valencia Llano argues that Cali's importance resulted from its connection to Buenaventura, the primary Pacific port granting access to the Andean interior, 2014: 232. Buenaventura, which began as a river port, was later converted to a maritime port and was controlled by Cali's elite until the Republican period, 221.

19. Escobar (1582) 1992: 346; West 1952: 126.

20. In the visitador's words, "No le es posible poder ejecutarlo en la provincia del Raposo y Dagua por lo penoso y intransible de sus caminos," AGN Visitas Cauca 62 4 D 6 (1761), fol. 1v.

21. For mention of gold in the mountains near Cali circa 1592, see González de Mendoza (1592) 1991: 550; see also González de Mendoza (1592) cited in Valencia Llano 2014: 237. It was the founding of Cali in 1536 and the need to identify a route from there to the Pacific coast that eventually led to the discovery and slow settlement of the Dagua River region, Valencia Llano 2014. For an excellent history of the Dagua area, see Martínez Capote 2005.

22. For more on early Indigenous populations, see Escobar (1582) 1992: 346; Romoli 1974: 382. The remaining native population was protected under legislation that made it difficult to employ their labor in the mines, see Jaramillo Uribe 1963: 5; Meiklejohn 1968, 1974. Cuadrillas were often composed of both men and women. For an interesting case of cuadrillas made up entirely of women, see Lane's discussion of Remedios circa 1634–1636, forthcoming; AGN Minas de Antioquia 5:1, fols. 1r–306v.

23. Colmenares 1975: 62.

24. Pérez de Montoya served on Cali's cabildo from 1756 to 1769. His titles in 1768 included capitan de la infanteria española, aguacil mayor de santo oficio, regidor perpetuo, teniente mayor de esta ciudad, corregidor de naturales, and alcalde mayor de minas, see Arboleda 1956: 2:341. In 1777, he was noted as regidor decano, Arboleda 1956: 2:406. Pérez de Montoya's elevated titles suggest he was a Spaniard, but I have not yet found documents to confirm this. The Cali census of 1777 notes him as married with six children and fourteen slaves; see Arboleda 1956: 2:406. For his marriage to María Francisca de Soto y Zorrilla, see ACC Sig. 5720 Col. P I-2 v. Several of those listed in the census in households of cabildo members were noted as "domésticos libres" and "servientes libertinos" alongside enslaved household members, Arboleda 1956: 2:405–406. Documents indicate Pérez de Montoya was a petulant character. In 1766, he worked to expel foreigners (non-Spanish Europeans) from Cali, including much-relied-upon French doctors.

This expulsion was based on a 1736 cedula; see Arboleda 1956: 2:222–223, 338–340. In 1759, Pérez de Montoya had a falling out with Cali's cabildo over celebrations for the newly installed regent, Charles III; see Arboleda 1956: 2:298. Later, in 1774, as interim alcalde ordinario, Pérez de Montoya demanded that all barking dogs, especially those that were known to threaten livestock, be put to death. Excluded from this death sentence were perros cusqueños (hairless dogs from Peru?), which supposedly did not cause the same harm as the others, AHC Fondo Cabildo, Carpeta 2, fol. 15r-v.

25. AHC Fondo Escribanos, Notaria Primera, libro 43 (24 February 1764), fol. 17r-v. De la Puente's father, Lorenzo, was a Spaniard, see Colmenares 1975: 181. In addition to owning land at Las Juntas, de la Puente diversified his assets by also owning land and pasture in more temperate parts of the Cauca Valley, including in Meléndez and Lille. For his land in Meléndez, see AHC Fondo Judicial, tomo 2, caja 107, legajo 1, fols. 282r–616v. For Lille, see AHC Fondo Judicial, tomo 2, caja 106, legajo 8 (1764–1766), fols. 9v–11v. De la Puente is also documented as owning a trapiche (sugar mill); see Arboleda 1956: 2:332.

26. For "Don Manuel Pérez de Montoya contra don Manuel de la Puente sobre habérsele introducido en las tierras de sus minas haciendo entables de cacahuales y platanares," see AGN Minas Cauca 38 2 D 14 (1763), fols. 223r–236v.

27. AGN Visitas Cauca 62 4 D 6, fol. 72r. Las Juntas was still noted as a sitio in 1780, see BNC RM 370, fol. 74r-v. See also Saffray (1869) 1948: 311.

28. Saffray (1869) 1948: 311. A rosier picture of Las Juntas comes from Miguel Pombo's 1850 account, which describes the lazy pleasures of passing the afternoon conversing, smoking cigarettes, and rocking in a hammock, lulled to sleep by the rush of the rivers (1850) 1936: 105–106.

29. The legend (l) notes "La Estancia de las Juntas que poseé don Manuel de la Puente" (the estate of Las Juntas owned by Manuel de la Puente). The estancia at Las Juntas had been purchased by Manuel de la Puente and his brother, Luis, from Francisco Laviano, mentioned in the map's legend as having owned a house (3) and two plantain groves (4 and 5) on the north side of the Dagua River. These were sold to the Real Hacienda to pay Laviano's debts, see AHC Fondo Judicial, tomo 2, caja 107, legajo 1, fol. 253r-v. When Luis de la Puente died, sometime around 1758, their mother inherited Luis's share of the land and sold it to Manuel, making him the sole owner of the estancia of Las Juntas, AHC Fondo Judicial, tomo 2, caja 107, legajo 1 (1766), fols. 231v–238v, 253r-v, 281v–282r. See also AHC Fondo Escribanos, Notaria Primera, libro 44 (1 September 1764), fols. 168r–169r.

30. The map's legend (n) identifies cacao, caymitos, zapotes, aguacates, guayabos, and chontaduros. Farther downriver, de la Puente grew enough cacao (at 6, 7, 8, 9)

to pay his *diezmos*, "tithes," see ACC Sig. 5457 Col. E I-5 j (1775–1776).

31. ACC Sig. 11511 Col. C IV-10 ea, fol. 36r–v. Pérez de Montoya reportedly purchased the mines of Aguasucia and Santa Barbara del Salto from the deceased Salvador Caicedo, see AGN Minas Cauca 38 2 D 14 (31 May 1763), fols. 230v–231v.

32. AGN Minas Cauca 38 2 D 14 (19 October 1763), fol. 236r–v.

33. ACC Sig. 5457 Col. E I-5 j (1775–1776).

34. The rubrics of these three individuals each appear four times on the back of the map. I thank Julie Stoner of the Library of Congress's Geography and Map Division for identifying these for me early in this study.

35. Vernaza, a native of La Spezia, Italy, was *escríbano público* for both Cali and its cabildo from 1750 until 1766, when he resigned during Pérez de Montoya's campaign to expel non-Spanish Europeans from Cali, see Arboleda 1956: 2:338–339. For Vernaza's role as escríbano in this case, see AHC Fondo Judicial, tomo 2, caja 107, legajo 1, fols. 231v, 240v. Vernaza purchased the office of escríbano público from Cali's cabildo for seven hundred patacones; see ACC Sig. 4263 Col. C I-12 nt (1750). Vernaza was one of few non-Spanish Europeans to enjoy a long, fruitful career in Cali. While I have not yet found evidence that he traveled to the Dagua River region, his name appears on numerous documents dealing with the region in his role as Cali's escríbano. By 1785, Vernaza owned the rights to mines between the Jamundí and Claro Rivers, closer to Cali, and was identified as a vecino of Cali, ACC Sig. 11393 Col. C I-21 mn (1785).

36. See Colmenares 1975: 103–106, chart 9.

37. The legend's explanatory text identifies Antonio Garcia (*sic*) as "uno de los testigos para este acto." At the time of the map's creation, Garcés y Saá was a member of Cali's cabildo, holding increasingly important positions from 1756 (*mayordomo*) to 1765 (*fiel ejecutor y familiar del santo oficio*), Arboleda 1956: 2:269, 305, 308, 323.

38. Evidence for African arrival to this area dates to at least 1705, when eight slaves were illegally brought into Raposo via the Atrato River, ACC Sig. 2661 (1705–1707).

39. Colmenares 1975: 101–102.

40. Arboleda 1956: 2:22. For Cali-owned mines in operation in the eighteenth century, see Colmenares 1975: 103–105, cuadro 9. Romero adds to this information, listing mines by region, 2017: 85–88, see table 5.

41. For a range of ethnonyms, see ACC Sig. 8806 Col. J I-17 mn (1762–1766); see also Wiersema 2020a.

42. Colmenares 1975: 107.

43. Martínez Capote 2005: 22, 115, 123–124. Today, Afro-Colombians comprise the ethnic majority of the Dagua River region's inhabitants. These Afro-Colombians are not, however, the direct descendants of the eighteenth-century inhabitants, see Romero 2002: 182–186.

44. For the large mine of Aguasucia, see AGN Minas Cauca 38 2 D 14, fols. 230v–231r. Aguasucia had been worked in 1733 by fifty enslaved Africans. In 1759, when its owner at the time, Salvador de Caicedo, died, it was valued at 16,000 patacones and was inherited by Caicedo's son-in-law, Fernando de Cuero, Colmenares 1975: 101–102. Cuero seems to have sold the mining camp of Aguasucia to Pérez de Montoya for a sum of 15,500 patacones, see AHC Fondo Escribanos, Notaria Primera, libro 43, fols. 51v–52v. Pérez de Montoya was still paying off this debt in November 1762, AHC Fondo Escribanos, Notaria Primera, libro 43, fols. 28r–32v. In 1763, Pérez de Montoya reported having bought enslaved laborers, tools, and "otros bienes" (other items) from the descendants of Caicedo. He also noted that three *platanares* (plantain groves) were part of this purchase, AGN Minas Cauca 38 2 D 14, fol. 228r–v.

45. See ACC Sig. 8806 Col. J I-17 mn. For San Ciprián, San Nicolás, and Santa Gertrudis, see ACC Sig. 3662 Col. C II-4 rc (1729–1735), fols. 1r–20r.

46. Colmenares 1975: 106.

47. For the mines of El Salto, Benedicciones, and Santa Gertrudis, see ACC Sig. 3662 Col. C II-4 rc (1729–1735); ACC Sig. 8806 Col. J I-17 mn (1762–1766). At this time, Saltico was a *paraje*, "stop," and La Cruz was a sitio.

48. See Lane and Romero 2001: 35–36.

49. See BNC RM 370, fols. 67r 74v. Eight reales was equal to one peso, or one patacon. I am grateful to José Carlos de la Puente for his help with this.

50. A fee of eight reales generally carried one from Las Juntas to El Salto, near the mines at Aguasucia. From El Salto, a second leg took travelers and supplies to Benedicciones. In addition to money, bogas received a half libra (or a half pound [0.22 kilograms]) of meat and a ration of plantains and tobacco, BNC RM 370 (1780), fols. 67r–74v.

51. Mario, a twenty-two-year-old boga (designated as Mina Carabalí, an ethnonym that suggests ethnic origins from Africa's Gold Coast and Bight of Biafra) from the mines of Triana and San Geronimo de las Benedicciones, was valued at 500 patacones, while the captain was valued at 400, see ACC Sig. 11347 Col. J I-17 mn (1764), fols. 4r–5v. Vicente, a thirty-year-old canoero (designated as Mina) at the mines of El Salto and Benedicciones, was valued at 525 patacones; the cuadrilla captain was valued at 550, ACC 8806 (1752), fols. 58v–59v.

52. Those from the Bight of Benin were long-distance traders, relying on canoes for transport in rivers and the ocean, Maya Restrepo 1998: 41–42. See also Dawson's fascinating discussion of African canoe culture, 2018: 99–250. For an insightful examination of canoe navigation as an elemental part of the Pacific Lowlands, see Giraldo Herrera 2009.

53. Smith 1970: 521–524.

54. Smith 1970: 532.

55. See Dawson 2018, especially chaps. 6, 7, 8.

56. Dawson 2018: 2–3.

57. See Dawson 2018: 128.

58. In parts of Africa, canoeing—and fishing from

canoes—was an essential skill learned during childhood. As adults, those living on the upper Congo knew how to expertly guide canoes through the vast river system of the Congo basin, Dawson 2018: 122–123.

59. For the canoe's central place for native inhabitants in seventeenth-century northeast North America, see Lipman 2015: 67. Sean M. Kelley writes of the esteem but also the autonomy enjoyed by enslaved African-born watermen in eighteenth-century South Carolina known as "patroons," noting it was not uncommon to see African patroons navigating boats without any whites aboard, 2016: 154–155.

60. See André 1884: 702; Hamilton 1827: 157–158; Mollien (1823) 1944: 296; Pombo (1850) 1936: 107–108; Saffray (1869) 1948: 311.

61. Pombo (1850) 1936: 107–109; see also Mollien (1823) 1944: 295. To balance the canoe, the bogas placed cargo at either end, leaving the passenger a small space of about three feet (one meter) in the center, Mollien (1823) 1944: 295; Pombo (1850) 1936: 108; see also Saffray (1869) 1948: 311–312.

62. For cargueros' vital place in nineteenth-century Dagua, see Mollien (1823) 1944. Mollien, who had survived the famed 1816 shipwreck of the *Medusa* before his travels to Colombia in 1823, wrote of his reliance on cargueros in the Dagua region. Their strength, familiarity with the terrain, seasoned feet, and muscle memory were often the only guarantees of getting from one place to the next.

63. Arboleda 1956: 2:102.

64. In the official's words, "Pues a cuatro o cinco días que me hallo sin una onza de carne en mi casa," AGN Milicias y Marinas, tomo 126, fols. 200v–201r. This letter to Cali's cabildo in March 1766 was written by Pedro García Valdez from his house in La Cruz (downriver from Las Juntas).

65. For mentions of Sombrerillo, see Arboleda 1956: 2:101–102, 3:40–42; Lane and Romero 2001; Pombo (1850) 1936: 111.

66. The entry for Sombrerillo in the legend is "11. Sitio de Sombrerillo: en este residen los cargueros que conducen a hombros, las cargazones que dejan estas canoas, y se internan para las provincias dichas."

67. "Que muchos cargueros, hasta 150, indio[s], negros, mulatos, mestizos, y aún blancos, están abroquelados en este sitio [Sombrerillo], algunos procedentes de remotas tierras, esclavos que huían, otros compelidos por censuras, y se mantienen allí no solo los forasteros sino los nativos de Cali," Arboleda 1956: 2:102. For original document, see AHC Cabildo, tomo 14, vol. 7 (17 February 1739), fol. 188r–v.

68. See Arboleda 1956: 2:102.

69. Elsewhere, I have referred to Sombrerillo as a free town (Wiersema 2018), following the discussion by Lane and Romero 2001, but I have not found evidence that it existed as such in any legal or formal sense. As late as 1780, Sombrerillo was still referred to as a *lugar*, see

BNC RM 370, fol. 74r. "Lugar," as Herrera Ángel notes, was a synonym for "sitio," 2014: 116n49.

70. The first Spanish colonial mention of Sombrerillo is in 1739, Arboleda 1956: 2:101–102. In the historical records, it shifts in designation from a sitio in 1764 to a *paso*, "stop." Sombrerillo is last mentioned in 1786, noted as one of three stops on the Dagua along with Las Juntas and Benedicciones, Arboleda 1956: 3:40–42.

71. Herrera Ángel 2014: 116–119.

72. Lane and Romero 2001: 35.

73. This is based on negative evidence.

74. Sites like Sombrerillo, with mixed populations including libres de todos colores, runaway slaves, white merchants, and Indians, went against numerous recommendations in the *Recopilación de leyes de los reynos de las Indias*, see, for example, *Recopilación de leyes de los reynos de las Indias* 1681, tomo 2, libro 4, titulo 7.

75. Hellman and McCoy 2017.

76. This royal sanctioning aimed to destabilize slave-based economies of settlers in the Carolinas and defend the Crown's interests, see MacMahon and Deagan 1996: 54.

77. See Landers 1990, 1999; MacMahon and Deagan 1996.

78. See Taylor 1970.

79. See Bassi 2016; Gallup-Diaz 2008.

80. The sites chosen for these free towns were surveyed, formal boundaries were established, and locations for houses and churches were identified, see Taylor 1970.

81. See Navarrete 2001, which mentions the palenques of Zaragoza (founded 1598) and Remedios (founded 1607) as examples.

82. See Zuluaga and Bermúdez 1997: 38–58.

83. Zuluaga and Bermúdez 1997: 41–47. While open to interactions with religious officials, El Castigo's inhabitants were unwilling to recognize civil authorities.

84. See Lane and Romero 2001: 34; see also Offen 2003: 57. Perhaps the most famous palenque in New Granada was San Basilio; see Navarrete 2011.

85. See Escalante 1973. Protections could extend even to slaves, as was the case with those on Jesuit estates who became the property of the Crown after the Jesuit expulsion from New Granada on 1 August 1767, see Souldore-La France 2006.

86. This palenque is also referred to as the "palenque de los Cerritos," Zuluaga and Bermúdez 1997: 58–79.

87. Rodríguez 2007; the palenque of Cartago is also mentioned in Sharp 1976: 156.

88. Mollien (1823) 1944: 298.

Chapter 6: The Map of the Yurumanguí Indians

An earlier version of this chapter was published in 2020: "The Map of the Yurumanguí Indians: Charting the Erasure of the Pacific Lowlands' Indigenous Inhabitants, 1742–1780," *Terrae Incognitae* 52 (2): 160–194.

1. This map is AGN M3, Ref. 125.

2. These wealthy people included Manuel de Caicedo of Cali and Pedro Agustín de Valencia of Popayán.

3. The case file is AGN Curas y Obispos 21 44 D 2 (1742–1780), fols. 14r–312v. There are three sets of pagination for this case file. I refer to those numbers that are stamped and clearly legible as opposed to those that are handwritten or stamped but faint.

4. Even as Spanish documents often discuss the decimation of Indigenous populations, Herrera Ángel demonstrates how archival census documents and linguistic information reveal the inaccuracy of these accounts, 2017. See also 2016: 222, 296–297.

5. Leal 2018: 30–32.

6. Cortés dates it to after 1700, working from the faint signature at bottom right of Manuel de Caicedo, whom she proposes as the *rubricador* (person who signed the map), 1967: 83n36.

7. In March and April 2019, Indigenous communities in Cauca protested the violence of armed groups and the Colombian government's inaction, in addition to its non-implementation of a 2016 peace accord and non-compliance with previous agreements. Today, 90 percent of the Indigenous councils and communities of the department of Cauca belong to the CRIC (Consejo Regional Indígena del Cauca), which was founded in 1971. I am grateful to Diógenes Patiño for directing me to resources that document this protest.

8. See n. 3. This file is one of thousands that have been digitized by the AGN as part of an initiative of former director Mauricio de Tovar.

9. AGN Curas y Obispos 21 44 D 2, fols. 198r–200v. Caicedo's letter begins, "En fuerza del superior orden de vuestra Excelencia, he procedido a la formación del mapa, e incluyo el que instruya a VE por lo que toca a la situación, y habitación de aquellos indios infieles y los ríos principales en que se hallan situados . . ."

10. Caicedo, in one instance, mentions "mapas" (AGN Curas y Obispos 21 44 D 2, fol. 198r), suggesting that the Map of the Yurumanguí Indians may have been compiled from several maps or that another map may exist. The map could also be a later, cleaner version of an earlier sketch. In his letter, Caicedo does not reference numbers from the map, but he does provide detailed descriptions that are easily correlated to numbers and features on the map.

11. AGN Curas y Obispos 21 44 D 2, fol. 24r. It is not known how long the Yurumanguí had occupied this area before Spanish discovery, nor do we know what this Indigenous group called themselves. The term "Yurumanguíes" was first used in 1940 by Franciscan friar Gregorio Arcila Robledo, see Arcila Robledo 1940. Following this established nomenclature, I refer to them as Yurumanguí. Their geographical range, as the map and case file indicate, extended north to the Cajambre River and south to the Naya River.

12. Jay Harrison notes that eighteenth-century vocabularios penned by Franciscans are rare. For the

Indian nations (*naciones*) of Spanish Texas, only one vocabulario (that of Pajalat) is known, personal communication, 2021; see Fray Gabriel de Vergara (1732) 1965. Pajalat had become the lingua franca of Mission Concepción, in Texas, by the end of the century, see Wade 2008: 204.

13. AGN Curas y Obispos 21 44 D 2, fols. 198r–200v.

14. Early scholarship related to the Yurumanguí includes Arcila Robledo 1940; de la Rue and Bruet 1943; Guhl 1947, 1948; Ortíz 1945; Rivet 1942; see also Loukotka and Wilbert 1968. Later scholarship for this area has focused on its Afro-Colombian history, see Romero 1997; Zuluaga and Romero 2009: 149–198. Inhabitants today are largely Afro-Colombian with a minority of Indigenous, who reside along the lower part of the Naya and Tambor Rivers (Cholo-Emberá) and in the higher part of the Naya basin or watershed (Paeces); see Negret et al. 1996; Celorio Mina 1971.

15. Herrera Ángel 2014: 68–69.

16. Development in the Naya area has been underway only since the 1960s, driven largely by the coca trade. Today the area is littered with landmines, see Rachel Nuwer, "The Daunting, Dangerous Task of Unearthing Colombia's Landmines," 16 July 2018, NOVA, PBS. org, https://www.pbs.org/wgbh/nova/article/demining -colombia.

17. Bernal 2017. Her description is "la frontera de la frontera, el último límite antes de que la naturaleza someta por completo al hombre."

18. This is based on the recorded travel time of Pedro Agustín de Valencia and that of Sebastian Lanchas de Estrada, AGN Curas y Obispos 21 44 D 2, fols. 34v–35r (undated) and 143r–144r (28 October 1768).

19. This itinerary is provided in an undated letter by Valencia, AGN Curas y Obispos 21 44 D 2, fols. 34v–35r, which was received in Santa Fé in April of 1756. The Map of the Yurumanguí Indians deceptively suggests that this section of the Pacific coast—rich in natural, mineral, and human resources—was easily reached by sea and that the region's many rivers were seamlessly navigated by canoe, guided by accommodating native inhabitants. This contention is, however, contradicted in the writings of Valencia and others, who noted how dangerous the passage could be, especially navigating the Gulf of Tortugas, fols. 34v–35r.

20. AGN Curas y Obispos 21 44 D 2, fols. 34v–35r, 143r–144r. If coming from Popayán, as Valencia did, an additional five to ten days were needed.

21. As part of these efforts, the Jesuits were expelled in 1767 and royal monopolies on aguardiente and tobacco were implemented, McFarlane 1993: 63, 236.

22. This dictionary can be found in AGN Curas y Obispos 21 44 D 2, fols. 218v–221r, 231r–233r.

23. Arcila Robledo 1940.

24. Ortíz 1945. This is referenced in Romero 1997: 45–47. For Lanchas de Estrada's diary, see AGN Curas y Obispos 21 44 D 2, fols. 146r–148v.

25. De la Rue and Bruet 1943.

26. Rivet 1942. "Hokan" refers to a supposed grouping of languages spoken mainly in California, Arizona, and Baja California. For problems with Rivet, see Poser 1992.

27. Guhl 1948.

28. As Guhl put it, "y no encontramos un solo Yurumanguí," in Bonilla 1984: 29–30.

29. Too little documentation exists to permit adequate classification of the Yurumanguí language, Campbell 2012: 69–70, 114; see also Adelaar and Muysken 2004: 60–61; Aikhenvald 2007: 190–191. Nevertheless, early efforts were made to tie Yurumanguí to known language groups; see Loukotka and Wilbert 1968.

30. Serrano García 2015.

31. This would probably have happened sometime before Cortés undertook the extensive cataloging of maps in the AGN's collection in the 1960s, see Cortés 1967.

32. The map along with information from the case file could also have facilitated historical archaeology for this group. The map, informed by Caicedo's letter, presents locations and distances that offer a rough sense of where dwellings were situated.

33. See AGN Curas y Obispos 21 44 D 2, fols. 67r, 83v–84v, 203r.

34. AGN Curas y Obispos 21 44 D 2, fol. 17r–v.

35. Otorola is noted as a native of Spain, "natural del reino de España," ACC Sig. 7892 Col. J II-10 cv (1758–1772), fol. 5r.

36. See ACC Sig. 3998 Col. C I-21 mn (1743), fols. 1r, 2v–3r.

37. ACC Sig. 3998 Col. C I-21 mn (1743), fol. 3v. Otorola's request to use Indian labor, while not unprecedented, was somewhat unusual. However, Cristóbal de Mosquera, a vecino of Popayán, used both Indian and African labor; see Marzahl 1978: 27n20, 27n26.

38. AGN Curas y Obispos 21 44 D 2, fols. 15r–17v.

39. ACC Sig. 9650 Col. C III-24 g (1753), fols. 4v–6r.

40. See AGN Curas y Obispos 21 44 D 2, fol. 17v; ACC Sig. 9650 Col. C III-24 g (1753), fols. 5r–6r.

41. AGN Curas y Obispos 21 44 D 2 (25 June 1748), fol. 18r.

42. AGN Curas y Obispos 21 44 D 2 (10 January 1751), fol. 17r–v.

43. AGN Curas y Obispos 21 44 D 2, fols. 19r–20r.

44. AGN Curas y Obispos 21 44 D 2, fols. 20r–21v. For costs and Otorola's expenses, see fols. 25r–27v.

45. "En atención a los inconvenientes que pueden resultar de que se facilite la comunicación de la ciudad de Popayán con la mar del sur, se declara débanse suspender la apertura que se intenta concluir desde la referida ciudad (Popayán) al río Naya . . . como de los perjuicios que en la extracción de sus oros pueden acarrearse del fácil comercio por la mar," AGN Curas y Obispos 21 44 D 2 (15 March 1751), fol. 33v.

46. AGN Curas y Obispos 21 44 D 2, fol. 32r–v.

47. Otorola is described as "ausente o muerto en el reino del Perú," ACC Sig. 11392 Col. J I-17 mn (1760), fol. 19r–v.

48. ACC Sig. 11392 Col. J I-17 mn (1760). In addition to mines, she also sold off associated houses, enslaved laborers, and tools.

49. Colmenares 1979: 83.

50. Patiño and Hernández Sánchez 2010: 6.

51. See Colmenares 1979: 83.

52. AGN Curas y Obispos 21 44 D 2 (1756), fols. 34r–35v.

53. The testimony of witnesses collected in support of the project was overwhelmingly favorable, stating they saw the proposed road as detrimental neither to the king nor to the people of the province but beneficial to everyone, AGN Curas y Obispos 21 44 D 2, fols. 44v–54v, 57v.

54. AGN Curas y Obispos 21 44 D 2, fols. 34v–35v. The subtext here is always that, with greater efficiency (i.e., a road, more enslaved workers, etc.), a greater quantity of gold could be mined, resulting in higher revenues for the Spanish Crown.

55. "No traer inconveniente la apertura del camino a los ríos de Naya y Yurumanguí, y antes sí, conocidas utilidades, puede vuestra excelencia si es servido conceder a don Pedro Agustín Valencia la licencia que solicita," AGN Curas y Obispos 21 44 D 2 (11 August 1757), fol. 57v.

56. Valencia proposed to settle and evangelize the "indios infieles" living in the mountains nearby, AGN Curas y Obispos 21 44 D 2 (1760), fols. 64r–65r.

57. AGN Curas y Obispos 21 44 D 2, fols. 64r–65r. Valencia had agreed to help fund the road and to support Christianizing efforts (fols. 81r–83r), contributing two hundred pesos a year (fol. 127v).

58. AGN Curas y Obispos 21 44 D 2 (10 October 1761?), fol. 80r. Valencia later provided credentials for Lanchas de Estrada, whom he described as the "capitan de la pacificación y reducción de los indios gentiles que habitan las cabeceras y montañas de los ríos de Yurumanguí, Cajambre, y juez de balanza de la real Casa de la Moneda de esta ciudad," AGN Curas y Obispos 21 44 D 2 (12 November 1770), fol. 244r.

59. For Lanchas de Estrada's diary and descriptions of the Indians, see AGN Curas y Obispos 21 44 D 2, fols. 143r–148v; for transcription, see Ortíz 1965. This, the dictionary compiled by Friar Cristóbal Romero (fols. 218r–221r, 231r–233r), and the map (AGN M3, Ref. 125) constitute the last tangible traces of this Indigenous group.

60. AGN Curas y Obispos 21 44 D 2, fol. 81v. Much of the "Misioneros de Yurumanguí" case file deals with the Colegio de Popayán's inability to take on this project because of their overcommitment in other areas. The alternative, the Colegio in Cali, did not have the requisite experience or expertise. For more on the challenges facing the Franciscans in the area at this time, see Serrano García 2015.

61. Silvestre mentions the discovery of Indians along the Yurumanguí and the reducción efforts undertaken by Valencia and the Colegio de Cali, (1789) 1950: 236.

62. Larrea is credited today as the author of the

Novena of Aguinaldos, or the novena, a set of prayers recited in Colombia, Venezuela, and parts of Ecuador during the nine days preceding Christmas.

63. AGN Curas y Obispos 21 44 D 2 (15 April 1767), fol. 93v; see also fol. 123r. Larrea had a vested interest in the success of the Colegio de Misiones de San Joaquín de Cali, as he had founded it a decade earlier, in 1757; see Serrano García 2015: 47.

64. Serrano García 2015.

65. AGN Curas y Obispos 21 44 D 2, fols. 98r, 126r. Serrano García describes Tamayo as "un seglar imbuido por un impulso evangelizador," 2015: 46.

66. AGN Curas y Obispos 21 44 D 2, fol. 107r.

67. AGN Curas y Obispos 21 44 D 2, fol. 127r–v.

68. AGN Curas y Obispos 21 44 D 2, fol. 128r.

69. See AGN Curas y Obispos 21 44 D 2, fols. 218v–221r, 231r–233r. On the Yurumanguí language, see Campbell 2012: 69–70, 114; see also Adelaar and Muysken 2004: 60–61; Aikhenvald 2007: 190–191.

70. On 29 August 1768, Valencia reported to the viceroy that, to complete the project, more money would be needed, AGN Curas y Obispos 21 44 D 2, fol. 166v. Friar Romero expressed this sentiment in a letter as well, AGN Curas y Obispos 21 44 D 2, fols. 136r–137r.

71. See Romero's report dated 16 June 1768, which cites the difficulty of trying to organize and evangelize these Indians, AGN Curas y Obispos 21 44 D 2, fols. 158v–159r.

72. AGN Curas y Obispos 21 44 D 2 (16 July 1768), fols. 161v–162r. Larrea commented on this as well, see fol. 168r (28 August 1768). The number of Indians in this area before this time is difficult to gauge. For late sixteenth-century populations, see Escobar (1582) 1992: 346.

73. AGN Curas y Obispos 21 44 D 2 (10 October 1768), fols. 170r, 310r.

74. AGN Curas y Obispos 21 44 D 2 (20 February 1770), fol. 187r–v.

75. AGN Curas y Obispos 21 44 D 2, fol. 187r. For other instances of infanticide, see Echeverri 2009.

76. AGN Curas y Obispos 21 44 D 2, fol. 171r–v, 187v.

77. AGN Curas y Obispos 21 44 D 2, fol. 187v. In his letter to the viceroy of 20 February 1770, Larrea noted, "La providencia más necesaria es la de la apertura del camino, sin ella es muy difícil que tengan incremento las conversiones," fol. 187v. Larrea understood that without a road, there could be no mission, and that without a mission, the perpetuation of the Colegio of Cali was hard to justify, see Serrano García 2015: 54.

78. In Larrea's words, "Se puede abrir con facilidad un camino muy breve y muy derecho. El sujeto de más eficacia y de imperio para abrir el camino es don Manuel Caicedo, alférez real de Cali. Me persuado de que con 500 pesos que contribuyan las reales cajas para los gastos necesarios, dejará el alférez real el camino abierto, porque tiene genio para ello. Sin estas providencias no es daba que el colegio pueda mantener las conversiones," AGN Curas y Obispos 21 44 D 2 (20 February 1770), fol. 187v.

79. AGN Curas y Obispos 21 44 D 2 (17 November 1770), fols. 250v–252r.

80. According to Caicedo, his great-grandfather had undertaken the pacification of Indians in the Chocó in 1684, AGN Curas y Obispos 21 44 D 2, fol. 281v. This bears mention as Caicedo continued this family tradition by involving himself in the very late pacification and reducción of the indios infieles in the Naya and Yurumanguí area, AGN Curas y Obispos 21 44 D 2, fols. 198r–200v, 251v. See also discussion in Colmenares 1975: 40–41, 101, 126.

81. Colmenares 1975: 135. This post was purchased, not elected.

82. As a result, Otorola's mining rights and associated assets went to the second bidder, Francisco Gerónimo de Mondragón, cura and vecino of the pueblo of Noanamá, ACC Sig. 11392 Col. J I-17 mn (1760), fols. 66v–67v.

83. See Caicedo's letter to the viceroy, AGN Curas y Obispos 21 44 D 2, fols. 198r–200v. With Caicedo's involvement, the road's destination and power dynamics shifted from Popayán to Cali. For a story with remarkable parallels involving Franciscan missionaries, provincial officials, and local rivalries, see Scott's recounting of the eighteenth-century mapping of the Mosetenes frontier in Bolivia and the mapmaker's personal investment in the region, 2015: 408–409.

84. Caicedo claimed he was given rights to mine by the viceroy, but he was unable to present documentation in support of this, ACC Sig. 11391 Col. J I-17 mn (1775–1776), fol. 18r.

85. AGN Curas y Obispos 21 44 D 2 (29 October 1774), fols. 302v–303r. See also letter dated 1 March 1775, fol. 308r: " . . . el fatal estado en que se halla el camino de la montaña de Yurumanguí cuya apertura ofreció hacer de su peculio Manuel de Caicedo" (March 1775). This is corroborated in ACC Sig. 11391 Col. J I-17 mn, fol. 13r: "Manuel de Caicedo no ha abierto camino alguno para las cordilleras de Naya y Yurumanguí como lo ofreció a su excelencia."

86. As the viceroy was told, the reducción could not be established because "no han hallado indios infieles con que poderlos poblar," AGN Curas y Obispos 21 44 D 2, fol. 310r.

87. AGN Curas y Obispos 21 44 D 2, fols. 34v–35r, 143r–144r.

88. AGN Curas y Obispos 21 44 D 2 (12 November 1770), fols. 244r–245r.

89. In his letter to the viceroy, Caicedo proposed using pre-existing Indigenous roads, specifically those that connected the dwellings of native inhabitants, AGN Curas y Obispos 21 44 D 2 (25 October 1771), fol. 281r–v. Caicedo estimated the cost of this road would be five or six hundred pesos.

90. The detailed ethnographic description in Lanchas de Estrada's diary can be found in AGN Curas y Obispos 21 44 D 2, fols. 146r–148v.

91. AGN Curas y Obispos 21 44 D 2, fol. 146r–v.

92. West also believed the twentieth-century houses bore resemblance to descriptions made by Spanish chroniclers. He notes that these elevated structures, which sit five to ten feet (one and a half to three meters) above the ground, were accessed by a notched-log, or chicken, ladder. While this design is useful for areas where flooding is common, this same style of structure is also used at well-drained sites, perhaps to protect inhabitants from predatory animals or people, West 1957: 116.

93. AGN Curas y Obispos 21 44 D 2, fol. 147r.

94. "Los entierran en la casa donde mueren, y encima del sepulcro queman sus bienes . . . y dejan la casa, y mudan a otra," AGN Curas y Obispos 21 44 D 2, fol. 148r.

95. AGN Curas y Obispos 21 44 D 2, fol. 148r.

96. AGN Curas y Obispos 21 44 D 2, fol. 146v.

97. AGN Curas y Obispos 21 44 D 2, fol. 146v.

98. AGN Curas y Obispos 21 44 D 2, fol. 147v. A thick, white worm was also part of their diet, fol. 146v.

99. AGN Curas y Obispos 21 44 D 2, fol. 146v. Lanchas de Estrada's writings reveal a keen interest in Indigenous lifeways and foodways. These things were of less interest to Caicedo, who omitted areas for food cultivation and avian domestication on his map.

100. See, for example, discussion in Nielsen 2019: 52.

101. AGN Curas y Obispos 21 44 D 2, fols. 198v–199r. The distance separating the dwellings labeled 9 and 10 is a half league (perhaps one and a third miles [two kilometers]), while 10 and 11 are separated by more than a league (over two and a half miles [four kilometers]). The distance between house 11 and house 12 was more than a league and a half (or nearly four miles [approximately six kilometers]).

102. AGN Curas y Obispos 21 44 D 2, fol. 147v.

103. For a fascinating discussion of Pre-Hispanic Indigenous roads, see Cardale Schrimpff 1996.

104. See appendix A, no. 16, where the text reads, "Camino que corre a las minas del río Yurumanguí."

105. This leg took three days, AGN Curas y Obispos 21 44 D 2, fol. 34v.

106. Caicedo underscored that he had walked every inch of the area depicted in the map, AGN Curas y Obispos 21 44 D 2, fol. 200r.

107. AGN Curas y Obispos 21 44 D 2, fol. 146r. They also used damajagua bark as a blanket, AGN Curas y Obispos 21 44 D 2, fol. 146v. Damajagua is a type of hibiscus whose bark was used by the Taínos and other Indigenous groups to make clothes, mats, etc. I thank Joaquín Rivaya-Martínez for this information.

108. AGN Curas y Obispos 21 44 D 2, fol. 147r. It is not clear whether this habit intensified with the incursions of the Spaniards.

109. AGN Curas y Obispos 21 44 D 2, fol. 146v.

110. AGN Curas y Obispos 21 44 D 2, fol. 148r.

111. Cardale Schrimpff 2005: 63.

112. AGN Curas y Obispos 21 44 D 2, fol. 199r. These lands were apparently not explored by Caicedo, nor were they visited by Franciscans or miners who made entradas to this region.

113. AGN Curas y Obispos 21 44 D 2, fol. 199r.

114. AGN Curas y Obispos 21 44 D 2, fol. 147v. The Yurumanguí fought with *dardos*, "spears," 7 feet (2.1 meters) in length and defended themselves with strong, tightly woven shields 3.5 feet (1.1 meters) in diameter, fol. 146r.

115. Monmonier 1991; see also Harley 1988: 57–76; 2002.

116. AGN Curas y Obispos 21 44 D 2, fol. 170r–v.

117. AGN Curas y Obispos 21 44 D 2, fol. 187r–v.

118. AGN Curas y Obispos 21 44 D 2, fols. 198r–200v.

119. AGN Curas y Obispos 21 44 D 2, fols. 281r–282r.

120. AGN Curas y Obispos 21 44 D 2, fol. 200r.

121. AGN Curas y Obispos 21 44 D 2, fol. 200r.

122. Moreno y Escandón referred to "ofertas hechas por Sebastián Sánchez, vecino de Popayán, y don Manuel Caicedo, vecino de Cali. . . . Se le encargado la apertura de un camino que no se conceptúa difícil a las habitaciones de los infieles, y puede conducir no solo a su reducción, sino también al aumento de la población y goce de las feraces tierras incultas y nada conocidas, abandonadas, y abundantes de preciosos frutos y principalmente de minas en los amagamientos de río Dagua y los nombrados Turunangui [*sic*] y Naya," ACC Sig. 12015 Civil IV-11 g (1772), fols. 13v–14r. For a transcription of the report, see Colmenares 1989: 1:168–169.

123. For more on this map, see Mejía 2016.

124. AGN Curas y Obispos 21 44 D 2 (12 December 1770), fols. 198r–200v.

125. As Caicedo put it, "Gasté en ida y vuelta cerca de seiscientos pats. [patacones] parte en los cargueros que llevé y lo más en herramientas, cascabeles, y alguna ropa y con todo no pasaron hasta dejarme casi desnudo y de esta forma salí por el río Cajambre," AGN Curas y Obispos 21 44 D 2, fol. 199v.

126. AGN Curas y Obispos 21 44 D 2, fol. 200r.

127. Herrera Ángel 2016: 33–35.

Conclusions

1. Nielsen 2019: 211–212; see also Cromwell 2018; Langfur 2006.

2. Kuethe and Andrien 2014: 1–3.

3. See Kuethe 1990: 31–34.

4. Codazzi in Barona et al. 2002: 105–106, 55, 105.

5. See Herrera Ángel 2016: 33–35.

REFERENCES

Acevedo Latorre, Eduardo. 1968. *Geografía pintoresca de Colombia: Nueva Granada vista por dos viajeros franceses del siglo XIX, Charles Saffray y Edouard André.* Bogotá: Litografía Arco.

Acevedo Latorre, Eduardo. 1986. *Atlas de mapas antiguos de Colombia, siglos XVI a XIX.* 3rd ed. Bogotá: Litografía Arco.

Adelaar, Willem, and Pieter Muysken. 2004. *The Languages of the Andes.* Cambridge: Cambridge University Press.

Adelman, Jeremy, and Stephen Aron. 1999. "From Borderlands to Borders: Empires, Nation-States, and the Peoples in between in North American History." *American Historical Review* 104 (3): 814–841.

Afanador-Llach, Maria José. 2016. "Political Economy, Geographical Imagination, and Territory in the Making and Unmaking of New Granada, 1739–1830." PhD diss., Department of History, University of Texas, Austin.

Aikhenvald, Alexandra. 2007. "Languages of the Pacific Coast and South America." In *The Vanishing Languages of the Pacific Rim,* edited by Osahito Miyaoka, Osamu Sakiyama, and Michael E. Krauss, 183–205. Oxford: Oxford University Press.

Almario García, Oscar. 2009. "De lo regional a lo local en el Pacífico sur colombiano, 1780–1930." *HiSTOReLo: Revista de historia regional y local* 1 (1): 76–123.

Álvarez Lleras, Jorge. 1923. *El Chocó: Apuntamientos de viaje referentes a esta interesante región del país.* Bogotá: Editorial Minerva.

André, Édouard. 1884. "América equinoccial." In *América pintoresco: Descripción de viajes al nuevo continente,* 477–859. Barcelona: Montaner y Simón Editores.

Andrien, Kenneth. 1998. "The 'Noticias secretas de América' and the Construction of a Governing Ideology for the Spanish American Empire." *Colonial Latin American Review* 7 (2): 175–192.

Appelbaum, Nancy. 2013. "Reading the Past on the Mountainsides of Colombia: Mid-Nineteenth-Century Patriotic Geology, Archaeology, and Historiography." *Hispanic American Historical Review* 93 (3): 347–376.

Appelbaum, Nancy. 2016. *Mapping the Country of Regions: The Chorographic Commission of Nineteenth-Century Colombia.* Chapel Hill: University of North Carolina Press.

Aprile-Gniset, Jacques. 2016. *La ciudad colombiana: La formación espacial de la conquista, siglos XVI y XVII.* Cali: Universidad del Valle.

Arboleda, Gustavo. 1956. *Historia de Cali: Desde los orígenes de la ciudad hasta la expiración del periodo colonial,* vols. 1, 2, and 3. Cali: Biblioteca de la Universidad del Valle.

Arcila Robledo, Gregorio. 1940. "Vocabulario de los indios Yurumanguíes." *Voz franciscana: Revista científico popular* 16 (179): 341–343.

Arias, Santa, and Mariselle Meléndez, eds. 2002. *Mapping Colonial Spanish America: Places and Commonplaces of Identity, Culture, and Experience.* Lewisburg, PA: Bucknell University Press; London: Associated University Presses.

Azaryahu, Maoz. 2008. "Tel Aviv: Center, Periphery and the Cultural Geographies of an Aspiring Metropolis." *Social and Cultural Geography* 9 (3): 303–318.

Baquero Montoya, Álvaro, and Antonino Vidal Ortega. 2004. *La gobernación del Darién a finales del siglo XVIII: El informe de un funcionario ilustrado.* Barranquilla: Ediciones Uninorte.

Barco Isakson, Carolina. 2017. "Virgilio Barco: Un liberal de verdad." In *La presidencia de Virgilio Barco:*

Treinta años después, edited by Carlos Caballero Argáez, 17–24. Bogotá: Universidad de los Andes.

Barona, Guido. 1986. "Problemas de la historia económica y social colonial en referencia a los grupos negros, siglo XVIII." In *La participación del negro en la formación de las sociedades latinoamericanas*, edited by Alexander Cifuentes, 61–80. Bogotá: Instituto Colombiano de Antropología.

Barona, Guido. 1995. *La maldición de Midas en una región del mundo colonial: Popayán, 1730–1830*. Cali: Universidad del Valle.

Barona, Guido, Camilo Domínguez Ossa, Augusto Javier Gómez López, and Apolinar Figueroa Casas. 2002. *Geografía física y política de la confederación Granadina*, vol. 1, *Estado de Cauca*, pt. 2, *Provincias del Chocó, Buenaventura, Cauca y Popayán, obra dirigida por el General Agustín Codazzi*. Cali: Colciencias, Grupo de Estudios Ambientales, GEA, Universidad del Cauca.

Barr, Juliana. 2007. *Peace Came in the Form of a Woman: Indians and Spaniards in the Texas Borderlands*. Chapel Hill: University of North Carolina Press.

Barragan, Yesenia. 2016. "Slavery, Free Black Women, and the Politics of Place in Chocó, Colombia." *Revista de estudios colombianos* 47: 57–66.

Bassett, Thomas J. 1998. "Indigenous Mapmaking in Intertropical Africa." In *The History of Cartography*, vol. 2, bk. 3, *Cartography in the Traditional African, American, Arctic, Australian, and Pacific Societies*, edited by David Woodward and G. Malcolm Lewis, 24–48. Chicago: University of Chicago Press.

Bassi, Ernesto. 2016. *An Aqueous Territory: Sailor Geographies and New Granada's Trans-Imperial Greater Caribbean World*. Durham: Duke University Press.

Beaule, Christine D., and John G. Douglass, eds. 2020. *The Global Spanish Empire: Five Hundred Years of Place Making and Pluralism*. Amerind Studies in Archaeology. Tucson: University of Arizona Press.

Bernal, Isabella. 2017. "En mula y en lancha, recorrimos la ruta más agreste del narcotráfico." Pacifista!, 2 January. https://pacifista.tv/notas/en-mula-y-en-lancha-recorrimos-la-ruta-mas-agreste-del-narcotrafico/.

Bethencourt, Francisco. 2013. *Racisms: From the Crusades to the Twentieth Century*. Princeton: Princeton University Press.

Bleichmar, Daniela. 2006. "Painting as Exploration: Visualizing Nature in Eighteenth-Century Colonial Science." *Colonial Latin American Review* 15 (1): 81–104.

Bleichmar, Daniela. 2008. "Atlantic Competitions: Botany in the Eighteenth-Century Spanish Empire." In *Science and Empire in the Atlantic World*, edited by James Delbourgo and Nicholas Dew, 225–252. New York: Routledge.

Bleichmar, Daniela. 2015. "The Imperial Visual Archive: Images, Evidence, and Knowledge in the Early Modern Hispanic World." *Colonial Latin American Review* 24 (2): 236–266.

Blond, Stéphane. 2019. "Administrative Cartography." In *The History of Cartography*, vol. 4, part 1, *Cartography in the European Enlightenment*, edited by Matthew H. Edney and Mary Sponberg Pedley, 25–31. Chicago: University of Chicago Press.

Bockelman, Brian, and Jeffrey Erbig. 2020. "Still Turning towards a Cartographic History of Latin America." *History Compass* 18: 1–15.

Bonilla, Maria E. 1984. "Solamente se ve lo que se sabe: Entrevista con Ernesto Guhl." *Boletín cultural y bibliográfico* 21 (1): 25–30.

Borucki, Alex, David Eltis, and David Wheat. 2015. "Atlantic History and the Slave Trade to Spanish America." *American Historical Review* 120 (2): 433–461.

Boussingault, Jean-Baptiste. 1985. *Memorias*. Vol. 1. Bogotá: Banco de la República.

Boyd-Bowman, Peter, and William Frederick Sharp. 1981. *Description of the Province of Zitará and Course of the River Atrato: Critical Edition*. Buffalo: Council on International Studies, State University of New York at Buffalo.

Bray, Warwick. 1984. "Across the Darién Gap: A Columbian View of Isthmian Archaeology." In *The Archaeology of Lower Central America*, edited by Frederick Lange and Doris Stone, 305–338. Albuquerque: School of American Research, University of New Mexico Press.

Brisson, Jorge. 1895. *Exploración en el alto Chocó*. Bogotá: Imprenta Nacional.

Bryant, Sherwin K. 2006. "Finding Gold, Forming Slavery: The Creation of a Classic Slave Society, Popayán, 1600–1700." *The Americas* 63 (1): 81–112.

Bryant, Sherwin K. 2014. *Rivers of Gold, Lives of Bondage: Governing through Slavery in Colonial Quito*. Chapel Hill: University of North Carolina Press.

Buisseret, David. 2007. "Spanish Colonial Cartography, 1450–1700." In *The History of Cartography*, vol. 3, part 1, *Cartography in the European Renaissance*, edited by David Woodward, 1143–1171. Chicago: University of Chicago Press.

Caldas, Francisco José de. 1942. *Semanario del Nuevo Reino de Granada*. Bogotá: Biblioteca Popular de Cultura Colombiana.

Calero, Luis F. 1997. *Chiefdoms under Siege: Spain's Rule and Native Adaptation in the Southern Colombian Andes, 1535–1700*. Albuquerque: University of New Mexico Press.

"Cali en 1765: Informe rendido al virrey sobre la supresión del estanco de aguardiente y los movimientos y subversivos que eso ocasionó." 1937. *Boletín Histórico del Valle*, nos. 43–45, 246–252.

Campbell, Lyle. 2012. "Classification of the Indigenous Languages of South America." In *The Indigenous*

Languages of South America: A Comprehensive Guide, edited by Lyle Campbell and Verónica Grondona, 59–166. Berlin and Boston: Walter de Gruyter.

Cantor, Erik Werner. 1999. "Extracción de oro: Encuentro de Emberá, afroamericanos, y europeos en la cuenca del Atrato, siglo XVIII." In *Construcción territorial en el Chocó*, edited by Patricia Vargas Sarmiento, 67–96. Bogotá: Programa de Historia Local y Regional del Instituto Colombiano de Antropología.

Cantor, Erik Werner. 2000. *Ni aniquilados ni vencidos: Los Emberá y la gente negra del Atrato bajo el dominio español, siglo XVIII*. Bogotá: Instituto Colombiano de Antropología e Historia.

Cardale Schrimpff, Marianne. 1996. *Caminos prehispánicos en Calima: El estudio de caminos precolombinos de la cuenca del alto río Calima, Cordillera Occidental, Valle del Cauca*. Calima: Fundación de Investigaciones Arqueológicas Nacionales.

Cardale Schrimpff, Marianne. 2005. "The People of the Ilama Period." In *Calima and Malagana: Art and Archaeology in Southwestern Colombia*, edited by Marianne Cardale Schrimpff, 36–97. Bogotá: Pro Calima Foundation.

Carney, Judith. 2017. "'The Mangrove Preserves Life': Habitat of African Survival in the Atlantic World." *Geographical Review* 107 (3): 433–451.

Carvajal, Griseldino. 1910. *Canalizacion interoceánica por el Chocó*. Cali: Tipografía Moderna.

Casey, Edward S. 2002. *Representing Place: Landscape Painting and Maps*. Minneapolis: University of Minneapolis Press.

Celorio Mina, Francisco. 1971. *Historia del pueblo de San Francisco de Naya y costumbres antiguas comunes a otras regiones*. Cali: Imprenta Departmental.

Chandler, David Lee. 1972. "Health and Slavery: A Study of Health Conditions among Negro Slaves of the Viceroyalty of New Granada and Its Associated Slave Trade, 1600–1810." PhD diss., Department of History, Tulane University.

Chandler, David Lee. 1981. "Family Bonds and the Bondsman: The Slave Family in Colonial Colombia." *Latin American Research Review* 16 (2): 107–131.

Chandler, David Lee. 1982. "Slave over Master in Colonial Colombia and Ecuador." *The Americas* 38 (3): 315–326.

Chipman, Donald E., and Harriett Denise Joseph. 2010. *Spanish Texas, 1519–1821*. Austin: University of Texas Press.

Cochrane, Charles Stuart. 1825. *Journal of a Residence and Travels in Colombia during the Years 1823 and 1824*. 2 vols. London: Henry Colburn.

Colmenares, Germán. 1975. *Cali: Terratenientes, mineros y comerciantes, siglo XVIII*. Cali: Universidad del Valle.

Colmenares, Germán. 1979. *Historia económica y social de Colombia*, vol. 2, *Popayán: Una sociedad esclavista, 1680–1800*. Bogotá: La Carreta Inéditos.

Colmenares, Germán. 1989. *Relaciones e informes de los gobernantes de la Nueva Granada*. 3 vols. Bogotá: Fondo de Promoción de la Cultura del Banco Popular.

Cooke, Richard. 1998. "Cupica (Chocó): A Reassessment of Gerardo Reichel-Dolmatoff's Fieldwork in a Poorly Studied Region of the American Tropics." In *Recent Advances in the Archeology of the Northern Andes*, edited by Augusto Oyuela-Caycedo and J. Scott Raymond, 91–106. Los Angeles: Institute of Archaeology, University of California Los Angeles.

Correa Restrepo, Juan Santiago. 2012. *De Buenaventura al Caribe: El ferrocarril del Pacífico y la conexión interoceánica*. Bogotá: Colegio de Estudios Superiores de Administración.

Cortés, Vicenta. 1967. *Catálogo de mapas de Colombia*. Madrid: Cultura Hispánica.

Cromwell, Jesse. 2018. *The Smugglers' World: Illicit Trade and Atlantic Communities in Eighteenth-Century Venezuela*. Chapel Hill: University of North Carolina Press.

Cuervo, Antonio B., comp. 1892. *Colección de documentos inéditos sobre la geografía e historia de Colombia*, sec. 1a, *Geografía y viajes*, vol. 2, *Costa Pacífica, provincias litorales y campanas de los conquistadores*. Bogotá: Casa Editorial de J. J. Pérez.

Curtin, Philip D. 1968. "Epidemiology and the Slave Trade." *Political Science Quarterly* 83 (2): 190–216.

Curtin, Philip D. 1969. *The Atlantic Slave Trade: A Census*. Madison: University of Wisconsin Press.

Curtin, Philip D. 1993. "Disease Exchange across the Tropical Atlantic." *History and Philosophy of the Life Sciences* 15 (3): 329–356.

Dampier, William. 1729. "A New Voyage round the World, Describing Particularly the Isthmus of America [. . .]." In *A Collection of Voyages in Four Volumes*, vol. 1, 3rd ed., 1–257. London: James and John Knapton.

Dávila Murillo, Hugo. 2020. "Cupica: Gran puerto marítimo." Chocó7días.com, 8 May. https://choco7dias .com/cupica-gran-puerto-maritimo.

Dawson, Kevin. 2018. *Undercurrents of Power: Aquatic Culture in the African Diaspora*. Philadelphia: University of Pennsylvania Press.

Deeds, Susan. 2003. *Defiance and Deference in Mexico's Colonial North*. Austin: University of Texas Press.

de Granda, Germán. 1977. *Estudios sobre un área dialectal hispanoamericana de la población negra: Las tierras bajas occidentales de Colombia*. Bogotá: Colombia Instituto Caro y Cuervo.

de la Rue, E. Aubert, and Edmond Bruet. 1943. "La hoya del río Naya: Estudio geológico y minero." *Revista de la Universidad del Cauca* 1: 137–160.

Delbourgo, James, and Nicholas Dew, eds. 2008. *Science and Empire in the Atlantic New World*. New York: Routledge.

del Castillo, Lina. 2006. "Mapping Power: Agustín Codazzi's Scientific Expeditions and the Formation of Nineteenth-Century Venezuela and Nueva Granada." In *Humboldt y otros viajeros en América Latina*,

edited by Lourdes de Ita Rubio and Gerardo Sánchez Díaz, 257–273. Morelia: Instituto de Investigaciones Históricas, Universidad Michoacana de San Nicolás de Hidalgo.

del Castillo, Lina. 2015. Review of *Geografía y cultura visual: Los usos de las imágenes en las reflexiones sobre el espacio*, edited by Carla Lois and Verónica Hollman. *Journal of Latin American Geography* 14 (3): 281–283.

del Castillo, Lina. 2017. "Cartography in the Production (and Silencing) of Colombian Independence History, 1807–1827." In *Decolonizing the Map: Cartography from Colony to Nation*, edited by James Akerman, 110–159. Chicago: University of Chicago Press.

del Castillo, Lina. 2018. *Crafting a Republic for the World: Scientific, Geographic, and Historiographic Inventions of Colombia*. Lincoln: University of Nebraska Press.

del Castillo, Lina. Forthcoming. "The Gran Colombian Mapping Commission." In *The History of Cartography*, vol. 5, *Cartography in the Nineteenth Century*, edited by Roger Kain, Imre Demhardt, and Carla Lois. Chicago: University of Chicago Press.

del Castillo, Lina, Sebastián Díaz Ángel, and Lucía Duque Muñoz. 2014. "Los mapas de la Gran Colombia." In *Cartografía hispánica, 1800–1975: Una cartografía inestable en un mundo convulso*, edited by Mariano Cuesta Domingo, 97–118. Madrid: Ministerio de Defensa.

del Castillo Mathieu, Nicolás. 1982. *Esclavos negros en Cartagena: Sus aportes léxicos*. Bogotá: Instituto Caro y Cuervo.

"Descripción superficial de la provincia del Zitará, con sucinto relato de sus poblaciones, establecimientos de minas y ríos de mayor nombre." 1983. *Cespedesia*, nos. 45–46, suppl. 4, 425–446.

Diaz Ángel, Santiago, Santiago Muñoz Arbeláez, and Mauricio Nieto Olarte. 2010. *Ensamblando la nación: Cartografía y política en la historia de Colombia*. Bogotá: Universidad de los Andes.

Diaz Ángel, Santiago, Santiago Muñoz Arbeláez, and Mauricio Nieto Olarte. 2013. "¿Cómo se hace un mapa? El caso del atlas de José Manuel Restrepo." In *Ensamblado en Colombia*, vol. 2, *Ensamblando heteroglosias*, edited by Olga Restrepo, 293–310. Bogotá: Universidad Nacional de Colombia.

Díaz Ángel, Sebastián. 2016. "Cartografías de El Dorado: Releyendo fragmentos de la historia minera de Colombia a través de algunos mapas (siglos XVI a XX)." In *Minería y desarrollo*, vol. 5, *Historia y gobierno del territorio minero*, edited by Juan Carlos Henao y Sebastián Díaz Ángel, 31–84. Bogotá: Universidad Externado de Colombia.

Díaz Ángel, Sebastián, and Lucía Duque Muñoz. Forthcoming a. "Northern Spanish America (Colombia, Ecuador, Peru, Venezuela)." In *The History of Cartography*, vol. 5, *Cartography in the Nineteenth Century*, edited by Roger Kain, Imre Demhardt, and Carla Lois. Chicago: University of Chicago Press.

Díaz Ángel, Sebastián, and Lucía Duque Muñoz. Forthcoming b. "Administrative Cartography in Spanish America." In *The History of Cartography*, vol. 5, *Cartography in the Nineteenth Century*, edited by Roger Kain, Imre Demhardt, and Carla Lois. Chicago: University of Chicago Press.

Díaz López, Zamira. 1994. *Oro, sociedad y economía: El sistema colonial en la gobernación de Popayán: 1533–1733*. Bogotá: Banco de la República.

Donoso, Juan Jiménez. (1780) 1954a. "Relación del conocimiento que hizo del río Atrato el capitán de ingenieros Juan Jiménez Donoso [. . .]." In *Historia documental del Chocó*, vol. 24, edited by Enrique Ortega Ricaurte, 235–241. Bogotá: Departamento de Biblioteca y Archivos Nacionales.

Donoso, Juan Jiménez. (1780) 1954b. "Relación del Chocó o de las provincias de Zitará y Nóvita [. . .]." In *Historia documental del Chocó*, vol. 24, edited by Enrique Ortega Ricaurte, 205–234. Bogotá: Departamento de Biblioteca y Archivos Nacionales.

Duque Muñoz, Lucía. 2006. "Geografía y cartografía en la Nueva Granada (1840–1865): Producción, clasificación, temática e intereses." *Anuario colombiano de historia social y de la cultura*, 33: 11–30.

Duque Muñoz, Lucía. 2009. "El discurso geográfico y cartográfico sobre los límites entre Nueva Granada y Venezuela (1830–1883)." *Anuario colombiano de historia social y de la cultura* 36 (1): 125–152.

Duque Muñoz, Lucía. 2012. "Geografía y cartografía en la etapa fundacional del estado colombiano: Entre la utopía liberal y las herencias coloniales." In *Independencia: Historia diversa*, edited by Bernardo Tovar Zambrano, 413–439. Bogotá: Universidad Nacional de Colombia.

Duque Muñoz, Lucía. 2013a. "Rutas e itinerarios de geógrafos, cartógrafos y naturalistas en el territorio de la Nueva Granada (1750–1847)." In *Impactos territoriales en la transición de la colonia a la república en Nueva Granada*, edited by Lucía Duque Muñoz, Jhon Williams Montoya Garay, Luis Carlos Jiménez Reyes, and Juan David Delgado Rozo, 127–183. Bogotá: Universidad Nacional de Colombia.

Duque Muñoz, Lucía. 2013b. "Límites y áreas de frontera durante la década de 1820 en la República de Colombia." In *Proyecto Ensamblando en Colombia*, vol. 1, *Ensamblado estados*, edited by Olga Restrepo, 131–144. Bogotá: Facultad de Ciencias Humanas, Centro de Estudios Sociales, Universidad Nacional de Colombia.

Dym, Jordana. 2019. "Administrative Cartography in Spanish America." In *The History of Cartography*, vol. 4, part 1, *Cartography in the European Enlightenment*, edited by Matthew H. Edney and Mary Sponberg Pedley, 82–89. Chicago: University of Chicago Press.

Dym, Jordana, and Karl Offen, eds. 2011. *Mapping Latin America: A Cartographic Reader*. Chicago: University of Chicago Press.

Echeverri, Marcela. 2009. "'Enraged to the Limit of Despair': Infanticide and Slave Judicial Strategies in Barbacoas, 1788–1798." *Slavery and Abolition* 30 (3): 403–426.

Edney, Matthew H. 2009. "The Irony of Imperial Mapping." In *The Imperial Map: Cartography and the Mastery of Empire*, edited by James Ackerman, 11–45. Chicago: University of Chicago Press.

Edney, Matthew H. 2019. *Cartography: The Ideal and Its History*. Chicago: University of Chicago Press.

Empson, Charles. 1836. *Narratives of South America: Illustrating Manners, Customs, and Scenery*. London: William Edwards.

Erbig, Jeffrey. 2016. "Borderline Offerings: Tolderías and Mapmakers in the Eighteenth-Century Río de la Plata." *Hispanic American Historical Review* 96 (3): 445–480.

Erbig, Jeffrey. 2020. *Where Caciques and Mapmakers Met: Border Making in Eighteenth-Century South America*. Chapel Hill: University of North Carolina Press.

Escalante, Aquiles. 1973. "Palenques en Colombia." In *Maroon Societies: Rebel Slave Communities in the Americas*, edited by Richard Price, 74–81. Baltimore: Johns Hopkins University Press.

Escobar, Fray Gerónimo de. (1582) 1992. "Gobierno de Popayán: Calidades de la tierra." In *Relaciones histórico-geográficas de la Audiencia de Quito, siglos XVI–XIX*, vol. 1, edited by Pilar Ponce Leiva, 332–358. Madrid: Consejo Superior de Investigaciones Científicas, Centro de Estudios Históricos.

Fermín de Vargas, Pedro. 1953. *Pensamientos políticos y memoria sobre la población de Nuevo Reino de Granada*. Bogotá: Banco de la República; Archivo de la Economía Nacional.

Fisher, John R. 1981. "Imperial 'Free Trade' and the Hispanic Economy, 1778–1796." *Journal of Latin American Studies* 13 (1): 21–56.

Friedemann, Nina S. de. 1971. *Minería, descendencia y orfebrería artesanal: Litoral Pacífico, Colombia*. Bogotá: Facultad de Ciencias Humanas, Universidad Nacional.

Friedemann, Nina S. de. 1976. *Tierra, tradición, y poder en Colombia*. Bogotá: Instituto Colombiano de Cultura.

Friend, Charles. 1853. "Notes of an Excursion from the Banks of the Atrato to the Bay of Cupica, on the Coast of the Pacific, in the Year 1827." *Journal of the Royal Geographical Society of London* 23: 191–196.

Fuentes Crispín, Nara. 2015. *Atlas histórico marítimo de Colombia, siglos XVI–XVIII*. Bogotá: Comisión Colombiano del Océano.

Fuentes Crispín, Nara. 2016. "Hacia el mar del sur por un río de oro: Un avistamiento prefigurado en mapas." *Boletín cultural y bibliográfico* 50 (90): 27–52.

Funnell, William. 1729. "A Voyage round the World: Being an Account of Captain Dampier's Expedition into the South Seas in the Ship *St. George*, with His Various Adventures and Engagements [. . .]." In *A Collection of Voyages in Four Volumes*, vol. 4, 3rd ed., 1–208. London: James and John Knapton.

Galindo Díaz, Jorge, and Laura María Henao Montoya. 2017. "Las fortificaciones perdidas del Darién: Los proyectos del ingeniero militar Antonio de Arévalo (1761–1785)." In *Defensive Architecture of the Mediterranean: XV to XVIII Centuries*, vol. 5, edited by Victor Echarri Iribarren, 55–62. Alicante: Publicacions Universitat d'Alicant.

Gallup-Diaz, Ignacio. 2001. "'Haven't We Come to Kill the Spaniards?' The Tule Upheaval in Eastern Panama, 1727–1728." *Colonial Latin American Review* 10 (2): 251–271.

Gallup-Diaz, Ignacio. 2008. *The Door of the Seas and Key to the Universe: Indian Politics and Imperial Rivalry in the Darién, 1640–1750*. New York: Columbia University Press.

Garrido, Margarita. 2005. "'Free Men of All Colors' in New Granada. Identity and Obedience before Independence." In *Political Cultures in the Andes, 1750–1950*, edited by Nils Jacobsen and Cristóbal Aljovín de Losada, 165–183. Durham: Duke University Press.

Gil Albarracín, Antonio. 2004. *Documentos sobre la defensa de la costa del reino de Granada (1497–1857)*. Almería-Barcelona: Griselda Bonet Girabet Editoral.

Gil Albarracín, Antonio. 2015. "Baterías, fortalezas y torres: El patrimonio defensivo de la costa de la provincia de Granada." *Revista PH* 87: 64–77.

Giraldo Herrera, César Enrique. 2009. *Ecos en el arrullo del mar: Las artes de la marinería en el Pacífico colombiano y su mimesis en la música y baile*. Bogotá: Universidad de los Andes.

Gómez, Pablo F. 2017. *The Experiential Caribbean: Creating Knowledge and Healing in the Early Modern Atlantic*. Durham: University of North Carolina Press.

González, Margarita. 1971. *El resguardo en el Nuevo Reino de Granada*. Bogotá: Universidad Nacional de Colombia.

González de Mendoza, Pedro. (1592) 1991. "Relación del cerro de Zaruma, distancia de leguas y asiento de minas y sobre los indios de aquella provincia." In *Relaciones histórico-geográficas de la Audiencia de Quito, siglos XVI–XIX*, edited by Pilar Ponce Leiva, 546–552. Quito: Marka Instituto de Historia y Antropología Andinas y Ediciones Abya-yala.

González Escobar, Luís Fernando. 1996. "Chocó en la cartografía histórica: De territorio incierto a departamento de un país llamado Colombia." *Boletín cultural y bibliográfico* 33 (43): 3–72.

Grahn, Lance Raymond. 1997. *The Political Economy of Smuggling: Regional Informal Economies in Bourbon New Granada*. Boulder: Westview Press.

Graubart, Karen. 2013. "Lazos que unen: Dueñas negras de esclavos negros en Lima, siglos XVI–XVII." *Nueva Corónica* 2: 625–640.

Griffin, Oliver. 2017. "Colombia's Secret Travel Path."

Raconteur, 17 February. https://www.raconteur.net /colombias-secret-travel-path/.

Gronim, Sara Stidstone. 2001. "Geography and Persuasion: Maps in British Colonial New York." *William and Mary Quarterly* 58 (2): 373–402.

Groot, José Manuel. 1869. *Historia eclesiástica y civil de Nueva Granada, escrita sobre documentos auténticos.* Vol. 1. Bogotá: M. Rivas.

Guhl, Ernesto. 1947. "La exploración de las fuentes de los ríos Naya y Yurumanguí." *Boletín de la Sociedad Geográfica de Colombia* 7 (4): 385–399.

Guhl, Ernesto. 1948. "La costa del Pacífico entre los ríos Dagua y Naya." *Boletín de la Sociedad Geográfica de Colombia* 8 (1): 99–113.

Gutiérrez de Alba, José María. n.d. "Impresiones de un viaje a América (1870–1884)." https://www.banrep.gov .co/impresiones-de-un-viaje/index.php/inicio/index.

Haguet, Lucile. 2011. "J.-B. D'Anville as Armchair Mapmaker: The Impact of Production Contexts on His Work." *Imago Mundi* 63 (1): 88–105.

Hamilton, John Potter. 1827. *Travels through the Interior Provinces of Colombia.* 2 vols. London: J. Murray.

Hansen, Caroline Anne. 1991. "Conquest and Colonization in the Colombian Choco: 1510–1740." PhD diss., Department of History, University of Warwick.

Harley, J. B. 1968. "The Evaluation of Early Maps: Towards a Methodology." *Imago Mundi* 22: 62–74.

Harley, J. B. 1987. "The Map and the Development of the History of Cartography." In *The History of Cartography*, vol. 1, *Cartography in Prehistoric, Ancient, and Medieval Europe and the Mediterranean*, edited by J. B. Harley and David Woodward, 1–42. Chicago: University of Chicago Press.

Harley, J. B. 1988. "Silences and Secrecy: The Hidden Agenda of Cartography in Early Modern Europe." *Imago Mundi* 40: 57–76.

Harley, J. B. 2002. *The New Nature of Maps: Essays in the History of Cartography*. Edited by Paul Laxton. Baltimore: Johns Hopkins University Press.

Hart, Francis Russell. 1929. *The Disaster of Darién: The Story of the Scots Settlement and the Causes of Its Failure, 1699–1701*. Boston: Houghton Mifflin.

Helg, Aline. 2004. *Liberty and Equality in Caribbean Colombia, 1770–1835*. Chapel Hill: University of North Carolina Press.

Hellman, Susan, and Maddy McCoy. 2017. "Soil Tilled by Free Men: The Formation of a Free Black Community in Fairfax County, Virginia." *Virginia Magazine of History and Biography* 125 (1): 38–67.

Hernández González, Manuel. 1996. *La emigración canaria a América (1765–1824): Entre el libre comercio y la emancipación*. La Laguna: Centro de la Cultura Popular Canaria.

Hernández Ospina, Mónica Patricia. 2006. "Formas de territorialidad española en la gobernación del Chocó durante el siglo XVIII." *Historia crítica* 32: 12–37.

Herrera Ángel, Marta. 1998. "Los pueblos que no eran pueblos." *Anuario de historia regional y de las fronteras* 4 (1): 13–45.

Herrera Ángel, Marta. 2009. *Popayán: La unidad de lo diverso: Territorio, población y poblamiento en la provincia de Popayán, siglo XVIII*. Bogotá: Universidad de los Andes.

Herrera Ángel, Marta. 2010. "Las ocho láminas de Humboldt sobre Colombia en vistas de las cordilleras y monumentos de los pueblos indígenas de América (1810)." *Internationale Zeitschrift für Humboldt-Studien* 11 (20): 84–118.

Herrera Ángel, Marta. 2014. *Ordenar para controlar: Ordenamiento espacial y control político en las llanuras del Caribe y en los Andes centrales neogranadinos, siglo XVIII*. 3rd ed. Bogotá: Universidad de los Andes.

Herrera Ángel, Marta. 2016. *El conquistador conquistado: Awas, Cuayquer, y Sindaguas en el Pacífico colombiano, siglos XVI–XVIII*. Bogotá: Universidad de los Andes.

Herrera Ángel, Marta. 2017. "La demografía colonial como proyecto político: Jaime Jaramillo y la ideología de la 'modernidad.'" *Anuario colombiano de historia social y de la cultura* 44 (1): 49–69.

Herzog, Tamar. 2008. *Defining Nations: Immigrants and Citizens in Early Modern Spain and Spanish America*. New Haven: Yale University Press.

Herzog, Tamar. 2015. *Frontiers of Possession: Spain and Portugal in Europe and the Americas*. Cambridge: Harvard University Press.

Hoppit, Julian, and Renaud Morieux. 2019. "Cartography and the Economy." In *The History of Cartography*, vol. 4, part 1, *Cartography in the European Enlightenment*, edited by Matthew H. Edney and Mary Sponberg Pedley, 360–367. Chicago: University of Chicago Press.

Hostetler, Laura. 2001. *Qing Colonial Enterprise: Ethnography and Cartography in Early Modern China*. Chicago: University of Chicago Press.

Howe, James. 1998. *A People Who Would Not Kneel: Panama, the United States and the San Blas Kuna*. Washington, DC: Smithsonian Institution Press.

Howse, Derek, and Norman J. W. Thrower. 1992. *A Buccaneer's Atlas: Basil Ringrose's South Sea Wagoneer*. Berkeley: University of California Press.

Humboldt, Alexander von. 2005. *Diarios de viaje en la Audiencia de Quito*. Edited by Segundo E. Moreno and Cristiana Borchart de Moreno (trad.). Quito: Occidental Exploration.

Humboldt, Alexander von, and Aimé Bonpland. 1966. *Personal Narrative of Travels to the Equinoctial Regions of the New Continent during the Years 1799–1804*. Vol. 6. Translated by Helen Maria Williams. New York: AMS Press.

Ireton, Chloe. 2017. "'They Are Blacks of the Caste of Black Christians': Old Christian Black Blood in the Sixteenth- and Early Seventeenth-Century Iberian Atlantic." *Hispanic American Historical Review* 97 (4): 579–612.

Isaacs, Jorge. 1867. *Maria*. Bogotá: Gaitán.

Isacsson, Sven-Erik. 1975. "Biografía Atrateña: La formación de un topónimo indígena bajo el impacto español (Chocó, Colombia)." *Indiana* 3: 93–110.

Jaramillo Uribe, Jaime. 1963. "Esclavos y señores en la sociedad colombiana del siglo XVIII." *Anuario colombiano de historia social y de la cultura* 1: 3–62.

Jaramillo Uribe, Jaime. 1987. "La economía del virreinato 1740–1810." In *Historia económica de Colombia*, edited by José Antonio Ocampo, 49–85. Bogotá: Siglo Veintiuno Editores de Colombia, Fedesarrollo.

Jiménez Meneses, Orián. 2004. *El Chocó, un paraíso del demonio: Nóvita, Citará y El Baudó, siglo XVIII*. Medellín: Facultad de Ciencias Humanas y Económicas, Editorial Universidad de Antioquia.

Juan, Jorge, and Antonio de Ulloa. 1748. *Relación histórica del viaje a la América Meridional*. Madrid: Antonio Marín.

Juan, Jorge, and Antonio de Ulloa. 1758. *A Voyage to South America: Describing at Large the Spanish Cities, Towns, Provinces, etc. on that Extensive Continent*. London: Davis and Reymers.

Kalmanovitz, Salomón. 2008. *La economía de la Nueva Granada*. Bogotá: Fundación Universidad de Bogotá Jorge Tadeo Lozano.

Karasch, Mary. 2016. *Before Brasilia: Frontier Life in Central Brazil*. Albuquerque: University of New Mexico Press.

Keiner, Christine. 2020. *Deep Cut: Science, Power, and the Unbuilt Interoceanic Canal*. Athens: University of Georgia Press.

Kelley, Sean M. 2016. *The Voyage of the Slave Ship* Hare: *A Journey into Captivity from Sierra Leone to South Carolina*. Chapel Hill: University of North Carolina Press.

Klein, Herbert S. 2012. "The African American Experience in Comparative Perspective: The Current Question of the Debate." In *Africans to Spanish America: Expanding the Diaspora*, edited by Sherwin K. Bryant, Rachel Sarah O'Toole, and Ben Vinson III, 206–222. Champaign: University of Illinois Press.

Klein, Herbert S., and Ben Vinson III, eds. 2007. *African Slavery in Latin America and the Caribbean*. 2nd ed. Oxford: Oxford University Press.

Kuening, Johannes. 1949. "Hessel Gerritsz." *Imago Mundi* 6: 48–66.

Kuethe, Allan J. 1990. "The Early Reforms of Charles III in the Viceroyalty of Nueva Granada, 1759–1776." In *Reform and Insurrection in Bourbon New Granada and Peru*, edited by John R. Fisher, Allan J. Kuethe, and Anthony McFarlane, 19–40. Baton Rouge: Louisiana State University Press.

Kuethe, Allan J., and Kenneth J. Andrien. 2014. *The Spanish Atlantic World in the Eighteenth Century: War and the Bourbon Reforms, 1713–1796*. Cambridge: Cambridge University Press.

Kveladz, Irma. 2019. "Cartographic Design and the Space–Time Cube." *Cartographic Journal: The World of Mapping* 56 (1): 73–90.

Lafuente, Antonio, and Nuria Valverde. 2005. "Linnaean Botany and Spanish Imperial Biopolitics." In *Colonial Botany: Science, Commerce, and Politics in the Early Modern World*, edited by Londa Schiebinger and Claudia Swan, 134–147. Philadelphia: University of Pennsylvania Press.

Landers, Jane. 1990. "Gracia Real de Santa Teresa de Mose: A Free Black Town in Spanish Colonial Florida." *American Historical Review* 95 (1): 9–30.

Landers, Jane. 1999. *Black Society in Spanish Florida*. Urbana: University of Illinois Press.

Landers, Jane G., and Barry M. Robinson, eds. 2006. *Slaves, Subjects, and Subversives: Blacks in Colonial Latin America*. Albuquerque: University of New Mexico Press.

Lane, Kris. 1996. "Mining the Margins: Precious Metals Extraction and Forced Labor Regimes in the Audiencia of Quito, 1532–1808." PhD diss., Department of History, University of Minnesota.

Lane, Kris. 2000. "The Transition from Encomienda to Slavery in Seventeenth–Century Barbacoas (Colombia)." *Slavery and Abolition* 21 (1): 73–95.

Lane, Kris. 2002. *Quito 1599: City and Colony in Transition*. Albuquerque: University of New Mexico Press.

Lane, Kris. 2011. "Gone Platinum: Contraband and Chemistry in Eighteenth-Century Colombia." *Colonial Latin American Review* 20 (1): 61–79.

Lane, Kris. 2021. *Potosí: The Silver City That Changed the World*. Oakland: University of California Press.

Lane, Kris. Forthcoming. "In the Shadow of Silver: The Gold of New Granada under the Habsburgs." In *Gold*, edited by Thomas Cummins. I Tatti Research Series. Cambridge: Harvard University Press.

Lane, Kris, and Mario Diego Romero. 2001. "Miners and Maroons: Freedom on the Pacific Coast of Colombia and Ecuador." *Cultural Survival Quarterly* 25 (4): 32–37.

Langfur, Hal. 2002. "Uncertain Refuge: Frontier Formation and the Origins of the Botocudo War in Late Colonial Brazil." *Hispanic American Historical Review* 82 (2): 215–256.

Langfur, Hal. 2006. *The Forbidden Lands: Colonial Identity, Frontier Violence, and the Persistence of Brazil's Eastern Indians, 1750–1830*. Stanford: Stanford University Press.

Leal, Claudia. 2018. *Landscapes of Freedom: Building a Post-Emancipation Society in the Rainforests of Western Colombia*. Tucson: University of Arizona Press.

Leon Giraldo, Guillermo, and Jimmy Humberto Campo Rodríguez. 2018. *Alcaldía de Dagua-Valle: Dagua moderna, pujante y productiva*. Dagua, Valle del Cauca: Dirección Local de Salud Municipio de Dagua.

Lipman, Andrew. 2015. *The Saltwater Frontier: Indians and the Contest for the American Coast*. New Haven: Yale University Press.

Loaiza Cano, Gilberto, and Maira Beltrán, eds. 2012. *Ensayos de historia cultural y política: Colombia, siglos XIX y XX*. Colección Historia y Espacio. Cali: Universidad del Valle.

Lopera Mesa, Gloria P. 2021. "'We Have the Land Titles': Indigenous Litigants and Privatization of Resguardos in Colombia, 1870s–1940s." PhD diss., Department of History, University Graduate School, Florida International University.

Loukotka, Čestmír, and Johannes Wilbert. 1968. *Classification of the South American Indian Languages*. Reference Series 7. Los Angeles: Latin American Center, University of California.

Lovejoy, Paul, and David Trotman, eds. 2004. *Transatlantic Dimensions of Ethnicity in the African Diaspora*. New York: Continuum.

MacMahon, Darcie, and Kathleen Deagan. 1996. "Legacy of Fort Mose." *Archaeology* 49 (5): 54–58.

Mancera Medina, Carol. 2005. "Documentos para el estudio de las vías de comunicación entre Antioquia y Chocó, siglos XVII, XVIII, y XIX." Informe final de trabajo de grado para optar por el título de Antropóloga, Universidad de Antioquia, Medellín.

Marín Leoz, Juana M. 2008. "Por la vía del Atrato: La designación de los gobernadores del Chocó por los virreyes Ezpeleta y Mendinueta (1789–1803)." In *Imperios ibéricos en comarcas americanas: Estudios regionales de historia colonial brasilera y neogranadina*, edited by Adriana María Alzate Echeverri, Manolo Florentino, and Carlos Eduardo Valencia Villa, 306–330. Bogotá: Universidade Federal de Rio de Jainero, Universidad del Rosario.

Mark, Edward Walhouse. 1963. *Acuarelas de Mark 1843–1856: Un testimonio pictórico de la Nueva Granada*. Bogotá: Banco de la República; Litografía Arco.

Martínez Capote, Ana Beiba. 2005. *Orígenes del municipio de Dagua*. Cali: Editorial Deriva.

Martínez Rubiano, Martha Teresa, and Luz Marina Bautista Estupiñan. 2003. *Cartografía de los territorios boyacenses*. Tunja: Banco de la República.

Marzahl, Peter. 1978. *Town in the Empire: Government, Politics, and Society in Seventeenth-Century Popayán*. Austin: University of Texas Press.

Maya Restrepo, Luz Adriana. 1998. "Demografía histórica de la trata por Cartagena 1533–1810." In *Geografía humana de Colombia*, vol. 6, *Los afrocolombianos*, edited by Instituto Colombiano de Antropología e Historia, 11–52. Bogotá: Instituto Colombiano de Cultura Hispánica.

McFarlane, Anthony. 1984. "Civil Disorders and Popular Protests in Late Colonial New Granada." *Hispanic American Historical Review* 64 (1): 17–54.

McFarlane, Anthony. 1986. "Cimarrones and Palenques: Runaways and Resistance in Colonial Colombia." In *Out of the House of Bondage: Runaways, Resistance and Marronage in Africa and the New World*, edited by Gad Heuman, 131–151. London: Frank Cass.

McFarlane, Anthony. 1993. *Colombia before Independence: Economy, Society, and Politics under Bourbon Rule*. Cambridge: Cambridge University Press.

McNeill, J. R. 1999. "Ecology, Epidemics and Empires: Environmental Change and the Geopolitics of Tropical America, 1600–1825." *Environment and History* 5 (2): 175–184.

McNeill, J. R. 2010. *Mosquito Empires: Ecology and War in the Greater Caribbean, 1620–1914*. Cambridge: Cambridge University Press.

Medina-Rivas, Miguel A., Emily T. Noriss, Lavanya Rishishwar, Andrew B. Conley, Camila Medrano-Trochez, Augusto Valderrama-Aguirre, Fredrik O. Vannberg, Leonardo Mariño-Ramírez, and I. King Jordan. 2016. "Chocó, Colombia: A Hotspot of Human Biodiversity." *Revista biodiversidad neotropical* 6 (1): 45–54.

Meiklejohn, Norman Arthur. 1968. "The Observance of Negro Slave Legislation in Colonial Nueva Granada." PhD diss., Department of History, Columbia University.

Meiklejohn, Norman Arthur. 1974. "The Implementation of Slave Legislation in Eighteenth-Century Nueva Granada." In *Slavery and Race Relations in Latin America*, edited by Robert B. Toplin, 176–203. Westport: Greenwood Press.

Mejía, Sergio. 2016. "Moreno y Escandón's *Plan geográfico del virreinato de Santa Fé de Bogotá, 1772*." *Imago Mundi* 68 (1): 35–45.

Miño Grijalva, Manuel. 2002. *La población de la ciudad de México en 1790: Estructura social, alimentación y vivienda*. Mexico City: Instituto Nacional de Estadística, Geográfica, Informática, El Colegio de México.

Mollien, Gaspard-Théodore. (1823) 1944. *El viaje de Gaspard-Théodore Mollien por la República de Colombia en 1823*. Bogotá: Biblioteca Popular de Cultura Colombiana.

Moncada Maya, José Omar. 2011. "La cartografía española en América durante el siglo XVIII: La actuación de los ingenieros militares." *Primero Simpósio Brasileiro de Cartografía Histórica, Paraty, May 10–13, 2011*.

Monmonier, Mark. 1991. *How to Lie with Maps*. Chicago: University of Chicago Press.

Montoya Guzmán, Juan David. 2008. "Guerra, frontera, e identidad en las provincias del Chocó." *Historia y sociedad* 15: 165–190.

Montoya Guzmán, Juan David. 2011. "¿Conquistar indios o evangelizar almas? Políticas de sometimiento en las provincias de las tierras bajas del Pacífico (1560–1680)." *Historia Crítica* 45: 10–30.

Montoya Guzmán, Juan David. 2013. "Una historia fallida: La conquista del Darién a finales del siglo XVIII." *Tareas: Centro de Estudios Latinoamericanos "Justo Arosemena" Panamá* 143: 27–47.

Morales Padrón, Francisco. 1952. "Canarias y Sevilla en el comercio de América." *Anuario de Estudios Americanos* 9: 173–207.

Morales Pamplona, Gloria Angélica. 2005. "Un esfuerzo de incorporación de la provincia del Darién al estado indiano." *Anuario de historia regional y de las fronteras* 10 (1): 151–180.

Mosquera, José. 2006. *Historia de los litigios de límites*

entre Antioquia y Chocó: Siglos XVI–XXI. Antioquia: Kan Sasana.

Mosquera, Sergio Antonio. 1997. *De esclavizadores y esclavizados en la provincia de Citará: Ensayo etno-histórico, siglo XIX*. Quibdó: Promotora Editorial de Autores Chocoanos.

Mumford, Jeremy Ravi. 2012. *Vertical Empire: The General Resettlement of Indians in the Colonial Andes*. Durham: Duke University Press.

Muñoz Arbeláez, Santiago. 2007. "'Medir y amojonar': La cartografía y la producción del espacio colonial en la provincia de Santa Marta, siglo XVIII." *Historia crítica* 34: 208–231.

Muñoz Arbeláez, Santiago. 2010. "Las imágenes de viajeros en el siglo XIX: El caso de los grabados de Charles Saffray sobre Colombia." *Historia y grafía* 34: 165–197.

Muñoz de Aronja, Pedro. 1983. "Descripción del gobierno del Chocó, sus pueblos de indios, el número de estos, reales de minas, número de negros y esclavos para su laboreo." *Cespedesia*, nos. 45–46, suppl. 4, 461–472.

Murphy, Robert Cushman. 1939. "The Littoral of Pacific Colombia and Ecuador." *Geographical Review* 29 (1): 1–33.

Mutis, José Celestino. 1957. *José Celestino Mutis: Diario de observaciones, 1760–1790*. Vol. 1. Transcribed, edited, and with a prologue by Guillermo Hernández de Alba. Bogotá: Editorial Minerva.

Navarrete, María Cristina. 2001. "Cimarrones y palenques en las provincias al norte del Nuevo Reino de Granada siglo XVIII." *Fronteras de la historia* 6: 97–122.

Navarrete, María Cristina. 2005. *Genesis y desarrollo de la esclavitud en Colombia siglos XVI y XVII*. Cali: Universidad del Valle.

Navarrete, María Cristina. 2011. *San Basilio de Palenque: Memoria y tradición; Surgimiento y avatares de las gestas cimarronas en el Caribe colombiano*. Cali: Universidad del Valle.

Navarrete, María Cristina. 2017. "Palenques: Maroons and Castas in Colombia's Caribbean Regions. Social Relations in the Seventeenth Century." In *Orality, Identity, and Resistance in Palenque (Colombia): An Interdisciplinary Approach*, edited by Armin Schwegler, Bryan Kirschen, and Graciela Maglia, 269–296. Amsterdam: John Benjamins.

Navarro Azcue, Concepción. 1992. "Incidencia de la emigración canaria en la formación de Uruguay, 1726–1729." *Tebeto* 5 (1): 103–132.

Negret, Álvaro José, Luís Alfonso Ortega, Alex Cortés, Luz Stella Cataño, María Patricia Torres, Pedro E. López, Nelson Pinilla, Marta Lucia Prado, and Hernando Vergara. 1996. *Estudio de viabilidad para la declaratoria de un corredor de conservación de las selvas húmedas del Pacífico colombiano: Informe de investigación*. Popayán: Museo de Historia Natural Universidad del Cauca.

Nielsen, Matthew. 2019. "Unruliness at the Margins: The Lower Orinoco in the Eighteenth Century." PhD diss., Department of History, Carnegie Mellon University.

Nieto Olarte, Mauricio, and Sebastián Díaz Ángel, eds. 2016. *Dibujar y pintar el mundo: Arte, cartografía y política*. Bogotá: Universidad de los Andes.

Nieto Olarte, Mauricio, Santiago Muñoz Arbeláez, Santiago Díaz-Piedrahíta, and Jorge Arias de Greiff. 2006. *La obra cartográfica de Francisco José de Caldas*. Bogotá: Universidad de los Andes.

Newson, Linda A. 1995. *Life and Death in Early Colonial Ecuador*. Norman: University of Oklahoma Press.

Newson, Linda A., and Susie Minchin, eds. 2007. *From Capture to Sale: The Portuguese Slave Trade to Spanish South America in the Early Seventeenth Century*. Leiden: Brill.

Offen, Karl. 2003. "The Territorial Turn: Making Black Territories in Pacific Colombia." *Journal of Latin American Geography* 2 (1): 43–73.

Orlando Melo, Jorge. 1992. "Atlas histórico de Colombia." *Revista Credencial Historia* 25: 3–14.

Ortega Ricaurte, Enrique, ed. 1954. *Historia documental del Chocó*. Vol. 24. Bogotá: Departamento de Biblioteca y Archivos Nacionales.

Ortíz, Sergio Elías. 1945. "Los indios Yurumanguies." *Boletín de historia y antigüedades* 32 (371–374): 731–748.

Ortíz, Sergio Elías. 1965. *Lenguas y dialectos indígenas de Colombia*. Bogotá: Academia Colombiana de Historia, Ediciones Lerner.

Oslender, Ulrich. 2016. *The Geographies of Social Movements: Afro-Colombian Mobilization and the Aquatic Space*. Durham: Duke University Press.

Parsons, James T. 1983. "The Migration of Canary Islanders to the Americas: An Unbroken Current since Columbus." *The Americas* 39 (4): 447–481.

Patiño, Diógenes, and Martha C. Hernández Sánchez. 2010. *Arqueología histórica en la Casa de Moneda de Popayán*. Popayán: Unicauca.

Pearson, Michael N. 2006. "Littoral Society: The Concept and the Problems." *Journal of World History* 17 (4): 353–373.

Peña-Ortega, Javier. 2020. "Ingenieros militares en el río Atrato: Cartografía y comercio (1760–1790)." *Fronteras de la historia* 25 (1): 76–101.

Peralta, Jaime Andrés. 2019. *El Chocó, sus gentes y paisajes: Vida cotidiana en una frontera colonial, 1750–1810*. Medellín: Editorial Universidad de Antioquia.

Pickles, John. 2004. *A History of Spaces: Cartographic Mapping, Reason, and the Geo-Coded World*. New York: Routledge.

Pinart, Alphonse Louis. 1890. *Vocabulario castellano-cuna*. Paris: Ernest LeRoux.

Pita Pico, Roger. 2015. "El correo en las guerras de independencia de Colombia: Incertidumbres y estrategias." *Dialéctica libertadora* 7: 20–34.

Pita Pico, Roger. 2016. "Amenazas a la fidelidad, seguridad y confianza real: El servicio de correo interno

en el Nuevo Reino de Granada tras las reformas de Pando, 1764–1810." *Memoria y sociedad* 20 (40): 223–241.

Pombo, Manuel. (1850) 1936. "Bajando el Dagua, 1850." In *La niña agueda y otros cuadros*, 105–118. Bogotá: Editorial Minerva.

Ponce de León, Manuel. 1986. *Acuarelas de la Comisión Corográfica: Colombia 1850–1859*. Bogotá: Litografía Arco.

Ponce Vázquez, Juan José. 2020. *Islanders and Empire: Smuggling and Political Defiance in Hispaniola, 1580–1690*. Cambridge: Cambridge University Press.

Portuondo, María M. 2009. *Secret Science: Spanish Cosmography and the New World*. Chicago: University of Chicago Press.

Poser, William T. 1992. "The Salinan and Yurumanguí Data in Language in the Americas." *International Journal of American Linguistics* 58 (2): 202–229.

Prado, Fabricio. 2012. "The Fringes of Empires: Recent Scholarship on Colonial Frontiers and Borderlands in Latin America." *History Compass* 10 (4): 318–333.

Pratt, Mary Louise. 2008. *Imperial Eyes: Travel Writing and Transculturation*. 2nd ed. London: Routledge.

[anonymous], "Primeros mapas de la Nueva Granada." 1905. *Boletín de Historia y Antigüedades* 4.

Proyecto Biopacífico. 1998. *Informe final general*. Bogotá: Ministerio del Medio Ambiente.

"Proyecto de Hurtado sobre minas, 1783." 1920. *Boletín de historia y antiguedades XIII*: 181–192.

Puig Samper, Miguel Ángel, ed. 2001. *La armonía natural: La naturaleza en la expedición marítima de Malaspina y Bustamante (1789–1794)*. Barcelona: Lunwerg Editores.

Rappaport, Joanne. 2011. "'Así lo parece por su aspecto': Physiognomy and the Construction of Difference in Colonial Bogotá." *Hispanic American Historical Review* 91 (4): 601–631.

Real Academia Española. 1732. *Nuevo tesoro lexicográfico de la lengua española A*.

Recopilación de leyes de los reynos de las Indias. 1681. Madrid: Ivlian de Peredes.

Restrepo, Vicente. 1888. *Estudio sobre las minas de oro y plata de Colombia*. 2nd ed. Bogotá: Silvestre.

Rivet, Paul. 1942. "Un dialecte Hoka colombien: Le Yurumanguí." *Journal de la Société des Américanistes de Paris* 34 (1): 1–59.

Robinson, David J., ed. 1992. *Mil leguas por América— De Lima a Caracas 1740–1741: Diario de don Miguel de Santisteban*. Bogotá: Banco de la República.

Rodríguez, Pablo. 2007. "La efímera utopía de los esclavos de Nueva Granada: El caso del palenque de Cartago." In *Tradiciones y conflictos: Historias de la vida cotidiana en México e Hispanoamérica*, edited by Pilar Gonzalbo Aizpur and Mílada Bazant, 73–92. Mexico City: Colegio de México.

Rodríguez Hernández, Nelson Eduardo. 2014a. "Cartografía de la frontera 'bárbara': Las representaciones del Darién a propósito del conflicto entre el virreinato de Nueva Granada y los Cuna." *Anuario de historia regional y de las fronteras* 19 (1): 59–78.

Rodríguez Hernández, Nelson Eduardo. 2014b. "El imperio contraataca: Las expediciones militares de Antonio Caballero y Góngora al Darién (1784–1790)." *Historia crítica* 83: 201–223.

Rodríguez Hernández, Nelson Eduardo. 2016. "La amenaza Cuna: Política de indios del gobernador Andrés Ariza en el Darién durante su primera década de gobierno en el siglo XVIII." *Historia caribe* 11 (28): 211–239.

Roller, Heather Flynn. 2012. "River Guides, Geographical Informants, and Colonial Field Agents in the Portuguese Amazon." *Colonial Latin American Review* 21 (1): 101–126.

Roller, Heather Flynn. 2014. *Amazonian Routes: Indigenous Mobility and Colonial Communities in Northern Brazil*. Stanford: Stanford University Press.

Romero, Mario Diego. 1991. "Sociedades negras: Esclavos y libres en la costa Pacífica de Colombia." *América Negra* 2: 137–151.

Romero, Mario Diego. 1995. *Poblamiento y sociedad en el Pacífico colombiano, siglos XVI al XVIII*. Cali: Universidad del Valle.

Romero, Mario Diego. 1997. *Historia y etnohistoria de las comunidades afrocolombianas de río Naya*. Cali: Gobernación del Valle del Cauca, Gerencia Cultural.

Romero, Mario Diego. 2002. *Sociedades negras en la costa Pacífica del Valle del Cauca durante los siglos XIX y XX*. Cali: Gobernación del Valle del Cauca.

Romero, Mario Diego. 2017. *Poblamiento y sociedad en el Pacífico colombiano, siglos XVI al XVIII*. 2nd ed. Cali: Universidad del Valle.

Romoli, Kathleen. 1953. *Balboa of Darién: Discoverer of the Pacific*. Garden City: Doubleday.

Romoli, Kathleen. 1962. "El descubrimiento y la primera fundación de Buenaventura." *Boletín de historia de antigüedades* 49: 113–123.

Romoli, Kathleen. 1974. "Nomenclatura y población indígenas de la antigua jurisdicción de Cali a mediados del siglo XVI." *Revista colombiana de antropología* 16: 374–478.

Romoli, Kathleen. 1975a. "El alto Chocó en el siglo XVI (Parte 1)." *Revista colombiana de antropología* 19: 25–67.

Romoli, Kathleen. 1975b. "El alto Chocó en el siglo XVI (Parte 2)." *Revista colombiana de antropología* 20: 24–73.

Rozo, Dario M. 1952. "Historia de la cartografía de Colombia." *Boletín de la Sociedad Geográfica de Colombia* 10 (4).

Saffray, Charles. (1869) 1948. *Viaje a Nueva Granada*. Bogotá: Biblioteca Popular de Cultura Colombiana.

Safier, Neil. 2008. *Measuring the New World: Enlightenment Science and South America*. Chicago: University of Chicago Press.

Safier, Neil. 2009. "The Confines of the Colony: Boundaries, Ethnographic Landscapes, and Imperial Cartography in Iberoamerica." In *The Imperial Map: Cartography and the Mastery of Empire*, edited by James Ackerman, 133–184. Chicago: University of Chicago Press.

Sagredo Baeza, Rafael, and José Ignacio Gonzales Leiva. 2004. *La expedición Malaspina en la frontera austral del imperio español*. Santiago: Editorial Universitaria, Centro de Investigaciones Diego Barros Arana.

Sánchez, Efraín. 1998. *Gobierno y geografía: Agustín Codazzi y la Comisión Corográfica de la Nueva Granada*. Bogotá: Banco de la República; Ancora Editores.

Sandman, Alison. 2008. "Controlling Knowledge: Navigation, Cartography, and Secrecy in the Early Modern Spanish Atlantic." In *Science and Empire in the Atlantic World*, edited by James Delbourgo, 31–51. New York: Routledge.

Sandoval, Alonso de. (1627) 1956. *De instauranda Aethiopum salute: El mundo de la esclavitud negra en America*. Transcribed by Ángel Valtierra. Bogotá: Empresa Nacional de Publicaciones.

Santa Gertrudis, Juan de. (c. 1790) 1956. *Las maravillas de la naturaleza*. Bogotá: Empresa Nacional de Publicaciones.

Santa Teresa, Severino de. 1956. *Historia documentada de la iglesia en Urabá y el Darién: Desde el descubrimiento hasta nuestros días*. Bogotá: Presidencia de la República de Colombia.

Scott, Heidi. 2015. "At the Center of Everything: Regional Rivalries, Imperial Politics, and the Mapping of the Mosetenes Frontier in Late Colonial Bolivia." *Hispanic American Historical Review* 95 (3): 395–426.

Sellers-García, Sylvia. 2014. *Distance and Documents at the Spanish Empire's Periphery*. Stanford: Stanford University Press.

Serrano García, Manuel. 2015. "La misión franciscana en el Yurumanguí." *Historia y espacio* 45: 39–61.

Sharp, Bartholomew. 1729. "Captain Sharp's Journey over the Isthmus of Darien and Expedition into the South Sea." In *A Collection of Voyages in Four Volumes*, vol. 3, 3rd ed., 45–82. London: James and John Knapton.

Sharp, William Frederick. 1970. "Forsaken but for Gold: An Economic Study of Slavery and Mining in the Colombian Choco, 1680–1810." PhD diss., Department of History, University of North Carolina at Chapel Hill.

Sharp, William Frederick. 1975. "The Profitability of Slavery in the Colombian Chocó, 1680–1810." *Hispanic American Historical Review* 55: 468–495.

Sharp, William Frederick. 1976. *Slavery on the Spanish Frontier: The Colombian Chocó, 1680–1810*. Norman: University of Oklahoma Press.

Shils, Edward A. 1961. "Centre and Periphery." In *The Logic of Personal Knowledge: Essays Presented to Michael Polanyi on His Seventieth Birthday, 11th March 1961*, edited by the Polanyi Festschrift Committee, 117–130. London: Routledge and Kegan Paul.

Sidbury, James, and Jorge Cañizares-Esguerra. 2011. "Mapping Ethnogenesis in the Early Modern Atlantic." *William and Mary Quarterly* 68 (2): 181–208.

Silvestre, Francisco. (1789) 1950. *Descripción del reino de Santa Fé de Bogotá*. Bogotá: Universidad Nacional de Colombia.

Sitjà, Jesús. 2012. "Los correos en el virreinato de Nueva Granada, primera parte (1717–1769)." *Academus* 16: 19–32.

Smallwood, Stephanie. 2007. *Saltwater Slavery: A Middle Passage from Africa to American Diaspora*. Cambridge: Harvard University Press.

Smith, Cynthia. 2020. "William Hacke: A Pirate's Cartographer." Worlds Revealed: Geography and Maps at the Library of Congress, 26 August. https://blogs.loc.gov/maps/2020/08/william-hacke-a-pirates-cartographer/.

Smith, Jennie Erin. 2013. "A State of Nature: Life, Death, and Tourism in the Darién Gap." *New Yorker*, April 22.

Smith, Robert. 1970. "The Canoe in West African History." *Journal of African History* 11 (4): 515–533.

Sotomayor, Maria Luisa, and Maria Victoria Uribe. 1987. *Estatuaria del macizo colombiano*. Bogotá: Instituto Colombiano de Antropología.

Soulodre-La France, Renée. 2001. "Socially Not So Dead! Slave Identities in Bourbon Nueva Granada." *Colonial Latin American Review* 10 (1): 87–103.

Soulodre-La France, Renée. 2006. "Slave Protest and Politics in Late Colonial Nueva Granada." In *Slaves, Subjects, and Subversives: Blacks in Colonial Latin America*, edited by Jane G. Landers and Barry M. Robinson, 175–208. Albuquerque: University of New Mexico Press.

Sprague, Thomas A. 1926. "Humboldt and Bonpland's Itinerary in Colombia." *Bulletin of Miscellaneous Information* (Kew Royal Botanic Gardens) 1: 22–30.

Stein, Stanley J., and Barbara H. Stein. 2003. *Apogee of Empire: Spain and New Spain in the Age of Charles III, 1759–1789*. Baltimore: Johns Hopkins University Press.

Suárez Pinzón, Ivonne. 2011. "La provincia del Darién y el istmo de Panamá: Siglos en el corazón de las disputas por la expansión del capitalismo." *Anuario de historia regional y de las fronteras* 16: 17–50.

Taylor, William B. 1970. "The Foundation of Nuestra Señora de Guadalupe de los morenos de Amapa." *The Americas* 26 (4): 439–446.

TePaske, John Jay. 2002. "Integral to Empire: The Vital Peripheries of Colonial Spanish America." In *Negotiated Empires: Centers and Peripheries in the Americas, 1500–1820*, edited by Christine Daniels and Michael V. Kennedy, 29–41. New York: Routledge.

Torres Lanzas, Pedro. 1906. *Relación descriptiva de los mapas, planos, etc. de las antiguas audiencias de Panamá, Santa Fé y Quito: Existentes en el Archivo*

General de Indias. Madrid: Tipografía de la Revista de Archivos, Bibliotecas y Museos.

Torres Lanzas, Pedro. 1985. *Archivo General de Indias: Catálogo de mapas y planos de Panamá, Santa Fé y Quito*. Madrid: Ministerio de Cultura.

Tovar Pinzón, Hermes. 2009. *Imágenes a la dériva: Los mapas y las habitaciones del pasado y la nostalgia*. Bogotá: Archivo General de la Nación.

Trautwine, John C. 1854. *Rough Notes of an Exploration for an Inter-Oceanic Canal Route by Way of the Rivers Atrato and San Juan in New Granada, South America*. Philadelphia: Barnard and Jones.

Tubb, Daniel. 2020. *Shifting Livelihoods: Gold Mining and Subsistence in the Chocó, Colombia*. Seattle: University of Washington Press.

Turnbull, David. 1996. "Cartography and Science in Early Modern Europe: Mapping the Construction of Knowledge Spaces." *Imago Mundi* 48: 5–24.

Twinam, Ann. 1982. *Miners, Merchants, and Farmers in Colonial Colombia*. Austin: University of Texas Press.

Tyner, Judith A. 1982. "Persuasive Cartography." *Journal of Geography* 81 (4): 140–144.

Urrutía, María Ezequiela, Antún Castro Urrutía, and Arminda Castro Urrutia. 1992. *Apuntes sobre geografía e historia del Chocó*. Colombia: Promotora Editorial de Autores Chocoanos.

Valencia Llano, Alonso. 2014. "Los orígenes coloniales del puerto de Buenaventura." *Historia y memoria* 9 (July–December): 221–246.

Valenzuela Acosta, Carlos. 2009. "Servicio de correos en el Nuevo Reino de Granada 1717–1769." In *Trayectoria de las comunicaciones en Colombia*, vol. 1, edited by Ana Maria Groot and Luis Horacio Domínguez López. Bogotá: Ministerio de Tecnologías de la Información y las Comunicaciones.

Vargas, Patricia. 1993. *Los Emberás y los Cuna: Impacto y reacción ante la ocupación española, siglos XVI y XVII*. Bogotá: CEREC-Instituto Colombiano de Antropología.

Vásquez Pino, Daniela. 2015. "'Los yndios infieles han quebrantado la paz': Negociaciones entre agentes europeos, chocoes y cunas en el Darién, 1739–1789." *Fronteras de la historia* 20 (2): 14–42.

Velandia, Roberto. 1999. *Cartografía histórica del Alto Magdalena: Honda, Girardot, Neiva*. Bogotá: Banco Central de la República.

Vergara, Fray Gabriel de. (1732) 1965. *El cuadernillo de la lengua de los indios Pajalates*, edited by Eugenio del Hoyo. Monterrey: Instituto Tecnológico y de Estudios Superiores de Monterrey.

Vergara, Saturnino. 1939. *Catálogo de los mapas, planos, cartas hidrográficas, etc., existentes en el Archivo General de Indias: Estudios de los planos y su documentación*. 6 vols. Madrid: Laboratorio de Arte.

Vila Vilar, Enriqueta. 1977. *Hispanoamérica y el comercio de esclavos*. Seville: Escuela de Estudios Hispano-Americanos de Sevilla.

Vila Vilar, Enriqueta. 1982. "Las ferias de Portobelo: Apariencia y realidad del comercio con indias." *Anuarios de estudios americanos* 39: 275–340.

Villegas, Benjamin, ed. 1992. *Mutis and the Royal Botanical Expedition of the Nuevo Reyno de Granada*. Bogota: Villegas Editores.

Wade, Maria F. 2008. *Missions, Missionaries and Native Americans: Long Term Processes and Daily Practices*. Gainesville: University Press of Florida.

Wafer, Lionel. 1729. "A New Voyage and Description of the Isthmus of America, Giving an Account of the Author's Abode There [. . .]." In *A Collection of Voyages in Four Volumes*, vol. 3, 3rd ed., 263–398. London: James and John Knapton.

Wallace, Ernest, and E. Adamson Hoebel. 1952. *The Comanches: Lords of the South Plains*. Norman: University of Oklahoma Press.

Ward, Christopher. 1989. "Historical Writing on Colonial Panama." *Hispanic American Historical Review* 69 (4): 691–713.

Weber, David J. 2008. *Bárbaros: Spaniards and Their Savages in the Age of Enlightenment*. New Haven: Yale University Press.

Weber, David J., and Jane M. Rausch. 1994. *Where Cultures Meet: Frontiers in Latin American History*. Wilmington: SR Books.

West, Robert C. 1952. *Colonial Placer Mining in Colombia*. Baton Rouge: Louisiana State University Press.

West, Robert C. 1955. *The Geography of the Pacific Lowlands of Colombia and Adjacent Areas*. Baton Rouge: Louisiana State University.

West, Robert C. 1957. *The Pacific Lowlands of Colombia: A Negroid Area of the American Tropics*. Baton Rouge: Louisiana State University Press.

Wheat, David. 2009. "The Afro-Portuguese Maritime World and the Foundations of Spanish Caribbean Society, 1570–1640." PhD diss., Department of History, Vanderbilt University.

Wheat, David. 2011. "The First Great Waves: African Provenance Zones for the Transatlantic Slave Trade to Cartagena de Indias, 1570–1640." *Journal of African History* 52 (1): 1–22.

Wheat, David. 2016. *Atlantic Africa and the Spanish Caribbean, 1570–1640*. Chapel Hill: Omohundro Institute of Early American History and Culture and the University of North Carolina Press.

Whitehead, Neil L. 1998. "Indigenous Cartography in Lowland South America and the Caribbean." In *The History of Cartography*, vol. 2, bk. 3, *Cartography in the Traditional African, American, Arctic, Australian, and Pacific Societies*, edited by David Woodward and G. Malcolm Lewis, 301–326. Chicago: University of Chicago Press.

Whitten, Norman E., Jr., and Nina S. de Friedemann. 1974. "La cultura negra del litoral ecuatoriano y colombiano: Un modelo de adopción étnica." *Revista del Instituto Colombiano de Antropologia* 17: 81–115.

Wiersema, Juliet. 2018. "The Manuscript Map of the Dagua River: A Rare Look at a Remote Region in the Spanish Colonial Americas." *Artl@s Bulletin* 7 (2): 71–90.

Wiersema, Juliet. 2020a. "Importing Ethnicity, Creating Culture: Currents of Opportunity and Ethnogenesis along the Río Dagua in Nueva Granada, c. 1764." In *The Global Spanish Empire: Five Hundred Years of Place Making and Pluralism*, edited by Christine D. Beaule and John G. Douglass, 267–290. Amerind Studies in Archaeology. Tucson: University of Arizona Press.

Wiersema, Juliet. 2020b. "The Map of the Yurumanguí Indians: Charting the Erasure of the Pacific Lowlands' Indigenous Inhabitants, 1742–1780." *Terrae Incognitae* 52 (2): 160–194.

Wiersema, Juliet. 2023. "Mine Owners, Moneylenders, Enslavers, and Litigants: Free Black Mining Dynasties in the Colombian Chocó, 1744–1784." In *At the Heart of the Borderlands: Africans and Afro-Descendants on the Edges of Colonial Spanish America*, edited by Cameron Jones and Jay Harrison, 108–132. Albuquerque: University of New Mexico Press.

Wiesner Gracia, Luis Eduardo. 2008. *Tunja: Ciudad y poder en el siglo XVII*. Tunja: Universidad Pedagógica y Tecnológica de Colombia.

Williams, Caroline A. 1999. "Resistance and Rebellion on the Spanish Frontier: Native Responses to Colonization in the Colombian Chocó, 1670–1690." *Hispanic American Historical Review* 79 (3): 397–424.

Williams, Caroline A. 2005. *Between Resistance and Adaptation: Indigenous Peoples and the Colonization of the Chocó, 1510–1753*. Liverpool: University of Liverpool Press.

Williams, Glyndwr. 1993. *A Collection of Original Voyages (1699): A Facsimile Reproduction*. Del Mar: Scholars' Facsimiles and Reprints, for John Carter Brown Library.

Wilson, Meghan, Tana Villafana, and Hadley Johnson. "Technical Study of the *Manuscript Map of Dagua River Region, Colombia*." Unpublished manuscript, Library of Congress.

Woodward, David, ed. 1987. *Art and Cartography: Six Historical Essays*. Chicago: University of Chicago Press.

Woodward, David. 2007. "Cartography and the Renaissance: Continuity and Change." In *The History of Cartography*, vol. 3, part 1, *Cartography in the European Renaissance*, edited by David Woodward, 3–24. Chicago: University of Chicago Press.

Woodward, David, and G. Malcolm Lewis, eds. 1998. *The History of Cartography*, vol. 2, bk. 3, *Cartography in the Traditional African, American, Arctic, Australian, and Pacific Societies*. Chicago: University of Chicago Press.

Zuluaga, Francisco Uriel, and Amparo Bermúdez. 1997. *La protesta social en el suroccidente colombiano, siglo XVIII*. Cali: Universidad del Valle.

Zuluaga, Francisco Uriel, and Mario Diego Romero. 2009. *Sociedad, cultura, y resistencia negra en Colombia y Ecuador*. 2nd ed. Cali: Universidad del Valle.

Zuluaga, Victor, ed. 1988. *Documento inéditos sobre la historia de Caldas, Chocó, y Risaralda*. Pereira: Universidad Tecnológica de Pereira.

Archival Documents Cited

Archivo Central del Cauca
ACC Sig. 3662 Col. C II-4 rc
ACC Sig. 2661 Col. J I-3 cv
ACC Sig. 3998 Col. C I-21 mn
ACC Sig. 4263 Col. C I-12 nt
ACC Sig. 5457 Col. E I-5 j
ACC Sig. 5720 Col. P I-2 v
ACC Sig. 7892 Col. J II-10 cv
ACC Sig. 8147 Col. J I-15 cv
ACC Sig. 8806 Col. J I-17 mn
ACC Sig. 9650 Col. C III-24 g
ACC Sig. 11347 Col. J I-17 mn
ACC Sig. 11391 Col. J I-17 mn
ACC Sig. 11392 Col. J I-17 mn
ACC Sig. 11393 Col. C I-21 mn
ACC Sig. 11501 Col. C IV-11 g
ACC Sig. 11511 Col. C IV-10 ea
ACC Sig. 12015 Col. C IV-11 g

Archivo General de Indias
AGI MP-Panama, 30
AGI MP-Panama, 151
AGI MP-Panama, 165
AGI MP-Panama, 193
AGI MP-Panama, 196
AGI MP-Panama, 250
AGI MP-Panama, 306
AGI MP-Panama, 309
AGI MP-Santo Domingo, 12

Archivo General Militar de Madrid
AGMM-COL-11/10
AGMM Ar.J-T.7-C.3-100

Archivo General de la Nación
AGN Aduanas 2 2 D 17
AGN Caciques e Indios 6 D 5
AGN Caciques e Indios 11 D 9
AGN Caciques e Indios 17 D 16
AGN Caciques e Indios 26 D 9
AGN Caciques e Indios 34 D 12
AGN Caciques e Indios 38 D 42
AGN Caciques e Indios 50 D 11
AGN Caciques e Indios 58 D 19

AGN Caciques e Indios 61 D 6
AGN Censos de Población SC EOR.22-CJ 12 CR 1 D 13 x
AGN Correos Cauca 18 1 D 9
AGN Correos Cauca 18 2 D 7
AGN Correos Cundinamarca 18 2 D 9
AGN Curas y Obispos 21 44 D 2
AGN Curas y Obispos 21 47 D 11
AGN Fábrica Iglesias 26 13 D 17
AGN Historia Eclesiástica 30 6 D 12
AGN Mejoras Materiales 36 17 D 31
AGN Milicias y Marinas, tomo 118 2
AGN Milicias y Marinas, tomo 126
AGN Minas de Antioquia, tomo 5 1
AGN Minas Cauca 38 2 D 14
AGN Miscelánea 39 103 D 40
AGN Miscelánea 39 107 D 23
AGN Miscelánea 39 141 D 28
AGN Miscelánea 39 141 D 43
AGN Miscelánea 83 D 70

AGN Negros y Esclavos 43 4 D 38
AGN Poblaciones Cauca 46 2 D 8
AGN Poblaciones Cauca 46 2 D 12
AGN Visitas Cauca 62 4 D 6
AGN Visitas Cauca 62 5 D 3

Archivo Histórico de Cali
AHC Fondo Cabildo, Carpeta 2
AHC Fondo Escribanos, Notaria Primera, libro 4
AHC Fondo Escribanos, Notaria Primera, libro 43
AHC Fondo Escribanos, Notaria Primera, libro 44
AHC Fondo Escribanos, Notaria Segunda, libro 4
AHC Fondo Escribanos, Notaria Segunda, libro 5
AHC Fondo Judicial, tomo 2, caja 106, legajo 8
AHC Fondo Judicial, tomo 2, caja 107, legajo 1

Biblioteca Nacional de Colombia
BNC RM 370
BNC RM 324, pieza 4 (1777), fols. 160–251

INDEX

Note: page numbers in *italics* indicate figures. Page numbers preceded by a *p* are plates.

ABBREVIATIONS

A New Map [. . .]: *A New Map of ye Isthmus of Darién in America, the Bay of Panama, the Gulph of Vallona or St. Michael, with Its Islands and Countries Adjacent* [. . .]

Carta del vireynato [. . .]: *Carta del vireynato de Santafé de Bogotá copia de la de Mr. D'Anville*

Carta esférica [. . .]: *Carta esférica del vireynato de Santafé de Bogotá por Mr. D'Anville, corregida en algunas partes según las últimas observaciones por D. Francisco Joseph de Caldas* (Spherical chart of the viceroyalty of Santa Fé de Bogotá by Mr. D'Anville, corrected in places following the recent observations of D. Francisco Joseph de Caldas)

Carte des provinces [. . .]: *Carte des provinces de Tierra Firme, Darien, Cartagene et Nouvelle Grenade*

Croquis del curso [. . .]: *Croquis del curso del río Dagua* [. . .] (Sketch of the course of the Dagua River)

"Exterior view [. . .]": "Exterior view of the projected fort at Caná"

Map of the Atrato River [. . .]: Map of the Atrato River and Pueblos of Cuna Indians

Map of the Chocó [. . .]: Map of the Chocó, Panama, and Cupica

Mapa de la tierra [. . .]: *Mapa de la tierra donde habitan los indios, Piles, Timbas y Barbacoas* (Map of land inhabited by Indians, Piles, Timbas and Barbacoas)

Mapa Geográfico [. . .]: *Mapa Geográfico de la provincia de Buenaventura en el departamento del Cauca* [. . .] (Geographic Map of the Province of Buenaventura in the Department of Cauca [. . .])

Pedernales [. . .]: *Pedernales jurisdicción de Guayaquil y conclusion de la de Popayán*

Plan geográfico [. . .]: *Plan geográfico del virreynato de Santafé de Bogotá* [. . .]

Plan que representa [. . .]: *Plan que representa el Golfo de Darien. Según el original del senor Tomas Jefferis, geógrafo de SM Británica año de 1775* (Map of the Gulf of Darién. According to the original by Tomas Jefferis [sic], geographer of His English Majesty, 1775)

Plano del curso [. . .]: *Plano del curso del río Atrato* [. . .] (Map of the course of the Atrato River [. . .])

Plano que demuestra [. . .]: *Plano que demuestra la immediación de Quibdó último pueblo de Chocó con los indios bárbaros nombrados pueblo de Chocó con los indios bárbaros nombrados Cunacunas* [. . .] (Map demonstrating the proximityof Quibdó, the last town in the Chocó, to the barbarous Indians known as Cuna [. . .])

Ruta de Antioquia [. . .]: *Ruta de Antioquia a Panamá por una parte de la provincia del Chocó* [. . .] (Route from Antioquia to Panama through a part of the province of the Chocó [. . .])

Tierra Firma [. . .]: *Tierra Firma item Nuevo Reyno de Granada atque Popayán* (Terra Firma. The New Kingdom of Granada and that of Popayán)

Traza de la manera [. . .]: *Traza de la manera como se ha de poner la cadena en la entrada del puerto de la Havana* (A sketch of how chains are to be placed at the entrance to Havana's port)

YNR: Yurumanguí/Naya River

27, *27*, 35, 77, 78; Dagua River and, 75, 78

Buenaventura (town), 1, *2*, 21, 22, *23*, *26*, 32, *34*, 102; cartographic elision of, 27, 30; Cupica and, 58, *59*, 132n34; Dagua River and, 11, 32, 70, 83, 92; slave trade and, 121n49; Sombrerillo and, 83, 84; unpleasantness of, 123n32, 132n34; *Mapa Geográfico* [. . .], 97, *98*. See also *Croquis del curso* [. . .]; Map of the Dagua River Region; Map of the Yurumanguí Indians; *Pedernales* [. . .] (Caldas)

Buga, 30, 54, 64, 65, 69, 73; merchants of, 125n23, 137n16

Caballero y Góngora, Antonio, 60, 64, 66, 134n74

cacao, 67, 120n28, 122n5; Atrato River and, 38, 40; Cupica and, *59*, 60, 62, *63*, 64, 132n34, 135n90; Las Juntas and, *76*, *79*, 80, 138n30

Cacarica, 42, 44, 129n129

caciques, 22, 123n16

caciques, Cuna, 49, 55, 126n45, 128nn99–100; of Tarena, 52, 128n99, 129n126, 129n145

Caicedo, Manuel de, 96–97, 100–101, *101*, 106, 143n80, 144n99; as alférez real, 96, 97, 143n81; exploration of the YNR region, 100, 102, 144n106, 144n112; and mining, 97, 143n84; road proposal, 96, 97–98, *98*, 101, 102, 143n83, 143n89; signature, 90, *90*, *91*, *91*, 141n6

Caicedo, Manuel de, letters by: map presentation, *90*, 90–91, 100, 101, 102, 141n10, 142n32; road proposal, 97, 101, 143n89

Caiman, 42, 44, 49, 50, 55

Caiman River, 46, 47, *p7*

Cajambre, 70

Cajambre River, *88*, 89, 95, 97, 98, *98*, *99*, 102, 141n11

Caldas, Francisco José de, 1, 60, 124nn44–45; *Carta del vireynato* [. . .], 27, *29*, *30*, 32, 124n45; *Carta esférica* [. . .], 30, *31*, *31*, 124n48; *Pedernales* [. . .], 32, *33*, 124nn48–49

Caledonian Indians (northern Cuna), 41, 52, 126n45; as hostile, 50, 53, 129n117, 130n152. See also Cuna Indians

Cali, *2*, 22, *22*, *34*, 35, 123n32; African presence in, 16, 83; cabildo of, 81, 84, 138n24, 139n35, 139n37 (*see also* Caicedo, Manuel de; Pérez de Montoya, Manuel); Colegio de Cali, 96, 142n60, 143n63, 143n77;

and the *Croquis del curso* [. . .], 32, *34*, 35, 82; gente libre presence in, 120n24; and the Map of the Dagua River Region, 77, 78, *78*, 138n18, 138n21; merchants of, 64–65, 69, 73, 78, 80, 125n23; and mining interests, 82, 87, 92; road to the YNR region, 93, 94, 97, *98*, 101, 102, 103–104; travel to/from, 83, 92, 97; vecinos of, 75–76, 79, 90, 91, 97, 139n35. See also Caicedo, Manuel de; *Carta esférica* [. . .] (Caldas); *Carte des provinces* [. . .] (Anville); Pérez de Montoya, Manuel; *Plan geográfico* [. . .] (Moreno y Escandón*)*

Calima, 70, 100

Callao, 58, 62, 66, 131n10. See also Lima; Peru

Caná, 45, *46*

caña de azúcar (sugar cane), 38, 64, 132n24. See also sugar

canoeros, 82, 119n61, 139n51. See also bogas

canoes, 35, 50, 52, 54, 130n155; African tradition and, 82–83, 139n52, 139n58; carving of, 47, 60, 62, 99, 137n134; depictions of, 76, *76*, *80*, 82, *88*, 89, 97, 100, *p9*; as essential to travel, 7–8, 77–78, 82, 92, 97, 100, 141n19. See also bogas; canoeros

cargueros, 9, 77, 82, 137n2; as essential, 83, 85, 92, 107, 140n62; Sombrerillo and, 83, 85, 86

Caribbean coast, 13, 19, 22, 41–42, 51, 60. See also Cartagena; Gulf of Urabá; Santa Marta

Caribbean Sea, *2*, *10*, 19, *59*, 60, 72, 124n3; Cuna control of access to, 41, 44, 51, 61; pre-Hispanic links to, 60, 131n14; rivers flowing to, 22, 61, 106. See also Atrato River-Caribbean Sea link; Cartagena

Carney, Judith, 16–17, 121nn64–65

Carta del vireynato [. . .] (Caldas), 27, *29*, *29*, 30, 124n45

Carta esférica [. . .] (Caldas), 30, *31*, 124n48

Cartagena, 13, 40, 41, 49, 136n109, 136n117; as administrative center, 14, 77, 126n62; defense of, 47, 73, 125n11, 127n64, 137n154; as distant, 1, 14, 16, 135n90; and pirates, 128n89, 137n154; and the slave trade, 16, 62, 68, 121n49; trade with Peru and Guayaquil, 62, 68

Cartago, 30, 54, 85, 120n34; merchants of, 64, 65, 69, 73

Carte des provinces [. . .] (Anville), 24–26, *25*, 123n29

cartography: administrative, 5, 118n29; creation of manuscript maps, 4–7, 10–11, 12, 119nn40–41, 119n43 (*see also* individual maps); and desire, 48, 128n88; and elision of secrets, 21, 22, 27, 32, 122nn6–7; as representation of space, 4, 119n39, 119n46 (*see also* scale); scale and, 5, 6, 7, 32, 35, 124n49; scientific, 4–5, 20; state-sponsored, 4, 20, 21; voids in, 1, 10–11, 19, 27, 36, 122n6. See also Comisión Corográfica; individual maps; land disputes; local knowledge; printed maps

cartography and distortion, 6–7, 57, 76, 105–106, 141n19; and Indigenous presence, 42, 44, 101

cartography and textual documents, 11, 20, 32, 105, 106, 118n13; Map of the Atrato River [. . .], 37, 48, 55; Map of the Chocó [. . .], 57, 62, 63, 72–73; Map of the Dagua River Region, 77, 80; Map of the Yurumanguí Indians, 35 (*see also* "Misioneros de Yurumanguí"). *See also* Caicedo, Manuel de, letters by: map presentation

Catholicism, 9, 41, 49, 50, 51, 129n129. *See also* Christianity

Cauca River, *10*, 22, 27, 38, 40, *59*, 98; as navigable, 77, 97

Cauca Valley, 11, 14, 97, 138n25; merchants of, 40, 125n24; river transport and, 38, 75, 84

Central Africa, 15, 82, 107

Cerro Naya, 35, *88–89*, 100, 101, 102

Chandler, David Lee, 16

Charles II (king), 118n32, 142n53

Charles III (king), 1, 40–41, 53; Bourbon reforms of, 5, 93, 107, 118n32; and free trade, 40–41, 125n16

charts, navigational, 19, 24, 27, 124n38, 124n42, 131n15

Chocó, the, 21, 48, *78*, 99, 120n38, 131n12; African presence in, 16, 122n84; Atrato River importance in, 37, 38, 40, 41, 131n4; defense of, 45, 46, 47, 53, 54; domestic economy and, 40, 64, 65, 121n40, 126n35; governorship of, 47, 49, 52, 54, 129n131, 130n172; platinum mining in, 120n38; reducción efforts in, 49, 50 (*see also* Cupica: reducción of; Murindo). See also Atrato River; *Carta del vireynato* [. . .] (Caldas); *Carte des provinces* [. . .] (Anville); Cuna Indians; Cupica; Map of the Chocó [. . .]; San Juan River (Micay River)

Chocó, the, and gold, 15, 40, 97,

"calculated inactivity" strategy, 39, 69–70, 106; of Cartagena, 47, 73; "closure" strategy, 38–39, 57, 125n11 (*see also* Atrato River travel restrictions); Cupica and, 58, 73; of Havana, 38, *39*, 47, 127n64; local knowledge as, 102–103, 108; and reducciones, 11, 45, 50–51, 53. *See also* Atrato vigía; fortresses; forts; palenques

Díaz de Perea, Nicolás, 53–54

Digua River, *88*, 100, *101*, 102

diplomacy, 49, 50, 53, 128n100, 129n112, 129n145; and runaway slaves, 84–85; spaces of, 47–48, 50, 54–55, 127n79, 129n126. *See also* gift-giving

diseases, 15, 121n64; European, 2, 15, 90, 101; malaria, 16, 121n43, 121n63; smallpox, 16, 96, 101, 121n51; yellow fever, 16, 121n63

distance, 135n95, 144n101; conveyed by text, 32, 35, 100, 142n32; local knowledge and, 6, 102; measured in time, 7, 32, 35, 92–93, 141n20, 144n105; topography and, 7, 15, 35, 97–98

distance creating peripheries, 2, 8–9, 53, 77, 87, 91, 103; for Cupica, 11, 58, 59–60, 63, 69, 73, 106; YNR region, 87, 91, 103

dyewood, 40, 120n28

Ecuador, 7, 18, 122n13; Quito, 13, 14, 136n112. *See also* Guayaquil

El Castigo, 84–85, 140n83

El Naranjo, *34*, 35, 92

El río Atrato y pueblos de indios Cunacunas (Map of the Atrato River [. . .]). *See* Map of the Atrato River [. . .]

El Salto, *34*, 35, 82, 92, 139nn50–51

Empson, Charles, 8

engineers, 1, 3, 60, 61, 75. *See also* Álvarez Lleras, Jorge; Arévalo, Antonio de; Bautista Antonelli, Juan; Codazzi, Agustín; Jiménez Donoso, Juan

England, 38, *39*, 40, 47, 48, 55, 84; Indigenous alliances with, 126n45. *See also* pirates, English

environments, 18; African adaptation to, 4, 15, 16–17, 83, 107–108; challenges of, 4, 9, 104, 106; Indigenous relationships with, 4, 11, 102–103, 107–108, 119n38; shaping peripheries, 7, 11, 91, 105, 106. *See also* climate

environments, aquatic, 57, 107; Cupica and, 57, 61, 132n24; Greater Chocó and, 83, 106, 107; Map of the Yurumanguí Indians and, 87, 88, 97; Pacific Lowlands and, 7–8, 18, 83, 105

environments, riparian, 7–8, 11, 75, 82–83, 88, *93*, 97; African adaptation to, 76, 107. *See also* individual rivers

environments, tropical, 16–17, 18, 41, 105, 107, 108; forest, *2*, 41; as impediment to colonization, 2, 91–92, 104, 106, 107; jungle, 1, 3, 7, 92, *92*

ephemerality: maps as records of, 1–2, 4, 5, 11, 12, 75, 105; of mining sites, 18; of settlements, 4, 12, 21, 48, 85. *See also* Map of the Yurumanguí Indians; Murindo (San Bartolomé de Murindo); Sombrerillo

Erbig, Jeffrey, 50, 129n122

Eslava, Sebastián de, 13

Europeans, 6, 14, 18, 83, 85, 122n8; interaction with Indigenous groups, 41, 49; and Pacific Lowland conditions, 7, 16–17, 92, 107–108, 121n64. *See also* foreigners

"Exterior view [. . .] " (Ariza), *46*, *46*

Ezpeleta, José Manuel de, 67, 68

Farallones de Cali, 77, 92, 97, *98*. *See also* Cordillera Occidental

Fernández, José, 62, 66, 67–68, 135n82, 135n85; as corregidor of Beté and Bebará, 66, 134n75, 136n111; and Cupica's church, 71–72, 135n81, 135n83; Indigenous list, 70, 136n126

Fisher, John, 41, 126n37

Flores, Manuel Antonio, 40, 45, 97

foreigners, 13, 138n24, 139n35; and cartographic secrecy, 122n6 124n39; Indigenous alliances with, 38, 48–49, 55, 126n45, 128n89; restrictions on travel, 16, 38, 123n15; and smuggling/illicit trade, 38, 40, 125n16; as territorial threats, 13, 45, 54, 128n89. *See also* Europeans; pirates

fortresses, 38, *39*, 45, 46, 126n54. *See also* Atrato vigía

forts, 45, 46, *46*, 47, 61, 70, 126n55; San Carlos, 46, 47, 49, 127n63, 133n60, *p7*

France, 38, 47, 48, 50, 55, 129n132; Indigenous alliances, 126n45, 128n99, 129n112; military action by, 137n154; status within New Granada, 127n70, 138n24

Franciscans, 87, 91, 93, 94, 101, 141n12, 144n112; Colegio de Cali, 96, 142n60, 143n63, 143n77; Colegio de Popayán, 95–96, 142n60. *See also* Romero, Cristóbal

free Blacks, 18, 83, 130n164

freedom, 15, 75, 82, 83, 84; escape, 70, 77, 84, 85, 91, 107, 136n131 (*see also* cimarrones/as); self-purchase, 10, 17, 85, 122n66, 137n2

free trade, 15, 40–41, 126n37

Friend, Charles, 60

frontiers, 3, 9, 12, 103; Atrato vigía and, 48, 55; the Chocó as, 125n23, 131n12; churches and, 58, 72; Cupica as, 58, 59; Dagua River region as, 81, 82; Pacific Lowlands as, 15, 17, 21, 101, 102, 104, 123n14; reducciones and, 37, 96; YNR region as, 87, 91, 92, 96. *See also* peripheries

fruit, 40, 64, 132n34

Galindo Díaz, Jorge, 125n11

Gallup-Diaz, Ignacio, 49, 55, 128n100, 129n133

Garcés y Saá, Antonio, 81, *81*, 139n34, 139n37

Garrido, Marta, 14

gente libre, 54, 131n175; presence in Cupica, 64, 71, 134n64, 137n141

gente libre de todos colores, 11, 14, 17, 18, 71, 120n18; Sombrerillo and, 11, 140n74

Gerritsz, Hessel, 36, 123nn17–18; *Tierra Firma [. . .]*, 22, *23*, 25, 26

gift-giving, 51, 53, 71, 128n92, 129n122. *See also* diplomacy

gold, 9, 13, *17*; currency, 39, 51; illicit traffic in, 39, 40, 95, 136n127; place in the economy, 10, 14–15, 21, 121n40; taxation of, 15, 39, 94, 142n54

gold export, 18, 95, 120n30, 131n16; majority export, 8, 15, 107, 122n5

gold mining, *17*, 22, 24, *32*, 35, *88*, 100, 105, 124n53, 137n134; alluvial, 1, 2, 15, 45, 103; and defense/security, 41, 45, 46–47, 122n9; and elision from maps, 19, 21, 22, 27, 32, 100, 102; free Africans and, 76, 83, 85; ground sluicing, 17–18, 122n76; importance to the economy, 5, 10, 14–15, 107, 142n54; and Indigenous labor, 15, 120n34, 137n1, 138n22, 142n37; and internal trade, 15, 40, 64, 121n40; mazamorreros, 18, 122n76; mining rights, 18, 21, 80, 97, 100, 139n35, 143n84; reales de minas, 18, 26, 32, 82; reservoirs for, 18, 122n73; tools for, 17–18, 122n75; and transportation routes, 40, 41, 58. *See*

136n132, 137n16; African presence in, 16, 17, 78, 122n8; as gold-rich, 14–15, 119n74, 120n34, 120n39. See also *Pedernales* [. . .] (Caldas); *Tierra Firma* [. . .]

Popayán (town), *2*, 21, 22, *22*, 27, 65, 90; Colegio de Popayán, 95–96, 142n60; enslaved Africans and, 16, 17; link to Yurumanguí, 93, 94, 95, 97, 102, 103–104; mining interests in, 87, 142n37; vecinos/merchants of, 91, 94, 124n44, 125n23, 142n37, 143n83. *See also* Caicedo, Manuel de

Portobelo, *2*, 47, 49, 128n89

Portugal, 39, 50, 129n122

Potosí, Bolivia, 1, 107

Prado, Fabricio, 9

Pratt, Mary Louise, 122n9

pre-Hispanic cultures, 32, 60, 100, 107, 131n14

printed maps, 1, 4–5, 21, 22–31, 118nn25–26; comparison to manuscript maps, 4–5, 10–11; conscious elision in, 21, 26, 32; lack of detail in, general, 2, 5, 12, 21, 36, 118nn25–26; lack of detail in, Pacific Lowlands, 20, 32, 105; voids in, 1, 10–11, 19, 36, 122n6; *Amérique Méridionale* (South America) (Anville), 26, *26*, 30, 32, 123n27, 123n29, 123n33; *Carte de la Province de Quito*, 21, 122n7; *Carte des provinces* [. . .] (Anville), 24–25, *25*; *Good Adventur Bay* (Hacke), 27, *29*; *A New Map* (Hacke and Morden), 22, 24, *24*; *Plan geográfico del virreynato*, 19, *20*, 26, *26*, 27, *102*; *Tierra Firma* [. . .], 22, *23*, 25, 26, 36

pueblos de indios, 21, 42, 66–67, 77, *p2–p3, p6–p8. See also* Beté; Cupica (reducción); Murindo; Pavarandó; reducciones

pueblos de libres, 84, 140n80

Puente, José Carlos de la, 118n27, 139n49

Puente, Manuel de la, 79–80, 81, 138n25, 138nn29–30

Puerto Pinas, 22, *24*

Punta Garachine, 22, *23*, 24, *24*, *25*

quebradas, 17, 18, 22, 82, 94; Aguasucia, *34*, 79, 81, 82, 83, 139n31, 139n44; San Nicolás, *88*, *89*, 94; San Vicente, *88*, 94

Quibdó. *See* Zitará (town)

Quito, 13, 14, 136n112. *See also* Ecuador

Raposo (province), 70, 94, 96, 122n84, 123n32, 139n38; gold in, 79, 97

Raposo (town), 26, 27, 78, *78*, 136n132

Rausch, Jane, 9

Real Audiencia of Santa Fé de Bogotá, 13, 39, 40, 121n40

real cedulas (royal decrees), 39, 40, 53, 68, 125nn16–17

reales de minas, 18, 26, 32, 82

Real Hacienda, 66, 68, 138n29

Recopilación de leyes [. . .], 41, 72, 135n100, 137n141, 140n74

reducciones, 35, 41, 49, 105; abandonment of, 128n92, 128n95; Banana, 42, 44, 50, 55; Beté, 65, 70, 71, 134n61, 134n77, 135n95; Caiman, 42, 44, 49, 50, 55; church importance to, 51, 66, 67, 68, 71–72; in the Darién, 40, 49; and Indigenous protection, 50, 129n107; individual flight from, 49, 65, 67, 71, 135n81, 136n126, 137n135; Napipi, 68, 69; San Ignacio de Opogodó, 67, 68, 135n95, 135n100; Tarena, 42, 44, 49, 50, 52, 55; Tiguere/Tigre, 42, 44, 49, 50, 52, 55; Truxi/Trujillo, 42, 44, 50. *See also* Bebará; Cupica; Lloró; Murindo; Murrí; Yurumanguí Indians, reducción of

Reichel-Dolmatoff, Alicia, 60

Reichel-Dolmatoff, Gerardo, 60

relocation. *See* Indigenous peoples, relocation of

resistance. *See* Indigenous resistance

revenue, royal, 13, 19, 41, 125n16; reliance on gold, 1, 15, 40, 81, 92, 93, 142n54. *See also* Real Hacienda; taxation; tribute

Rico, Antonio, 51, 53

Río de la Plata, 13, 50, 122n5, 129n122, 130n159

Rivaya-Martínez, Joaquín, 144n107

Rivet, Paul, 94, 142n26

roads: connecting to rivers, 65, 66, 67, 68, 69, *77, 78*, 97, *98*; difficulty of using, 8, 32, *76*, 78–79, 80, 83, 85, 138n20; Indigenous, 35, 94, 97, *99*, 99–100, 102, 103, 143n89; lack of, 4, 92, 120n28, 121n40, 123n14; mail service and, 136n117; Map of the Choco [. . .] and, *59*, 61, *65*, 66, 67; Map of the Dagua River Region and, *76*, 77, *78*, 78–79, 80, 82, 83; Map of the Yurumanguí Indians and, *88*, *99*, 100; for mines, *88*, *99*, 100; opposition to, 66, 95, 96, 103–104. *See also* infrastructure

roads, planned/proposed, 8, 11, 67, 105, 135n89, 136n112

roads, planned/proposed, YNR region, 93, 94, 95, 103–104, 142nn53–54; Juan Ventura de Otorola and,

94–95; Manuel de Caicedo and, 96–98, 101, 102, 143n83, 143n89; Pedro Agustín de Valencia and, 95, 142n57; proposed reducción and, 96–97, 143n77

Rodríguez, Pablo, 85

Roller, Heather Flynn, 47, 71

Romero, Cristóbal, 94, 96, 101, 143nn70–71

Romero, Francisco Antonio, 54

Romoli, Kathleen, 120n18

royal decrees (real cedulas), 39, 40, 53, 68, 125nn16–17

Ruta de Antioquia [. . .] (Ariza), 61–62, *p8*

Saffray, Charles, 7, 77–78, *80*, 126n35, 132n20

salt, 51, 62, 121n64, 125n24

San Agustín, 30, 124nn46–47

San Antonio, *34*, 35

San Bartolomé de Murindo. *See* Murindo

San Carlos, 46, 47, 49, 127n63, 133n60, *p7*

Sandoval, Alonso de, 15

San Ignacio de Opogodó, 67, 68, 135n95, 135n100

San Juan River (Micay River, Noanamá River), *10*, 22, *22*, 27, 30, 89, 123n16, 123n30; travel restrictions on, 16, 125n24

San Nicolás, *88*, *89*, 94

Santa Barbara del Salto, *34*, 81, 82, 139n31

Santa Fé de Bogotá, 1, 3, 13, 67, 121n50, 136n116; Real Audiencia of, 13, 39, 40, 121n40; as viceregal capital, 5, 14, 18, 26, 53, 73; viceregal government in, 66, 69, 72, 95, 96, 102, 103–104

Santa Fé de Bogotá, as distant, 2, 9, 14, 53, 106; from Cupica, 11, 58, 59–60, 69, 73, 106, 134n71; from the Dagua region, 75–76, 77

Santa Gertrudis, *34*, 82

San Vicente (quebrada), *88*, 94

San Vicente (sitio), 96

scale, cartographic, 5, 6, 7, 32, 35, 124n49

secret information, 5, 21, 27, 100, 124n39; navigational charts, 19, 27, 28

Sellers-García, Sylvia, 8

Sharp, Bartholomew, 27, 123n24, 124n42. *See also* pirates, English

Sharp, William, 58–59, 122n77, 125n24

Shils, Edward, 8

silla, 8, *9*, 119n67